Dedalus Original Fiction in Paperback

FALSE AMBASSADOR

Christopher Harris was born in London in 1951. After study-
ing art, he had a vast array of different jobs before returning to
university to take a degree in biology and teach science. He
now lives in Birmingham with his wife, a university lecturer,
and writes full-time.

Christopher Harris' first novel, *Theodore*, was published to
great acclaim in January 2000. He is currently writing a novel
on science, art and reptiles called *Brute Art*.

D0715770

Christopher Harris

False Ambassador

Dedalus

For further information about Christopher Harris's writing please visit his website
www.christopher-harris.co.uk

Published in the UK by Dedalus Ltd, Langford Lodge, St Judith's Lane, Sawtry, Cambs, PE17 5XE
email: DedalusLimited@compuserve.com

ISBN 1 903517 00 1

Dedalus is distributed in the United States by SCB Distributors,
15608 South New Century Drive, Gardena, California 90248
email: info@scbdistributors.com web site: www.scbdistributors.com

Dedalus is distributed in Australia & New Zealand by Peribo Pty Ltd,
58 Beaumont Road, Mount Kuring-gai, N.S.W. 2080
email: peribo@bigpond.com

Dedalus is distributed in Canada by Marginal Distribution,
Unit 102, 277 George Street North, Peterborough, Ontario, KJ9 3G9
email: marginal@marginalbook.com web site: www.marginal.com

Dedalus is distributed in Italy by Apeiron Editoria & Distribuzione.
Localita Pantano, 00060 Sant'Oreste (Roma)
email: apeironeditori@hotmail.com

First published by Dedalus in 2001
Copyright © Christopher Harris 2001

Typeset by RefineCatch Limited, Bungay, Suffolk
Printed in Finland by WS Bookwell

A C.I.P. listing for this book is available on request.

Theodore

' . . . it portrays the young Theodore as curious, sensual and very human, anxious to understand what exactly constitutes enlightenment, assailed by religious doubts and constantly at odds with the frequent irrational beliefs of the religious men surrounding him. The greatest strength of Harris' novel is the clear and simple presentation of its often complex moral ideas. Ultimately, this is a novel of curious decency, simply and movingly written by a first-time author of real promise.'

Christopher Fowler in the Independent on Sunday

'Theodore of Tarsus – who became Archbishop of Canterbury in 668 – was a significant figure in ecclesiastical history, and his story is told in this well researched first-person novel what follows is an interesting account of the homosexual saint's life during strange and turbulent times.'

Andrew Crumey in Scotland on Sunday

'At its heart, however, Theodore is a beautiful and poignant love story, examining the passion between twin souls – a love too intense to remain chaste. The author challenges us to consider that while Christianity owes a lot to such love, it will never acknowledge the debt.'

Murrough O'Brien in The Daily Telegraph

'The headline "Archbishop of Canterbury in Gay Sex Shock" may be every tabloid editor's dream, but, in the seventh century, it was a reality, at least according to Christopher Harris's first novel. However speculative the premise, Harris's research is impeccable and he displays remarkable organisational abilities in chronicling the life of Theodore, first as a clerk in the service of Emperor Heraclius, then as archbishop at "the world's misty northern edge". The theological debates on the nature of the incarnation are somewhat fusty, but the scenes of war and episcopal intrigue are vividly described. Despite the novel's lack of an authentic sounding voice, its very

modernity underlines its relevance for the self-deceptions within today's Church.'

Michael Arditti in The Times

Theodore, described as the heretical memoirs of a gay priest, was 7th in The Guardian's Top Ten Paperback Originals for January 2000.

'These fictional memoirs of Theodore of Tarsus, a homosexual priest with heretical tendencies who became Archbishop of Canterbury in the 7th century, will appeal to admirers of *Memoirs of a Gnostic Dwarf.*'

The Gay Times

'the author is adept at evoking the feeling of the time, from the strange world of the Cappodocian monks and the hollow grandeur of Constantinople, to the decay of Rome and the squalor of England. The author explores Theodore's humanity and faith by depicting him as a homosexual, giving the book a philosophical twist that well matches the uncertainty of his times.'

Roger White in Heritage Learning

'While we wait for the historical Theodore to emerge from the labours of professional scholarship, we have the Theodore of Christopher Harris' ambitious and wide-ranging novel to educate and entertain us.'

Catherine Holmes in The Anglo-Hellenic Review

'This is Harris' first novel and Dedalus, an innovative and imaginative small publishing house, are to be commended for finding a new author of such talent and storytelling skill. This book was a pleasure to read.'

Towse Harrison in The Historical Novel Society Review

CONTENTS

PROLOGUE

As we neared Venice, Brother Lodovico had a chest brought up from the hold. We had all seen it before, but not its contents. It was large, and iron-bound, and it took four men to heave it through the hatch, and two to slide it along the deck. When it stood before him, Lodovico produced a key from the folds of his habit, unlocked the chest, and reached into it. He pulled out a long gown of flimsy muslin, looked at it, shook his head sadly, then dropped it back in the chest. Then he tugged out a short jacket of figured silk, then a long brocade coat, then a fur hat trimmed with a feather. He dropped those on the deck, muttering to himself.

The dozen men who lounged on deck left aside their cards and dice, or nudged each other awake, pointing at the friar. Soon we were all watching. He called back the men who had brought up the trunk, and had them upend it, tipping its contents onto the deck. A rich cascade of slithering silk, soft velvet, striped cotton, flowered satin and stiff, white linen spread about the friar's callused feet, joined by tumbling hats, slippers, belts and boots.

"Ambassadors!" he said, looking up at us at last. "It is time to get ready."

We gathered round, looking, curiously but without enthusiasm, at the heap of gaudy clothing.

"You know your characters," Lodovico said. "You know your countries and the kings and princes you represent. Now you must dress like the men you are supposed to be. And remember! The rulers of the West will not take kindly to impostors. We must convince, all of us!"

There was a murmur from the men, but whether of agreement or dissent, I could not tell. Lodovico stooped, and reached into the pile.

"This is the sort of thing," he said, lifting an embroidered robe and holding it against his grey habit. "Anything fancy will make you look Eastern." We held back. He waved

the robe. "Come on! Dress yourselves! Do you want the Venetians to see you for what you are?"

A few men shuffled forward and began to inspect the clothes. They tugged garments from the pile and held them up, feeling the rich fabrics. Some of them smiled, remembering, perhaps, the adage that a man is made what he is by the clothes he wears. By putting on those clothes they would make themselves better than they were. With luck, there might be no need to return to what they had been. A few of them discarded their own ragged and travel-stained clothes, and stood naked, or nearly so.

"Wait!" Lodovico said. "Ambassadors should not smell like goats. You had better wash yourselves before dressing." He called for buckets to be lowered over the side, and watched while the men sluiced each other then dried off, shivering in the breeze. "Pay particular attention to your hands," he said. "They will be seen, and you should not look as though you have done manual work."

I looked at my hands. They were scarred and grazed, with knobbly, swollen joints. Some of the marks were war wounds, which need not dishonour an ambassador, but much of the damage was done by the hard labour I did at Constantinople.

After washing, the Trapezuntine, who was at least Greek, put on some loose trousers and struggled into a tight silk coat with wide red and green stripes. His friend, representing Sinope, was a huge man with a full black beard. He put on a similar coat, which would not button up, and added a red hat, domed and trimmed with fur. The Trapezuntine snatched up an even grander hat, garnished with fluttering pheasant feathers. They capered and twirled, each mocking the other's pretensions, while Lodovico scowled.

"You may look the part," he said. "But you cannot play it. Ambassadors are grave men, they do not mince or prance!"

The two Greeks puffed out their chests, held their arms stiffly and attempted a dignified stroll along the deck.

"Ridiculous!" shouted Lodovico. "Even the prostitutes in Venice could teach you a lesson in dignity!" The Greeks smirked. "Not that I know anything of Venetian prostitutes,"

Lodovico said. "And nor should you. Steer clear of anything of that sort. Women will have the secrets out of you before you've had what you want out of them. Keep away from women. Remember who you are supposed to be. Be grave! Be noble! Practise!"

The Sinopite took the Trapezuntine's arm and led him, bowing and gesticulating, to the stern-castle. They would need all the dignity they could muster. Even in the West it was known that Sinope and Trebizond were all but lost to the Turks, and could deliver little, whatever their ambassadors might promise.

Lodovico turned from the Greeks and shouted to the rest of us in a language I did not understand. The other men put on the clothes they had chosen. I watched while the Persian, a small, dark man, wrapped himself in a spangled silk robe, then put on an embroidered waistcoat and a conical felt hat. The Mesopotamian pulled on a muslin shift trimmed with silk and gold thread, then wound a saffron-coloured turban round his shaven head, leaving a gap for his plaited topknot. The Mingrelian and Iberian, having little idea of what they were supposed to be, dressed themselves in whatever they could find. The Georgian, dressed in bright pantaloons and a short jacket, resumed his chess game with the grey-bearded Armenian, while the other ambassadors squabbled over the remaining clothes.

I held back, reluctant to dress up like a fool, though aware that the longer I delayed, the more absurd my costume would be. Lodovico approached me.

"You, too, must get ready," he said, in his Tuscan Italian. He was fluent, and persuasive, in many languages, though not English. "You must look like a Scythian."

"How can I do that?" I asked. "Scythia is just a name to me, a distant place of romances and legends."

"That is its advantage. No one else will know anything of it either. Besides," he said, pointing at the men clustered around the chest. "Do you think they know their countries?"

"Some of them do."

"Remember your oath," Lodovico said, stroking his wooden

crucifix. Though I knew him to be trickster, he played the simple friar when it suited him, and an oath was an oath, whomever it was made to. "You promised," he said. "And I have done my part." He pointed towards the bows, where a sailor was peering ahead, shading his eyes with a hand. "We are nearly there, nearly at Venice."

"And then?"

"You are to play the Scythian ambassador, as you agreed. You are to carry yourself gravely, and promise troops for the new crusade against the sultan."

"In what language?"

"Any language you like, as long as no one understands it. I would not recommend English. But you know some Turkish?"

"Yes."

"Then speak in Turkish. Add some nonsense if you need to. I will translate everything you say. No one will know the difference."

"He will," I said, nodding towards the Karaman Turk who stood apart, glaring at the impostors with whom he had been obliged to associate himself. He alone was genuine.

"He won't give us away. He is in a difficult position. His master, the Emir of the Karamans, has rebelled against Sultan Mehmet, and is desperate for Western help. If he reveals our imposture his mission will fail, and I would not like to return to the emir under those circumstances. Or to the sultan, if he defeats the emir. The Turks use some very cruel punishments."

"I know." While we spoke the sky had filled with thin cloud and the wind had risen.

"Then you know how much you owe me," he said. "I got you away from them, and I brought you here." He turned and gestured at the empty horizon, as though a wave of his arm could make Venice appear from beneath the sea.

"I got away from the Turks myself. You got me away from Trebizond."

He turned back to me, touching his crucifix again. "All you have to do is remember your oath and play your part."

"For how long?"

"Until I am made patriarch."

"And then?"

"You will be free to go."

He walked away, reeling slightly as the ship pitched. Recovering his balance, he kicked a hat towards the chest with the skill of a Shrovetide footballer. The wind tugged at my clothes, reminding me that I should soon take them off. But what would I be without them? I had been a soldier, and fancied myself a gentleman, fitted out accordingly. I had been a pilgrim, penitent and humbly dressed. I had been a slave, and still wore the clothes I had escaped in. If I put on the dregs of Lodovico's clothes-chest, I would be no better than an actor, playing King Herod in one scene and Rumour in the next. But even actors are themselves, afterwards, in the tavern. Dressed as a Scythian, speaking Turkish mixed with nonsense, known by no one, I would be nothing.

I gripped the ship's side and watched the grey sea slip past the hull. The sky was growing darker. I shut my eyes and listened to the sea slapping against tarred planks, and the wind whistling through ropes and stays. Each time the ship slid slowly from wave to trough I felt the deck drop gently beneath my feet. With each fall, the timbers shuddered, groaning like a sick man lowered into bed. The ship's frame was twisting and creaking, fitting itself to the shifting shape of the sea. I knew that sound of warping wood. I had heard it before. It was in my father's house, where, each night, as a child, I had fallen asleep to the sound of green oak settling and drying, shifting in the wind.

I felt sick, but it was not the sickness the sea brings. It was the sickness of a man who longs for home, and knows that he will not see it without much trouble and danger.

"The snow was deep and soft, and as white as . . ." My father hesitated, unable to think of a suitable comparison.

"As white as what?" I asked.

"As white as you like. What's the whitest thing you can think of?"

My blanket was coarse and grey. I lifted my neck from the hard, chaff-filled pillow and looked about the room. Though the house was younger than I was, the walls were cracked and discoloured, and the boards and beams above me were shadowed and smoke-stained. The yellow candle-light illuminated little else. I thought of white things I had seen in the fields and hedgerows: sheep, swans, chalk, puffballs, hawthorn flowers, bleached bones. Some of those things were truly white. Others only seemed so, according to the season and the brightness of the day. What was the whitest thing? The thing that would always be bright and clean?

"Bone," I said. "Whalebone."

"Well then Thomas, the snow was as white as whalebone."

"And the emperor?"

"I am coming to him. First we must have the procession." He paused for a moment, searching for memories, gathering words to tell them. "Not all the snow was white. The snow on the road to Blackheath was fouled with dung, and trampled by hooves and feet and the wheels of wagons. My boots leaked, and my feet were cold and wet." He shivered, and pushed his hands into his coat-sleeves. "But it was a fine sight. There were drums and trumpets, and flags and banners. There was a great crowd of nobles there, riding along with the new king, all showing their colours. They were warm enough in their thick cloaks. The king's cloak had an ermine collar, and under it he wore a coat of red and black velvet, brought from Italy. His heralds' tabards were quartered with lions and lilies, to show he was King of France as well as King of England, though some said he wasn't either. The emperor had just come from the King of France, so I don't know what he made of it. If he had any doubts, he kept them to himself, just like the nobles. They didn't look down at the dung and trampled snow. They didn't notice the men and servants trudging behind them, slipping on frozen mud. They looked at each other, smiling and laughing, trying to catch the king's eye. They wanted to show how loyal they were, and win preferment for themselves, but only a year before, half of them supported King Richard. They had thought young

Bolingbroke a usurper, but they wanted to be with him when he celebrated Christmas at Eltham Palace. It is always wise, Thomas, to support the king, whoever he may be."

My father paused again, reflecting, perhaps, on the sudden end of his own royal service.

"They were dressed in all the colours you can think of, and all the richest fabrics. When the clouds let the sun through, they shone out against the grey sky like the figures in the cathedral window."

I could not imagine real people looking like those luminous saints and martyrs.

"And the emperor?"

"We met him at Blackheath. He was there with his followers: some Greeks from Constantinople, some priests, of the sort they have, and some Italians to translate. There were not many of them, but they had come a long way."

"Were they dressed brightly?"

"No. They were all wrapped in thick, dull cloaks. They felt the cold, coming to our country."

"But under their cloaks?"

"The emperor wore white, and he rode a white horse. He and his followers wore long silk robes. I never saw anything so clean and white. They were like snow. And his beard. That was like snow, too." He scratched his own beard, which was full and brown, as he was not yet forty. "The emperor was waiting patiently in the snow. He seemed almost made of snow, he was so still and white. The heralds greeted him, then the king greeted him. Then there were compliments and courtesies and long speeches in the cold while the rest of us stood and froze. Then the king and nobles escorted him back to Eltham, while we all trudged along behind. We knew we'd have to serve them when we got there. At the palace, everything was ready. The great hall was hung with tapestries and lit with lamps and candles. All the other rooms were furnished with the sort of comforts that nobles need."

He looked around our room, savouring its emptiness.

"There was jousting, and music, and the king entertained the emperor to a great feast. They had the best food that could

be found, seasoned with spices from the East, though, as the emperor was from the East, he would have been used to that. All the Greeks and Italians took out little silver forks and used them to pick up their food. They wouldn't touch it with their hands. They didn't drink much, either, just a sip, now and then. The emperor took his sips in threes, to signify the Holy Trinity, I think. The emperor was a grave man, with a noble face. Did I say he had a long white beard? He was old, much older than I am now, but he held himself upright, as though he was twenty years younger. He prayed constantly. He was very pious, even though he was a heretic. He was wise, too. No one could understand him, but his Italian interpreters said he was wise, and learned too. All the Greeks are. They know the Secrets of Life. All the Secrets left over from the Old Days and written down in books. At least that's what the Italians said."

My father sat silently for a while, regretting that lost knowledge, dreaming about what he would have done with it, remembering romances about magic and treasure, before resuming his story.

"But the emperor had a flaw. He was after money. That was why he came to England. His city of Constantinople was besieged by Sultan Bayezit, and he wanted money to defend it. Money or men, but chiefly money. Money is more constant than men, and can be carried to where it is wanted without being fed or watered. Money doesn't tire or rebel. But it has to be spent to achieve its purpose. That's its drawback. Money has to be spent."

The candle was burning low, its flame guttering. My father watched it, seeing, perhaps, an emblem of money's transience.

"It was an odd thing," he said. "I'll never forget that I saw the Emperor of the Romans begging the King of England for help. He had already begged from the princes of Italy and the kings of France and Spain, and from both popes." He thought for a moment. "There was a puzzle!" he said. "Constantinople is the greatest city in the world, or so the emperor's men said. It is a city of wonders, guarded by deep water and high walls, and full of treasures saved from the lands the Greeks once ruled. You wouldn't believe what they said about the place.

16

They told us about marble palaces, and churches full of gilded images and jewelled bibles. And busy harbours and rich markets, and wide squares where people stroll in the shade of rare trees that give fruit all year round. There are statues everywhere, of saints and emperors. They even said there were bronze statues that move and speak, but I don't believe it. If that was true, they'd be worse than heretics."

"If his city is so rich, why did the emperor have to beg?"

"That's the puzzle! Perhaps his men exaggerated. Men do, when they're far from home. Some of the Italians said that Constantinople is old and ruined, and that all the churches and palaces are empty, and that Florence and Venice are greater. Perhaps the emperor's men told us what their city had been, or might be, if it could be saved."

That was one of my father's stories. He had many others. Some were about kings, and emperors, and treasure. Others were about battles and loot. A few were about old books with secrets in them, which made men rich. My father had a craving to make himself rich, which he nearly did once. His stories filled me with dreams, and led me to wander. I was always looking for something, though not always the same thing. But my dreams also set me apart, making me think myself better than other men, sometimes provoking resentment.

PART ONE
1428–1436

1 Wild Men

"What I say is this," Ralph said. "Take what you want, when you want it. And if they don't give us what we want, we'll skin 'em!"

And he had no sooner said it than we were nearly skinned ourselves. We had followed some boar tracks into a forest. That was our right, or so Ralph said. The forests and the game that was in them were as much ours as anyone's. That was why we had deserted, stealing away from the camp at night and following him south into a land where there was no law. Once we got clear of the regent's men Ralph told us that we were free, and heroes, and that we would soon be eating roasted meats as often as we liked. He was a big man, with a black beard that obscured half his face like a shaggy bush, and made him look fiercer even than his size suggested. No one liked to argue with him when he said the boar were ours and only wanted killing, even though hunting would be more trouble than robbing peasants. Ralph led us into a stand of young trees thickly tangled with undergrowth, and we stumbled after him, not daring to cry out when the brambles tore our legs or branches lashed our faces. Brave free men do not complain of such things, so we let ourselves be whipped like penitents for the sake of a feast.

The thin straight beeches of the forest edge gave way to gnarled oaks. Great boughs hung over us, forking and spreading, bearing branches that twined and interlocked. The leaves were turning, but there were still plenty of them, and little light penetrated their dense canopy. Where brush and brambles could not grow, ivy cloaked the forest floor, concealing humps and hollows and knotted roots. Fallen trunks lay like dead men, crumbling to tinder when kicked. The damp air was filled with the smell of rank herbs, and of toadstools and rotting timber. We struggled on for a while, watching Ralph's broad shoulders barging through the dense undergrowth. We blundered into fallen branches, tripped over rotten stumps or

slid into drifts of dead leaves. The men's usual chatter faltered and died. The dismal silence of the wilderness was only broken by the sound of breaking branches, or the rasp of men's breath, or a wordless grunt when someone slipped and fell. In that eerie hush a sigh seemed a roar, a grunt a mighty oath, the snapping of twigs the rattle of gunfire.

"What's the matter boys?" Ralph said when he realised we were falling behind him. He climbed on to a fallen trunk, settling himself into a mossy hollow. "I thought you was all country boys," he said when we had caught up. "Ain't there forests where you come from? I know about Thomas, of course. He comes from the Fens. Got webbed feet, he has."

I felt reassured by Ralph's mockery. His theme was familiar and his voice broke the forest's silence. The others all laughed at my expense, and I did not bother to tell them that Norfolk was not all fens, or that my father owned a fine house raised up on a hill. I had told them before, and they still laughed.

"I can see why Thomas is scared," Ralph said, looking down at me from his woodland throne. "He's only a little'un. How old are you, boy?"

"Fifteen," I said, conscious that I was small for my age. "And I'm not scared."

"Hear that?" Ralph said. "If young Thomas ain't scared, there's no call for any of you to be." He slid off the tree trunk, then stood before us rubbing his mossy hands on his leather jerkin. They were big hands and I was always careful to keep out of their reach, even when Ralph was smiling.

"What about the boar?" Fat Henry asked.

"What about them?"

Henry's fleshy face made an ample battleground for the feelings that vied behind it. Fear of the boar fought with hunger and the prospect of eating a tender young sounder. "We've lost 'em," he said, his face settling into sorrow.

"No we ain't," Ralph said. "They're in here somewhere. Don't none of you know nothing about hunting?" No one answered. "What we've got to do is keep on till we get to a clearing, to somewhere open where we can see their tracks again. We'll catch 'em all right. Just you wait and see."

I thought of boar, picturing their bristling backs and cruel tusks, remembering stories of how dangerous they could be when provoked. Under Ralph's direction we cut poles and sharpened them into spears.

"These aren't much use," Fat Henry said, surveying our handiwork. "They need iron heads and good strong cross-bars."

"They'll have to do," Ralph said.

"We've got no hounds."

"We'll have to be our own hounds."

"How can we be men and hounds?"

"Use your noses. And your eyes."

Despite Fat Henry's doubts, our new weapons gave us a little more courage as we plunged deeper into the thickening murk. We lost sight of the sky, and of the sun, and had no way of knowing what course we were following. The forest swallowed us up, taking us into its hollow belly, encircling us with wooden ribs. I started to see shapes in cracked oak bark. Eyes winked from knots and furrows. Mossy holes formed limbs and paunches. Gashes dripped green slime like dribbling mouths. There were faces in the shadows, and wild creatures seemed to stare out of the gloom. But they vanished when I looked at them directly. Were they spirits of the place, I wondered, or real beasts?

I remembered stories I had read at Sir William's house, tales of monstrous creatures from the world's wild places. Silently, to distract myself from the fear I felt, I recited their names and thought about their natures. Griffins, manticores, chimeras, dragons, unicorns and basilisks were all hybrids of other beasts. Heads, bodies, tails, legs, backs, haunches, hooves, claws, tongues, horns, scales, hides, were all jumbled up in the descriptions I had read. Why, I wondered, as I struggled to keep up with Ralph, would God have done that? Why would He have mixed and muddled His own creations, as though limbs and bodies were no more than clothes drawn at random from an ill-packed chest? Perhaps such creatures were not God's, but the devil's. If so, the other sort, the beasts with a human element, were more terrifying. Centaurs, satyrs, giants,

lycanthropes, ogres, dwarfs, mermen, anthropophagi, pygmies, and troglodytes were distorted men, man-beasts, or men that became beasts at times. It frightened me that a man could become a wolf. What could be worse than that? To feel yourself shifting shape, sprouting hair, growing fangs, craving raw flesh, longing for darkness and wild places. That was devilish, to shackle a man to a beast's body, or to fill him with beastly yearnings.

Then, seeing in a flash of sunlight what looked like a crusted pelt, I remembered the cynocephalus. It was the most fearsome of the monsters I had read about in Sir William's books, a creature with a man's body and a mastiff's head. It had a snarling mouth, hands like paws, and a long, shaggy coat. By rolling in mud it could make itself invincible to both blade and ball. Surely such beasts were not real, or lived only in the distant Indies?

My thoughts were interrupted by Ralph's order to halt.

He had led us to a more open part of the forest, where there were patches of bare, leaf-strewn ground lit by shafts of light from above. When I caught up with him I saw that the land sloped down slightly. It looked as though the forest's edge might not be far off. Ralph told us to fan out and look for tracks. I shouldered my spear, wondering how much use it would be if a bristling tusker crashed out of the undergrowth, and shuffled forward, peering at the forest floor. I had served Sir William as a page, not as a huntsman, and had little idea what to look for. There were twigs and acorns among the leaves, and maggot-eaten mushrooms, but nothing, as far as I knew, to show that game had passed that way. I looked up at the other men, who were advancing as aimlessly as I was, staring at the ground or probing heaped leaves with their spear tips. Then, just as I was watching him, one of the men was swallowed up by the ground. There was a sound of breaking, cracking branches, the man's cry as he dropped, then a horrible scream as he disappeared from view. We froze, looking at the spot where the man had stood. His screaming continued, echoing round the forest, disturbing birds that called and cackled harshly.

Ralph ran forward first, shouting at the rest of us to follow. When they reached the spot where their comrade had disappeared, the men formed a rough scrimmage, some pushing forward to get a better view, others pulling back for fear of being swallowed up themselves. I dropped to my knees and pushed between their legs, shuffling along until I could see down into the hole. The smell of mouldering leaves hung in the air. The man's twisted body lay at the bottom of a pit, surrounded by broken branches and dusted with powdery leaves. A sharpened stake, its end red with fresh blood, stuck out of his back. The stake had torn through bone and flesh, and pink, twitching guts poked out of the ragged wound. As we watched, his legs kicked, and more blood gushed from around the stake, soaking his ripped jerkin and running away into the leafy earth.

"Let's get him out," Fat Henry said.

"He's done for," Ralph said, stepping back from the brink. The other men disentangled themselves and regrouped around Ralph.

"He's not dead yet," Henry said. "Listen."

The man's screaming had stopped, but there was a muffled gurgling sound coming from his half-buried mouth. He was still breathing, and stinking offal was oozing from the hole in his back. Flies were already buzzing around him.

"We'll leave him where he is," Ralph said. "And here's why. Someone dug that trap. And put that spike there. And whoever it is will have heard the noise, and they'll be here soon to see what made it."

"We can't just leave him there."

"Like I said, he's done for. The best thing we can do is throw some earth over him."

"While he's still alive?"

"What d'you want to do, then? Stick him with your boar-spear?"

"No, we should wait, then give him a decent burial. And we should pray for his soul."

"He's nothing but dead meat now. Look at him! Food for the worms!"

"If he dies without prayers he'll be no better than a beast."

"You're fools, the lot of you!" Ralph shouted. "Do I have to do everything for you?" He took his spear and stabbed it at the edge of the pit, sending dry, leafy earth down over the dying man. "Come on! Lend a hand!" He thrust the spear into the earth a few more times, loosening the edges of the pit. A couple of the others took their spears and helped, but most of us hung back. Then Fat Henry spoke out again.

"No! It's wrong."

Ralph's face filled with rage. None of us had defied him before, even though he constantly told us we were free. He gripped his spear and stepped forward, and I feared that Fat Henry would end up in the trap. But it did not come to that. Instead, Ralph's advance was checked by a short spear that hit the ground ahead of him. He looked up puzzled, then a moment later, there was a great cry, and a pack of wild creatures emerged from the bushes. They had the bodies of men, but were filthy and half-naked. The things they wore were not clothes, but scraps and rags tied together with strips of leather or woven grass. Some wore shaggy pelts like the one I had glimpsed earlier. Their hair was matted, tufted with mud and stuck with bones and twigs. Some had beards that hung down to their waists. Were they the half-men I had feared? None of them, as far as I could see, had mastiff's heads, but they howled like wolves and snarled like terriers, baring yellow fangs as they opened their mouths wide. The horrible, inhuman noise they made echoed among the tree trunks. It so terrified me that, though I wanted to flee, I could not put one foot in front of another. I stood motionless while the wild men continued their display. They came slowly out of the thicket that had concealed them, waving short spears, banging crude clubs on the ground, grunting rhythmically. Every so often one of them would stoop or crouch, then leap into the air and launch some missile at us. A stick struck me, but it was half-rotten and did no more than jolt me out of my stupor. Other men were hit by stones, or mud, or handfuls of dung. I heard Ralph say something about holding fast, but I could only think of the pit behind

us and the mangled body that lay in it. I did not want to die in a wilderness.

The savages rushed towards us then, waving their weapons and yelling. Their snarls and grunts, incomprehensible at first, resolved themselves into words. I stood for a moment, transfixed, trying to make out what they were saying. I realised that they were speaking a sort of French, saying that they would salt us down for the winter if they caught any of us, that they had done it to some other Englishmen, that we had better watch out if we did not want to be eaten. Were they truly inhuman? Or were they men like us, only more desperate? Then one of the savages dashed forward and swung a great club at a man standing only a few yards from me. He turned to run just too late. I saw the crudely hewn bough smash into the man's head, and his shocked expression as he fell forward, and the blood and brains that spewed from his crushed skull. I felt the thud as he hit the soft ground. That was enough for me. I ran, but took only a few steps before a pole shot out of the undergrowth and caught my stumbling feet. As I fell, a dwarfish figure emerged from the bushes and grabbed me. I felt callused hands grip my arms and pull them behind my back. The stunted savage climbed on top of me, pressing me down into the soft mould until I feared I would choke on powdered leaves. I twisted and struggled, trying to turn my face away from the ground. The savage on my back shifted his weight, shuffling forward, pressing on my head, but loosening his grip on my arms. I feared he would go for my neck, sticking me like a pig. I did not want to end up as salt meat, feeding savages for the winter.

When the savage shifted again, I jerked my body round, twisting it so that I faced upwards. I was not free, but I could see my captor. He sat astride me, looking down, his grimy face only inches from mine, his teeth bared in a cruel grin. They were sharp, yellow, stuck with stringy fragments of flesh. Despite his small stature, the savage was well fed, and strong. His mouth came down, moving towards my neck, opening and closing, drooling and mumbling. By turning over I had made

his task easier. Unless I stopped him, he would bite my throat out.

Then, as drops of stinking spittle splashed over my face, a thought struck me. If the savage had to use his teeth, he could have no knife. Mine had been in my hand when I tripped, but it must have fallen unseen to the ground. The savage leaned further forward, preparing to bite at my flesh. As he did so he raised his hindquarters, which had been pressing down on my arms. Quickly, I felt at my belt. My eating knife was still there. It was short, but sharp. There was only one place I could reach. I slipped the knife from its loop, then plunged it upwards, forcing it into the savage's breech. His mouth opened wide, yelling with pain, jerking back from my throat. As his hindquarters pressed down again, I pushed the knife away, then dragged it up, ripping it through his dangling cod and yard. Blood and shit gushed over me, fouling my hose and coat. But the savage leapt back, clutching at the gash from which his innards were pouring. There was no need to cut him again. I knew he would soon be as dead as the man in the pit.

Leaving the savage to trip and stumble in his own guts, I rolled away, scrambling to my feet. Then I headed down the slope as fast as I could, feeling my fouled coat slapping against my thighs. I kept going until I could no longer hear the wild men's taunts, and could see the edge of the forest ahead of me. I crashed through tangled undergrowth and out into a sunlit meadow. The grass was as high as my waist, and I fell into it gratefully, lying among the flattened blades until I got my breath back.

Of the men who went into the forest, only a dozen came out. Ralph was the last to emerge. There was blood on his spear-tip, and a grim smile on his bruised face. "Savages!" he said. "D'you hear that jibber-jabber they were speaking?"

"It was French," I said.

"It didn't sound like French to me. Anyway, you're only a boy. What do you know?"

"I killed one of them."

"A little fellow like you?" A smile spread across Ralph's

face, making a pink gash in his black beard. "O' course you did, Thomas. O' course you did."

I pointed at the foul mixture that spattered my clothes.

"I reckon you shit yourself running away," Ralph said. The others laughed. "Still, it ain't surprising. There's better men than you that's done that. And told lies about it afterwards."

Without meaning to, I had given Ralph what he needed, a chance to reassert his authority. He led us away, into the open where we could see our enemies coming, and might hope to avoid them.

After that came another humiliation. We ran into a gang of ragged children, who blocked our way, crowding round us and pulling at our clothes with bony fingers. They had stick legs and pot bellies and faces like skulls. They stared up at us with wide eyes, whining that they were starving, begging us to give them food. Ralph refused, saying honestly that we had no food, but the children were not put off. They swarmed over us like rats, tugging at our clothes and hair, gripping hands and legs, climbing onto backs, nipping our skin with sharp teeth, all the time shrieking like squabbling seagulls. Ralph threw his body this way and that, and struck out at the little bodies that tried to drag him down. He looked like a baited bear trying to throw off the dogs, and the rest of us were no better. We had to pull the children off each other as though they were leeches, then drive them away with sticks and swords. But they reformed ahead of us and started to bombard us with stones. They must have laid in a great stock, and some of the children were very skilled, both with the hand and the sling. Ralph, being an easy target, was hit more than once, and blood trickled down his face from a gash on his forehead. One of the other men was so enraged that he charged at the gang, wielding his sword. The oaths he shouted were stopped instantly when a score of stones hit him and he pitched forward onto the ground.

Ralph ran forward then, and some of us followed. We got close enough to see the fallen man's blood running into the bare earth of the path, but no closer. The children launched a

new volley of stones and we were forced to withdraw, leaving the man where he lay.

There was no arguing that time. Even Fat Henry backed off silently.

"Those weren't children," Ralph said as we trudged back the way we had come. "They were a devil's brood. Conjured up by the French, I shouldn't wonder." Ralph rubbed the dried blood on his brow. "Just like those savages in the forest. They weren't human either."

"I reckon Ralph's right," one of the other men said. "Those savages had tails."

"And cloven feet!"

"Devils, all of them."

"The whole land's cursed!"

Ralph could hardly argue with them. He was always telling us about sorcery and bad luck. Among Sir William's men he had a reputation as a wrestler, but I never knew him to do much more than talk. When the nights were dark and the drink was in him, he talked of life's injustices, and of ours. And when we marched, he talked about our leaders' folly and the faulty tactics they were using. He liked to dwell on the unreliability of the French, who had risen against us in Maine, and the greed of the nobles, who disobeyed orders, changed sides and repudiated oaths, all the time grabbing what wealth they could until the people had nothing left to pay taxes with. It was the same back at Orléans, where we had spent a winter digging trenches and raising embankments. The ground was hard frozen, but we hacked at it with picks, slowly extending an earth circle round the besieged city.

"The dauphin's a fool," Ralph said. "Everyone knows that. He's ugly, feeble and stupid. He's afraid of the dark. He's afraid of everything. He couldn't win a war on his own. He couldn't win a game of dice! He couldn't piss in a pot without a servant to hold his yard for him."

The men sniggered, and one of them illustrated the point by pissing against the embankment and watching the steam rise into the icy air.

"It's the dauphin's cronies that rule for him," Ralph said.

"And a rotten bunch they are! When they ain't gambling and drinking, they're fighting each other for their whores. Mistresses they call 'em, but they're whores just the same. But the French nobles ain't fools, like the dauphin. They've got one big advantage that means they'll win this war, fool for a ruler or not."

Ralph had got his audience by then, and we leaned on our shovels, keen to hear what he would say next.

"They're in league with the devil! That's where the dauphin's true power lies. Everyone knows how the dauphin spends his time with astrologers and alchemists. Well, some of his cronies do worse than that. They get together in dark cellars and conjure up the devil himself. They make him rise up from Hell, and hold him captive by spells, and get him to grant them what they want. That's why we can't win! The devil has promised them victory!"

I never knew how much of Ralph's talk to believe. But there must have been something in it. Sir William would not mention the dauphin without crossing himself, and said that we were doing God's work, as well as King Henry's, by driving him from France. That was why he sent me to the trenches, saying I was more use there than serving him. That was a breach of the agreement he had made with my father, but I could hardly complain, and was still digging when Joan the peasant girl rode into Orléans at the head of a relief column.

After that, it was all over in a few days. Thousands more Frenchman arrived, and we could do nothing to stop them reaching the city. Urged on by Joan, and by the priests, who told them that the Holy Ghost was on their side, the French sallied out repeatedly. They filled trenches, and stormed redoubts, and burned fortifications. She led charges that no man would have led, and the English seemed to lose their reason when they saw her. Men dropped their swords, and threw down their shields and helmets as they ran. Afterwards they swore that they had seen angels in the sky, or fiery spirits goading on the French knights. Whatever it was that inspired the French and enchanted us, they captured our camps one

by one until we were driven away from the city and into the countryside.

But for Joan I might have been a hero like my father, not a starving deserter wandering lawless France. She was the cause of everything that happened to me afterwards. I saw Joan myself. I am sure I did. She rode a horse and wore armour and swung a battle-axe, just like a man. They said she was a girl like any other, in appearance, at any rate. Ralph was one of those who thought otherwise.

"I told you so," he said. "That Joan's a fiend, conjured up by the dauphin's cronies. She's protected. She's got magic for a mailcoat. That's why we can't kill her. And that's why we can't win."

Sir William died at Orléans, and I might have died with him had I still been his page. Ralph and I were lumped in with a lot of other masterless men and sent to do garrison duty in the parts of France that were still English. Ralph found a new audience for his grumbling, turning his attention from the dauphin to King Henry.

"The king's only a boy," he said. "And he's a simpleton, they say. He spends all his time praying, and ain't fit to rule. The regent's no better. He rules France for himself, not for the king. But the king ain't such a big fool as we are for fighting for him. If we're to fight, we ought to fight for ourselves, and get the benefit of what we win."

We had not been paid for weeks, and it did not take much more of Ralph's talk to persuade a score of men to desert with him.

After circling round the starving children, we wandered for a while, heading gradually south, away from the sharp winds that blew the last leaves from the trees, leaving us with no cover but gorse and ditches. Ralph kept up his talk of loot and feasts, but I could see that there was nothing to be had by terrorising poor peasants, even if we could catch any. There were too few of them, and of us. The people still living in the countryside had little left that was worth stealing, and we were not strong enough to attack towns or fortified houses.

Sometimes we came across corpses strung up in trees. In one place there were a dozen of them, all stripped and mutilated, swinging slowly in the wind. Their empty eye sockets seemed to watch us as we passed, warning us what to expect if we crossed men more powerful than we were. The crows watched too, hopping and flapping, waiting to resume their feast. There were days when everything we saw seemed to be dead or starving. We roamed the countryside for weeks, foraging rather than looting, living off fruit found in untended orchards, or mushrooms gathered in the woods. Game, which was scarce anyway, disappeared, and we were reduced to grubbing for roots and nuts like pigs in an orchard. Fat Henry, much thinner by then, died from all the toadstools and other foul things he ate. Ralph made us tumble his body into a ditch and scratch earth over it with sticks, not out of respect, he said, but to deny the dead flesh to the savages. One of the other men, ignoring Ralph's disapproval, muttered something he thought sounded like a prayer.

Some of the men were barefoot, and I only had some wooden clogs to walk in because they were too small to fit any of the others. Ralph kept telling us that the weather was better south of the Loire, that the land never froze, that grapes grew all year round, and that wine was so cheap that it was given away freely. I knew all that was false, as my mother had told me all about life in Guyenne. But I said nothing. When we reached the Loire the water was running high, and the bridges had either fallen or were fortified. We stood on the sandy bank, looking across a windswept stretch of water that might as well have been the sea. We could not cross to the land promised by Ralph, so we trudged along the bank, hoping for an unguarded bridge or an abandoned boat.

We were camped by a ruined farmhouse, and were trying to roast some scrawny hares when Umberto's men found us. We should have set sentries, or at least posted someone on what remained of the roof, to keep watch. But we did not, and were exhausted and still unfed when a dozen well armed men rode into the yard, their mounts stepping neatly through the gaps

in the fence. Ralph stood as quickly as he could, and tried to face the men, but one of them covered him with a handgun. It was a clumsy weapon, and I knew he would not be able to fire it easily without dismounting, but its inaccuracy was its strength. We were huddled closely round the fire, and the shot might have hit any of us.

None of us moved. We sat by the fire hopelessly, while more men rode in behind the others, fanning out as they came through the gaps. Some of the men jumped down from their mounts, drawing their swords as they stepped towards us. Unlike us, they wore helmets, and some had mailcoats under their leather jerkins. They were clearly a well-organised force, though they wore no colours to show who their master was. It was almost a relief to see them, as though they had come to rescue us. One of the men called out in French, telling us to get to our feet. We obeyed, knowing that we had little chance of escaping alive if they were the dauphin's men.

Ralph seemed dazed. He had led us until then, dominating us with his size and rough tongue, but he had no idea how to face the men who had caught us. He looked from the men to us, and back again, licking his lips as though about to speak. But he said nothing.

I was the youngest of Ralph's men. They thought me just a boy. But they were children themselves when it came to speaking French. They understood nothing, and could not make themselves understood, even to the peasants we had tried to rob, except by blows and curses. And that language would not work with the men who faced us then. I saw the growing impatience in their faces. They must have thought us simple, not worth dealing with. They would kill us, I thought, just for sport, as boys throw stones at village idiots.

The man with the gun still covered us, and I watched the glow of his match anxiously. One of the others stepped forward and asked who led us. Ralph stayed silent. I was the only one who could talk to them.

"He does," I said, pointing at Ralph.

"And do you speak for him?"

"I can. What do you want?"

"What have you got?"

"Nothing. We are poor men. We have only these hares we are cooking, which you are welcome to share."

"You are the regent's men?" he said, looking with distaste at the hares, which, unattended, were charring in the flames.

"We were."

"Deserters," he said, looking round at his colleagues. One of them stood forward and spoke to Ralph in English. "It's dangerous here. You can't just wander around. This is Umberto's territory."

"Who is Umberto?" Ralph asked, looking slightly happier. They were not the dauphin's men, and, as we had nothing to steal, they probably had no reason to kill us.

"You'll find out."

It was almost dark. The men kindled torches from our fire and quickly searched the ruined farmhouse to make sure we had not hidden any booty there. Before they led us away they insisted that we were roped together. "It's for your own safety," the English speaker said. "We wouldn't want you getting lost in the dark."

We stumbled along among the horses, barely able to see the path, tripping in potholes and slithering in mud. Ralph muttered to me as we went. "Who do you think you are?" he said. "You little squit-tail! You spoke out of turn back there. And you can keep quiet from now on. I'm the leader, and I'll do the talking."

The rest of Umberto's men were camped in a clearing, and had organised themselves like an army, with tents pitched neatly in lines, and a well set fire where men toiled over pots and cauldrons. Once inside the camp, we were untied and taken to the men's leader.

Umberto was a short, broad man with dark, bulging eyes and a protruding chin that was cleft like a pair of buttocks. He had that chin well scraped with a razor, even in the field, and his clothes, too, were rich, hinting at a life spent at court rather than at war. Under a fur-trimmed winter cloak, he wore a brocade doublet of rakish cut, and parti-coloured hose tucked into leather boots. A pair of greyhounds stood beside him,

alert and graceful. They looked gentle, but, like all hunting dogs, they were capable of savagery. Umberto looked a gentleman, but his cruel eyes revealed his true nature.

I watched while Ralph told our story, looking from the rags he wore to the fine clothes of the Italian, wondering what Umberto had done to get his wealth. I had heard of such men, leaders of free companies that preyed on the French, English and Burgundians alike. In a way, we were lucky to have been caught by him. Unlike the dauphin's men, he had no particular grudge against us. We had not defied him, or taken anything of his. But I could not help being afraid. How many men had been killed on his orders? How many houses burned and villages despoiled before Umberto made himself master of the lands he claimed? We might get away with our lives, but I knew that we would not get anything from him without making a bigger sacrifice ourselves.

Ralph seemed to think we had found what we were looking for. He stood before Umberto, towering above him, not noticing his contemptuous expression, boasting.

"We were at Rouen," Ralph said, though he was far too young to have been at that famously bloody siege. "And at Falaise, and Caen, and Paris, too. But Orléans, that was our greatest day. You should have seen us there!"

Umberto, who must have known as well as we did what a disaster Orléans was for the English, smiled grimly but said nothing.

"We are all brave men," Ralph said. "All tested in battle and skilled with weapons. We'll do anything, fight anyone," he said, his voice weakening. Umberto stood silently, running a gloved hand over a greyhound's head, looking at us sceptically. His men could kill us easily, if they wanted to, or send us out into the cold if they thought us not worth the bother of killing. It would amount to the same thing. We knew how empty the countryside had become, and could smell the stew that seethed over the glowing fire. Warming ourselves and filling our bellies seemed more important than anything else.

Then Umberto spoke. His greyhounds pricked up their ears when they heard his voice. His English was broken but his

meaning was clear enough. He told us that, as his company was a free one, if we fought for him, we would indeed be fighting for ourselves, and would have the benefit of what we won, which would be greater for having been won by a bigger company. There would, of course, be terms and conditions, but nothing that a brave and honourable man would hesitate to accept. While Ralph treated with Umberto, I kept quiet and listened to what was being said around me. Unlike most of my companions, I could understand what the men of the free company said among themselves, in a gabble of French and Gascon. It was clear that they thought us a half-starved rabble, no use in battle. I had my doubts about them, too, but I kept them to myself. We could not go back.

Umberto tugged off a glove and, with visible revulsion, held out his hand. Ralph knelt and kissed it, then the rest of us knelt in the mud and swore allegiance, giving up our freedom to join the free company. Umberto, leaving a deputy to deal with us, retired from the clearing to his tent. The greyhounds trotted after him. Then, at last, we were allowed to draw close to the fire and receive a dole of stew.

When Umberto told us that our first task would be to help him capture a castle, I was uneasy. Something told me that it would be all risk for us, and all gain for Umberto. But it was cold by then, bitterly so, and it was clear to us that if we wanted to eat we would have to fight. And as Umberto told it, the castle would be warm and comfortable and full of every-thing a man could want to get him through the winter, even the bitterest. There was to be no siege. We would take the castle quickly or not at all. And if we failed, Umberto said, we would starve. So my fellow deserters cheered and took their places among Umberto's men, ready to march to the castle.

Whoever occupied the castle had been lazy, allowing woodland to grow up around it, and ditches to fill up. They set no lookouts that night, and Umberto's men were able to climb over some low earthworks and creep near to the walls without being seen. As the first faint light of dawn crept into the eastern sky, we took up our positions.

My companions were put in the advance party that was to storm the gates. I held back, fearing to join them. It was obvious that Umberto did not care whether we lived or died, and that if the attack faltered he might withdraw his men leaving us to be cut to pieces by the gate's defenders. I was wondering whether I might slip away and hide somewhere when one of Umberto's sergeants beckoned me.

"You there," he said. "The small fellow. Come here."

I meekly went to him and stood while he looked me up and down.

"What's your name?" he asked. He was a tall, long nosed man, who had to stoop to speak to me.

"Thomas Deerham, sir."

"I am Fulk the Burgundian," he said. "You'll remember my name. And if you know what's good for you, you'll do what I say."

"Yes sir."

"Can you crawl?" Fulk asked.

"Crawl?" I feared he would ask me to humiliate myself in some way, but had no choice but to answer. "Yes sir, I think so."

"You'll do," he said. "Follow me."

I followed the Burgundian sergeant to a nearby grove, where a cloaked figure held a darkened lantern. As we approached, he swung open the lantern's door and shone its light in my face. "You'll need this," the cloaked man said, closing the door again and handing me the lantern. "And this." He picked up something from the ground and thrust it into my arms. It was a sack of something light, perhaps tow, which stank of pitch and brimstone. "And you must be very careful to follow all the instructions Fulk gives you.

"You must carry these with you," Fulk said as we walked away. "And make sure the lantern stays lit."

"What, sir, am I to do with these things?"

"What I tell you. But first you must get to your place." He led me up a low bank of grassy earth, stopping at the top. "See over there?"

In the grey dawn light I could see that the sergeant was

pointing to a dark streak ahead of us. "That there's a ditch," he said. "And at the end of it's a gully. And the gully goes up into the courtyard. You're to crawl along it."

"Into the courtyard?"

"That's right."

"And what am I to do there?"

Fulk gave me a few curt instructions, telling me what I was to do and when I was to do it. "There's just one more thing," he said, reaching behind him. "You'll need this, too." He pulled a heavy lump hammer from his belt and held it out effortlessly. I had to hang the sack from my belt before I could take it. "At the end of the gully," he said, while I was still fumbling with the sack, "you'll find a grille. It's old, and rusted through, or so we've been told. A good thump with the hammer and you should have it out in no time." He looked up at the sky, assessing its brightness. "Now," he said. "To the gully."

I ducked down and scrambled towards the ditch. I dreaded lowering myself into it at first, tearing a stinking channel filled with dung. I peered in, looking out for the glint of water, then I sniffed. It was no more than a rain ditch, half blocked with undergrowth. I slipped down the slope, testing with my feet before sliding right in. I crouched down and crept along, as quietly as I could, until I reached the outlet.

I put the sack and lantern down and stood, listening. Behind me, in the darkness, I could hear the clinking of armour, the murmuring of voices and the stamp of feet. Surely the castle's occupants would hear us and wake up? If I was to slip away, that was the moment. But the sergeant had said that other men would follow me up the gully, and they were sure to be nearby, watching me. If they came and found me shirking, they would kill me and crawl over my body. I was of no account to them. If I could not go back, I would have to go on. I felt the stonework around the opening of the gully. It was cold, almost icy, and slippery with moss. I kicked off my wooden clogs, which would be no use to me in climbing. Then I arranged the sack so it hung behind me, stuck the lump hammer in my belt, held the lantern ahead of me, and

began to crawl, awkwardly supporting myself on one elbow. I had to stop frequently and pass the lantern from one hand to the other before I could go on. My knees and elbows were soon rubbed raw. The hammer weighed me down and caught in my legs. Further in, the stone was bare and smooth, and I could hardly get a purchase. I lay flat and wriggled like a maggot, arching my back and pressing my bare feet against the slimy stonework, holding the lantern carefully above my chest. All the time I was in the gully the damp soaked into my clothes until I was wet through.

When my head hit the grille I almost fell back. Gripping the sides of the gully with icy fingers, I paused to get my breath back, shivering with cold and effort. The smell from the sack pricked my nose until I feared I might sneeze and give myself away. But there was no sound coming from the courtyard. Were the defenders sleeping? Or were they cunningly waiting for us in silence? And there was no sign of anyone following me up the gully. My instructions were to act when I heard the attack start. But I would have to knock the grille through before I could do anything, and that would make a noise.

I touched the lantern. It was still hot. I held my hands close to it, trying to warm them. Then I heard a shout, and a great crack as something was swung against the gates. Suddenly there was uproar in the courtyard, as men began to run and shout orders. I could hear plenty of men inside, though I could not see them from where I lay. I realised then that I did not know who the defenders were. They might have been French or English, or a mixed company like the one I had joined. Very carefully, under cover of the rising clamour at the gates, I hammered at the grille. It was indeed very rusty, and I saw that I would soon have it free if I wanted to. But did I want to? It was clear that I could not take the gates on my own, and I had no wish to die in the attempt.

If the attack failed, I might lie in the gully as long as I wished, but would starve or freeze if I did. If I rejoined the remnant of the company they might blame me for their failure. If Umberto's men did break in, and found me still lying in

the gully, they would regard me as a traitor. If I did as I was told, and was seen doing it, I might be a hero. Whatever I did, I risked death. My best hope, I decided, was to knock the grille through, then raise it slightly so I could see into the courtyard. Then I could see how the attack was going and act accordingly.

With a few quick upward blows I knocked out the supporting bars and heaved the grille down so that it rested on my bowed head and hunched shoulders. I waited like that, gathering my strength. Then I heard a tremendous sound of smashing timber and men's voices raised in triumph. I lifted my head, the grille with it. The first thing I saw was my fellow deserters bursting through the shattered gates, Ralph at the head of them, swing an axe wildly. He cut down one or two of the defenders before they knew what was happening, but they rallied quickly, and were soon setting about my fellows with their swords. Two of them marked Ralph as a leader. They took turns to lunge at him, stepping back as he swung his axe, stepping forward again when the blade had passed. They seemed to be playing with Ralph, mocking his size and clumsiness. His bulk made him an easy target, and he wore no armour, just a studded leather jerkin.

Ralph looked round hopefully at the men he led. They lingered by the shattered gates, keen to keep something behind them. None of them came forward to help Ralph. While he hesitated, one of the defenders raised his sword, lifting it high above his shoulders. The blade glinted for a moment in the feeble light. Then it crashed down into Ralph's head, cutting skin, smashing bone, sending him staggering to the ground, brains spewing out of his broken skull like porridge from an overturned bowl. His killer stepped over the fallen body and advanced to the gates. The rest of my fellows stood there terrified, unable to go forward or back, knowing that Ralph's talk had led them to their deaths.

It was time for me to act. I reached down and pulled up the sack, tugging out a handful of stinking tow. Then I opened the door of the lantern and pushed the tow in, holding it until it lit with a feeble bluish flame. Carefully, I pushed the tow back

into the sack and closed the mouth for a moment. Thick, sulphurous smoke poured out. It swirled around me, filling my mouth and nose. I gulped air, but my throat felt as though it had been stabbed. I had no choice then. If I did not get rid of the sack, I would suffocate. I braced myself against the sides of the gully and jerked up my head and shoulders, flinging the grille up into the courtyard. Then, heaving myself upwards so that I could see better, I threw the sack, as hard as I could, into the knot of men battling for the gate. Smoke billowed out of the tumbling sack, engulfing the men, blinding and choking them. They staggered, coughing, rubbing their eyes, dropping their weapons.

A moment later, the first of the Umberto's men burst through the gateway. Their faces were swathed with cloths, which they had, I learned later, soaked in urine. They swung swords and battle-axes, hacking at anyone not swathed like themselves, not bothering to distinguish between the defenders and my fellow deserters. They soon gained the courtyard, then rushed through the inner gates pursuing the fleeing defenders. Other men poured in behind them, some carrying buckets of earth, which they threw over the smoking sack. With the fresh air that blew through the open gates, the courtyard began to clear, but the remaining smoke was blowing towards me, clinging to the ground like mist over water.

I had no wish to choke in that gully, or to be cut down by Umberto's men. I needed somewhere to hide until the fighting was over, and the attackers battle-fury had abated. I climbed out, and scuttled round the courtyard, keeping close to the wall like a rat. Then I huddled behind a stone buttress, part of the outworks of the gate. I wondered for a moment whether, once the attack had been pressed, I might dash out of the gate and make my own way through the country to some place of refuge. Umberto's men would not come after me once they had installed themselves in the castle and were enjoying its luxuries. But I was soaked and barefoot, and knew of no place of refuge. I would be easy prey for all the other bands of deserters and robbers that infested the country. I considered what to do, but could think of nothing except

hiding behind that buttress, so I hid, pressing myself against the cold stone as hard as I could, waiting for a chance to escape.

The fighting was almost over. Umberto's men were dealing with the last of the defenders, cutting throats and hamstrings, gouging out eyes, hacking at necks and limbs. I dropped to the ground and rolled quickly, turning two or three times on the stony floor, towards the gate. Once among my former companions, I dipped my hand into their congealing blood and slopped it onto my face. I scooped up more, splashing it over my arms and legs, rubbing it into my coat. Then I lay on the hard ground, feeling the blood stiffening, waiting for the fight to end. I did not want any of Umberto's men to find me when they were still in the mood for killing. It was not pleasant to be lying among mangled corpses, fouled by stinking guts and shit, but I judged it necessary for my survival. And my survival, I decided, was the most necessary of all things.

I lay for a while, looking out of half-closed eyes, until I saw Fulk, the sergeant who had instructed me. He stood out because of his height. I groaned a little, and squirmed, and with as much difficulty as I could simulate, raised myself up onto knees and elbows. In truth, I was bruised and cut enough after all my crawling and climbing. The sergeant, seeing where I had lain, and that the grille was knocked through, knew that I had carried out my orders. He called over some of his men, who cleaned me up and gave me a wineskin to drink from. I did not ask why no one had followed me up the gully. In battle, lies are as common as changes of plan.

After playing such an important part in capturing the castle, I thought I would be a hero to the free company. But Fulk disabused me of that idea.

"You followed orders," he said. "That's all. And if you know what's good for you, you'll carry on obeying orders, especially when I give them."

"See them?" Fulk said, a few weeks later. He raised his wine cup and waved towards the top table in a gesture that might have been friendly or contemptuous. Umberto was there, surrounded by his newly arrived entourage. There were men

dressed in silks and satins, who talked quietly and sipped their drinks. Umberto's greyhounds curled elegantly at his feet, occasionally snapping up scraps or growling at the other dogs, the mastiffs and spaniels and harriers, that wandered the hall freely, feeding where they could.

There were women among the new arrivals, and servants, as well as musicians and others of that sort. In their baggage were chests of fine clothes from Italy and Flanders, and rich Arras tapestries, which they hung on the dark walls to make the castle seem more like a palace. There was talk of jewel-boxes full of gold and silver and precious stones, and of other treasures, of which Umberto was said to be fond. But I was never sure whether to believe it. If Umberto had so much, what need had he to rob and pillage? Why did he not live like the gentleman he thought himself?

"Those men," Fulk said, waving his cup again at the top table. "They're soft."

All around me, men were drunk. But Fulk was sober. That made his words all the more surprising. Not knowing him well, I said nothing, but listened to the gentle buzzing of the shawms that accompanied our meal. I was keener to get hold of some food than to listen to Fulk. The cooks had laboured for days, and the dishes they produced were carried to the hall by relays of servants. There was roasted boar and venison, swans and herons, eels and lampreys, stewed rabbit, and a score of other dishes, all dressed as artfully as the season would allow. There were tarts and pies and sweetmeats, and puddings of rice and saffron, and many rich foods of a type I had rarely eaten before.

"They're soft," Fulk repeated. "Not all of them, I'll admit. Umberto's a hard man. You don't want to cross him. And a few of his gentlemen are tough enough. And the women don't count, obviously." He pointed to the top table again. "But there are men there that don't fight. They don't go out and rob and pillage like we do. They take. And they take from us. To buy their fancy clothes and luxuries." He gnawed at a lump of rabbit, then pulled a bone from his mouth, drawing it slowly between his lips. He pointed the bone at a tapestry that

hung nearby. It showed a man in armour hesitating before three naked women with an apple in his hand. "What use is that?" he asked. "Whores with their tits out! What you want is the real thing, not a picture. But not them," he said, gesturing at the top table again. "They prefer pictures."

Fulk threw the rabbit bone to a wandering hound, and watched while it crunched the morsel up. I hastily stuffed my mouth with boar, so as to be unable to reply. It was good to eat that meat, a kind of revenge for the futile hunt Ralph had led me on.

Fulk banged his cup on the table. "What do you think?" he said.

"I don't know," I said, after gulping the last of the boar.

"You know what?" he said.

"No."

"I reckon you're soft, too." He looked me up and down. In honour of the feast, I had been given some new clothes. They were better than the rags I had been wearing for most of the winter, but hardly as fine as those worn by Umberto's favourites. Fulk himself was dressed in a gaudy brocade doublet, though he had shown his contempt for such finery by spattering it with grease and sauce. Why did he think me soft?

"I've earned my place here," I said, perhaps more forcefully than I intended. "I helped capture this castle."

Fulk peered at me down his long nose. "You threw a sack," he said.

"I did more than that. I worked through the winter with the other men. I've dug ditches and felled trees and raised palisades. This place is much stronger than when we took it."

"Slave's work! Unless you learn to kill like the rest of us, you will never be a man."

"I have killed," I said, thinking of the savage in the forest. But no one had seen, or believed me then, and no one was alive to confirm that we had even been in that fight. To the men of Umberto's company, I realised, I was just a boy, and would have to prove myself.

I looked around the hall. The men and women at the top table looked as gentle as any courtiers, and chatted to each

other in French and Tuscan. But the men I sat with were an ugly lot, and the fine clothes they wore did nothing to disguise their disfigurements. To them, a scarred brow, or missing ear or finger, was a badge of their trade, something to be flourished at a victim to show they meant business. They spoke a rough jargon, composed of words from half-a-dozen languages, that marked them out from honest men just as surely as their scars. They were the worst of men, and proud of it. And I was one of them. I feasted with my new companions, filling my belly while I could. I did not know what lay ahead of me, but I had survived. That was a good start.

Yet Fulk's accusation bothered me. If he thought I was soft, I would have to show him that I was not. But what if he was right?

As a boy, I had no wish to be a soldier. I longed to learn Latin and understand what was written in old books. But my father would not let me go to school, still less to the university, as I wished to.

"Your brother Walter's the one for that," he said. "He's the eldest, so he'll go to university and learn the law. That way he can protect us when others try to take what we've got. That's the way of it in this world. If you don't watch out, others will take everything. But one lawyer is enough. I won't send you off to school. There's something wrong with you, boy. You spend too much time thinking and dreaming. If you ever got to the university you'd fall among the friars and take up their way of life. I know you! You'd become an idle scholar, and what's the use of that? Among the friars, you'd end up begging and preaching and earning nothing."

I might have answered that I got my habit of dreaming from my father, but I knew better than to interrupt him when he was praising Walter.

"You'll be a soldier," my father would say when he had ruled out scholarship. "That'll make a man of you. War will make your fortune, just as it would have made my fortune if I hadn't been swindled. Look at Sir William! His family were farmers a couple of generations back, but they made their

fortune in France. You can learn from him, and go off to war with him. And if you don't come back rich, you might as well not come back at all!"

My father knew what he was talking about. He had served Sir John when he was a boy. By his own account, he was not much of a page, and learned little of what a page should, but Sir John, who might have taught him by example, was not much of a knight. Later, he called my father his squire, though he flattered himself by doing so. Sir John was a man who went wherever the wind blew. He had supported King Richard when Bolingbroke rebelled, then sworn loyalty to Bolingbroke when he made himself king. Later, Sir John led his men abroad, to fight the French. They defended the king's lands in Guyenne, campaigned in the Dordogne, and skirmished among the vineyards of Bordeaux, saving the city from the Count of Armagnac's men. Later they were at Blayc when the great siege was rained off, and the Duke of Orléans had to withdraw his sodden army. After that, the French king went mad, and Guyenne was left in peace for a few years.

It was in Bordeaux that my father met and married my mother, Genevieve, a wine-merchant's daughter. The merchant only agreed to the marriage because Sir John had promised my father an estate in Norfolk, in return for his good service. Robin and Genevieve returned to England, but there was no estate. My mother nearly went back to France when she discovered the truth, but she was already carrying my brother Walter. Perhaps my father knew all along that there would be no estate.

It was from my mother that I got my dark hair, and a skin that turns brown in the sun, leading many to take me for a southerner. My skill in languages also came from her. And my father? What I got from him is a mystery.

2 The Free Company

Not long after the feast I had a chance to prove myself when Umberto led the first raid of the season. After a winter confined in the castle, there was a cheerful mood among the men. Umberto rode at our head with six of his favourites, all gaily dressed and attended by their squires and grooms, just as though they were at a tournament or on a hunting expedition. But he never took his hounds raiding. They were too precious to him, more valuable than any man.

The rest of us followed, taking our places according to our station, and it was a pleasure to be riding through the flat country by the Loire, seeing from my saddle the land I had trudged on foot, only a few months earlier. Spring had come, and the land was green and full of promise. The banks were crowned by clumps of yellow-flowered gorse, and the meadows were carpeted with dandelions and daisies. The trees were heavy with blossom, and I wondered who would pick the fruit when it ripened, as the countryside was deserted. The land was empty and neglected, and many of the farms and villages we passed had been abandoned, and would produce nothing until peace made them safe from raids like ours. However, that first expedition was not directed at peasants or villagers, but at a Burgundian who had fortified a church and was raiding lands Umberto considered to be his. The Burgundian, we were sure, was not expecting us. His company was smaller than ours. It was quite likely that they would surrender as soon as they saw us. The raid was an exercise, a proof of Umberto's superiority.

It did not trouble Fulk that he would be fighting a compatriot.

"Why should I care?" he said, when a Gascon raised the matter. "We're a mixed company, and fight for ourselves, not for our countries. Besides, there's Burgundians and Burgundians. I don't much care for those Flemings the duke rules.

Merchants, not soldiers, that's what they are. Always looking out for a profit."

The Gascon grunted his agreement. Flemings apart, I never could see the difference between a Frenchman and a Burgundian, though their rulers found plenty to disagree about.

We rode on, until a scout announced that the church was not far off. Umberto and his gentlemen dismounted and had their squires arm them. The rest of us were allowed to sit for a while in the shade, for it was a slow business. They stood like statues, only raising an arm now and again, while the squires strapped on their armour. They started with a mailshirt, then fixed backplates and breastplates, and then cuisses and vambraces and greaves, and many other pieces, all hinged and strapped to be as light and flexible as possible. I watched keenly, wondering whether I would ever be rich enough to possess such a suit of armour myself. Umberto's was the finest the armouries of Milan could supply, and the burnished steel flashed brightly in the dappled sunshine. I knew from what my father had told me of Agincourt, and from what I had seen at Orléans, that men so well armoured are not always much use in battle. However, Umberto proved effective enough on that day.

The squires' last touch was to lower heavy bascinets onto their masters' heads. While they were working, the grooms had led off the riding horses and brought up the destriers that carried Umberto's followers into battle. When all was ready, they thundered off, and the rest of us followed, though without fresh horses. We had no great weight of armour to bear, and did not count as gentlemen.

The church was squat and heavy, not built in the high style of town churches. It looked as though it had grown out of the ground. There was a bell tower, on which some men were stationed, but little else in the way of defence. There were no earthworks, just a half-built palisade. They must have been working on it as we approached, as there were timbers and tools thrown down on the ground, and heaps of chips and shavings littered the fresh green grass. The smell of sawn wood hung in the air, but there was no sign of any workmen.

We halted on a nearby hill, and Umberto sent down a herald, who called out a challenge, daring the Burgundian to come out and fight. He was offered a single combat, a contest between favourites, or a full battle. He could surrender, if he preferred, and be spared, with all his men. Free companies, I thought, could not be so bad if they treated each other with such respect. The former occupants of our castle had not been so lucky. Perhaps we would watch a formal combat, then ride back as cheerfully as we had come. But there was no answer from the church. Instead, an arrow shot from the bell tower and buried itself in the herald's chest. He toppled forward and slid off his saddle, but one foot stayed hooked in a stirrup. When his frightened horse shied and galloped off, he was dragged behind it, fresh blood spattering the new grass.

In that moment our carefree mood vanished. Umberto spurred his horse forward, then after a few steps, reigned it back, cursing. His favourites cursed louder, Fulk barked an order, and we all dismounted, men and horses all milling around in a confused mass. Even as I struggled to tie up my mount, my guts knotting at the prospect of actual fighting, Umberto set off down the slope to the church, his gentlemen clanking behind him. They crouched low as they ran, defying the arrows that glanced off their armour. I was relieved when Fulk shouted that we were to hold back rather than follow them.

Umberto's battle-axe was already raised high as he took the last few steps to the church. As soon as he reached the doors, he slammed its blade into their ancient timbers. The sound echoed strangely through the empty countryside. He left the axe there for a moment, watching the quivering shaft, then heaved it out and stood back. His fellows had reached the safety of the porch, and each took his turn, stepping up and swinging their weapons against the door. Sharp blades and spiked hammers struck the boards, splintering them until the door burst open.

When he judged that the moment was right, Fulk shouted the order to advance. I took my sword in my right hand and held my shield high, leaving only a small gap below the brim

of my helmet. I had no wish to be brought down by an arrow. I knew well enough that no one would bury me or say a prayer over my corpse. We ran down the slope, desperate to reach the door without being hit. But Umberto's men were inside by then, and the defenders were too busy to think of us. Fulk got in first, with some of the more experienced men just behind him, but I was not last. I was determined to prove my worth, and to win whatever was to be won in such actions, whether it was money, praise or promotion.

The noise inside the church was deafening. Women were screaming, and men shouting, and steel was clashing on stone and wood. The light slanted down from the small, high windows, catching the armour of Umberto's gentlemen, who had surrounded the Burgundian, and were battering him as fiercely as they had battered the church door. There was no pretence at chivalry. They attacked him from all sides, hacking at his arms and legs, making it impossible for him to hold up a weapon. They knocked him off balance with blows to his steel-clad head. They jabbed at the joins in his armour, cutting straps and tendons. They swung at his chest so that his breastplate caved in. His armour was sliced through repeatedly, the cut edges biting into his flesh. The noise was terrible. It was like chains and cymbals and cauldrons, all thrown together in some echoing place and rattled by giants. The Burgundian must have been deafened as well as stunned. For a moment, only conflicting blows kept him standing. Then Umberto took a swing at his helmet, crushing the forged steel and sending his rival reeling. He crashed to the ground as loudly and as limply as if his suit had been empty.

Umberto raised his axe, then smashed it down at the fallen man's helmet, hitting a hinge and loosening the visor. He swung again, catching the visor's peak, ripping it off, revealing the Burgundian's face. It had no features, nothing that could be called human. It was just a red pulp. But Umberto did not stop. Watched and guarded by his favourites, he raised his axe repeatedly and smashed it into the dead man's face. The Burgundian had defied him, and he would obliterate him.

I did not see what happened next, as I was in the thick of

the fighting myself by then. As soon as the Burgundian fell, my fellows began hacking and slashing at a motley crowd of defenders, most of whom were trying to run rather than fight. They were as lightly armed as I was, and stood even less chance against a well-wielded axe. But my new companions had seen Umberto's anger. They could not afford to be less ferocious than their master. And I knew that I could not afford to hang back. The men would not tolerate anyone who watched them kill, but did not himself kill. I remembered how I had ripped out the savage's innards. Something like that, done in front of all the others, would prove me a man. But I could not find a man to fight. The defenders were shrinking back, trying to avoid danger, to be captured rather than killed. So I copied my fellows, doing what they did, wielding my sword vigorously while hitting nothing. My lack of ardour made no difference. All around me, bodies sagged and slumped as hammers pierced steel and blades cut through flesh. The defender's swords were useless, and were soon dashed out of their hands. It was not long before a dozen men lay dead on the church floor, and twice as many begged for mercy on their knees.

We routed out the men and women who were hidden around the church, dragging them from dark corners and driving them into the nave. When the fighting stopped we had fifty captives, twenty of them women. The defeated men continued to beg, prostrating themselves, looking up at us with their faces smeared with blood and dirt. They swore that they had never meant to defy Umberto, but had been pressed into it by the Burgundian.

When he knew the church was safe Umberto called his squires and had them lift off his helmet. Then he surveyed the captured men. They gripped Umberto's legs and pleaded to join our company. They tried to kiss his mailed hand, and pledged eternal loyalty. He watched them beg, listening to their humble words with a cruel sneer.

"These men have no pride," he said. "They are no use to me. Take them outside."

First they were stripped, and any of their clothes and

weapons that had any value were thrown in a heap for us to take away. Next they were paraded naked in front of their women, and had to stand in the sun, pale and bruised, while anyone who felt like it insulted them. Some of the women, who had been their captives, cursed them roundly, and said it served them right for what they had done. The women cannot have expected any better from us. A few of the bolder men called out that they had learned their lesson, and were readier still to join us. But that was not Umberto's plan. He had enough men for the time being, and the Burgundian's company was worth more to him dead than alive.

When the captives had been humiliated enough they were led away be killed. They fell to the ground and had to be dragged up the hill. When they were goaded with swords, they begged and shrieked and put up hands to fend off the blades, not caring that their hands were cut to pieces. What was a gashed hand compared to a cut throat? Some of them had to be trussed like pigs before they would submit to death. That made us despise them even more. How could we do our work well when they howled like beasts?

Fulk stalked the hilltop, urging his men on, giving advice and quelling arguments.

"Get behind your man," he said, when he saw me hesitating. "Or are you scared?"

The man I had been given to kill was bigger than me, and struggled vigorously, even though he was tied up, and well held by one of Umberto's Gascons. But seeing Fulk, and hearing the sneer in his voice, made me determined to do the deed boldly.

"Not too close though," Fulk said, seeing me move in. "He might shit himself. If he hasn't already."

The Gascon laughed, and our captive almost shook himself free, but Fulk stepped over to hold his other arm. I positioned myself carefully, trying not to get too close to my victim.

"Always get your man by the hair," he said. "If he has hair. If not, get your fingers in his eye sockets. Then pull his head back."

Fulk's presence seemed to calm the man. He had hair, so I grabbed it and pulled.

"Now," Fulk said. "Stick your blade in the side of his throat. Then jerk it forwards."

I cut his windpipe cleanly, and had a moment to step back before the blood gushed out of his severed veins. It poured down him, not me. Fulk and the Gascon allowed the limp body to drop.

"That's it. Killing in battle's one thing. But if you kill in cold blood, do it cleanly."

Fulk strode off, giving a general order to lop off the dead men's ears and noses.

"We should've done that before we killed 'em," the Gascon muttered. "They might've talked then. Told us what they done with their gold." He kicked the blood-soaked corpse, as though it might still reveal some secrets.

"Maybe they didn't have any," I said.

"You know so much? You show me how to carry out Fulk's orders."

"Why don't you?"

The Gascon was short, but broad. He gave me a menacing look. "You soft?" he said.

I bent over the dead man and began to cut. I felt the tearing of flesh and gristle, then the scrape of bone, as my blade cut round his head. It was impossible to do that cleanly, and the man's blood fouled my shins and feet. All around me, other men were doing the same. When we had trimmed their corpses like butchers, we strung ropes around their necks, but before hoisting the bodies up, each man's yard was cut off. The Gascon cut our man, and seemed to take pleasure in handling the limp member, severing it, pushing it into the man's slack mouth, and using a sharp stick to make it stay there.

Those mutilated corpses, swinging from the trees, blossom fluttering down on them like gentle snow, would warn anyone what to expect if they defied Umberto.

I tore up some tufts of long grass, sat under an unburdened tree and tried to clean myself. The blood was already clotting, and my hose stuck stiffly to my legs. Then Fulk sent us down to the church to deal with the women. Umberto and his men

were in the nave, talking quietly in Tuscan while their squires unbuckled the various parts of their armour. Umberto's fury had abated. He had taken no part in the slaughter and mutilation of the prisoners. The women cowered in a corner, awaiting their fate. I joined a gang of half a dozen men, who clearly relished the job they had been given. Grinning and bantering, they shoved hands between the women's breasts, hefting them like fruit, feeling for hidden valuables. They ran their hands up thighs and down haunches. They made the women lift their skirts, and poked beneath them, probing their captives' secret places.

"Here's a hairy one," they called out. Or, "Seen the size of these?"

But they did not rape the women there and then. That would have been against the custom and practice of the free company.

Because I was new to the task, I was obliged to search the women no one else wanted, the ones who were ugly or old, or too ragged to own anything worth stealing. But one woman was being avoided for a different reason. She sat calmly, watching us with a contemptuous gaze, silently daring anyone to touch her. She was better dressed than the other women, and her bearing, even when sitting on the bare floor, was haughty. But that was no bad thing, I thought. If any of the women had concealed valuables about them, it would be her. She might be the Burgundian's woman, a prize to be delivered to Umberto.

I stepped forward boldly, determined to play my part. I told the woman to stand, giving my untried voice as much authority as I could muster. She obeyed, slowly and deliberately, and I found that she was taller than me. When I reached out to touch her she looked down at me with a condescending smile, letting me know that whatever I saw or touched, I was so far beneath her that it counted for nothing. All my new-found boldness melted away. She stood stiffly while I ran a hand over her sides, and flinched when I dared touch her breast, as though my fingers were as cold as ice. When I bent to lift her skirts, she fixed me with a glare so terrible that I was utterly cowed. I glanced briefly at her legs, noting how pale and clean

they were, then gave up and let her go. I did no better with the next woman, who was as meek and humble as any, and would have let me pry and probe anywhere, had I the heart for it.

When we finished, Fulk went over to Umberto, who was standing for his squire, waiting for the last of his armour to be removed. Fulk asked which of the women he would like. Umberto's answer silenced the church.

"Do you know me?" he shouted. Fulk, surprised by Umberto's rekindled rage, mumbled a reply. "Evidently you do not know me," Umberto continued, not quite so loudly but just as forcefully. Everyone in the church was watching. The squires ceased from disarming their masters, the men stood idly, and the women, crouching on the cold floor, looked up with a mixture of hope and fear flickering across their faces. If their captors fell out, who knew what might happen to them?

"Have you ever known me take a woman by force?" Umberto said, glaring at Fulk. The sergeant, though he towered over his master, looked somehow smaller. Whatever he thought, he dared not answer, and Umberto carried on. "I have no need of force. I can have any woman I want. I have never raped a woman or taken a girl's virginity against her will," he said. "That would be to behave like a beast. Where is the pleasure in that? Where is the subtlety? To take by force what can be had by flattery or persuasion? No. Not for me."

No one dared say that we all seen Umberto behaving like a beast, furiously smashing the face of the man who had defied him.

Fulk stepped back muttering, "But the men . . ."

"The men!" Umberto shouted. "They are just men. What do I care how they take their pleasure? So long as they do not kill men who might be ransomed. What do I care about them? They are no better than beasts. If they want to endanger their immortal souls by indulging in the sin of rape, so be it." With that, Umberto strode out of the church, his squires hurrying after him, picking up armour as they went. All but one of the gentlemen followed, forming a clanking procession out into the open air and sunlight. Only Amadeus

remained, and he was a cruel, stubborn southerner who might have rivalled Umberto, given the chance.

The men, who had stood like statues throughout Umberto's tirade, looked at each other and began to chatter.

"You heard our master," one of them said. "If we want to, it's up to us."

"That's right," another man answered. "It's only what's due to us."

"If we're no better than beasts, let's do as beasts do."

There was a general cheer, but a loud voice cut through it.

"Hold back!" Amadeus glared round the company, who knew his anger and were silenced. "Whatever Umberto said, you can wait," he said. And the men waited while Amadeus shrugged off the last of his armour and strode towards the women. He gestured for them to stand, which they did. He inspected them carefully, then chose the haughty woman and led her to the back of the church. Amadeus was not fastidious like Umberto. He did not care who saw him unfurl his yard and take his pleasure. He threw the woman on the altar and slapped her hard across the face. As she fell back he tore at the front of her dress. The rich fabric ripped loudly, falling open to reveal her breasts. He fumbled with her girdle, but its fastenings were too intricate, and quickly gave up trying to loosen it. Instead, he grabbed her skirts and bundled them up, forming a thick roll of cloth round her waist. She was not naked, but he could see what he wanted. And so could the men. They had shed blood, and would shed their seed. They watched with stiffening yards while Amadeus climbed on top of the woman and forced himself inside her. She did not resist, but tugged at her bundled clothes, searching for something.

The men had been silent until Amadeus entered the woman. At that moment they turned away from the altar as though in response to an order. A sudden outpouring of voices filled the silence of the nave. The men began to shout and push. They wanted to grab their own woman and get on with it before Amadeus finished, before Umberto changed his mind. A few of them took hold of women and dragged them off, then others tried to stop them, wanting to make sure of

their own turns. They scuffled, staking a claim by grabbing an arm or breast. In a moment the nave was filled with the sound of shouting soldiers and weeping women.

I had never seen such a scene before, though I was to see it played out many times in the years I served with Umberto's men. Free companies have their traditions and privileges, and their ways of doing things. There are always men who claim precedent, and others who dispute it. And there are men who did badly last time and are determined to make up for it. As there was little loot on that occasion the women were all the booty we had.

I was watching the growing riot, wondering where I stood and what I should do. Fulk came into the church, and seemed about to speak, to quell the disturbance, when the nave was filled by a scream. We all turned towards the altar, expecting to see that Amadeus had killed his victim. Some gentlemen were like that, not wishing any commoner to share their pleasures, even though it went against the rules. But it was not the haughty woman who screamed. Instead, she was struggling free from the weight of Amadeus's body, a bloodstained knife in her hand. The body rolled off the altar and hit the floor like a sack, blood flooding out onto the worn slabs. She rolled back and sprang to her feet, facing us all with the knife held out.

"Cut her down," Fulk shouted.

Half a dozen men, me among them, drew knives or swords and advanced. She did not hide behind the altar, but stepped forward proudly, a grim smile on her face. With her free hand she gathered her ripped clothes round her. We hesitated, glancing at each other uncertainly. Fulk repeated his order, but still no one struck. The woman looked at the men who faced her, then fixed me with a withering stare. Her lips moved, and she seemed about to speak. I wondered what would happen to me if Fulk knew that it was me who had failed to search her. I did not hesitate any longer. She still held her knife, but loosely, without skill. I knocked it from her hand with a sideways blow, then, as she looked with surprise at her empty hand, I

plunged my long knife into her belly. When the blade went in she did not look shocked, but satisfied, as though she had sought her own death. And perhaps she had, as some say there are worse fates, though I cannot imagine them. She did not make a sound, not even a groan. She fell to the floor, and her blood mingled with that of the man she had just stabbed.

When they saw what I had done, the men who had stood by all rushed forward and thrust knives and swords into the body, competing to inflict the worst wound, to cause the most damage. She had only just fallen. Any of them might claim to have been her true killer.

I stood with the long knife in my hand, watching two rivers of blood flow together. The beautiful body I had not dared inspect was no more than a butchered carcass, twitching and flapping as each blade struck. I felt sick and confused. I wanted to be a hero, to be thought a man by Umberto's men. To do that, I had to kill. Men killed in battle. Gentlemen killed in jousts and single combats. But I had killed a trussed captive and a dishonoured woman. And I had only killed them because others told me to.

I felt a hand on my shoulder, and looked round to see Fulk looming over me.

"Well done, lad," he said. "You did what you had to. That's two in a day. We might make man of you yet."

I had done the right thing. I had pleased Fulk. He would no longer think me soft. Fulk removed his hand from my shoulder and turned to the others. "Strip her and string her up."

They cut away the sodden clothes and dragged the body outside. Fulk knelt by the fallen man, feeling his face and neck, pressing an ear to his bloodstained chest.

"He's still breathing," he said. "He's not dead." Then, as Umberto strode back into the church, Fulk began to shout at the onlookers. "What are you waiting for? Find a wagon! Get some bedding! There must be some, somewhere. Bring some water to clean him. If we can get him back to the castle, the chaplain might be able to fix him up."

Even I could see that Amadeus would not last the day. But there was nothing else to be done, and men reluctantly

abandoned their women and went looking for wagons and bedding. Before long we were trundling back to the castle, sadder, and no richer, than when we had set out, a line of roped women trailing behind us.

There were many more raids that year, and for several years afterwards. Each spring we went out to despoil the countryside and bring back whatever we could. At first Umberto led us, but later he often stayed at the castle with his hounds and favourites, and we were led by Fulk. Throughout the hottest part of the year we sweated in steel and leather, attacking neighbouring strongholds, repelling rival raiders and imposing Umberto's rule on the surrounding country. Sometimes we lost a few men, and sometimes our numbers were swelled by the men we had defeated.

The raiding went well for a year or two, and the loot was plentiful. We held up mule-trains and wagons, raided small towns, waylaid merchants, burned villages and kidnapped travellers for ransom. Sometimes we rode out just for show, to remind townsfolk of what we might do if they failed to pay their protection money. One summer we kept a particular lookout for children, whom Umberto could sell to Gilles de Rais, a baron who had fought alongside Joan at Orléans. I have no idea what the baron wanted children for, but he was willing to pay a good price if they were young and pretty. And this same man was the Marshal of France, charged with doing away with the likes of us, among other things.

We thought ourselves grand then, and above other men. Our dealings with French nobles like the marshal seemed to prove it. But the truth is we were brigands, and I robbed and slaughtered like the rest of them. We killed as farmers plough and herdsmen herd. We pretended that death meant nothing to us, and sometimes it was not pretence. I toiled with the men, learning to fight as they did, with no regard for fairness or chivalry, thinking only of what could be got, and how little could be risked. But I was always glad when autumn came, and the end of the campaigning season approached. We would make a last effort to fill the castle's cellars, intercepting supply

wagons, grabbing what we could from cowering peasants, then we would retire behind the high walls.

Raiding was a risky way to live, and not all our enemies were so easily defeated as that Burgundian and his company. We had to avoid the regent's men, and the dauphin's, unless there were few enough of them to be overpowered. If we raided their supply trains we always had to move on quickly, before bigger parties caught us and took back our booty.

And we were not the only ones living as we did. New companies were always forming from the hordes of deserters that swarmed the countryside, and some of them were as strong as we were. Sometimes we found ourselves fighting for what we took, not just with those we took it from, but with others who would take it from us. Then we seemed, not brave free men, but starved hounds quarrelling over a gnawed carcass.

Often there was not enough booty to go round, and I always came last in the sharing out. If I was lucky enough to grab something for myself in the confusion of a raid, I had to hide it well to be sure of keeping it. Bigger men than me would claim anything I had as theirs, and, if I did not hand it over in a spirit of brotherly co-operation, would take it by force. I realised then that my father had been lucky to get as much money as he had from warfare, even though he complained of being cheated by his fellows. How had he done so well when I was doing so badly?

Perhaps the answer was that was that my father had fought in real battles, unlike the sieges, skirmishes and routs I had seen. His greatest triumph, so he used to say, was Agincourt, where a ragged English army had defeated the French and slaughtered thousands of their finest knights. Everyone who fought on that day had made himself rich and come home a hero. There had been no battles like it for twenty years, or so it seemed. That was why I found it so difficult to enrich myself. I often wondered what my father would have thought of the life I led then, and what I would tell him when I returned.

However badly it went for the rest of us, Umberto and his

favourites lived well, despising the men who kept them warm and well fed. As Ralph used to say when he was persuading us to desert, "When a stag is killed, the hound gets the paunch, but the master gets the haunch."

The favourites lived like drones in a hive, enjoying what the rest of us gathered from the countryside. I wanted to be like them, not like the men I fought with. I was not content to feed on what Umberto's friends did not want. I wanted to live like a drone, too, to elevate myself above my fellows. And why not? I owed them nothing. They stole from me, and would happily have let me die, just as my former fellows died when we took the castle. My survival since was due more to my care in avoiding danger than to their care for me. If I were to escape the dangers of brigandage, I would have to become a courtier. I began to study Umberto and his favourites, watching and listening, trying to learn their secrets.

When Umberto stood, I noticed, he stood still. And when he moved he did so effortlessly. He liked to give the impression that what he did, he did easily, and that if he made an effort he could achieve much more. He cultivated the Golden Mean of behaviour, avoiding excess in deed or manner. That, his chaplain once told me, was the essence of a courtier.

I set myself to learn Italian, of the Tuscan sort spoken by Umberto. His favourites all spoke it, and sang and recited in it, too. They said it was the most civilised and poetic of languages, and most fit for a gentleman. Most of Umberto's favourites could sing and some played on the lute, protesting, without conviction, that they lacked talent. They valued literature, and were always quoting scraps of poetry to each other. If they did not actually read, they posed prettily with a book. If I got the chance, I decided, I would learn about books, too, and make myself better than the illiterate men I fought with. With luck, I might make my fortune and be able to return to my family.

Yet there was someone in the company determined that I should not better myself. That person, who had a name, but

not one I am willing to remember, was Umberto's *buffone*. Kings and great lords keep fools to divert their followers and convince themselves that they are beyond criticism. Umberto, fancying himself a great man, had an ugly French hunchback who capered and grimaced at his command. I have heard it said that fools are often wise men in disguise, but that hunchback lacked wit, and subtlety. Had he been tall and straight, he would have been a bully, but as he was, he had to rely on mockery and sarcasm. His face, as misshapen as a gargoyle's, was a picture of brutality. Its tics and twitches betrayed the twisted man's bestial nature, just as surely as Umberto's calm face concealed his true thoughts.

There was no cleverness in his jokes, just mockery. Umberto despised crudity, but his men, whatever their language, were entertained by the hunchback's obscene antics. In a real court, jesters have licence to mock all, even the most exalted. But Umberto's fool knew better than to mock his master, or his master's favourites. He made the weak and powerless his butts, picking on outsiders like me, getting laughs by mocking gauche youths or clumsy servants. I hated the *buffone*, and tried to avoid him, but he often followed me, imitating my gait and posture.

The men of the company valued the *buffone's* power to avert the evil eye, and they always touched his humped back before they went off marauding. I could no more have touched him than I would have touched a toad, and perhaps that was the reason for my bad luck. Had I been willing to play his game and laugh with my tormentors, I might have been accepted. His buffoonery was thought beneficial by the men, though I never found it so.

The fool noticed me because I had fallen in love. That marked me out from the other men, who boasted that they could have as many women as they wanted, and saw no sense in wasting fine feelings on them. Falling in love also went against my father's advice. My mother used to say that he loved his house better than he loved her, and he never denied it.

"That's the way it should be," he said. "Any man who loves

more than that should be sent to the apothecary for a good strong draught of borage and hellebore."

The fool seemed to notice my feelings for Catherine almost before I did. He mocked my dreamy smile and drooping posture, calling out whenever I appeared in the hall.

"Here comes the little courtier," he said, putting a hand on his hip and mincing after me. "What a fine fellow he thinks he is! And all for a serving girl! He's in love, and what a mug's game that is. Love's a trick. It's how scheming women get weak men to do what they want. None of you would fall for that, would you, boys?"

Flattering his audience was as much part of his performance as taunting his victims, and the men roared their approval. But I was not like them. I was superior, or so I thought. And I was haunted by the memory of the woman I had cut down on my first raid. Her haughty face, and the way she had calmly killed and then been killed, made me hold back from forcing myself on captives.

As the fool said, Catherine was a serving girl. But she was the most beautiful woman I could imagine. She was young, and slim, and high breasted. Her every gesture seemed more elegant than the affected posing of Umberto's women, and her glance froze me like the stare of a basilisk. She pretended not to notice when the fool mocked me, even when he insulted me grossly, calling me a worm, a maggot, a creature too small and feeble to make love properly to a woman. Her attitude gave me hope. Surely, if she shared their contempt, she would have laughed at me like the others. But with the fool drawing attention to me it was impossible to linger in the hall. To avoid him, I took to lurking in passageways, pretending to be on an errand, hoping to bump into her. I was always drawn towards the kitchens, where serving girls of all sorts constantly came and went. I often saw Catherine, but never dared speak to her, except once.

I had been waiting in a passage near the kitchens for what seemed hours, and was pacing and twitching with fear and anticipation, inwardly rehearsing the words and gestures I would use when she appeared. Each time I heard footsteps my

hopes and fears surged up, wrestling with each other until I was almost incapable of speech or movement. When she finally appeared, bearing a basket of fruit for the hall, I knew that I had to speak, or forever stay silent. With legs that seemed as limp and tangled as ropes I stepped forward and blocked her way. She stopped and looked at me, her faint smile revealing that she had read my thoughts. I struggled to remember the words I had rehearsed, and had assumed a manly posture, puffing out my chest and throwing back my shoulders. I drew breath to speak, ready to say whatever came to mind, trusting that it would serve. After all, lovers are often said to speak nothings, and it is the fact of having spoken that counts. But nothing was all I said. Before my mouth could form any words Catherine had burst into laughter.

Her shoulders heaved and her breasts bounced and she gripped the handle of her basket harder, fearing her fruit would fall to the ground. My mouth opened and closed silently. She was everything I wanted, and I was unable to say so.

Then I realised that she was looking over my shoulder, to something behind me. I turned, and there was Umberto's *buffone*. He had not been there before, I was sure of that, but just when I needed my pride and dignity most he had appeared. He simpered and smirked, bending his already-bent back in a mock bow, raising a crooked arm in a jerky flourish. His gestures were quite unlike the simple sincerity I aimed for, but they had the effect he intended. Catherine took her basket and went, her laughter echoing along the passage.

"Why pick on me?" I asked, when Catherine had gone. It was the first chance I had had to talk to the fool without an audience. "Why can't you leave me alone?"

"Because you make it so easy. Telling everyone that your father was a hero! You mark yourself out. *'My father was a hero,'*" he said, mimicking my voice. " *'He fought at Agincourt, you know!'* Do you think the men of this company care about that? They've all got heroes for fathers. Some of them are heroes themselves, or would be if it wasn't for their bad luck." He took a step towards me and gave me a grim smile. "And now you've done me the great favour of falling in love. It

couldn't be better! You've made yourself my victim," he said. "The men are just waiting for it. Don't expect any quarter from me."

"Can't you think of anything better to do than mocking me?"

"Mockery is my trade. It's what I do. Mockery is in my nature." For a moment, he looked almost sad, a state I had never seen him in before. "What else can I do, looking like this?" He held out his hands, exaggerating their crookedness, raising them to frame his face. If carved in stone, he might have spouted water from a church roof. "I was born like this," he said. "Some say my mother coupled with a beast. There was one, a great shaggy beast that roamed the countryside where I was born. It had the body of a bull, and the head and tail of a snake, and feet like a turtle. It had green fur, and breathed fire. There were lots of stories about it, about how it raided villages and destroyed the crops and ate virgins." He leaned forward, thrusting his face into mine. "It did more damage than the English." His hands pounced, grabbing my wrists. "They killed it," he said. "The men of Le Mans rode out and cut off its tail. That was its weak spot. After that they were able to slice the beast in two, or so they said. It might all be nonsense, of course, but one thing is true. Everyone has a weak spot."

I said nothing, but tried to back away, to free myself from his grasp. But the fool was not finished with me. "Maybe my mother didn't couple with the beast," he said. "Maybe she was frightened by it when I was in the womb. I don't know. I never saw her. She took one look at me and dumped me with the monks. And if I had a father, I never saw him. But that beast was put together all wrong, just like me."

The fool gripped my wrists harder, his ragged nails digging into my flesh. "You know what the monks used to say?" I shook my head. "That the devil made me, not God." His voice sank to a pathetic whine. "It was just an excuse. If I was the devil's not God's, they could do what they wanted with me. And they did. They whipped me, and used me, and made me do everything there was to do that was foul and unclean. It

was those monks that planted the seed of hate in me. I ran away from them as soon as I could. But maybe they were right. Maybe I am the devil's creature. Or maybe God is crueller than men think. Either way, what can you expect from me but devilry?"

When winter cold gripped the countryside there was little choice but to stay in the castle and make the best of a cold season in a strong place. Umberto and his favourites assembled in the hall, which had a huge fireplace with a chimney. That was a great convenience for them, and kept the air sweet and free of smoke. But it was usually denied to the rest of us, and we gathered wherever a fire could be lit, burning the huge heaps of firewood the peasants had been forced to bring us, drawing close to the fire so that before long we all stank like smoked hams. Our worst hardship was boredom. The men told stories, played cards and dice, or laughed at the fool, who was at his worst then, knowing that neither his audience or his victims could get away.

I longed to escape from all that, and I did so, in the end, with the help of a wound. I got it in one of the last raids of autumn, when we were reckless in our greed for loot. The cut in my leg was a clean one, which I hardly noticed at the time. But it would not heal properly. It ached, and wept pus, and made me limp like an old man. As the winter cold bit harder the ache turned into a pain that kept me awake at night, and made me fear that unless my leg could be cured I might never fight again. What would be the fate of one who could not run and leap and climb, or wield a weapon without stumbling? Umberto was ruthless, and would not retain any followers who could not serve him well. I might be thrown out into the countryside, which was growing colder as the worst winter anyone could remember took hold of France. Perhaps, if I was lucky I might find work in the castle, but only as a servant. My scheme to make myself a gentleman was failing before it had begun.

As the Great Freeze deepened, everyone talked of food and firewood, and how there would be nothing to steal next spring if all the peasants froze to death. All I could think about

was my leg. I tried not to limp as I went round the castle, wandering from warm place to warm place, but the fool, who had killed my love, whose one talent was to watch men carefully and spy out their weaknesses, saw and mimicked me. He shuffled about after me, hardly needing to exaggerate his own ungainly gait, letting a wince play across his ugly face each time his left foot touched the ground. I held myself straighter and fixed my face in a grim smile, but he still mocked me. Before the next raiding season began, I would have to get the leg cured.

Umberto's barber was skilled at shaving his master's cleft chin, and at dressing his hair, and at making his followers look more like women than men, but if he knew anything of wounds he kept that knowledge to himself. If any of the men were wounded badly, they died, as men always do in battle, and if they were only scraped they made light of it and bound up the injury themselves.

I feared I would never be cured, until one day the chaplain saw me hobbling along and, instead of passing me by hurriedly as he did with most of the men, stopped and looked.

"What is wrong with your leg, young man?" he asked.

"It is a wound, sir," I said. "But I have bound it up."

"Have you shown it to anyone?"

"No, sir, it is best not to show off wounds, unless they are safely healed and a sign of valour."

He looked me in the face, studying my expression carefully. His eyes were close together, and set deep in a narrow, bony face. A ring of straggly hair ran round his head, forming a natural tonsure. "What is your name?"

"Thomas Deerham, sir."

"Haven't I seen you before?"

"It was me you gave the sack and lantern to, just before we captured the castle."

"Of course! The Greek Fire. It worked quite well, as I recall. But it would have worked even better if I had had all the right ingredients."

I thought the smoking mixture had worked quite well enough, and might have killed me if it had worked any better.

The chaplain stared at me again. I wondered why he did not look at the leg.

"You are afraid," he said. "I can see it in your eyes. You fear being thrown out if you cannot fight."

"I daresay it will not come to that, sir." He was Umberto's chaplain, and I though it best to make light of the wound in case he told his master and ended my service.

"Nonsense!" he said. "If it still hurts, this long after the raiding season, then it must be festering. Do you know where my chamber is?"

"The little room above the chapel?"

"That is the place. You may come and see me after I have finished in the chapel. I may be able to do something for your leg. In fact, you might come to the chapel with me now. I am not so sure of my skill that I do not think a little prayer would be of no assistance."

I followed him to the chapel and watched while he set out the vessels and vestments. There were many of them, as Umberto was not afraid of raiding churches, and sent the less valuable loot to his own chapel. The chaplain fussed over each item, holding things up and gazing at them, placing them straight, then moving them again. He was like a merchant setting out his stock to its best advantage, determined to make a sale.

"Will our master Umberto come?" I asked.

"Come here? To the chapel? Why should he do that? It is a long time since Easter, and Christmas is still a few weeks away."

"I thought he might come here to pray."

"What for?"

"For victory. Or to give thanks for what he already has."

"Let us not speculate about our master," the chaplain said. "Though his soul may be in my care, he prefers to guard it himself." He looked up from the vessels he was arranging and gave me a warning look. "How often do you come here to pray?"

"I was here at Easter."

"Just like the others. Once or twice a year, whether you

have sinned or not!" He put down the last of his vessels and stood by the altar as though giving a sermon. "I used to think the winter was a good time for faith," he said. "But that was before I came here. Most men, when the winter comes, think of the sins they have committed in the year, and of the price they will pay in the life to come, and that stirs up their faith."

I remembered what the fool used to say, that the chaplain had been a friar, and that some terrible sin had led to him being expelled from his order. But others said that there was no sin bad enough for that, and that the friars would have anyone. It struck me later, when I knew him better, that that was why he was so careful in the chapel. He fussed and fiddled with vestments and vessels, arranging everything neatly, following every detail of the ritual. It was as though he would save his own soul, if he saved no one else's. That was the merchant's bargain he had made with God.

"But not Umberto's men," he said. "Nothing stirs up their faith. They are not like regular soldiers, who face a foe as dangerous as themselves. Brigands do not pray before they fight. It is their victims who do the praying. And men whose sword-arms are seldom stayed by the God their victims call on will not think to call on that God on their own account. For most of the time men like you think yourselves beyond prayer and retribution, and only remember that their deeds have consequences when they are on the brink of death. They do not know what sin is, still less virtue. Are you proud to be one of them?"

"No," I said. "And yes." The chaplain looked at me sadly, but how could I answer him? "It is the only life I know."

"If only you soldiers would listen," he said. "I can preach. I have the tongue for it. I can tell men the truth of what will happen to them and what they have done wrong. And I can baffle them with learned nonsense if that's what they prefer to hear. Yet no one comes to hear me but once or twice a year. I come here, not every day, I confess, but often enough. I preach, I pray, I chant, I celebrate the mass. But who sees or listens?"

I offered him no answer, and he turned and looked at the

little altar before dropping to his knees and bowing before it. He knelt there muttering to himself for some time, and I wondered whether I might creep away and leave him to pray alone. But a twinge of pain in my leg reminded me why I was there. I stood, as far away from the chaplain as I could manage, watching him while he went through the ritual, saying words in Latin I could not follow, touching and lifting cloths and vessels, making gestures with his hands. He did not look to me to take part in what he was doing, and when he had finished he tidied everything away as though the vessels were no more than the tools of a carpenter or tailor.

"We have dealt with souls," he said. "Now we can deal with bodies."

I followed him up the narrow steps to his room, where he invited me to sit down on a stool. I hesitated to sit before him. His status was hard to assess. His learning surely gave him precedence over me. But he urged me to sit.

"How else can I get a good look at your leg? Do you expect me to grovel on the floor while you stand?"

So I sat, and waited while he put on his eyeglasses and bent over me. I felt strange as he tugged at my hose and uncovered the cloths I had used to bind up my leg. He gently lifted my leg and poked at the oozing wound, making me flinch.

"It is as I thought," he said. "I can treat this, but not now. I will have to make a poultice. For the moment, I will put some sour wine on it and bind it with a fresh cloth."

He did as he said, and told me to come back the next day. When I did, he had a pot boiling on the small brazier that heated the room. He lifted the lid and showed me a greenish stuff bubbling at the bottom of the pot.

"What is it?" I asked.

"Cabbage simmered in sour wine, and some rue and wormwood, of course."

"Will it heal the wound, sir?"

"It will, but there is something I must do first. Unroll your hose so I can get the bandage off." When the wound was exposed he poked at it again, muttering himself. "You must not tell anyone I have done this," he said.

"What is secret about a poultice? My mother used to put soaked bread on grazes."

"It is not the poultice, but what I am going to do now that you must keep secret."

"What is that?"

By way of an answer, the chaplain took my leg and twisted it, so that I tipped over and nearly fell off the stool. I had to hold myself up by putting both hands on the floor. While I struggled to keep my balance I felt a sharp pain in my calf. "Priests are not suppose to practise surgery," he said, ignoring my cries. "But who would willingly let themselves be cut by an ignorant barber? I have read what Galen and Hippocrates wrote, and I know what the barbers do not."

The chaplain cut again, then scraped the wound out. I did my best not to gasp or struggle, though feeling the knife piercing my flesh was far worse than the original wound had been. "The poultice will do no good unless it gets inside the wound," he said, gripping my leg harder. He slopped the scalding cabbage mixture on my leg and bound it up again, then let go of me.

"There," he said, smiling at me. "That wasn't so bad, was it?"

I nodded and mumbled some thanks, then crept off to a quiet place where I could sob and whimper unobserved. I did not feel much like a soldier then. But the poultice worked, and after a few more applications the wound stopped weeping and the pain began to fade. I was impressed by the chaplain's skill, and by his knowledge, and even more so by the fact that they were secret, and came from old books. I had heard of such things before. My father often used to tell me about the Greek emperor who came to London when he was a boy, and the secrets he knew. And Ralph used to say that the dauphin's men got their devilry from old books. That was how they conjured up Joan. Ancient Secrets passed down in old books would serve those who knew them. What else did the chaplain know? And what else could he do?

3 The Feast of Fools

When, just after Christmas, a gang of men came into the hall, carrying a carved chair and a bundle of silk robes, I was not surprised. I had heard them plotting the Feast of Fools, and knew what to expect. And I had seen the bustle of servants going to and from the kitchens, carrying the ingredients for a great banquet. We were in for a day or two of disorder, when the world of the castle would be turned upside-down, and the men would indulge themselves before returning to duty and allegiance. The gang let out a great cry when they saw the fool, hailing him as their master. They strode towards him, holding up the chair and robes. The fool, as I knew from the men's whispering, was to be their Lord of Misrule. As soon as he saw them bearing down on him, the fool knew it too. I could see the terror in his face, as he remembered the mockery he had heaped on various members of the company, and anticipated the humiliations they had in mind for him. His deformed hands opened and closed, clutching at nothing, while his chest heaved with agitation.

The fool looked at the men, flinching from them as they drew closer. Then he looked round the room like a cornered beast, panic filling his ugly face. I looked on with pleasure. I hated the fool, and could think of nothing better than watching him being mocked. I imagined what I would do to him if I had the power, and wished I had the wit to torment him as he tormented me. Then I saw that the fool was looking at me.

"There!" he said, stabbing a stumpy finger in my direction. "There's your Lord of Misrule. He's the one you want. Not me!" The men hesitated, lowering the chair and robes, looking from me to the fool and back again. I stepped back, trying to hide myself behind the stonework of the fireplace. "You'll have some sport," the fool said, a smile splitting his face. "He thinks he's a cut above the rest of us. Let's give him a taste of being a lord. Then we'll see how he measures up. I've got some ideas. Let's have him, boys!"

Those men, who could kill or rape without a qualm, who thought themselves the worst and toughest in the world, were weak and easily led. They instantly forgot their plans and did what the fool suggested. Without saying a word, they spread out, holding the robes like a net, then advanced, driving me into a corner. I backed away, but there was nowhere to go. They caught me, and pulled off my doublet. Then they pulled off the rest of my clothes, until I stood before them, naked and shivering.

"Not much of a lord, is he?" one of the men said. "More like a skinned rabbit."

The others made less favourable comments, comparing me to a salt herring, a sprat, or a pressed squab. I looked around the room, hoping that none of the women could see me.

"You're right, boys," the fool said. "He doesn't look up to much. But when he's dressed up, you'll see!"

They wrapped me up in cold silk and itchy brocade, draped my neck with jewels and stuck a fur-trimmed hat on my head. They seemed to have picked the clothes at random, as though they had found them jumbled up in a forgotten chest. When they were satisfied with my appearance they shoved me into the chair and hoisted it above their shoulders. The men marched me around the room, swinging the chair carelessly from side to side, chanting mock praise while the fool capered in front of them.

"There he is!" the fool shouted. "The boy with a hero for a father. The boy who thinks he's better than the rest of us. The boy who would make himself a gentleman, if he could."

I looked around for help. Where was Umberto? Why was he permitting this disorder among his men? Where was Fulk? He would have stopped it. But, even as I was hurtled round the hall, I knew the answer. Umberto had withdrawn, to his chamber or some other place, and would remain there until the Feast of Fools was over. He would not challenge the men.

When the men had had enough of carrying me around they set the chair down at the head of the hall, where Umberto would have sat. I tried to get out of the chair, but two strong men held me down.

"Oh no, my lord," the fool said. "Do not exert yourself. There is no need to stir, everything you need will be brought to you."

I was enthroned, but had no power. It was clear that the fool would rule on my behalf. Perhaps real lords are constrained like that, and can only do what their followers permit or what custom allows. While I pondered my predicament, some servants set up trestles, boards and benches. The men sat, and called for drink until a cask was carried in. It was set down before me with great ceremony, and carefully broached. A jug was drawn off and shown to me, but I was not allowed to drink.

"This wine is not good enough for a lord," the fool said, waving the jug away. "You must have the best!"

The cask wine was served to the men, but much to my surprise they did not drink it, but waited silently while two of Umberto's pages came into the hall. They were dressed in the finest looted livery, and bore themselves proudly as though serving their master. One of them carried a jug, holding it high in front of him like a consecrated vessel. The other boy held a pewter wine cup as though it was the Holy Grail. The boys, ignoring the men's jeering, approached and bowed ironically, then poured some wine from the jug. I was about to reach out for the cup when the fool sprang forward and stopped me.

"Oh no, my lord," he said as he forced my hand down. "You cannot drink yet. There is a question you must answer first." The fool turned away from me so that he could wink and grimace at the men. "Are you pure?" he asked.

I did not know how to answer. It was obvious that the fool would not give me wine unless I said I was pure. And I wanted wine more than anything, to help me through my ordeal. I had heard enough of the men's mutterings to know what lay ahead of me, though the fool, having turned things his own way, would doubtless improvise. But saying I was pure would make my mockery worse.

"Are you pure?" the fool repeated. "You can tell me. I will be your confessor."

The men began to hammer their cups on the table. The fool asked his question again. I knew there was no escape. Whatever I said, they would twist it.

"I am pure," I said, so softly that only the fool could have heard me.

"There you are boys! He says he's pure. We'll have to do something about that, won't we? But first, a drink!"

The two pages stepped forward, holding out their vessels just as though they were serving in church. One placed the cup on the boards in front of me. The other gracefully poured a thin stream of wine into the cup.

"Drink!" the fool said, when the pages had stepped back. I drank, but without pleasure, as the wine was as sour as verjuice. I doubt that any of the men saw me wince, as they all raised their own cups then. While I struggled to swallow a mouthful of bad wine, the men let out a great cheer as they downed their first draughts. Noise filled the hall as the men called out for more wine and drummed their cups. Boys rushed about filling and emptying jugs, while others came in from the kitchens and began to lay out plate and trenchers. They were quickly followed by others bearing dishes and baskets of food. There were fritters and pastries filled with minced meat and fruit, and fish in sauce, and roast fowls served with their tail feathers on, and sweet puddings and spiced custard tarts. The cooks must have known that the men would punish them if they did not do their best, and all their dishes were as fine as any they might have served to Umberto. Even so, the men threw as many tarts and pastries as they ate, and their clothes were soon splattered with custard. When they had disposed of the smaller dishes they began to tear at the fowls, ripping off limbs and scooping out stuffing.

I reached out for some fish fritters but the fool stopped me. "Those are not good enough for my lord. You must have something better." He stuffed a fritter into his mouth and gulped it down, then called over one of the pages. "Surely the cooks have prepared something special?" he asked.

The fool ate a few more fritters while the boy was gone, showering pastry over his parti-coloured coat. In between

mouthfuls, he gave me gloating looks, but I saw pity in the boy's eyes when he returned with a dish of sauced fish and set it before me.

"Eat!" the fool urged. The men paused to watch me, bones between their teeth, shreds of fowl-flesh hanging from their greasy lips. I held back, knowing what was in store. The fool gave me a reproachful look. "You mock the men," he said. "How can they eat well when you reproach them by abstaining?"

I scooped up a lump of fish and popped it quickly into my mouth. It was dry, fibrous, unsoaked and so salty that I could hardly swallow it. The fool watched while I turned the morsel over in my mouth. A foul fishy smell filled my nose until I almost gagged.

"What! Is it not to my lord's taste? The cooks must have done their work badly."

My throat seemed to close, but I forced the mouthful down then swigged some of the sour wine. It did little to quench my thirst. The fool called the page back and made him take the fish away, but I knew the ordeal was not over. A new dish was placed before me that looked just the same as the last. When I dipped into it I found that the fish had been sauced with the strongest mustard. It was followed by soused gurnard, dry bacon, pickled samphire, and red herring, all so salty or sour that I could hardly eat a mouthful. The worst dish was diced meat dressed with so much pounded rue that my tongue burned and blistered. I poured the sour wine down my throat, but it seared my raw tongue like boiling oil, and I was obliged to spit it out. The fool looked at me sadly.

"I would have thought," he said, addressing his words to the men, who had stuffed themselves full while I toyed with inedible dishes, "that our young lord here might have learned something from his stay with us. But no! He eats like a peasant when surrounded by the finest gentlemen. He turns down delicacies the rest of us would be glad of. Do you think he is worthy of his office?"

There was an indistinct roar from the men, who were very drunk by then. But the fool knew how to lead them. "Shall

we depose him?" he asked. "Or shall we give him one more chance?"

I prayed that they would depose me, that I would have a chance to get away.

"Once more chance," the men shouted. They wanted their fun, and knew that if I were deposed one of them would take my place.

"Are you sure?" The men shouted their agreement, and the fool called for another dish to be set before me. The men hammered their wine-cups while the dish was held high and carried through the hall. It was a large andouille, lumpy, mottled and roughly tied, floating in a whitish sauce. Its end, fat, fleshy and folded, seemed to wink at me from the plate. The dish mocked me by name and appearance, being a by-word for doltishness and looking like a man's privy parts.

The pages and all the men were watching me expectantly. I reached for the knife that had lain unused on the table. The fool reached out and gripped my arm. "That is not the right way," he said. "Not for a boy that wants to be a gentleman."

My anger rose, and I was tempted to pull my arm free and plunge the knife into his misshapen chest. But I had the advantage of still being sober, and saw that harming the fool would be my last act. The men would never let me harm their true ruler, the one who mocked them but led them so easily. Not unless I could find a way of undermining his rule. I let go of the knife and reached out for the andouille, gripping its slippery skin with my fingers. The fool looked on, licking his twisted lips. I knew what he wanted me to do, and saw no way of avoiding it. I raised the fat sausage to my mouth and stared at its folded tip. Andouille was not my favourite dish, but it was tolerable if the filling was fresh and well cleaned. Carefully avoiding the sauce, which had aroused my suspicion, I bit into the sausage. The skin burst, releasing foul lumps of tripe and fat. The stink that filled my mouth made me think of long-dead corpses and festering dungheaps.

"What is the matter?" asked the fool, speaking loudly so that the men could hear him. "Is the flavour too coarse for his lordship? Perhaps he should try a little of the sauce."

The fool snatched the andouille from my hand and skipped away from me. He raised the sausage up, holding it as high as he could with his crooked arms, stroking its thick shaft until the grease ran down his sleeve. Then he plunged it into the sauce, stirring it vigorously so that the unbitten end was well covered. The men were hammering their cups again, and chanting, "Swallow it! Swallow it! Swallow it!"

The fool went down on his knees and fell forward, thrusting the andouille up and into my face. I could feel his crippled body pressing against mine, and smell his unwashed flesh mingling with the stink of putrid tripe. My lips were stung by smeared sauce. The men were still chanting, urging me to swallow the loathsome sausage, but I could not bear to open my mouth. I stared down at the fool, gritting my teeth, willing him to back off. Perhaps if I succeeded in defying him, he would loose his power over the men. I glared at him, slowly shaking my head to show him that I would not give in. The chanting faltered. The men were watching, waiting to see what we would do. The fool looked up at me, a sly expression creeping over his face. I felt his free hand fumbling under my lordly robes. He grinned at me. Then his hand lunged, and in one swift movement the fool grabbed my cod and yard, jerking and twisting until I gasped with pain.

At that moment the fool shoved the puckered sausage-end between my lips. He had defeated me, and preserved his power. But I had only a moment to savour my shame. The sauce was spiced with the hottest horseradish. It burned my already raw and blistered mouth so sorely that I cried out, showering the fool's shaggy head with fragments of pig guts. He did not flinch, but shoved harder, forcing the sausage further into my mouth, which it burned like a red-hot iron. I could take no more, and leapt up, tipping my chair over and sending the fool sprawling in the ground.

"What?" he said, looking up at me in mock reproach. "Do you use your servant like this?"

"If you are my servant," I said, raising my voice for the first time, "then bring me water." If I could only make him obey one order, I might weaken the fool's influence.

"You heard him boys!" the fool said, scrambling to his feet. "He wants water."

Before I had time to regret my request, servants came in from the kitchens bearing pails. The fool grabbed one of them and, with carefully practised clumsiness, swung it at me. It was useless to resist him. Whatever I said or did the fool would turn it against me. I was showered with icy water, and the men, having reached the stage of drunkenness when almost anything seemed amusing, burst into laughter. One of them grabbed a pail from a passing servant and threw water at the fool, who ducked and dodged it expertly. Then others joined in, dousing each other and throwing the remains of the feast. The fool, tumbling comically as he went, scuttled out of the hall and towards the kitchens. Before long, the boards and trestles had been overturned and the hall was full of brawling men. The rushes on the floor, sodden and strewn with bones and crumbs, resembled a well-trampled swamp, and the servants cowered in corners for fear of being hit. The mock battle reached its peak, with whirling bodies everywhere, swinging at each other with fists and feet, with smashed boards and broken trestles. For a moment it seemed that everything in the hall would be wrecked, that every man would be wounded, that the free company would destroy itself in an access of freedom. Then the men, drunk and tired, slowed down. A few feebly fought on, but most fell to the floor, panting with effort, their breath clouding the cold air.

The short winter day was almost over, and the servants, carefully avoiding the lying men, brought lanterns and rush lights and set them around the hall. There was a calmness about their actions which reassured me, and made me think the feast might soon be over. Though soaked and shivering, I was glad at the turn the entertainment was taking. The men had had their fill of food and drink. They had lost interest in the fool's antics. Their brawling had exhausted them, and not involved me. With luck I might be able to follow the fool's example and slip away. I tried to think of places where I might hide, where I would be safe. Perhaps the chaplain would shelter me.

Then the fool reappeared. He was capering at the head of a small group of dancers, who skipped into the hall accompanied by drums and bagpipes. The fool wore his usual motley coat, but his troupe was dressed as savages. Their costumes were sewn with ragged hemp and fur, and their faces covered by beast-masks. They carried clubs, which they beat on the ground like morris-men's staves while they leapt and howled. The few men who were still standing drew back to give the dancers room to move, stamping their feet in time and shouting encouragement.

The piper and drummer stationed themselves on either side of me, adding to my torment as well as blocking any possible escape. The fool skipped back to the kitchens while the savages formed a circle and continued their dance. The pipes squawked and the drums throbbed, and the dancers twirled and hopped. Every so often, they stopped, bent, and vaulted over each other, miming the rutting of beasts. Then, one by one, they broke out of the circle and advanced on me, grunting and gesticulating, lifting their shaggy costumes and displaying their buttocks and private parts.

The dancers reminded me horribly of the savages I had fought in the forest. I feared that they would drag me from my chair and make me join them. But my fate was worse than that. The fool reappeared, grinning madly and leading a troupe of girls. They shivered in thin gowns, and looked far from happy. When the savages saw the girls they let out a great roar and rushed towards them. They circled the girls, barking and snarling, lunging at them with clawed hands, tugging at their clothes. The knot of girls broke up, shrieking, and at their centre I saw Catherine. She was clothed as their queen, in a gown of marbled silk sewn with green vine leaves and the ripest of red grapes. Her face was pale but tinged with pink, and her hair was coiled and bound. Among those savage beast-men and frightened girls she seemed an emblem of freshness and ripeness. She was calm, too, though she must have had a good idea of what was about to happen.

The savages drove the girls into the centre of the hall and

made them sit on the food-strewn rushes. Then they took their clubs and formed a cordon, driving the watching men back. The fool took Catherine's hand and led her to me. He bowed before me, sweeping off his hat with a flourish. A shower of andouille fragments fell to the floor. Catherine, after the fool had nudged her, curtseyed, just as she might have done to Umberto.

"My lord," the fool said. "It is time to take your pleasure."

The men cheered, and there was something in their voices more terrifying than the barks and snarls of the dancers. They were not trying to sound like beasts, yet they did, and I feared them, and what they might do next.

The fool summoned the pages, who, despite my struggling, pulled off my wet clothes. The men laughed to see me naked again, and joked that the fine feast I had eaten had done nothing to fill me out.

"All that salty food's dried him up," the fool called out.

I shrank back into the chair, trying to cover myself as best I could. Catherine still looked calm when the pages led her forward. Why was she not scared? Did she not fear sharing my humiliation? Or was she part of the plot?

At the fool's command, the pages roughly shoved Catherine so that she fell on top of me. She was heavier than I expected, and the way she struggled and twisted told me that she was far from willing. I tried to draw back even further into my chair, so that the carved wood pressed on my naked flesh like a friar's penitence. Catherine twisted round so she looked away from me.

"What is the matter, my lord?" the fool said. "Is she not to your taste?" He caught hold of one of the pages, bent him over and tugged down his hose. "Perhaps you would prefer one of these boys?"

I shook my head. The fool fondled the page's naked buttocks. They were white and smooth, like a girl's. The fool shoved his fat codpiece at the boy's rear, burying it between his soft thighs. The men jeered.

"Now's your chance," the fool said, letting the page go. The boy pulled his hose up quickly "You'd better prove

yourself," the fool said. "Or one the others will have her." A chorus of voices volunteered, and some of the men tried to push through the cordon of savages, but the fool carried on with his game. "Take her in your arms," he said. "Show us what you can do."

I could not bear to think of one of the men having her, so I put my arms round her rigid body and tried to pull her close to me.

"That's no good!" the fool said. "Surely you don't need to be shown how?"

I tried again, but my feeble caresses did not satisfy the fool, who capered around us, watching every move. "It must be her clothes," he said. "Let's have them off."

The pages pulled Catherine off me, then unfastened her silk gown, which fell to the floor. She stood before me as naked as she had been in my dreams, and every bit as beautiful. I looked at her pale, unblemished skin, at her small round breasts, and at the parts of her that I had hardly dared imagine. But nothing stirred. I was cold, wet, hungry, and watched by a hall full of men, all of them half-mad with drink. And my private parts still ached from the manhandling the fool had given them.

The pages laid Catherine's gown over the wet rushes to form a rough bed, then made her lie down on it. The men all pressed forward against the savages' cordon, eager to watch or take my place. I was pulled to my feet, but only so that the fool could mock me again.

"Call that a yard!" he said. "It's more like an inch. I've seen bigger on babes in arms. It should be as big as a fat andouille! What's wrong with you?"

The fool looked round, but only a few of the men were still watching his performance. Some of the others had unfastened their codpieces, and were fondling their yards while eyeing up the girls. They would not wait long for the fool to conclude his performance. And if it was up to me, it would never be concluded.

"You'll just have to do your best," the fool said. He spoke loudly, trying to command attention, but there was a

hollowness in his voice that told me that he too was afraid. I only had a moment to reflect on that, then I was flung forward. As I fell on top of Catherine, the piper and drummer started up, and the men began to bang out rough rhythms on plates and cups. They stamped and shouted and urged me on, but I could do nothing. Catherine lay beneath me as stiff as a plank, but I was as limp as a wet rope.

"Our Lord of Misrule has failed us!" the fool shouted. The rough music ceased and the pages dragged me upright. "What d'you think, boys? Shall we depose him?"

There was a ragged chorus of approval, then the piper and drummer, urged on by frantic signals from the fool, started up again. But the savages, seeing the way things were going, ignored the signals, lowered their clubs, and stood back, allowing the men to press forward. They formed a ring round us, swaying unsteadily, leaning on each other. Some of them were so close I could smell the wine on their breath. The world shrank to a rush-strewn circle holding me, the fool, Catherine, and the pages and musicians. The men stared dully at us, waiting for something to happen. Had I been clothed, I might have stepped back, joined the men and become a spectator. But I was naked and humiliated, the object of their pleasure. They were losing patience with the fool. What would they do if he lost control of them? The musicians faltered, their beats and blasts lapsing into silence.

"I'll show you something!" the fool shouted. "Something you've never seen." He leered comically at Catherine, who still lay on the floor, held down by the two pages. A few of the men laughed. The fool grimaced lecherously and fiddled with his oversized codpiece, tugging at the ribbons that held it in place. I thought it was just another bit of comic business, something to keep the men amused and on his side. Then he pulled out his yard. Like the rest of him it was grotesque, monstrously out of proportion. It might have belonged to a bull or stallion. Or perhaps to a boar, for it was kinked and twisted. There was a gasp from the audience.

"I told you!" the fool said, gripping his member like a sword and swinging it from side to side. "You've never seen

anything like this before. And now I'll show young Thomas here how to use it."

Catherine began to squirm and kick, and almost threw off the pages. Her hair had come uncoiled and hung in ragged plaits. The fool dropped to his knees and shuffled forward until he was on top of her, all the time holding his stiff yard in front of him. I could not bear to watch, or even to think of that gross member touching Catherine. Before the fool could press himself into her, I threw myself onto him, kicking and punching as hard as I could. Grabbing his motely coat, I dragged the fool off Catherine and threw him onto the rushy floor. He lay on his humped back like a beetle, his misshapen legs flailing uselessly in the air, his half-stiff yard flopping against his belly. His wet lips moved, but no words came out. While the fool and I watched each other, wondering what to do, Catherine stood up, trying to cover her nakedness, looking desperately at the men who pressed ever closer. They cheered and laughed as Catherine ran at them and tried to push her way through the circle. Some of them tried to grab her. Others pushed her away. But they would not let her escape.

The fool started to struggle to his feet. I kicked him hard, crushing his cod with the ball of my foot. He fell back, his face contorted with anger. The circle around us was breaking up, the men looking for women before it was too late. I took hold of Catherine, trying to protect her. For the first time, her naked flesh stirred me. My aching yard began to stiffen. But the noise in the hall grew louder, driving out faint lust. The drum and pipes began again. The savages, resuming their dance, chased the girls round the hall. All around us there were screams and shouts and bestial howls. The men rushed off to join the chase, lurching drunkenly at the girls, dragging them to the ground. But there were not enough girls to go round, and the men were soon brawling again.

That was the moment to escape. I looked around for a way out of the hall, determined, if I could, to lead Catherine to safety. She might love me after all, if I saved her. But before I could move, two men emerged from the mêlée. I knew one of them well. He was the Gascon who had held down the man I

had killed on my first raid. The other was a Norman who had only recently joined us. It irked me that he had already been accepted by the other men, that he shared their pleasures and prizes while I was mocked and rejected.

I tried to keep myself between them and Catherine, but the Gascon seized my arm and yanked it up behind my back. The Norman pulled Catherine away from me, ignoring her screams. The fool had got to his feet by then, and called out to the Gascon, telling him to hold on to me. I struggled, kicking and elbowing, trying to free myself from the Gascon's grip. I remembered the fool's trick, and tried to reach the Gascon's codpiece with my free hand. But before I found it, I felt the chill of steel against my neck.

"Remember how to kill a man?" the Gascon said, his lips close to my ear. "Cleanly, that is." He pressed the knife harder. It punctured my skin. "Anyone can butcher a man, but it takes skill to do it neatly."

I knew very well what a knife like that could do, and so did the fool. He was hopping up and down with pleasure. "You keep hold of him," he said to the Gascon. "Hold him just like that. And if he squirms, you can do what you like with him."

The Gascon pulled my head back and slid his knife-blade gently along my skin. I felt warm blood trickling down my neck. I remembered the man he and I had killed together, the gushing of his blood, the scrape of my knife against his skull, the way his mutilated body had swung from a blossom-laden tree. I imagined my own corpse, slit-throated, bled dry, lying on the filthy rushes, ignored by the rutting savages writhing around me. Death was so easy, and so close. I stood as still as I could, determined not to provoke anyone.

The fool gave me a nasty smile, then turned to look at Catherine. She was enfolded in the Norman's arms, trying to resist his attempts to haul her off.

"You can bring her here," the fool said, hoping to halt the Norman's retreat. He stepped forward, but the Norman dragged Catherine back.

"Hold her," the fool said, gripping his resurgent yard. I had obviously not hurt him badly enough. Perhaps he was so

brutish that he did not feel pain like other men. "Hold her down for me. I'll show our Lord of Misrule how it's done."

"She's mine," the Norman said, hardly looking at the fool. He pushed Catherine to the ground and bent over her.

"You'll get your turn," the fool said, tugging at the Norman's shoulders. "But I'm going first."

"Not you, you monstrosity!" the Norman said, shoving the fool off. "You're not fit to have a woman, no more than he is." He jerked his head at me, and the Gascon tightened his grip. The fool stepped back, a look of panic on his face. His yard was drooping. All around us men, women, savages and boys lay on the filthy floor taking their pleasure, or yielding to it. The fool had stirred them up, played on their passions, driven them to excess. But he had lost control, and could only look on while the Norman's buttocks plunged repeatedly between Catherine's thighs. She had given up struggling, and lay beneath the Norman limply, almost as though she was dead. Her white skin was spattered with food and bits of rotten rushes.

The fool turned to the Gascon. "Make him watch," he said. But I was already watching. I could not look away. The prick of the Gascon's blade made no difference. I saw Catherine defiled, felt the last of my love die, and knew that if those were men, I was not one of them.

"I heard what they did to you," the chaplain said, when I went to him with my wounded throat. I expected him to say something soothing, but he did not. "We have to put up with these things," was all the solace he had to offer. "Don't pity yourself," he said, dabbing at the scabbed cut with an astringent potion. "There can be no order without disorder, no rule without misrule, no virtue without vice."

The chaplain was right. I did pity myself, just as I envied others and hated the fool. I could think of nothing more loathsome than his misshapen form, or the twisted character that drove him to such cruelty. Though he had told me so, I did not believe that in taunting and humiliating me, he was only doing his job, just as I was only doing mine when I

fought and robbed and slaughtered. I failed to realise that, despite his grotesque appearance, the fool was a man like other men, driven by the same desires and weakened by the same fears. And the fool's ugliness must have made his desires sharper and his fears more terrible. I understood nothing of that at the time. The truth was revealed later by the chaplain, and by the fool himself.

Often, during that bitter winter, even after my wounds had healed, I went to see the chaplain. When I wanted to escape from the fool's persecution or the men's boisterous antics, I climbed up to the room above the chapel where he lived. It gave the best view of the surrounding countryside from its narrow windows, and if no lookouts were posted there, as they sometimes were, I would pass time talking with the chaplain, and looking at his books.

"Can you read?" he asked, when he noticed my interest.

"I can," I said. "I was a page once, and my master wanted all who served him to have the accomplishments of a gentleman."

"I daresay books are useful to military men. I have some books here that describe the arts of war, and how castles can be built and taken." He reached into a chest and pulled a book out. "It was from this one, I think, that I got the idea of smoking out the castle's defenders with pitch and brimstone." He opened the book and leafed through its pages. "I don't suppose they taught you any Greek?"

"No, sir."

"I thought not." He shook his head sadly, then pushed his eyeglasses further up his nose. "Look at this," he said, showing me a page of ciphers and symbols. "Each sign stands for a substance, each number for a quantity. With subtle variations and by adding rare ingredients we can make . . ."

"Gold?"

"No, gunpowder." The chaplain went on to tell me how adding quicksilver made bullets fly faster, and adding realgar made them fly truer, but I was not really listening.

"Did they teach you Latin?" he asked, when he had finished telling me about powder and projectiles

"A little. Do you have Latin books as well?"

"Of course! What would a gentleman's library be without them? These are all Umberto's books, not mine. In that book chest there are histories, commentaries, dialogues, discourses, travellers' tales, speeches, homilies, philosophy, herbal lore and spells, all in Latin."

"Can books make a man rich?" I asked.

"Rich? What makes you think books can do that?"

The chaplain's tone was scornful, and I regretted putting my question so bluntly. "It was my father," I said. "He told me. He heard it from some Greeks that came to London from Constantinople. They told him that there were old books full of ancient secrets, and that a man who knew them could make himself rich."

"Was your father rich?" The chaplain smiled, but it was a tolerant smile. I expect he thought me foolish, but he must have seen something else in me, that could be brought out with a little encouragement.

"Not as rich as he might have been," I said, remembering my father's constant complaints. "He would have had enough to build a castle, if his comrades hadn't swindled him. That was what he used to say. As it was, he got enough to build a fine house."

"And how did he get his wealth?"

"He was a soldier." I had learned not to describe my father as a hero. "He fought at Agincourt."

"Agincourt!" the chaplain said, his smile vanishing. "What a disgrace to my country that battle was! It was not won by English longbows, as your countrymen like to pretend. It was not won at all. Certain victory was thrown away by the pride and stupidity of the French nobility. They argued about precedence, and about tactics, then let themselves be slaughtered by commoners they would not deign to fight. Such men are not fit to rule. That is why France is in the state it is in. That is why I am here, risking my soul among brigands and outlaws." The chaplain paused, pondering his bad luck. "So tell me," he said, after a while. "How, *exactly*, do you think your father made his money?"

"By fighting and ransoming, I suppose."

"Then you had better learn to do the same. That is how men get rich in France, though the pickings are not as good as they were. Even Umberto cannot get as rich as he would like to be."

"But the books" I said. "Surely there must be secrets in them?"

"There are secrets, yes." The chaplain plucked at the sleeve of his gown, raising the cloth to show me how threadbare it was. "But do I look like the sort of man who could make himself rich?"

I sat for a while, thinking about the chaplain's words. I had already discovered that I could not win much by fighting. The other men would not let me. Unless I could find a way of getting the better of them, I would never make myself rich, and never be able to return home.

The chaplain had turned his back on me, and was rummaging through his book-chest, muttering to himself. Then he pulled out a book and held it up, saying, "Perhaps this is the sort of thing you had in mind?" He opened the book and held it out, but he would not let me take it. I looked at the pages he had chosen, wondering at the charts and symbols, and at the little scribbled paragraphs that filled the spaces between them.

"What is it?" I asked.

"It is a compendium of wisdom, a collection of secrets culled from a score of ancient books. There are things in here known only to a few Saracen conjurors. With a book like this, or so the compiler claims, it is possible to summon up the devil and obtain everything a man might want."

So, my father had been right. The books of ancient wisdom he had told me about really did exist. And wisdom meant power, if it could control the devil. I imagined myself compelling others to do my will, making them obey me and supply my every need. I gazed again at the pages, searching for meaning. But all I saw were lines and squiggles and minute spidery writing.

"I don't understand it."

The chaplain smiled, and closed the book. "Of course you don't. I daresay they only taught you enough Latin to chant the Psalter. How could you expect to understand arcane matters like these?"

"I could try."

The chaplain made a dry sound in his throat that might have been a smothered laugh. "You could," he said. "But you would be better off learning how to fight, or to suck up to Umberto and his favourites."

"I have tried that. I fight, but the others take what I win. And the fool has made sure that I will never be anything to Umberto's favourites than the butt of his jokes. I want to better myself, to know the reasons and causes of things, and to make myself wiser than I am."

The chaplain opened his Saracen book again, turning to a different page. "This kind of knowledge is not for you," he said. "Or even for me, if I am honest about it." He pointed at some writing that wandered down the page like a river, filling the gaps between a pair of pictures. They showed the naked bodies of a man and woman, each part marked by mysterious symbols. "Words are not always what they seem," he said. "Even when you think you understand them they have deeper meanings. Language is not straightforward. It has layers. And as for the pictures . . ."

"So you do not understand?"

"Not this," he said, shutting the book and dropping it into the chest. "Perhaps it is just as well. Some knowledge is too dangerous to be used."

"But not all?"

"No."

"Then I want to learn. I want to know what you know."

"I studied at the university in Paris." He spoke haughtily, perhaps tired of my questions. "How could you hope to reach my level? You are too ignorant even to begin."

"If I am ignorant, that is why I want to learn."

Eventually the chaplain relented, and undertook to improve my Latin. He did so by making me read the Psalter, but he

constantly questioned me to make sure I properly understood the words. He made me read the Bible, too, and questioned me about that. But he would say no more about old books and their secrets. I learned what I could, and might have found out no more, had not the fool asked for the chaplain's help. That was surprising, as the fool mocked the chaplain just as he mocked everyone else, bending and shuffling, and peering through fingers curled to represent the chaplain's eyeglasses. The fool would never have asked the chaplain for help had he not been driven by an urgent and terrible need.

I was with the chaplain when the fool called on him. As soon as his ugly face appeared at the door I stood up, ready to push past him and escape down the stairs. I could not bear to be in the same room as him. But the chaplain took my arm and held me back. "Sit down, Thomas," he said. "Let us hear what our visitor has to say."

Reluctantly, I resumed my place, trying not to catch the fool's eye.

"I want to know something," the fool said, still panting from having dragged his short legs up the stairs to the chaplain's room.

"What sort of a thing?" the chaplain asked.

"Something to help me." The fool looked around the bare room, fixing on the book chest as the place most likely to be of use to him. "There must be something in those old books?"

I resented the fool's question, which seemed to mock my own attempts to acquire learning.

"There are lots of things in those old books," the chaplain said, not quite concealing a smile. "If you want to be helped, you had better tell us what the trouble is."

"I'm not telling him," the fool said, jerking his head in my direction.

"As you can see, Thomas is here, and I am not going to throw him out."

"I'll not talk in front of him."

"Is it a medical matter? Something embarrassing? I see you walk with discomfort. The winter diet exacerbates . . ."

"It's nothing like that."

"Then tell us."

"Not him."

"Thomas and I were having a most instructive discussion. He is showing great promise as a scholar."

"I don't care about any of that," the fool said, glaring at me.

"But you have just said that you were interested in my books, and it is books that I have been discussing with Thomas. I am sure that whatever you want to know will be of great interest to him."

"I'm sure," the fool said, with a sneer. "But I'm not telling him anything. I came here to speak to you. How did I know he'd be here?"

"I am teaching him. I might even make him my assistant."

"Assistant!" the fool snapped. "What do you want an assistant for? What do you do all day but mumble in the chapel and hide up here afterwards? There's nothing you need help with, unless . . ."

The fool fell silent, realising that he had made a mistake. He shuffled his feet and stared at the ground. His chest heaved as he struggled for breath. Then he seemed to collapse like an empty wineskin. His face sagged, and his mouth opened and closed silently. I wondered what the chaplain meant about making me his assistant. He had never said anything about it before.

"I'm sorry," the fool said eventually. "Can you help me?"

"That depends on what you have to tell us," the chaplain said, mildly. "Not all troubles have easy solutions. And the remedy may be in your hands rather than mine. Now, what is the nature of the problem?"

The fool muttered something inaudible.

"I am sorry," the chaplain said, cupping a hand to an ear. "Perhaps it is my age, but I failed to hear what you said." He turned to me. "Did you hear him, Thomas?"

"No." I was so delighted to see the fool's discomfiture that I could hardly keep a straight face. The fool saw my suppressed smile and grew agitated again. He raised his voice. "Remember, if you tell anyone else what I tell you, I will make your lives miserable with mockery."

For the first time, the chaplain looked sternly at the fool. "You have told us nothing yet," he said. "And if you continue to waste our time like this, I will have to ask you to leave. Despite your aspersions, I am a busy man, though the nature of my work is clearly beyond your comprehension. Now, will you tell us what the trouble is, or will you go?"

The fool took a deep breath, filling his misshapen chest. "It is love," he said.

"Love?" the chaplain said. "I can advise you on the love of God. And on the love of scholarship. As for any other kind . . ."

"It is the other kind," the fool said. "I am in love."

Led on by the chaplain, the fool told us how he loved the most beautiful of the castle's women, one belonging to one of Umberto's favourites. He wanted to win her, but knew his ugliness counted against him. The chaplain nodded wisely as he listened, but I almost laughed out loud. The fool, who knew every man's weakness and exploited it, was weak himself. He had mocked me for loving Catherine, and had destroyed that love, and there he was, not only confessing his own weakness, but begging for help.

When the fool went on with his story I realised that it was not so funny. I remembered what he had tried to do to Catherine. I saw horrible visions of his twisted body entwined with the woman's naked white limbs. I had no wish to help the fool win his love, even supposing such a thing possible. I had not forgiven him for what he did to me during the Feast of Fools, and never would. But I realised that, just by hearing his story, I had gained a hold over the fool. Whatever he threatened, he would not dare to mock me again.

"Such things are not uncommon," the chaplain said.

"I know that," the fool said. He shot me a sly glance. "What I want to know is can I prevail?"

The chaplain thought for a while, gazing vaguely out of one of the slit windows. "Did you have any thoughts," he asked eventually, "as to how you might win this woman?"

"My mind is sharp enough," the fool said, drawing himself up as straight as he could. "It is my person that she despises.

Though not ill-formed for one of my nature, I know that she will never look on me with anything but contempt."

"So what do you propose?"

"I would like to appear before her as other men."

"You want her to see you as though you were of full stature, in proportion as a normal man?"

The fool scowled at the chaplain's choice of words, but agreed that that was what he wanted.

"You understand that it will not be easy? And that Thomas and I will have to work long and hard to devise a solution?" The fool looked at me resentfully, but nodded his agreement. "And of course," the chaplain said, "you will have to give us something in return."

"I'll stop mocking you." The fool paused for a moment. "Both of you."

"We will need more than that. For the kind of service we will perform for you, there will be expenses. There are things that we will need, to achieve what you wish."

"Potions, you mean? Magic things?"

"There will be things of that sort, of course. But you cannot expect me to reveal everything. Not yet. Give us time to think and prepare. We must look in the old books. And you must be ready to follow any instructions we give."

"How will it work?" the fool asked. "Will there be anything devilish involved?" There was an odd expression on his face. He trembled, but I could not tell whether it was with hope or fear. What did he, who had hinted he was the devil's creature, want of the devil?

"Devilish?" The chaplain fixed the fool with a cold stare. "What do you take me for?"

The fool looked disappointed. "I didn't mean . . ."

My mind filled with conflicting thoughts. I longed for nothing better than a chance to study the chaplain's methods and to share his knowledge. If he could transform the fool into a normal man, he could do anything. Ever since he had shown me the Saracen book, I had hoped he might produce it again and use its power to command the devil to grant us our dearest wishes. That was what the dauphin had

done, and he had made himself king and almost won back his country.

Yet the last thing I wanted was to help the fool, or to see any improvement in his condition. The idea that he might profit from the chaplain's skills, that he might actually win the woman with our help, was abhorrent. But I had seen hints in the chaplains face, if not in his words, that the fool's transformation would not be pleasant. However things turned out, providing the fool was not too successful, there might be consolations for me.

"Let me ask you something," the chaplain said, relaxing his expression into one of kindly tolerance. "Who made the world?"

The fool thought for a while, as though the question was a trick, before hazarding an answer. "Our Lord God Almighty?"

"Exactly. And what was the devil, before he rebelled?"

"An angel?" The fool sounded uncertain.

"He was indeed. And who made the angels?"

"Almighty God."

"And can God, who is all-seeing, all-knowing, and entirely good, have created anything evil?"

The fool's face creased with effort as he considered the chaplain's question. But he said nothing. I wondered about the answer, too. The fool, as he had once told me himself, was an example of something that a good God could not have created. Both in form and in nature he was as loathsome as anything I had seen.

"Let me reassure you," the chaplain said. "What God has made is good. And there can be nothing that God did not make. And all powers that there are, even those that are hidden in old books and known only to scholars, are powers permitted by Him. Providing, of course that we use them well and that our intentions are good." He waited for a moment to see the fool's reaction. "Now. If you have no more questions, I must get on."

The fool left, a mixture of emotions playing across his ugly face.

"Am I really to be your assistant, sir?" I asked, when we

could no longer hear the fool's heavy feet clumping down the stairs. The chaplain did not answer me at first, but sat for a while, smiling to himself. "My assistant?" he said. "I am sure you will be of some use. But I am not sure how."

"What will you do?"

"Help him, of course."

"And will he win his woman?"

"Who can say? Not me! I know nothing of women. Perhaps you do?"

"I know that she is very beautiful, and that he is very ugly."

"Umberto is hardly handsome, either, yet he does not go short of women."

"Umberto? Surely . . ."

"Surely what? Do you think he is listening at the stairs? Do you think he ever listens to anything I say? Well? The fact is he has a chin like what is vulgarly called an arse, as you must have noticed. And if you shrank him down to the fool's size he'd be almost as ugly." He waited for a moment for me to absorb his seditious words. "Yet, as I said, he does not go short of women. So, what does that teach us?"

"That women like men who wield power?"

"Perhaps. But think of the dauphin. He, too, is an ugly man, by all accounts, yet he is not much admired, despite the fact that he rules half a kingdom."

"Then he must be very ugly indeed."

"And weak, and foolish. But most of all, he lacks what Umberto has in abundance, the gravity of a courtier."

"I do not think the fool could be grave, any more than he could be handsome."

"No? Well, we will have to see what we can do."

"So you can make him handsome?"

"Oh, I will transform him. I will make him into something else. He will not be the same after I've finished with him."

4 Transformations

The first thing we did was to draw up some scrolls. People are impressed by scrolls, the chaplain said, the more so if they are mysterious. We wrote them out on parchment, paper not being grand enough for our purpose, using red ink that looked like blood. I held the pen awkwardly, like a boy wielding a wooden sword. But I made the effort, sure that it would help bring me wisdom. My writing never was neat like a scholar's, but the chaplain passed over my lack of skill, and showed me how to form the letters in his own special way. He favoured the antique manner, with flourishes and curlicues to make the words more beautiful. The fool, he was sure, could not read, and would see only the shapes of the letters. It was a new sort of work for me, sitting in the chaplain's room and copying, but it suited me better than the drinking and gambling the other men indulged in when not campaigning. I studied the words I copied carefully, trying to make out their secret meaning, searching for Secret Knowledge.

The words came from several of the old books the chaplain had in his keeping. He never said the words were written in blood when he showed the scrolls to the fool, nor did he say the words were magic, any more than he explained what they meant. Instead, he baffled the fool, and me, with a lot of fine long words strung together in a sort of verse. I was sure the words contained hidden wisdom that would be revealed to me when we transformed the fool.

The words pleased the fool, and he paid for the parchment promptly, though not happily, as the chaplain made him hand the money to me. I had done the copying, so I was to be rewarded. The fool was eager to begin at once, to transform himself and win the woman.

"Surely you do not think that this is all there is to it?" the chaplain said as he rolled up the parchment and tossed it into a chest. "Words, however powerful, cannot work alone. There

are instructions here." The chaplain pointed at the rolled up scrolls. "Things that must be done if we are to succeed."

"What things? Will there be potions? You said there would."

"Potions?" The chaplain unrolled one of the scrolls. "Potions," he repeated, running his finger down the words I had copied. "Yes, there are certainly will be. Of two sorts. One to be slipped into the lady's drink. The other to be applied to you."

"Applied?" The fool looked suspicious.

"Rubbed."

"Rubbed where?"

"On your body."

"What part?"

"All of it, of course. We cannot just transform part of you. You must be renewed entirely."

The fool smiled at that thought, but it was an ugly twisted smile, that made me fear for the woman, if she ever fell into his hands. "How soon can you make these potions?" he asked.

"Soon enough, when the moment is right. But their manufacture will depend on the aspect of the moon, and the conjunctions of the planets, and on certain ingredients being available. We will have to send for some of them, perhaps to Paris, and you will have to provide us with the wherewithal."

The fool crept away, promising to get us more money, and the chaplain began experimenting with potions. The one for the woman was no more than a decoction of harmless herbs, such as might be taken for a headache or a good night's sleep. But the fool's potion was full of foul things. We began with urine, which the chaplain made me provide. I did so gladly, knowing that the fool would anoint himself with it, though hoping it would not be too effective. Would the potion work by transferring some of my youth to him? The chaplain would not say, but added pitch and brimstone left over from his attempt to make Greek Fire. We thinned them down with spirits of wine, then added dung and fish guts and boiled the mixture in a closed alembic. The chaplain seemed satisfied at first by its disgusting smell, but later he decided that it might

be best if the fool did not guess its ingredients. He added aromatics: wormwood, fennel, asafoetida and cloves, saying the fool would pay well to make the potion seem sweeter.

When the fool next came to see us he handed over some coins, and this time the chaplain took them, despite the vows he must have taken if he really was a friar. After that the fool was allowed to view the dark flask the potion was kept in, and briefly to smell it when the chaplain whipped the stopper off.

"It smells strong," the fool said, wrinkling his snub nose.

"It is strong," the chaplain said. "Do you think we would palm you off with a weak potion, one unfit for its purpose? The job must be done properly."

"Then we are ready?"

"Not quite."

"But you've got the scrolls, and the potions, and I've paid well for them. What more can you want?"

"*We* want nothing," the chaplain said, patiently. "We merely serve your needs. It is you who wishes to be transformed."

The fool seemed calmed by the chaplain's mildness. "So what more is needed?" he asked.

"Amulets. And charms. And talismans. The scrolls and potions will not work on their own. We must place magical objects around the place to trap the power we wish to harness. Only then will the transformation take place as you wish."

"I suppose these talismans will cost me?" The fool looked angry.

"There may be a little expense, but most of the magic objects can be made from things we have at hand, or that can be got without too much difficulty. It is mainly a matter of the time and trouble it will take us to find or prepare them."

The chaplain did not rush to complete the preparations. He seemed determined that the talismans should be as unpleasant as the potion, and that the fool should be desperate from waiting, and ready to do anything we asked, without question. I think he also knew that the weather was still too cold for what he had in mind, and that the ceremony would be best left until almost the start of the campaigning season.

We did the business with the fool in the cellar. It was a big place, beneath the hall, and the space under its arches was full of barrels and bundles, among which things and people could easily be concealed. The darkness there, the chaplain said, was just what we needed. By the light of several candles, the chaplain strewed powdered chalk on the floor to make a many-pointed star. I had to hold a book up, and a candle with it, so that the chaplain could see what shape to make from a picture that was copied there. I also had to rub out some of his chalk lines with a besom, so he could make them again, but better. While we worked we could hear footsteps reverberating on the boards above our heads, and other sounds, too, of shouting and laughing, all of which, the chaplain said, would cover up any noise we might make.

When he was satisfied with the chalk lines, we set the talismans at each corner. There was an elf-stone shaped like a ribbed horn, a desiccated toad, stretched out like a leaping man, a pickled goat's pizzle, the bones and skins of various creeping beasts, some dried owl turds, and an eye, plucked from the corpse of a captive who was put to death not long before. I was glad the chaplain had got the eye himself, and not made me do it.

Near the centre of the star the chaplain placed a beaker of some liquid I had not seen before.

When all was ready, we summoned the fool.

"Have you done what I asked?" the chaplain said.

"Not myself, but I have arranged it."

"So the potion will be put in her wine?"

"It has been promised." The fool looked around the cellar, trying, in the dim light, to see what we had got ready. "Can we start?"

"Of course. Will you stand in the centre?" The fool did as he was asked. "There is a beaker near your feet. Drink the contents."

"Me? Drink? You never said anything about that. It was her that was meant to drink a potion."

"Do you want this to work?"

"What's in it?"

101

"You can't expect me to reveal that."

The fool bent and picked up the beaker, sniffing its contents suspiciously. It cannot have smelled too bad, and was perhaps no more than spirits of wine infused with roots and herbs, as he swigged it down quickly, licking his twisted lips afterwards. He had a weakness for drink, which Umberto's men knew well. The chaplain watched, then spoke to me.

"Thomas? Will you recite the first scroll?"

I raised the scroll and tried to read. But the light was dim, and the letters were ornate and hard to make out, even though I had written them myself. I hoped it would not make a difference that I got some of the words wrong. I feared that the words I misspoke would have no meaning, and no power, or that they might misfire and call up the wrong spirits. I had no wish to fill the cellar with uncontrollable demons. But the chaplain did not seem troubled. He let me carry on, then read his scrolls in a low but clear voice. When we had finished, he asked the fool to lift each of the talismans to his lips and kiss it. He began, as directed, with the elf-stone. There was no harm in that, or not much if you did not think of what its horned shape might mean, so he raised to his lips and kissed, looking at us out of the corner of his eye. Then he went on to the other talismans, cautiously kissing each object in turn, skimming it past his lips if it offended him. Only the eye startled him. He grasped it firmly and brought it to his mouth. But when it was close to his face and he was able to make out what it was, he shuddered and nearly dropped it. The eye was far from fresh, and stank of decay. He could hardly avert its evil power by touching his own hump. He lowered it, and almost let the slippery gobbet fall from his hand. I thought he might throw the eye down there and then, but he stood and breathed deeply a few times before clasping the eye so firmly to his mouth that I thought he might actually swallow it. But he only held it briefly to his lips, then dashed it to the ground in disgust. He spat into his hand and rubbed his lips with spittle, regardless of any effect that might have on the power of the talismans he had kissed.

When he had recovered his composure the fool returned to

the centre of the chalk star, looking at the chaplain with a mixture of hope and fear.

"Now for the potion," the chaplain said. "Take those clothes off!"

The fool slipped off his motley coat and fiddled reluctantly with his shirt-ties.

"Hurry up!" the chaplain said. "Get those clothes off!"

"What, all of them?"

"Of course. The potion must cover all of you, or its effects will be incomplete. Do you want to face your beloved half-transformed? You would be more grotesque then than you are now."

The fool frowned at the chaplain's comment, but he must have thought he was within reach of what he wanted most, and swallowed the insult, tugging his clothes off clumsily. Naked, he was even more repulsive than I had imagined. His trunk was short and broad, and his limbs stuck out oddly, as though he had been broken and badly mended. Shaggy hair hung from his chest and groin, making him look more like a werewolf than a man. His yard, which had seemed so huge when he tried to climb on top of Catherine, hung slackly. He stank, too, though not as badly as he would soon. Not wanting to approach him closely, the chaplain held out the flask.

"Aren't you going to rub it on?" the fool asked.

"That would never do," the chaplain said, not quite suppressing a shudder. "If I were to as much as step over the chalk line the power would be diminished. And if I touched you . . ."

"All right. I'll do it." The fool took the flask and pulled out its stopper, sniffing at the neck. The face he pulled was so hideous that I wondered whether the chaplain had added something else to the potion, something unspeakable, or perhaps deadly. The fool took a deep breath, his malformed chest heaving jerkily, then he tipped the flask over his head. Foul-smelling brown liquid spurted onto his patchy hair, then trickled over his hunched shoulders. He shook the flask again.

"Not all at once," the chaplain said. "Rub that lot in, then put more on. Work it in gradually."

The fool rubbed, smearing himself methodically with that filthy concoction. Then he poured out more and spread it over his chest and arms, working down to his groin and legs. Just before he reached his feet, the chaplain told him to stop.

"But you said all over. I want it to work."

"Your feet are the one part of you," the chaplain said, inaccurately, "that is well-formed. There is no need for them to be transformed."

"Am I ready?" The fool said, looking down at his mal-formed body. "Am I transformed?"

I saw then what the chaplain knew all along, that people will see what they want to see, and that the fool was ready to believe himself a normal man if we told him he was one. Perhaps he was also drunk, or drugged, after drinking the chaplain's potion.

"There are just the final scrolls," the chaplain said. He took one himself and gave me the other, and we began to read. That was the most difficult part of the ritual, and one we had practised beforehand. We had to read our lines alternately, each waiting for the other, in a sort of sing-song voice such as priests use. I suffered a moment of unease then. The chaplain had said that there was nothing devilish in our work, but how could I be sure? In any case, it was too late. The business was almost over.

A moment later we had finished our chanting and stood silent before the fool.

"Am I transformed?" he said again, his voice quavering with apprehension. It seemed to me that he did stand a little straighter, and that his back was somewhat less humped. But he was hardly transformed. The candlelight played on his face, which was lit also with an expression of hideous joy. It was obvious that he imagined himself as handsome as Umberto's most dashing follower.

As instructed, at that moment I threw some powder at one of the candles, which made a great cloud of smoke that bil-lowed around the fool. It was not choking smoke, such as Greek Fire makes, but a gentler vapour, more like mist. When it drifted down the fool stood there just as ugly as before, but

the chaplain staggered back, shielding his eyes, as though from an apparition of unbearable beauty.

"It has worked?" the fool said.

"Yes!" the chaplain said. "It has worked. You are transformed! You are everything you longed to be. You must go to her now."

"What? Like this? I am naked."

"Do you think she will object? You are clothed in beauty! Go now! You cannot fail."

The fool stepped out of the chalk star, not noticing that his gait was as crooked as before. His yard had begun to swell. He hesitated for a moment, then scuttled up the steps like a crab that knows it will soon be boiled, heading for the hall and his love's room.

"Quick!" the chaplain said, as soon as the fool was out of sight. "We must leave no trace."

I picked up the besom and brushed out the star, blending the chalk into the dry earth, walking over it to obliterate my sweeping with footmarks. Then I strewed straw over the place, and dragged an empty chest to where the hunchback had stood. While I worked, the chaplain gathered up the talismans into a sack, bundled in the scrolls and stood ready by the steps. "Grab a lantern," he said, then he dashed towards the steps.

"Wait!" I said. "What shall we do with his clothes?" The fool's coat, shirt and hose lay in heap where he had dropped them.

"Leave them," the chaplain said, disappearing up the stairs.

I followed him as quickly as I could, suddenly noticing the pain in my leg, barely looking back as I climbed. We crept past the hall, pausing only at the latrines, where the chaplain tipped the talismans down the one of the holes, then climbed up to the room above the chapel.

Our hearts pounding, we sat down. The chaplain's Bible was open at an appropriate chapter, paper and ink were set out on the table, and we set the candles beside us, as though we had been studying there all evening.

"It didn't work," I said. The chaplain gave me an odd,

reproachful look. "Did I do something wrong?" I said. "Was it the words I muddled?"

"No. You played your part well."

"Then why was the fool not transformed?"

"Thomas, you didn't really believe . . ."

"I don't know. I thought . . ."

The chaplain sighed. "I must confess," he said. "For a moment, I almost believed that we had transformed him. But not into a normal man. When I saw him, lamp-lit and wreathed in smoke, I thought we had conjured up a fiend from Hell."

"You thought the magic had worked?"

"It was not magic, or anything like it. I composed the ritual carefully. There was no possibility of it working. And yet . . ."

"It might have worked by accident?"

The chaplain shuddered. "God watches over us, and his angels guide us. But the devil watches us, too, and his demons try to lead us astray."

"What have we done?" I asked.

The chaplain sat up straight, composing his face into a calm and confident expression. "We have taught the fool a lesson," he said.

"But he is Umberto's fool. He will have his revenge, and it will be worse than anything he has done before."

"You cannot know how much he has harmed me."

"I can imagine it. The fool has mocked us all at some time or another."

"Not him! Umberto has harmed me. He has imperilled my immortal soul." The chaplain gave me a grim look. "Do you remember that raid when Amadeus was killed by a woman he was trying to rape?"

I would never forget the face of that woman, or my part in the two deaths that resulted from her pride. "I remember," I said.

"Well, they brought Amadeus back here and gave him to me to deal with. But there was nothing I could do. There wasn't much life left in him by the time they tipped him off the wagon."

"We all knew he would die. I am sure Umberto knew it too."

"I'm sure he did. But it wasn't a cure he was after. He wanted absolution."

"For a dead man?"

"He wasn't quite dead, otherwise it would have been out of the question."

"So you gave it to him?"

"I had to. Even though he was a rapist. And even though he could give no sign of contrition. Umberto forced me. Men like him think the words work like magic. As soon as they are said, the man is saved. But that's not the way things are. To be saved from his sins a man must repent. And he must do a penance. Something for every sin, that matches its gravity. Otherwise his soul is lost, whatever words a priest says, willingly or not."

"I don't understand. Why is your soul in danger?"

"Because I gave an invalid sacrament. I asked God to save the soul of an unrepentant sinner, so I am a sinner myself."

I did not know what to make of the chaplain's qualms. It seemed a lot of fuss to make over a few words. I mused on what he had said, turning the ideas this way and that. It had hardly occurred to me before that night that I had a soul or that it might be in danger. I had not been to church often enough, or heard enough sermons, for that. But I had heard the men talk of such things. They all knew that their souls could be pulled back from the brink of Hell like straying beasts. All it took was the right words said by a priest. They would hardly have done what they did without that reassurance. And I had heard men say that you could buy your way out of any sin, if you had the money. Now the chaplain was telling me that the words lacked power without repentance. But it was his own soul he was really concerned about. He must have considered it much finer than anyone else's if he thought it would be imperilled by a few involuntary words.

It made no sense to me. It was hardly the chaplain's fault if Umberto made him give absolution. It was more my fault than his, given my negligence in searching the woman. Or

perhaps it was hers, a consequence of the sin of pride. If the chaplain's soul was in danger for giving absolution to a rapist, and the rapist was damned for his crime, what was my likely fate when I had both abetted the crime and killed its victim? I thought of all the bad things I had done, and how little choice I had about doing them. Can we sin, I wondered, if we have no choice? A man who cannot choose must be beyond good and evil.

And that, I realised, was the fool's excuse. Mockery, he claimed, was in his nature. He had no choice. If he did not mock me, he would mock someone else.

"What shall we do now?" I asked.

"Sit calmly," he said. "Breathe deeply, and look at this text."

He pointed at the open pages of the Bible, indicating that I should read the verses he had chosen. I tried to compose myself as though we had been there all evening, but I could not read. I thought about sin and redemption, and about the fool, and the cellar, and what we had done there. The chaplain sat as silently as I did, thinking his own thoughts, and we were still sitting at the desk staring vacantly at the rich pages, when Umberto's men came to get us.

We were hauled down the steps and along the narrow passage to the hall. I thought we might be left there to sweat, but we were quickly shoved through a door into Umberto's private apartment. Umberto stood there waiting, his broad face full of anger, the cleft in his chin puckering as he ground his jaw. I could not help noticing that, for once, he had been shaved badly, and a tuft of hairs sprouted from the cleft. The fool trembled beside him, wrapped up in blankets, still stinking of the potion he had rubbed himself with. Fulk stood beside the fool, obviously under orders to watch him closely, in case of further madness. I saw from Fulk's fierce expression that I had failed him. The words of encouragement he had once given me, however grudgingly, had proved misplaced. I was terrified, but the chaplain kept calm, standing beside me as though he had been summoned to give his opinion on some scholarly matter.

"I could have you killed," Umberto said, glaring at the chaplain. "You are nothing to me. Nothing!" He waited for a moment before continuing. "Sometimes I think it would be no bad thing if every priest and friar in the world were hanged! God will guide and judge us without your intervention. And you're no use when I do ask for your help. You quibble when I ask you to give absolution! I can manage without you. There are dozens of wandering friars and dispossessed clerics who could do your duties in the chapel. I can read well enough, and there are others who can write letters for me. You would not be missed."

The chaplain attempted to speak, but was silenced by Umberto's glare.

"And you!" Umberto said, turning to me. "I cannot even remember your name. You are insignificant. I do not believe you have ever contributed anything to my campaigns. My hounds are more use than you are." The greyhounds trotted out of the shadows, their hot breath misting the air. Umberto bent and patted them. "They are wiser than you," he said, "and more loyal. They are worth their keep. But you! You are no more than an extra mouth to feed. You are not even worth killing! I should drive you out into the freezing countryside and let you fend for yourself!"

Umberto looked over my shoulder and nodded. I was struck from behind and flung down onto the floor. I lay there with my face pressed into the rushes, which were old, and full of foul things. Vermin crept and wriggled beneath my eyes, and the stink of rotten food filled my nostrils. I imagined myself lying dead on a dunghill, consumed by worms and maggots. One of the hounds licked and nuzzled my ear.

It occurred to me that the countryside was no longer freezing, and that being driven out into it might be preferable to some of the other things Umberto might do. Carefully, I tried to turn my head away from the stinking rushes. No one stopped me, so I slowly twisted my body round, raising my head until I could see the chaplain. He kept calm, even when Umberto turned back to him and resumed his rant. "You have made a fool of my *buffone*," he said. "And you have risked the

immortal souls of everyone in my castle by practising witchcraft."

By then, though I had pondered the fate of my own soul, I was more afraid of punishment in this world than in the next.

"Look at my *buffone!*" Umberto said. The fool stood beside him, looking warily at Fulk, evidently wondering how things would turn out. "He is naked! What could be more offensive to civilised men? Or to gentlewomen, for that matter." I remembered the Feast of Fools, and how it had ended. Did Umberto really not know how his men behaved? Or did he prefer to delude himself? "You, my chaplain," he said. "You should know better. Was it not for the shame of nakedness that Adam and Eve were driven out of Paradise? Yet you insult me and all my followers with this display of gross nakedness."

With the fool's distressed state all too apparent, and his deformed body barely concealed by blankets, I thought that there could be little doubt about what we had done. I was ready to confess everything, even to things we had not done, if there was any chance of getting out of that place alive. But the chaplain was braver than I was.

"But my lord," he said. "I know nothing of this. Thomas and I were in my room studying. I have hopes of making a scholar out of him, and knowing how my lord values scholar-ship, I thought the attempt well worth making. He might be of assistance in some of the work my lord requires of me." Somewhat to my surprise, Umberto listened, and the chaplain went on. "With respect, my lord, it is clear that the fool is mad. He has been overcome by some fever, perhaps brought on by a passion that has fermented over the winter. The season is notorious for bringing on lunacy of all sorts. Some authorities blame the food we are obliged to subsist on . . ." Umberto glared, and the chaplain halted for a moment. "Of course," he went on, "the food my lord gives us is excellent. I was only illustrating my point with a general observation on the winter diet. It may be that the fool has not been eating wisely, despite the abundance on offer. And illness is just as likely to be caused by the thickening of the air brought on by extreme

cold. Woodsmoke, too, is held to be harmful, though others say it is curative. Perhaps I might examine him? It is possible that a remedy might be found in one of the old books in my lord's library. There are potions, I believe, that are efficacious in some such cases, though sadly not all."

The fool squirmed at the mention of potions. I listened to the chaplain with admiration, though I feared that Umberto would not believe a word he said. And Umberto clearly had his doubts, for he asked the chaplain about the ceremony in the cellar, listing the things we had set up there, which the fool had obviously remembered well.

"There was no such ceremony," the chaplain said. "Do you really imagine, my lord, that I would befoul myself by robbing corpses and scavenging for animal dung? And if you doubt me, have the cellar searched. You will not find any scrolls, or talismans, or magic chalk stars. Those things exist only in the fool's imagination."

My admiration for the chaplain's coolness changed to fear, then. How could he be so sure that we had removed everything from the cellar? He might easily have overlooked a talisman, and I might have failed to obliterate a chalk line. But Umberto had anticipated the chaplain's suggestion, and just then two men came up from the cellar and announced that they had searched it thoroughly. One of them, with obvious reluctance, carried the fool's clothes, which he dropped quickly on the rushes.

"Is that all you found?" Umberto said.

"Yes sir."

"No scrolls or talismans or chalked stars?"

"No sir. Nothing like that. Just those clothes."

The fool's expression changed then. A calmness came over him as he realised where he stood. He knew that the chaplain had outmanoeuvred him, and made him look a bigger fool than he thought himself. His only choice after that was to claim that the foolery was his, not ours. His ugly face folded itself into a wide grin as he began to mumble his new story. The whole thing was a jape, he said. He had stripped himself and run through the hall, calling out the name of his supposed

beloved, to entertain Umberto and his favourites. He was simulating madness because he knew it would amuse, and he had blamed us, and accused of witchcraft, as part of the prank. He went on, elaborating his story with would-be clever touches, labouring a thin joke until his master's contempt became obvious.

"Do you expect me to believe this nonsense?" Umberto said, when the fool stopped prattling.

"But sir, it is true," the fool said, hitching the blankets around him. "Every word." He looked at us imploringly. Of course, we knew the truth, but the fool knew that we would not reveal it any more than he would.

Umberto looked down at me. "You can stop grovelling," he said. "Get up!" I stood, and brushed myself down as well as I could, taking my place by the chaplain.

"Well?" Umberto said.

"It must be as he says, my lord," the chaplain said. "For we know nothing of any devilish deeds in the cellar, and I perceive now from the fool's face that I was wrong. He is merely agitated, not mad."

From that moment, the fool, the chaplain and I were locked together in a pact of lies and concealment. We had got away with it, but I did not feel safe. Unlike the fool or the chaplain, I was just another fighting man, and could easily be disposed of if some dangerous deed was needed. And, whatever Umberto thought, I was sure that Fulk knew more than he said.

The fool kept his promise, and I was able to appear in the hall without being mocked. Perhaps I was no longer a satisfying victim. Being enthroned as Lord of Misrule had pricked my swollen head just as surely as the chaplain's knife had burst the suppurating wound in my leg. The pus of pride had leaked away, and if I still felt an occasional twinge of superiority I was careful not to show it.

I kept clear of the chaplain for a while, partly from choice, partly because the start of the campaigning season drew near, and Fulk kept us busy with mock fights and other preparations. My wounded leg had healed well enough for me to

walk and ride without difficulty. The scar on my neck made me look more fearsome. I did not like my fellow brigands any more than I had before, but when the first raids began, I went out with them and played my part, winning a little booty for myself and making sure I was seen to act bravely. It was not long before I felt the need of less boisterous company, and climbed again to the room above the chapel.

"Well," said the chaplain, "Have you come for further treatment?"

"No. My leg is cured now, and I am grateful, believe me."

"But you want something else?"

"I came to pass the time."

"Perhaps you wish to be transformed?"

"No. The lesson we taught the fool was good enough for me too."

"I might still transform you into a scholar."

"Can it be done?"

"I said I had hopes of it. I had better lend my words some truth by attempting the deed."

"You have a lot of books here." The chaplain's chest was open, its contents emptied out. There seemed to be far more books than I remembered, and they were spread over the floor and bed, as well as on the small table, which was also piled with scraps of closely-written paper.

"Too many," he said. "And, as if there weren't enough already, there are always more books coming out of Constantinople. Sometimes I think a flood of books is spreading across Christendom. But I'm not sure they add anything to what we know already."

"So why do you fill your room with them?"

"Umberto has set me a task. I think it is a sort of penance. I am sure he suspects we did have something to do with the fool's madness."

"He cannot prove it?"

"Not now. He could have dragged the ditch for the things I threw down the privy, but it is too late for that. I think we have got away with it, but there is no harm in obliging one's master." A self-satisfied expression crept across the chaplain's face.

"Umberto might not have been so displeased as he pretended, to see his fool humiliated," he said. "Foolery is all very well in its way. It serves a purpose. And by tolerating it, Umberto shows himself to be a generous leader. But too much of it is a bad thing. It threatens the natural order of things. You know how Umberto affects dignity and restraint? Perhaps the Feast of Fools went too far for him. And he won't have been pleased to think that his *buffone* was lusting after one of his women. We may have done Umberto a favour, as well as ourselves."

The chaplain seemed to have forgotten how much he hated his master, and how his soul had been endangered. Perhaps, I realised, the old scholar was not as clever as he pretended to be.

"What task has he set you," I asked.

"I am to compile a compendium of wisdom, drawing on the thoughts of the old philosophers and the Fathers of the Church."

"Will you write it in Latin?"

"No. In the Italian of Tuscany. Umberto wishes the compendium to be of value to those less learned than he thinks himself. The finished work is to be sent away to Florence, and copied in the style of Poggio. I can't see the point of that style of writing myself. Where is the beauty, with no embellishment? A child could do it! But Umberto follows the fashion in such things, and he see the shapes of the letters even if he has no idea what the words mean. In any case the finished volume will bear his name. The book will be a monument to his cultivation."

The chaplain looked ruefully at the disorder on his table. I guessed that he was going to ask me to help him, and that was not a task that appealed to me. I wanted to share his knowledge, not his labours.

"Will you share with me the secrets of your old books?"

"You sound like the fool again."

"I only want to learn."

"You have learned a little already."

"I want to know more. Will you share your secrets with me?"

The chaplain looked at me oddly. "That remains to be seen. But if you agree to help me, there is one secret I might share with you, something that young men of your type would all do well to learn, or so I believe."

"What is that?"

"The secret of love."

I was disappointed. The chaplain had already admitted that he knew nothing of love. And as for his books, what did old philosophers or the Fathers of the Church know? Love was for the young, and had nothing to do with books, except for romances of the sort the chaplain would hardly have in his collection, even if Umberto's ladies enjoyed reading them. And the fool, by his own example, as well as his mockery, had amply demonstrated the folly of love. Without meaning to, he had done me a service.

"Not the secret the fool wanted?" I said. "Not potions and incantations?"

"No. Perhaps I have not expressed myself clearly. Love is not quite the right word. It is a delicate matter. One which one such as myself might not be supposed to know about."

"And do you?" I said, puzzled.

"In a manner of speaking. But not directly, you understand. I have no experience of love, or the arts that can provoke it."

"But you have read about it in old books . . ."

"You have guessed well." He turned to rummage in the chest, and pulled out a book. It was a thin thing, of stitched quires, its leaves tattered from overmuch fingering. "It is in here," he said. "Or I think it is." He licked a finger and turned a few of the pages, peering at the words until he found what he wanted. *The Secrets of Love,*" he read.

I sat and waited while the chaplain turned a few more pages, determined not to be impressed by anything he told me. I did not want to be misled and humiliated like the fool.

"Here it is," the chaplain said, adjusting his spectacles and peering through them. He began to read, but in a peculiar sort of Latin, quite unlike the verses he had encouraged me to study earlier. I listened carefully, picking out a few familiar words, but not detecting any meaning at all.

"I don't understand," I said, after I had let him read for a while.

The chaplain looked up, sighing. "This passage deals with certain amatorial techniques of an anatomical-manipulative nature, which, if practised diligently, and with dexterity, result in mutual gratification of the venereal type, or rather, with which gratification may be given, with the resultant reciprocation occuring subsequently, if not simultaneously. That is to say . . ."

"I am sorry, but I still do not understand."

"Do you understand anything? I thought it might be possible to make a scholar of you, yet here I am, explaining the one thing that most young men, whether scholars or not, would be only too happy to have knowledge of, and you still can't understand me."

"I'm sure I will understand well enough, if only you can explain it simply."

"What I am trying to tell you, Thomas, is how to pleasure a woman!"

I sat silently for a moment, surprised by the chaplain's words. He too was silent, his face reddening at his own unaccustomed directness.

"And this is in that book?"

The chaplain held the book up, and studied the page again. "It is, Thomas. That is why it is called the *Secrets of Love*. Now let me explain, as simply as I can. The book refers to certain parts of a woman, which of course, I have never seen, and know nothing of, which are called her *pudenda*."

"Yes?"

"Now *pudenda*, as I am sure you realise, if you have been paying attention to your Latin, is plural. The parts are several. And among them is a part, which, if touched in the right way, can give her pleasure. Are you following me so far?" I nodded my head. The chaplain's face turned a deeper red, and he raised the book slightly to cover his embarrassment. "Now, this part is not the part you may be thinking of, and of which you no doubt have some experience." I nodded again. "That part, or so I am informed, merely acts as a receptacle for the

membrum virile, or male member, and as a conduit by which the new-born must reach the world. That is not the part the book refers to at all."

"So where is it, then?" I asked, puzzled.

"I am afraid the book lacks precision on that point. The writer seems to assume some knowledge in the reader, and I, of course, have none. It tells us what to do with the part, how to manipulate it and give a woman pleasure, but not where it is."

"So how am I to find it? Is there a picture?"

"No." The chaplain shuddered slightly.

"But the other book you showed me, the Saracen book, had pictures."

"They were symbolic." The chaplain turned the pages. "Now, it says here that the part is rather like the pearl in an oyster." He paused. "It's a long time since I last ate an oyster."

It was a long time since I had eaten an oyster, but I remembered their folds and frills of moist flesh. I shuddered at the memory of my humiliation with Catherine. I thought of other girls, and of tentative gropings and the rebuffs that had followed. I tried to imagine what lay under the skirts of the girls I had so feebly chased. Dimly, I began to understand. I thought I knew what the part might be. But I was puzzled by the apparent simplicity of the chaplain's revelation.

"This method that must be used to give a woman pleasure. Are you sure there are no amulets, no potions?"

"Nothing like that is needed. Just the natural members that God has given you." The chaplain went on, looking at his book, naming parts in Latin, reading out passages and translating them.

"Is this not widely known?" I asked.

"Did you know it?"

"No."

"Yet you have some experience . . ."

"A little." I did not know how much he had been told about the Feast of Fools, and did not intend to enlighten him.

"And yet you did not discover this part or its purpose."

I avoided his question. "But other men must know of it."

"Of course," he said. "The Ancients did, or it would not be in this book. And some men, perhaps with more experience than you, must have discovered it for themselves. But many men would scorn such knowledge. What do they care for a woman's pleasure, as long as they get theirs? And some say that women cannot experience such pleasure, or that those that do are no more than wantons."

"And you?"

"I know nothing except what is in this book. But it seems to me that, if giving such pleasure is possible, then doing so is a way to win popularity. And for someone in your position, who does not have the power to command women to come to his bed, popularity would be a good thing. I presume that any woman pleasured in the way described would willingly return for more."

I thought for a while about the chaplain's words, while he looked again at the book. "Does Umberto know of this?" I asked.

"That is difficult to say. I have drawn it to his attention, as was my duty, and he has cast his eyes over the passage in question, but who can say whether he understood it? It may be that his Latin is not as good as he would like me to think it is, and that he is too proud to admit what he does not understand. His favourites make great show of their reading and learning, but the latter is as shallow as a summer pond. Perhaps Umberto's is no deeper." A sly look came into the chaplain's face. "It *may* be," he said, "that Umberto cannot read and write at all, and merely pretends to be literate because he thinks a love of books is the mark of a gentleman."

I determined to try out the new knowledge the chaplain had given me. I selected one of the servant girls, who I thought might be willing. And I determined also that I would not hang back, but would press my attentions on her boldly, just as the other men did, not caring about rejection, for there were other girls and would be other opportunities, or so I told myself. It was my timidity that had helped the fool make a fool of me.

I lurked in a passageway near the kitchens until a girl I fancied went by carrying a basket. She was almost as tall as me, and slender, but for her breasts, which were high and full. I caught her by the waist, pulling her towards me, as I had seen other men do. Her hair smelled of woodsmoke, and of all the delights of the kitchen. She told me to let her go, and threatened to scream and call out for the cook, who was not far off and waiting for her. That was what had happened before, and I had usually given up at that point. But I had decided to be bold, and would not let her go. She struggled and tried to get away, and I was afraid she really would call out.

It was no use telling her that I would die if she did not let me love her, or anything like that. I had heard all the answers before.

"Wait," I said. "I have something for you."

She turned and faced me, holding out her hand. "Let's see it then."

"It's not something you can see."

"Oh!" She looked at me sourly. "What kind of thing might it be then?"

"It will make you happy."

"There's not much that can do that. Not that you can't see and put in a purse, anyway."

"This will."

"What?"

"What I can do for you."

"You're not going to make me a promise, are you? Let me guess. You'll give me something, some day, when you can. But you want something from me, right now."

"It is a promise, but I can deliver it in a moment. I promise to give you pleasure."

"Well, that's a novelty! I've been asked to give pleasure often enough, but I've never been offered it. Where d'you learn a thing like that? Not from that chaplain you hang around with?" She looked at me oddly, and I am sure I must have blushed. A real girl seemed very different from what I had imagined when listening to the chaplain's obscure words. "I wouldn't fancy any pleasure you might have learned from him."

"No," I said. "It is nothing to do with him. Just give me a moment and I will prove it."

I must have roused her curiosity, if nothing else. She put down her basket and led me into a storeroom where we were soon enfolded in each other's arms. After we had kissed and cuddled for a while, as custom requires, she unfastened her smock and revealed her breasts. I was glad enough to see them, for they were full and round, and served as markers, like twin hills showing the way a traveller must go if he is to reach his final destination.

Encouraged by her willingness, I reached under her skirts, lifting them up and out of the way. I felt her thighs, which were warm and welcoming, slipping my hand upwards until I found her *pudenda*. She parted her legs, expecting me to thrust into her, to finish quickly, so that she could rearrange her clothes and get back to her duties. But I did not enter her. I held back, keeping my hand where it was, and probed gently, slowly exploring a place I had visited only briefly before. After a while, I found what I was searching for and began to fondle it, following, as best I could, the advice of the ancient authority the chaplain had read to me. The method evidently worked, as she squirmed and sighed with pleasure, sometimes so loudly that I feared someone would hear her. I kept up my touching and stroking for as long as seemed desirable—the book had given little guidance on that point. Then, fearing that we would be discovered if I delayed any longer, I plunged into her. What the chaplain had called my *membrum virile* was by then as big as it had ever been, and as ready. I slipped into her as quickly as a cannonball into a hot barrel, and, just as quickly, was discharged. My whole body shuddered with the shock of it, like one of the great bombards at Orléans.

The next time I saw that serving girl, I did not have to persuade her. She threw down her burden and dragged me into a dark corner, demanding that I did what I had done before. After that I tried the same thing with other girls, and found that I was successful more often than not. My

new-found boldness brought me as much success as the skill the chaplain had taught me. That was a secret well worth knowing in itself. And I learned that all the girls were not the same, that some were easier to please, some too timid to abandon themselves, others so seemingly pious that they cried out to Our Lord at the conclusion of our exercises.

"Well?" the chaplain said, when I next went to visit him. "Has it worked?"

I tried to look innocent, as though I had not understood, or forgotten what he had told me. But he was not fooled. "You know what I mean," he said. "The method I explained to you, of giving a woman pleasure. Have you tried it?"

His eagerness was almost indecent in one of his status, and I wondered whether the fool had been right in telling everyone that the chaplain had been expelled from his order for committing a sin of the flesh. But his ignorance had seemed genuine when he read to me from that old book, and I could hardly deny him the truth after he had helped me.

"I have," I said

"How many times?"

"Several."

"You must take care," he said. "An excess of venery can be harmful. It can consume the spirits and weaken the brain."

"I don't think I have had an excess. Not yet."

"Did you do it with one woman?"

"With several."

The chaplain leaned forward, rubbing his hands as though washing them. "Did it work?" he asked.

"As far as I can tell."

"What do you mean by that?"

"How can I tell whether someone else is enjoying themselves?"

"By looking and listening, of course. Even the fool knows when the men laugh at his jokes. Not that that happens very often these days."

"Then it would seem that the method you described to me is correct. The women all seemed to enjoy themselves, according to the signs they gave."

"Tell me how," the chaplain said, stepping across the room to his desk. "Tell me how you could tell."

"Do you want me to describe what I did?"

"Yes!"

"But it may have been a sin. You have warned me about that."

"Lust generally is. If you feel guilty you can always be absolved."

"By you?"

"Yes, but first you must confess. Are you contrite?"

"Yes," I said, though I did not feel contrite.

"Then tell me what you did." He picked up a pen and sat ready to write down whatever I told him.

5 Arras

I made a foolish mistake in Arras. It would be easy to blame my youth and inexperience, or the fact that I was in a big town for the first time with money in my purse. My red doublet was perhaps a little warm for the season, and might have fitted a larger man better. But I thought I looked well in that outfit, and that others might think so, too. I daresay I walked with a swagger, as young men often do, not knowing how foolish they seem. By then, though I was not much more than twenty, I thought I had succeeded in making myself a gentleman. I imagined myself the equal of Umberto's favourites, perhaps even their superior. I had spent much of that summer reading the chaplain's books, and debating with him what I had learned from them. I even dared question some of what I read, thinking that what was written centuries ago might no longer be true. The chaplain was surprisingly forbearing, pointing out that one thing, at any rate, still seemed to be true, even if he could not vouch for it from his own experience. And that thing played a big part in my downfall. Among all my other follies, I was chiefly misled by the small success I had had among the serving girls of the castle, which made me think myself a great adept of the Secrets of Love.

We had little warning of our departure for Arras. It was in August, when we would normally have been campaigning, except that that year had been an unusually quiet one. Our journey was hastily arranged. Only when we were riding north, choking on the dust raised by a crowd of men, horses and mules, did I began to understand why Umberto had left the castle, and what opportunities the journey might offer me.

"It's the peace conference," the chaplain said, struggling to keep control of his mount. "The pope has sent various of his minions to make your king and the dauphin and the Duke of Burgundy come to some sort of agreement and stop the war."

"Why should Umberto care about peace? He lives by war."

"Precisely. Peace will end his living. How many raids have

you been on this season? Hardly any! Otherwise, how could you have spent so much time hanging around my room and distracting me from my work? The French are growing stronger, and Umberto's authority is waning. If the powers that are gathering in Arras stop fighting each other, they'll have the resources to secure their frontiers and govern their territories properly. There will be no room for free companies like ours. If Umberto cannot attach himself to a great lord he will become nothing. He must make his peace with one of them, or be driven out of his holdings."

"What will happen to him then?"

"There are plenty of opportunities for men like him. The Italians pay well for others to fight for them. That way they can keep their elegant hands clean. For the more conscientious there are the wars in Lithuania. That unfortunate country is full of pagans and heretics, and the Teutonic Knights need more men to deal with them. Or the Poles might hire him, to fight the Knights. Perhaps our leader will save his soul by fighting the Moors in Spain, or the Turks in the Morea. There are many of his countrymen there, and mine, too. Anyway, the talks may fail. In which case, Umberto will go back to the castle and resume his former life."

"And us with him," I said. Brigandage had begun to pall, especially after the trouble we had had with the fool, who, though he had not betrayed us, had made our position in the castle uncertain. Even the pleasures revealed to me by the chaplain's old book had caused trouble. Several of the girls who had once spurned me were competing for my favours so obviously that other men in the company were muttering about rearranging my features to make them less attractive. Fulk was particularly jealous, though he was careful not to show it. I had the feeling that he was waiting for something, some evidence or opportunity that would utterly destroy me. In the meantime he stirred up resentment among the men, and there was the danger that, in the middle of a raid, a sword or halberd belonging to one of my fellows might strike me accidentally.

"Not necessarily," the chaplain said, looking around cau-

tiously and dropping his voice. "There may be opportunities in Arras."

There were no rooms to be had anywhere in Arras, but when Umberto saw an inn he liked the look of, he sent his men in to throw out the guests. They were merchants, and when they protested that their goods were still inside the inn, Umberto had them thrown out into the street. Some of the ejected guests complained that they had already paid for their rooms, so a few coins were flung into the dust at their feet. Only when all was ready did Umberto himself appear, finely dressed and well attended, looking like a man who knew nothing of violence. Despite his peaceable pose, he refused to hand over his weapons, or ours, to the innkeeper, as Burgundian law required. We soon discovered that few of the other visitors had handed over their weapons, and the streets of Arras were full of armed men, some escorting noblemen or bishops, others wandering the town on their own account, taking advantage of the crowds and confusion to pick pockets and start brawls. They mingled with monks, priests, merchants, soldiers, all wearing their customary costumes, and with women, both respectable and otherwise. The noise of the town amazed me, and I was almost deafened by the calls of the criers and hawkers, who told news, made proclamations, sold wares, scolded rivals and haggled over prices, shouting loud enough to drown the ringing of church bells. Cities were busy places, I realised, and the lives of city people different from that of soldiers, who idle when they are not fighting and find nothing urgent except retreat.

Umberto ignored the bustle around him, and organised his visit to Arras like a campaign, assigning everyone duties, issuing instructions and hearing reports on the day's activities. Fulk was sent off to make contact with the Duke of Burgundy's retinue. Other men were assigned to followers of the dauphin and the regent. All had instructions to find out how the land lay, and see what rewards might be got from offering to serve those sovereigns. The chaplain was to

approach the Cardinal of Santa Croce, who had convened the talks, and would influence the outcome. I was assigned to the chaplain as his bodyguard, which did not please me. I was still young, and had seen little of town life. I was excited by the confusion and clamour in the streets, and wanted to tour the taverns with the other men, doing what they did. But the chaplain insisted that I went round the city with him, telling me that the alleys were full of thieves and cutpurses, and that the watchmen would as soon arrest us as one of their fellow citizens.

"Where are we going?" I asked on our first outing. The chaplain led me down a narrow street lined with shops, in which cakes and sweetmeats were laid out on boards.

"To a church," he said, waving away a cloud of flies that rose from a dish of sweet pastries. I must have looked disappointed. "It will do you no harm," he said. "When did you last visit a church?"

"I was in the castle chapel not long ago."

"Longer ago than you think."

"Why must we go to this church?"

"To see someone. We can't approach the cardinal directly, any more than we can walk into the citadel and parley with kings or dukes. These things must be done indirectly. I must go and see a priest I know. We will talk about old times, and people and places we once knew, and eventually we will get round to the business at hand. He will pass me on to someone else, who will know another man, and so on. Eventually I will find out who I need to speak to get an introduction to the cardinal's retinue. Then I will be able to begin pleading Umberto's cause. It may take some time."

After seeing the priest we visited various churches and monasteries, as well as some of the more select inns and guesthouses, seeking out men who might have influence. The chaplain seemed to know Arras well, and led me round its narrow streets so quickly that I hardly had time to look where I was going. I followed his black gown as it billowed behind him, making the chaplain look like an enormous crow. He dashed down alleys and through doorways, sometimes pausing

for a moment to get his bearings before rushing on as though afraid to be caught in the open. We were frequently jostled, and jeered at by drunkards, and had we carried anything of value they would have stolen it. I felt vulnerable, and wanted a few more armed men about me, but I had instructions not to draw my sword. The chaplain was keener to attend to his business than avenge slights and insults. And, as it turned out, more men would have impeded his true business.

We criss-crossed the city, sometimes walking in shade so deep that we seemed to be toiling along the bottom of a valley. But just when I thought the darkness would never end, we would emerge in a wide square lit with a blaze of bright sunshine. There were markets full of women selling fish, poultry, cheese, and vegetables from the countryside. It was obvious that Artois was not devastated like the Loire country. And Arras made its own wealth. We caught glimpses of court-yards where weavers worked, and where their colourful wares were on sale. There were bales of wool stacked everywhere, all sent from England, perhaps from Norfolk, where the merchants bought it from men like my father.

For everything fine in Arras, there was something sordid. Elegant women stepped through filth, clutching perfumed handkerchiefs to their noses. Stocks and gibbets stood before churches, their victims ignored by laughing strollers. Silk-clad moneylenders jostled with grimy fishwives, and richly vested priests stumbled over wandering pigs. The smell of good food wafting from tavern windows was overpowered by the stench of the dung carts. And not far from the fine houses of the wool merchants were the stinking dye works, with their vats of colours and mordants. The dyers, their hands, arms and faces blotched with every colour, looked like wild savages. They sounded wild, too, and shouted constantly in their thick dialect. Perhaps the dyes they used drove them mad. I was not tempted to linger in their quarter.

There were places that seemed dark, even when bathed in light. Bonfires smouldered under cauldrons of bones, shower-ing us with smuts, and choking us with smoke as surely as the chaplain's Greek Fire. There were heaps of rags everywhere,

and the heaps quivered as dogs and children mined them for anything of value. Surly beggars glared at us from foetid hovels, or lurched into our path, holding out suppurating hands and demanding alms. Others, healthier-looking, tried to clutch at us, offering us pleasures that I barely understood. But we rushed on, even faster than before, mangy dogs yapping after us.

Every so often, and without any warning, the chaplain would stop. His gown would sink round him like a struck sail, and he would announce that we had reached our destination. Usually I had to wait outside, feeling conspicuous and exposed, watched by beggars and urchins. But sometimes I was allowed to follow him inside, and was given a place to rest. Despite the heat outside, the places he visited were always cold and musty, as churches and suchlike places tend to be, in my experience.

For much of the time my mind was not really on our mission, but on the women we saw in Arras. The squalor of the city made their beauty shine out like flowers on a dungheap. The August sun was too strong for them to go about cloaked and hooded, though they were careful to shade their faces under wide hats trimmed with lace and ribbons. As we wandered the city I gazed at them, drinking in their loveliness, enjoying the richness of their dress, longing for their company. I saw more lovely women in a few days than I had seen in the whole of my life. But none of them compared to the girl I saw hanging around the inn. I was not sure who she was. She did not serve there, though she was of the serving class. Nor was she related to the innkeeper, a dried-up stick of a man, who was more interested in money than anything else, and had no family. As soon as I saw her I wanted her. She was full-faced, with brown eyes, and hair of the same colour that was gathered up and garlanded with fresh herbs. Her dress was simple, and she always wore a spotless white apron. She needed nothing grander than that to show off her figure. And though she smiled happily at everyone, she seemed attached to no one.

I found her beauty as daunting as her easy manner was

pleasing, but I was determined to speak to her. Often, while I stood about waiting for the chaplain, I rehearsed the words I might use to attract her attention. Sometimes I was mocked by children, who, seeing me hanging around outside a church and muttering to myself, thought me an imbecile. But I cared nothing for them, and thought only of the girl.

It was not easy for me to get away from my duties. When I was not escorting the chaplain, I was expected to attend Umberto, not doing anything in particular, but swelling his entourage and increasing his apparent importance. One afternoon, while the chaplain was reporting his day's business to Umberto, I managed to speak to her. Though not vastly experienced, I knew enough by then to make my meeting with her seem accidental, and to conceal my interest. As I brushed past her in the inn-yard, where I had been stationed for some time, I made a polite remark about the August heat. It was no masterpiece of eloquence, but it served, and she stopped and talked to me, showering me with smiles and glances until I was almost speechless with desire. I could not linger, as I was expected back in the inn, but I did find out that she was called Hélène.

That night as I lay in bed, with the chaplain beside me, and a dozen snoring soldiers ranged round the room, I thought of nothing but her. I imagined new encounters with her, the witty words I would say, and the pleasures we would share.

But the next time I saw Hélène she seemed not to know me. She smiled and chatted just as before, but gave no sign that we had ever met. And she glanced and waved at others who were passing in the street, turning her eyes away when I wanted nothing more than to gaze into them. When I asked her whether we would meet again, her answer was evasive.

"If you happen to be here when I am," she said, "then we will surely meet again."

Whenever I could slip away from my duties, I hung around in the inn-yard or in nearby streets, hoping to see Hélène again. Sometimes I was successful and we exchanged a few words. Once she allowed me to stroll with her to the end of the street, and I escorted her gallantly until she left me at the

corner with a puzzling remark about having to meet someone else. My dreams became more vivid, and it was a torment to share a bed with the chaplain. I feared that I would reach out for him in the night, imagining him to be her. I knew that, if I was not to driven mad with desire, I would have to ask her outright for what I craved. I had conquered the girls at the castle, so I would conquer Hélène.

The next time we met, I spoke boldly.

"Of course, I *could* go with you," she said, giving me a glance that weakened my knees. "But there is one little thing . . ."

"What?"

"You will have to give me a little money."

"Money?" My heart sank at the mention of that word. She wore no striped hood or yellow ribbon. Nothing in her appearance marked her out as a girl that required to be paid, and I had not thought of her in that way. Yet what else could she have been?

"It is only a little, and I don't want it for myself."

"Then what is it for?"

"Oh, don't glare at me like that. To pay for a place to meet, of course."

"But why should we pay for that?"

Hélène sighed, in such a way that all my doubts fled. "I can see you're a country boy. Look around you! Can you see any empty barns or woodland groves waiting to receive us?"

I was proud of my elegant appearance, and did not like being called a country boy. But I had to admit that the city lacked the things she mentioned.

"You must have noticed that Arras is full up," she said. "And they say it will stay full up for as long as the peace talks go on. There's hardly a bed to be had, or even a stable to shelter in. If we are to meet, and to be alone, I will have to use my ingenuity."

"And my money."

"Haven't you got enough?" she said, pleadingly. "I thought you liked me? I though you wanted to be with me? You said so."

And so, seeing that Hélène was right, I gave her a few coins. I was sure that those few were all that would be needed. Once we had spent some time together alone, I would be able to persuade her by other means. She went away happy, and said she would send a message to let me know where and when we would meet. For the next few days the chaplain trudged Arras, his mood darkening, but I almost danced as I followed him, thinking of nothing but the pleasures I would soon share with Hélène. Eventually she sent a boy who said I was to follow him to a house where she would be. It was a narrow house, crowded in with many others in a poor part of the town where the stink of dungheaps was more overpowering than usual. I was led up some rickety steps to a room, in which she lay on a couch, covered with a thin sheet. I could see that she was naked under it, and wondered at her forwardness, for we had done nothing but talk until then.

Hélène stirred on her couch as I went into the room, raising a pink hand to mop her brow, and causing the sheet to fall away from her bosom.

"I am sorry that you find me like this," she said, quickly tugging the sheet back into place. Her voice was faint and feeble.

"Like what?"

"Can't you see I am ill?" she said. "It is the heat, and the surroundings I am obliged to live in." She wrinkled her nose with disgust, glancing to the window, which must have opened directly over a dungheap.

"You live here?" I said, wondering why I had been asked to provide money.

"Not here," she said, sitting up, though keeping the sheet around her. "But hereabouts. Arras may seem a fine place to a country boy like you, and maybe it is for the rich. But for the likes of me, life here is hard."

"What can I do?" I said, sitting beside her on the couch. She did not object, but moved away from me, pulling the sheet tighter around her. That made her less accessible, but emphasised her shape in a way I found maddening. I reached out to touch her, but she pushed me away.

"No," she said. "Did you not hear me say I was ill? I thought you would want to talk to me, to make me feel better, not to press yourself on me when I am too weak to resist and too ill to share your pleasure."

Her talk of pleasure would have roused me further, had she not stirred up guilt by reminding me she was ill.

"What is wrong with you?"

"I cannot say." She looked coy. "Perhaps you can guess?"

"No."

"Well, there are some things best left unsaid, between a man and a woman."

I had no idea what she meant, and perhaps she meant no more than to keep me at bay. We talked a little longer, and she allowed the sheet to slip several times, giving me glimpses of her breasts. Then an old woman came into the room and said it was time for me to go, though she said it in such a thick accent that I hardly understood her. She stood over us, waiting, and I could say no more to Hélène before I left.

I walked back to the inn both angry and aroused, and thinking so little of where I was going and who saw or followed me that it was a wonder I was not robbed, or arrested by the watchmen.

The next day, while I trudged round yet more churches and friaries, I was in almost as dark a mood as the chaplain. We were both being frustrated in our chosen business, because both of us had too little to offer.

Hélène seemed to disappear from the streets after that encounter in the house. She sent messengers who told me where and when I might meet her, but there were always obstacles. The places they sent me to were hard to find. I was greeted with laughter when I asked for the Red Door, or the Sign of the Horn, or of the Cock, Ass or Capon. Once, when dodging the watchmen from backstreet to alleyway, I stumbled into one of the squalid places I had marched through with the chaplain. Seeing that I was alone, men emerged from the shadows with clubs and torches. I drew my sword and ran fast. Sometimes, if I found the right place, I was turned away by her brothers, who seemed angry with me, as though my

attentions dishonoured their sister. Hélène later denied that they were her brothers, but would not tell me who they were. Another time they sent me to the river, and I waited on the waterfront, watching the mayflies skim the surface. They darted over the sluggish water, swarming briefly before carpeting the river with their corpses. Mayflies are creatures for making you think, and I thought long and hard about their short lives before I realised that no one was coming to meet me.

Whenever Hélène and I did spend time together there were always others present, or her illness returned, requiring medicine which I had to pay for. In the course of two weeks I spent almost all my money and got only hints and promises in return.

Somewhere in Arras, perhaps in the unreachable citadel, nobles and ambassadors were gathered together with their advisors and retainers, eating feasts, making speeches and negotiating. Elsewhere, in busy streets and taverns, lesser men passed their time, waiting for the lords to decide whether it was to be war or peace. But I was still doomed to spend my time in churches, which, like Arras itself, were both grim and beautiful. They rose up into the sky, their arches light and delicate, but were filled with mementoes of death and corruption. Rich men's tombs were carved with scenes of doom and decay, and the walls were covered in morbid paintings. There were grinning Death's Heads, Dances of Death, Last Judgements and Harrowings of Hell. Horned and bat-winged devils seemed to mock me while I stood around waiting for the chaplain to conclude his business. But, though he spoke to many priests and friars, he seemed no nearer to his goal of an interview with the Cardinal of Santa Croce. One afternoon, after I had stood for a particularly long time in a gloomy church, the chaplain emerged from a side-door scowling.

"It's no use standing there with a foolish expression on your face," he said. "You should look around you and study the lessons on these walls." He waved his hand angrily at an

elaborate painting, full of demons and sinners. "Can you read that inscription?"

Some faint Latin words curled round the bony feet of a scythe-wielding skeleton. I tried to make them out, but before I could decipher the inscription the chaplain did it for me.

"I am what you will be," he read. *"And you are what I once was."*

"What does it mean?"

"It means that death awaits us all. And so does Hell, unless we redeem ourselves."

"And how are we to do that?"

"By doing our duty."

"To Umberto?" I said. The chaplain had already hinted at other aims, but had said little about them since we reached the city. I hoped to draw him out, and discover what he was planning.

"Of course we must do our duty to him. That is why we are trudging round all these churches, trying to make contact with the cardinal. And if we don't come up with something soon, then I fear we will be back at the castle, and the prospects of redemption are slim there." He pointed at the church wall, where, high above the tormented sinners, Our Saviour was painted. "We might do well to consider our higher duties. To God, and the Church."

"You might, but I am only a soldier."

"Do you not feel the prick of conscience?"

"No."

The chaplain scowled at me again. "Well, you should," he snapped. "You have indulged in lust, as you confessed to me not long ago."

"But you encouraged me."

"I encouraged you?"

"You explained the secrets of love and urged me to try them out."

"You must have misunderstood. I showed you an old book, just as a matter of interest. No one would believe that I, Umberto's chaplain, would encourage you to indulge in venery."

"But you did, and you wrote down what happened afterwards."

"I heard your confession."

I wanted to hear no more about my duty, or about the consequences of sin. I had served Umberto long enough. And as for God, let the chaplain serve Him, if that was what he wanted. I was too young for that. I had tasted pleasure, but not had my fill. I had seen what life was like in Arras. For a man with money, cities were surely the place to be. I realised how much I had missed by living in the castle. Life there, shut up in the winter, only able to ride abroad in company, seemed a sort of imprisonment. I might have brooded on, but the chaplain interrupted me.

"I know your trouble," he said.

"You do?"

"It is the girl, isn't it?"

"What girl?"

"I am not a fool, Thomas. I know the doltish look of a young man in love, even if I know nothing of love myself. And I have seen that look on your face often enough since we got to Arras."

"But . . ."

"Thomas, you are in love with that girl who hangs around the inn. And that is why you are lost in dreams half the day, and sunk in gloom for the other half. Not to mention neglecting my safety as we walk about the town. You are supposed to be guarding me!"

"I am sorry if I have not been attentive enough to your safety."

"You are forgiven, Thomas. Now tell me that I am right about the girl."

"You are right."

"She will only lead you to unhappiness," he said, gesturing towards the painted sinners on the wall.

"Not if I win her."

The chaplain studied the sinners, peering at them over, then through, his spectacles. "But you cannot," he said.

"I won the others, back at the castle, using the secrets you taught me."

"The secrets you *think* I taught you."

"One way or another, I won them, and I will win her."

"How many times have you seen her?"

I hesitated before answering. "Often."

"Really?"

"A few times."

"I've only seen her once, myself."

"And did you not think her beautiful?"

"I never think of such things," he said, taking off his spectacles. He rubbed his eyes vigorously with the knuckle of a thumb, then stood blinking for a moment. "But there is something you should think of."

"Not the consequences of sin?"

"That, of course. But there is something else."

"And that is?"

"That real love cannot be bought."

"I am not buying her."

"That is not what I have heard. The men say that you have paid her. There's nothing wrong with that, in their eyes. But, according to them, she's given you nothing in return."

"They don't know her. Or me."

"I think they know you far better than you think. And so do I."

"Nonsense! You understand nothing.

"I will overlook your impertinence, Thomas, if you will listen to what I am telling you. She's a trickster, and she's only after your money."

"She's not!"

"It's not just a matter of money, either. She'll have her minders, if I'm not mistaken."

"She has two brothers."

"Is that what they call themselves? They'll be behind it. Making you run round Arras chasing wild geese. Face up to it, Thomas, they've made a fool out of you, just like we made a fool out of the fool. I am telling you this for your own good."

"I don't believe you! You are just telling me this because

you are jealous, because you can't have women yourself. What did the fool call you once? A eunuch, that's it!"

The chaplain walked away from me without saying a word. And, when I watch his black-clad back disappearing through the church door, I knew that he was right, and that I was wrong, and stupid, and that Hélène really had made a fool of me. That was the way of it, and there was nothing I could do. I ran after the chaplain, and when I caught up with him I held on to his black gown and pulled him round to face me.

"I'm sorry," I said. "I didn't mean it. It was anger. I'm sorry I said those things."

The chaplain forgave my rudeness, and made no further mention of my stupidity, but my mood was blacker after that. I began to see fiends and devils from church-wall paintings, even when we were not in church. They lurked in shadows and haunted my dreams, taking the form of Umberto and his fool, and of Hélène's two brothers. Wandering the town became almost as great a torment as staying at the inn, and the gloomy churches of Arras became a haven. I was almost sorry when the chaplain announced that he had found out whom to approach. A week or so later he presented himself to Aeneas Sylvius Piccolomini, the Cardinal of Santa Croce's secretary.

I stood in the background, watching the two of them talk. Piccolomini was seven or eight years older than me, and I could see that he had not been a fighter. He had soft hands, and a fine face which, though dark in complexion had not been scorched by the sun or blasted by the wind. His hair was not shaved high over his ears in the northern fashion, but was long and curly, and hung over his shoulders like a woman's. He had thrown off his velvet coat on account of the August heat, and the linen shirt he wore under it was clean and fresh as though it had just been washed.

I did not pay much attention to what they said. The chaplain went on in his usual roundabout way, speaking in Tuscan, dropping in obscure words and bits of Latin to make himself seem cleverer. Piccolomini listened without much interest,

nodding his head occasionally, but clearly wanting the chaplain to leave. There were no grim reminders of death in that pleasant room, and I daydreamed about what city life might be like for one who was free of servitude and had the means to enjoy it. My father had always kept clear of the town, complaining at the expense of everything. But he had been swindled out of half his money. If he had got it all, I might have been brought up in a house full of beautiful things, within reach of all the pleasures of the city.

When the chaplain's droning broke through my reverie, I realised that he had abandoned his plea for Umberto and was talking about himself. He was telling Piccolomini how learned he was, and how much he knew, listing books and writers. He was hinting at things he knew that were not in books, though he was so vague that I could not imagine what they were. I listened more carefully to what the chaplain was saying, and realised that he was trying to take service with the cardinal.

But the cardinal's secretary was not encouraging.

"What can you do?" he asked, after the chaplain had held forth on his own merits for some time. "Apart from reading and writing."

The chaplain looked wounded that his great learning had been so described. "As I have demonstrated," he said, "I can speak fluent Italian, in the manner of Tuscany."

"So can I," Piccolomini said. "It is my native language. What use is that to me?"

"As I am sure you must have noticed, my Latin is good."

"I should hope so."

"My native language is French."

"What use is that? Arras is full of Frenchmen, and they all seem well able to speak for themselves. Neither you nor your master Umberto are any use to me, or to the cardinal."

I was wondering what I ought to do. It was clear that the chaplain's scheme would come to nothing. He, and I, would have to continue serving Umberto, doing whatever he commanded, going wherever he led us. Perhaps Fulk or his other envoys would succeed, and we would all take service with a

great prince. But it seemed unlikely. I felt sure that we were doomed to return to the castle, where my misery and confusion would continue. After our argument in the church, the chaplain might no longer support or protect me. It might be better, I thought, if I betrayed him. If I went to Umberto, and confessed, selectively, my part in the fool's humiliation, then I might win preferment at the chaplain's expense. It was not right, I knew, but I feared that the chaplain would do the same to me, and we must all do what is necessary to save ourselves. The fact that the chaplain was trying to escape Umberto's service would count in my favour, if I could prove it.

Then I noticed that neither the chaplain nor Piccolomini were speaking. They stared at each other silently for a moment, then Piccolomini pointed at me.

"What about him?" he said. "Is he another Frenchman?"

"Him?" the chaplain said. "He is no one." His dismissive tone seemed to confirm my suspicion that he would betray me if it suited him. Instead of keeping silent, as my station required, I spoke out.

"I am English, sir," I said in my best Tuscan.

"English." The secretary gave me a long look, like a man about to buy a horse. "What are you to him?" Piccolomini asked.

"I am his bodyguard, sir."

"Do you like being his bodyguard?"

"Yes sir, I like it well enough."

"Yet you are a young man. Surely there are things you would rather be doing?"

I glanced at the chaplain, who was watching me anxiously. "Perhaps, sir. I don't know."

"Do you like serving this Umberto I have just heard so much about?"

"No sir."

"And you speak two languages?"

"More, sir. I speak French as well, and some Gascon, and . . ."

"Now *you* might be useful. But to me, rather than the cardinal."

The chaplain drew breath as though about to speak, but Piccolomini held up a hand to silence him. "You may go," he said. "And you," he said, turning to me, "may stay."

The chaplain took a few steps towards the door, then halted and looked back at me. "Thomas," he said, frowning anxiously. "We have our duties to attend to. Umberto will want to hear a report on what we have achieved so far."

Piccolomini waved a hand at him, as though wafting a bad smell from under his nose. "You may leave," he said to the chaplain. "But I want this young man to stay."

The chaplain hesitated in the doorway, glaring at me silently. I knew that if I did not follow him he would immediately denounce me to Umberto, putting all the blame for the fool's humiliation on me, just as I had thought of putting it all on him. There would be no going back to the castle after that, or to the inn, though that might be no bad thing. I would even be at risk in the streets of Arras, where Fulk's men might search for me. But Piccolomini had said I might be useful to him, and he looked powerful enough to protect his servants.

I stood my ground, the chaplain left, and I knew that I had escaped. I was free of the free company and its brutality, and of the fool's mockery, and of the chaplain's fickle guidance. On that day I began my service with Aeneas Sylvius Piccolomini, and all it led to.

"I expect you would like to know all about me," he said. "Who I am, and what I have achieved, and what my mission is."

I muttered something humble, and Aeneas held forth, telling me of his youth in Italy, and how, despite the noble blood of his family, he had once been a cowherd. He smiled as he told me that, as though it was astonishing and not altogether to be believed. But it seemed natural enough to me, despite the softness of his hands. Doubtless he had tended a cow or two in his youth, just as I had, before I was sent off to Sir William. It was the rest of Aeneas's story that was strange and enviable. He claimed to have been so clever as a youth that, despite his family's poverty, he was welcomed at the universities of Siena and Florence, where he studied all the things

I had wanted to study, and more besides. He had, he said, with an even wider smile, been made secretary to the Cardinal of Santa Croce, and given many important commissions, some both secret and dangerous.

"I have travelled widely," he said. "I have seen much of the world. And now I am about to embark on a new voyage."

"To England, sir?" His destination was obvious enough, if he wanted an English speaker. And the thought of returning home, and in such noble and learned company, pleased me.

"Before I say anything else, you must swear secrecy."

"With respect, sir, how can I swear when I do not know what you will ask of me?"

"It will be nothing dishonourable. I just need an interpreter, and a guide. I will pay well for someone who knows England and English, and can speak my language."

It did not seem the moment to admit that I had not seen my homeland for seven years, and knew little of recent events there. "I can do that," I said.

"Then will you swear to keep my affairs secret?"

"I swear."

Aeneas Sylvius Piccolomini had a Bible brought and made me swear on it solemnly.

"Your guess was correct." Aeneas said when the servant had left. "I am to go to England. And to Scotland. The cardinal has appointed me as his ambassador."

"Sir, will you have a royal passport, and letters of introduction and a safe conduct?" I knew all about those things, as we had orders to search all captives in case they carried such useful documents. "And will you have a lot of servants?" I imagined the splendour of a return to England in an ambassadorial retinue, dressed in livery, bearing rich gifts, protected by Aeneas.

"Not many servants," he said. "Not all ambassadors travel openly. Some must take care that no one knows their business. The cardinal knows that I can be trusted." Aeneas paused for a moment, then asked me a question.

"How many sides are there in a war?"

"Two, I suppose."

"No. Think about these recent wars. There are far more than two sides. True, France has fought against England, but the Welsh and Scots have fought, too, and the Bretons and Gascons, and Germans, Bohemians and Italians have died in France. The French have often fought each other, Burgundians against Armagnacs, and noble factions vie for power in England. It is not just a war between two nations, or even two kings, but a war between all the nobles of the North, all out to grab as much land and booty as they can. And it is not just kings, and nobles who would make themselves kings. The peasants have risen and fought their masters. It is a war of all against all."

"Which side will we be on?"

"The side of peace. But before the cardinal brings peace, there are things to be done. I am to be as a scout is to an advancing army. I must find out how the land lies and report back to the cardinal. There will be one or two messages to deliver, and some requests to make, but you needn't be troubled by the details. My work must be done in secret. Diplomacy is a complex business, and if all the parties involved knew everything at the start there would be no negotiating."

For the purpose of his journey, Aeneas disguised himself as a merchant, but his retinue was fine enough. He had a servant to look after him, and a couple of porters, who carried cudgels as well as their master's baggage, and were big men, well capable of defending us. I daresay my time with the brigands counted for something as well as my ability to speak English. Aeneas gave me a long knife of Italian steel, with instructions to use it if necessary. But he dressed me in a good wool coat, and told me that, as far as anyone else was concerned, I was a merchant like him, and that I was to speak his language at all times, except when I was speaking to my countrymen on his behalf.

6 England

At Calais, I made sure my speech had a foreign sound, as though I had learned my own language late instead of being born to it. That was not difficult after the time I had spent with Umberto's mixed company. Even so, we were doubted and delayed by the regent's men, and it was not until a passing cardinal vouched for Aeneas that we were allowed to set sail for Dover. But the cardinal's help was our undoing, for once in England Aeneas could not claim to be other than he was, and King Henry, having just heard that the Burgundians had abandoned England and allied themselves with the French, refused to allow him to go on with his journey.

"He is still only a boy," Aeneas said of the king. "And he does what his minders tell him. If they say that I had a hand in persuading the Duke of Burgundy to desert him, then he will believe them and consider me his enemy."

In London the people were full of anger at the Burgundians' treachery. We were obliged to hide from the rioting crowds, and saw little of the city. After only a few days we were sent back to Calais, and had no choice but to make for Flanders and try to sail from there.

We sailed, but I would rather that we had not, as a great storm blew up, which drove us far off course and nearly sank the ship. Waves rose as high as houses, and we rolled down them like a runaway wagon, crashing into the troughs then rising to begin our fall again. After I had vomited up the entire contents of my stomach I crept below and wedged myself into the hold. The storm went on so long that the ship's motion became almost familiar, and I even managed to sleep for a while. But it was sleep full of tormenting dreams of drowning and being swallowed by whales. When I awoke we were so far north that ice floated on the water and the ship's crew said that they had no idea where we were.

"We must be well beyond the seventh clime," Aeneas said,

when he saw the icy waste that surrounded us. "No life can exist for long up here."

After the storm, the ship limped south, the crew bailing and patching as we went, until the sight of land brought hope to all on board. Aeneas and I sat on deck, wrapped in all the clothes we had, trying to warm ourselves in the feeble sunshine. Aeneas pointed at the coast that lay to our left, all cliffs and inlets and mountains capped with snow.

"Ask the crew where they think we have got to," he said. His skin was grey, his dark eyes looked bruised and sunken, and his curly hair was soaked, and hung round his face like seaweed.

I went forward and spoke to the lookout. There were some Flemings in Umberto's company, and I had heard enough of their speech to be able to ask a simple question.

"They say we are off Norway," I said, when I returned to Aeneas.

"Norway? I wonder how they can tell? I suppose they must observe the seas and the rocks, and take soundings and sample the seabed. Sailors know the winds, and the way clouds form over mountains and islands, and how the weather changes all those things and makes them look different. They must memorise lists of landmarks, and what they stand for, just as scholars memorise words and what they mean. Just as you seem able to memorise words, when you speak to foreigners. They are useful skills, both of them."

Aeneas looked beyond me to the foredeck, where a gang of men was pumping the bilges. They heaved doggedly on wooden levers , calling out a rhythmic chant in their gurgling language. While they worked, a leather pipe fitfully gushed water over the side. Aeneas watched and listened for a while, then turned back to me.

"What are words?" he asked.

"Words," I said, puzzled by the question. "Words are noises that stand for things."

"Yes?" His pale face brightened, and I saw that he expected more of me, that he wanted to distract him with talk.

"We use words to say what we mean and get what we want," I said.

"Is that all?"

"It is all I can think of," I said, knowing that Aeneas wanted to tell me the answer, not to hear anything I might have to say.

"Shall I tell you what words are?" Aeneas said. "Words are the images of ideas and things. It is words that enable us to think, and to explain our ideas to others. Most men deal only in things. Simple men, living simple lives, might almost manage without language, just as beasts do."

"Beasts have their call and cries," I said.

"They do, Thomas. But what do they mean by them?"

"Mean?"

"What do their cries signify, beyond expressing brute passions? Fear, hunger, lust and violence: that is the life of a beast. What need have they of words to express that? Growls, barks and roars do well enough for them. Some men live no better than beasts, yet they have language. And not just one language, but many. That is the real puzzle, Thomas: why do men use so many languages? Why not one Universal Tongue, or *Panglossa*, such as men spoke before Babel?"

I thought of the language Umberto's men had used, a pungent stew of words taken from French, English, Tuscan, Breton, Gascon, Flemish, and other languages besides. But that was hardly a Universal Tongue, any more than the fool's motley was a Universal Coat. I had no answers to any of Aeneas's questions, but I could see that asking them had cheered him up. He ignored my silence and sat watching the sailors heaving at the pump.

"Your countryman Roger Bacon thought he could see traces of the Universal Tongue in the grammar that all languages use," Aeneas said, after he had observed the sailors for a while. "Do you think he was right?"

"I don't know, sir, I have never heard of this Bacon."

"But you speak several languages. Do they use one grammar, or many?"

"I know little of grammar. I learn by listening."

Aeneas looked disappointed by my answer. He was proud of his eloquence in his own tongue, and often boasted of speeches he had made and audiences he had held spellbound

for hours. But I think he was a little envious of my skill in learning languages. I had not thought much of it before, but I do have that ability, inherited perhaps from my mother. It was why Aeneas employed me, and it has stood me in good stead on my travels. For men who cannot understand what is said around them are like infants, and can easily be taken advantage of.

"Perhaps it is just as well that there are many languages," he said. "Having only one language would be like seeing things from only one point of view. I daresay that when you were soldiering, your company would always post more than one lookout, or send ahead several scouts?"

"They did."

"I thought so," he said, gazing at the distant coastline. The ship rocked gently, and the rhythm of the pump began to slow. After a while Aeneas spoke again. "Languages are like the isolated observations of sailors, like fragments of an unknown land, dimly glimpsed. Our crew, as you have established, know where we are. Doubtless they have sailed this way before, and know those headlands and the country that lies beyond them. But there are other countries. You have heard, no doubt, the tales of those who claim to have found other lands north of Iceland or west of Greenland? There are many such stories, and they are not all legends. The Portuguese have discovered many new islands in the Ocean. They are like alchemists; they go in search of gold and bring back knowledge. Who knows what they will find if they succeed in rounding Cape Bodajor and sailing beyond Guinea?"

I had read some travellers' tales as a boy, fanciful reports of expeditions to China or the Indies, but knew nothing of the places Aeneas spoke of. I wondered whether any land existed beyond the Ocean, but I nodded, as wisely as I could, allowing him to continue.

"Well, each new island sighted, each cape or headland found, is a glimpse of a world we know nothing of. Some of them may be little parts of a great continent, like the land-marks our crew have identified. They know that the land of Scandinavia lies beyond those mountains. The capes and

coves on the way to Guinea indicate the greatness of Africa that lies beyond. And who is to say that Hy-Brazil, St Brendan's Isle, Tir Na Nog, or the Isles of the Hesperides, if they exist, are not signs of other continents that may lie to the west? Ptolemy thought so. It takes a cartographer to piece together sailors' lore and map the world. He puts together all the seas, gulfs, bays, rivers, lakes, plains and mountains, and all the duchies, kingdoms, principalities and empires to make a Universal Map."

Aeneas gazed for a while at the mountains, then carried on.

"Languages, too, are isolated sightings and soundings, things glimpsed faintly through fog, man's feeble attempts to understand what little each of us sees of the world. Each language has one set of words for one set of things or ideas. A man who speaks only his native tongue knows only his native land. But put the languages together, bundle all our observations into one, and we create a Universal Tongue, and understand the whole world."

Aeneas paused and looked at me. The respect I saw in him was gratifying for a young man like me. "And that, Thomas," he said, "is something you are better at than me. You are setting sail on a sea of tongues. You are further along the path of piecing together that particular type of knowledge. If it is possible to know the world through its languages, you will know it sooner than I will."

"If it is possible," I said. "But I don't know. Languages are just different ways of saying what you want. And knowing that much is good enough for me."

"Poor Thomas, then," he said, shaking his head. "To have a gift and not value it! You are like a pretty nun."

I did not think I was much like a pretty nun. As it turned out, a nun's vocation would not have deterred Aeneas from enjoying her prettiness. But I saw what he meant, and wondered later whether he might have been right. Perhaps knowledge of the world through languages was a better secret than the one I had looked for in the chaplain's old books. When Aeneas spoke he had no ancient book before him, no scroll covered with antique script, such as the chaplain had used.

Aeneas spoke as he thought, with ideas as bright and fresh as newly minted coins.

Though he had seemed calm at sea, Aeneas had obviously been shaken by the danger we were in. When we finally landed in Scotland he insisted on walking barefoot to a nearby shrine, even though his feet froze and could only be warmed by stamping as he stepped. It surprised me to see Aeneas so pious, but I did not follow his example. I had no wish to cap one discomfort with another, and thought his piety enough for two.

Later, I asked him about his penitence.

"I was thanking God," he said. "Because I was not ready to die. He preserved us, and I am extremely grateful for that. Whatever our fate might be in the life to come, there is much to be enjoyed in this life. Travel, companionship, the pleasures of the table, and those of the bedchamber. This life is good, if it is lived well."

When Aeneas had made his peace with God, we went quickly to the king's court. Aeneas conducted his business there secretly, without my help. He must have found someone who spoke Latin, or perhaps his own language, and I was glad enough that he did, for it was as well that I did not know his mission. I could be made out a traitor if I had knowingly helped anyone treat with England's enemies. Scotsmen had fought alongside the French at Orléans, as I knew well. Even helping the enemy unknowingly was treachery enough, so I will state, here and now, that I never knew what it was that Aeneas went there to do or say. It may not have been against King Henry's interests, for some say that he was led into war by his advisors, and that he himself was a pious man who preferred peace. And Aeneas always said that he was trying to bring peace.

The king of Scotland gave Aeneas two horses, as well as gold for his expenses, and we set off for England in more style than we had arrived in. Aeneas was determined not to cross the sea again except by the shortest possible route, even if that meant lies and disguises, and a long land journey to Dover.

Though Aeneas praised my skill at learning new tongues, I could never understand the native speech of the Scots. If they did not speak English, or something like it, I was obliged to use one of the porters as a translator, though I could never be sure that he told them what I wanted him to tell them. But if any inconvenience was added to our journey by that, Aeneas bore it well, and told me stories as we travelled. He talked as we rode, or when we rested by the roadside, and in the evenings when we huddled in cold inns or sheltered in the squalid houses of peasants. I think he did it as much to entertain himself as to inform me, for he like to hear himself talk, and there was little opportunity for him to address anyone else in a land where few spoke his own language. He was also, I think, trying to distract himself from the pain he felt after his feet froze, which stayed with him throughout the time I served him, and lasted, I later discovered, the whole of his life.

Aeneas told of princes and peasants, of friars and warriors, of virgins and lovers, of fools and wise men. Some of his stories came from the Old Days, when men were wise, and the Caesars ruled the world. Others came, like Aeneas himself, from Italy, or from the East, where many wonders are to be found. I liked hearing about love. Despite what the chaplain had told me, I still knew little of its secrets. But the tales of warlike valour and chivalry sounded unconvincing to me. I knew the truth about war.

The oddest story, I thought, was one about a merchant who took a bath. Aeneas told it to me while he was soaking his feet in a bowl of hot water, and lamenting the lack of public baths in the wild country we were obliged to travel through. I had never seen a public bath, a thing Aeneas said was common enough in Italy and Germany, and he had to describe the scene, telling me how people of all sorts gather to disport themselves in water that wells up from the ground already hot. It sounded unlikely to me, like something from one of his eastern fables, but Aeneas said that men and women bathed together, naked, in large halls half filled with water, with spectators watching them from galleries above. Only the steam, he said, preserved the bathers' modesty.

The merchant in the story wished to bathe, but feared losing himself in the crowd. It was not just a matter of pride, though, like everyone else, he marked himself out by his clothes, their style and quality denoting his status. His fear was deeper. Among those naked, splashing bodies, he would be indistinguishable from anyone else, even to himself. Having removed his clothes he hesitated before plunging into that stew of flesh. He felt that, like a fowl in a cauldron, his component parts might be separated by the hot water he was about to immerse himself in. His individuality, his soul perhaps, might be lost forever. He looked around the changing room for something to preserve his identity, and seized upon a wisp of straw, which he picked up and tied around his arm. With the straw in place, he thought, he would know himself, and so would anyone else.

He plunged in and wallowed for a while, enjoying the warmth of the water. I daresay he enjoyed the sight of the female bathers too, though that was not part of Aeneas's story. He had almost forgotten his fears when a pair of burly men waded towards him through the waist-high water. One of them reached out and tore off the merchant's wisp of straw, fixing it round his own arm. The new wearer of the straw then said, "I am you now, and you are no one. You might as well be dead."

The merchant panicked then, and began to thrash about in the water, fearing that he really had lost his soul. He thought he would melt away, like a boiled fowl turning to broth and shreds. Then he realised that all that thrashing about would hasten the process, and he stopped still, allowing himself to float, realising that he had made so much noise that everyone was staring at him. He was the centre of attention, and all the other bathers noted him, knowing him by sight, if not by name. By that mischance with the wisp of straw, his identity was restored to him.

"But why should the merchant think himself so different from all the other bathers?" I asked.

"He wasn't so different, just different. We are all individuals and entitled to our identity."

"Can you really lose your identity by losing your clothes?"

"No. Of course not. The merchant confused essence and accident. That is not uncommon in men who think too much of themselves. They imagine that if their achievements are undone, they will no longer be themselves. Whereas the poor man knows that if he succeeds in life, he will still be himself, only richer."

I never forgot that story, for it sometimes seemed to me that I was like that merchant. I never went naked in a bath-house like he did, but I have often been obliged to dress up in other men's clothes, taking on an identity that was not my own.

A few days later we were caught in a storm in the middle of a bare heath. Icy rain lashed our skin, and cold wind cut right though our clothes. The wound in my leg began to ache again, but I knew it was worse for Aeneas. He could hardly walk, and I had to shoulder some of the luggage so that he could ride on one of the horses. We trudged on, looking around for shelter, but there are few trees in that wind-blasted land. Just when I thought we might have to crouch down by the roadside with only the horses and baggage to break the wind, one of the servants saw what he said was a house, not far off. I could see nothing but a hump on the ground, but even that would have been welcome, so we dragged ourselves towards it. It proved to be a house made of turf, with grass-grown thatch for a roof.

I pulled aside the ox-hide door and peered in. Inside, I could see nothing at first, but the smell was strong enough, and hinted at what lived in the house. There was smoke, and wet wool and never-washed bodies, and dung both of men and animals. I could hear the bleating of goats and the murmuring of women, and the rush of wind through the tattered roof. At the centre of the room, a fire glowed, and by its feeble light I made out something of the interior. I looked carefully around, studying the faces and forms of the people in the house, and saw only women there.

"Where are the menfolk?" I asked the porter.

He consulted with one of the women. "They are not far off," he said. "They have retired to a strong place, where they will be safe from robbers."

"Are there many robbers around here?"

"So they say."

But there was nothing to steal in that miserable hovel. The only thing of any value was an iron cauldron that sat in the fire pit, a heap of peat smouldering beneath it, and a stew of scraggy meat and water simmering inside. We waited, drying our boots and feet by the fire, making ourselves as comfortable as we could on the bundles of bracken that served for benches. The women stirred the stew, murmuring gently among themselves, hardly louder than the wind outside.

"What sort of men would leave their womenfolk unprotected?" Aeneas said.

"Men who care more for their own safety than for their wives' honour," I suggested.

"Wives? Do you think these people know the sacrament of marriage? They are like beasts, who hold their mates in common, and couple whenever they can."

"Yet they speak, and you said that beasts do not."

"Who can say whether what these people utter is speech? To my ear it sounds much like the mewing of cats. I know that cats can make themselves understood. They can mew for food, and howl for a mate. And they know how to win affection from their owners." He paused and smiled, perhaps remembering some childhood pet. Aeneas could be sentimental at times, perhaps because of the soft life he had led. "But language?" he said. "I think not."

I knew that those people talked well enough in their own language, even if I could not understand them. I think Aeneas knew it, too. But at that moment, he preferred an idea that pleased him to the truth. And perhaps he was already thinking about what he would do later, and how it could be justified.

Every so often one of the women would stab at the meat with a stick, until she decided that it was tender enough to be served. She called over a couple of the women, who pushed a stick through the cauldron's handle and lifted it off the fire. I

looked around, wondering whether trestles and boards would be brought out from a dark corner, but the house was as empty as I had thought it was. There was no furniture, and nothing to serve as such. If we were to eat the stew, we would have to eat it as we were, seated on heaps of bracken. But there were not even any of the roughly-turned wooden bowls that peasants usually have. Instead of bringing us our portion, the women simply strewed more bracken by the cauldron, then tipped it so that broth ran through the fronds and soaked into the earthy floor. Steam rose from the filthy floor, and the meat lay in gobbets on the greasy bracken. But it did not lie there for long. The women rushed forward to grab what they could, picking over the rank goatflesh to get the best bits, without thinking of their guests. Only when they withdrew did we get a chance, and found that what was left was all bones and sinews, with very little flesh. When one of the porters brought out a half loaf for us to eat, the women seized it for themselves. They had never seen bread so white, and tore off chunks, stuffing it into their mouths.

I chewed miserably on a meagre shin, finding little but hide and bone. I had hoped for something better after our dismal journey. But Aeneas did not seem too unhappy. "We will have the rest of our hospitality later," he said, sucking at a lump of gristle. "But first, let me tell you a story." He finished what he was eating, pronounced himself satisfied, and wiped his hands on a bunch of bracken.

Aeneas began a story about a sultan and his court, who lived long ago and far away, in the East. Reclining on a heap of filthy bracken, he described the richness of the sultan's palace and the beauty of his harem, and the fierceness of the eunuchs who guarded them. He told how the sultan was tired of everything, and longed for variety instead of endless luxury, and how his lustful desires had been stirred by an unwashed servant girl.

When he had finished the story Aeneas stood up. He was still a little unsteady, and had had to stamp his feet a few times to restore the feeling in them. He surveyed the hovel, peering carefully into the gloom. The women saw him and stopped

their chattering. Aeneas walked towards them, shuffling through the bracken, doing his best not to hobble. He chose the prettiest of the women and, after a few smiles and gestures and wordless sounds of the sort that might have calmed a timid beast, led her away into the shadows, to where the bracken was heaped deepest. He did not trouble to go behind one of the wattle partitions, where he would doubtless only have found goats and dung and vermin. I sat, surrounded by the others, wondering what to do. None of them was as fair as Catherine, and all were a good deal dirtier. Yet they were women, and they were available, as their glances and gestures made clear.

As Aeneas no doubt intended, I imagined myself a sultan in his harem, free to make my choice. But I found his story unconvincing, and knew that, were I a powerful ruler, I would have filled my bed with the world's most beautiful women, and those most skilled in the arts of love. Years later, when I was enslaved by the Turks, I learned that Sultan Mehmet was more interested in boys, and that his wives were kept as a matter of policy, a sultan being judged by such things, as a lord is by the number of knights who follow him. Whatever the sultan's true tastes and habits, that night in a Scottish hovel was the nearest I ever came to sharing his opportunities.

I chose one of the women and led her away, to a corner far from where Aeneas was engaged with the woman of his choice. I cannot say she was clean, or particularly attractive, but she looked better than most of the others, and was willing to go with me. I did not have to persuade her, she lay back on the bracken and rolled up her skirts, spreading her legs wide, waiting for me. I took my pleasure quickly, not troubling to please her. I would not be passing that way again, and in truth the smell of her was so strong that I could not bear to lie with her for long. As soon as I had finished I climbed off her and went to another corner where I lay on the bracken and slept.

Later, I regretted my haste. As things turned out, she was the last woman I lay with for some time, and she lingered in my memory for far longer than I would have liked, during the long years of my confinement.

When we rode off the next day, Aeneas asked me to entertain him with a story.

"But why?" I asked. "You are much better than I am at telling stories."

"That is why I want you to tell me one. It is a skill all men should have. Stories entertain and divert. They inform and instruct. They can get us out of trouble, and into it. A good story can earn you a drink or a dinner. And just at the moment, I am tired, and do not feel like talking."

"What sort of story shall I tell?"

"Any sort you like."

I was ashamed to tell him any of my experiences, or any of the yarns I had heard from the men I had served with. What did Aeneas care for war and brigandage? And what else did I know? I thought hard, remembering my childhood and stories my father had told me. My father was free with his stories. They cost nothing, were not used up in the telling, and may or may not have been true. He told me many tales of things that he had done or seen in France, or of things that men he knew were supposed to have done. Once, when he was still Sir John's page, he had seen the Emperor of the Romans, and that story was the one I loved to hear most often. I thought it would impress Aeneas, for he had often told me tales of kings and emperors, most of which were made up as far as I could tell. But my father's story was true, and I had always thought it unjust that, in an age when we are ruled by fools and fanatics, a noble emperor had to wander the world, cap in hand.

I remembered my father's words, but told the story in my own. I described the splendour of Eltham palace and the elegance of King Henry's court, and my father's place in it. I described Emperor Manuel and his plight, and how he wandered Christendom, seeking money to defend the doomed city of Constantinople. It was the greatest city in the world, my father had told me, and I had met others who said the same, and one or two who even claimed to have been there. What I did not remember, I invented, like any good storyteller. But I was careful to explain how noble the emperor was, and how humble, and how little he got from his wanderings.

I felt sad afterwards. The story reminded me of my father, and the hopes he had for me, and how long it was since I had seen him. I would have ridden silently after that, but it turned out that Aeneas knew the story well, and added to it.

"The emperor was a wise man, just as your father said. He wrote many books. And he was luckier than he seemed to your father. Just when things could not have got any worse, the Wheel of Fortune rolled, sending a saviour from the East."

"A saviour?"

"After visiting England, the emperor went back to the French. At Paris, he found that King Charles had gone mad, and none of the other kings would help him. That might have been the end of the emperor's hopes. His city was certainly doomed. Then he heard news that Sultan Bayezit had lifted the siege."

"Why did he do that when he could have captured Constantinople?"

"Because he had to face a greater enemy. Tamburlaine, the King of the Tartars, had ridden against him. Bayezit rushed eastwards and faced the Tartars at Ankara. And it was the emperor's greatest luck that Bayezit was defeated."

"Was he killed?" I asked.

"No. The sultan's fate was far worse than that. When the Wheel of Fortune raises one man up, another is always dashed to the ground. Bayezit was captured by Tamburlaine and carried about in a golden cage. Later, he beat his brains out against the bars. He went mad after being deposed, just like your King Richard."

"And the emperor?"

"He went back to Constantinople, and ruled for a long time afterwards. And Constantinople really is a great city, full of treasures and books. Or so they say. Unfortunately, I have never been there myself. The emperor only died ten years ago. His son John is emperor now, and the Turks press on him, just as they pressed on his father. And the princes of the West do nothing to help him, either." Aeneas paused, sighing sadly. "It would all be so different if mankind spoke only one tongue. Then there would be no opportunity for error or discord. I

suppose that is the disadvantage of our many languages. They give us many points of view, but those points of view seldom agree."

Throughout our journey, Aeneas took an interest in everything he saw. He asked me about the birds and beasts, the trees and houses, the livestock and crops, and the manner of life of the people. Often I was sent off to ask foolish questions, as though the people of my own country were Moors or Saracens, which I only managed by pretending to be a foreigner too. When we entered more inhabited lands, Aeneas insisted on stopping at every town and seeing its sights. We visited tombs, chapels and cathedrals, which Aeneas compared with those he knew in Italy. Sometimes he had words with the priests, speaking with them in Latin and without my help. At Durham he met various gentlemen, who gave him some useful information, but I do not know what it was as I was not permitted to join them. The same thing happened at York, and at several other places, and it seemed to me then that there was more to his mission than he had told me. The help I gave him might well be counted treason if anyone came to know of it, but Aeneas treated me so well, and was such agreeable company, that I could not think ill of him, and was sad when our journey drew near its end

I had come to admire Aeneas. As well as being amiable and amusing, he had money in his purse, which he could spend as he liked. I could not tell whether he was rich himself. The stories he told of his childhood suggested that he was not. If so, he had done well to get hold of the money he had, and the right to dispose of it. He had power and influence. He moved among princes and bishops, and they listened to him, or so he said. And how did he get that influence? Through learning, the very thing I had longed for, and which my father had denied me. Aeneas had never been condemned to go to war, or been made to do anything he did not want to do. I wondered whether he would keep me in his service when his mission was over. I had made myself very useful to him, and he might be useful to me, if I could win a share of his wealth and

knowledge. But he gave me no sign, and kept his plans to himself.

Eventually, after much walking, riding and talking, we reached London for the second time. By then the anger over the Burgundian treachery had died down, so we were able to see something of the city. It seemed a fine place to me, as big and rich as any place I had been in. But Aeneas knew Italy, and I did not.

"This is a filthy place," he said, as we entered the city. "I had not thought to see savages living like this, yet it is England's greatest city, is it not?"

"I believe so," I said. "Though, of the others, I have only seen what you have seen."

"Take it from me," Aeneas said. "London is not much of a city. There will not be much to detain us here. However, there is an establishment I want to visit. A most interesting one. It is a house run by nuns, but devoted to pleasure."

"I thought nuns were devoted to prayer and penance"

"Penance can be had there, too."

"And where is this house?"

"That, alas, I do not know. But there are some merchants in the city who do. They are Venetians, unfortunately, but they should tell me what I want to know if I approach them in the right way." He gave me a look that was both sad and appealing. I knew that our journey would soon be over, and that the house he spoke of must be important to him. Later that day we went off in search of the merchants, and Aeneas, after speaking certain words in a sort of Italian I could not understand, was admitted into their presence. He had a private meeting with them, and no doubt they discussed many things of interest to men who spend their lives abroad. When he emerged from the merchants' chamber he was smiling.

"The house I spoke of," he said. "It is a little way outside London. In a place called Walthamstow."

We reached the place in the evening, having crossed a dreary stretch of marshland so empty that even robbers did not bother to frequent it. We left the porters at an alehouse with

just enough money to last them the night, and went in search of the nunnery. There was fierce mastiff at the gates, which leapt at us, straining its leash, snarling and slobbering. I backed away, but Aeneas boldly stepped forward, speaking to the dog in gentle Tuscan, reaching out a friendly hand. The mastiff allowed itself to be patted, then slunk back to the gatehouse. The gatekeeper, seeing that we were foreigners, pretended not to understand me, even though I abandoned my false accent and spoke clearly in his own language. Aeneas drew a coin from his pouch and gave it to the man, who let us into an unpaved yard, pointing silently to a heavy oak door.

"There you have it," Aeneas said, as we stepped carefully across the puddled yard. "An example of a man so savage that words are beyond him. The dog obeyed me, but his master has to be shown a thing before he understands it."

We went up to the door and knocked. When a hatch was opened, Aeneas stepped forward and spoke some religious formula through the bars. He did not forget to offer another coin. We were left for a while, and had time to contemplate the house we were trying to enter. In the flickering light of the gatekeeper's torch it looked ordinary enough, a timber-built dwelling such as a merchant might have lived in.

"Language is everything," Aeneas said while we were waiting. "Language make us human, and it makes us moral. Men without language are no better than beasts. And surely, being better than beasts should be our goal."

"Should it?" I was puzzled that Aeneas should have chosen that moment, when he might have been preoccupied with more pressing thoughts, to deliver another lecture on human nature.

"It should indeed," he said "We must strive to be human."

"Human? How can we be anything else?"

"Some men, as we have observed, and as I am sure you know from your own experience, live like beasts. Others try to be better than men, aping the angels. That was Joan the peasant girl's mistake. She tried to be a saint. And what happened to her?"

"She was burned as a witch."

"Exactly! That is the price of hearing voices and dabbling with miracles. The best of men, and women, aspire to no more than humanity. They rise above savagery, but do not try to be saints. Take my advice, Thomas. Make the most of yourself. Use your talents and abilities. Take your opportunities as they come, without regretting the consequences. Try not to cause harm, of course. But above all, look out for yourself."

"Is that what you will do?" I still wanted to know what was in store for me, whether Aeneas would retain me in his service.

"I will certainly use my talents and pursue my opportunities. Who knows, perhaps they'll make me a bishop."

"A bishop?" He was not even a priest, as far as I knew, though it may be that he was, and had kept it from me. Though he was full of stories, he had revealed little of his own life and circumstances. And he revealed nothing then of any plans he might have had for me. Instead, the door swung open and we were ushered into the house.

There was nothing remarkable about the room we stood in. Its limed walls were bare but for a latticed hatch, and the floor was strewn with clean rushes. The only furniture was a settle, which stood against the wall furthest from the door.

An elderly nun greeted us, and Aeneas spoke to her in Latin. He really had no need of me, and might have left me at the alehouse with the porters. But I am glad he did not, as I learned something that night, something that no old book could have taught me.

After a whispered conversation, which I strained to overhear, the nun led Aeneas away, leaving me in the bare room. He looked back at me as he left, but said nothing. Guessing that he would be gone for some time, I lay on the settle and gathered my coat around me, prepared to sleep a little, if sleep came. Perhaps I did doze a little. The journey across the marshes, during which I kept a constant lookout for robbers while listening to Aeneas's talk, had been tiring. Nothing stopped him from thinking, and he found something to say even about the Hackney Marshes, which he compared to various unhealthy places near Rome. Had we been attacked,

he would have studied the robbers and formed some notion about their nature, or about the lawlessness of the English.

If I did sleep, and had not just lapsed into Aeneas's habit of aimless cogitation, I was woken by groaning sounds coming from the hatch nearby. I sat up and looked at the hatch. There were glimmers of light showing through the latticework, and the sounds I could hear were those of a man in pain. As quietly as I could, I crept over to the hatch and peered through it. I could only see the upper part of a small room, but that was enough. What I saw startled me, and momentarily distracted me from the noises I had heard. On the far wall, lit by the flickering light of a dozen candles, was a painting. It was cruder than those I had seen on the walls of Arras churches, but just as grim. In the centre of a busy scene a haloed martyr was having his guts drawn out by a windlass. Hybrid monsters, partly men but mostly beasts, grinned as they heaved on the handles, relishing the saint's agony as his entrails coiled round the windlass like fat sausages. Beside him were other martyrs, impaled on stakes, roasted on gridirons, boiled in cauldrons of oil, torn apart with red-hot tongs, gnawed by wild beasts or broken by heavy wheels, all attended by grimacing, capering devils bearing goads and flails.

No doubt Aeneas could have told me who the saints were, and why they were being so cruelly tormented, but he was otherwise engaged. To view the lower part of the room I had to drag the settle to the hatch and stand on it. From that new vantage point I was able to see what lay beneath the wall painting. Aeneas lay face down on a bare wooden frame, a truckle bed with no mattress. He wore only his shirt, which was hoisted up to reveal his bare legs and buttocks. His naked flesh glowed white in the candlelight, so much so that I did not at first notice the dark-clad figure crouching by his feet. When her hood fell back I saw that she was a nun, much younger than the one who had greeted us. Her right sleeve was rolled up, and she held a small scourge, with which, after muttering a few words, she struck the soles of Aeneas's bare feet. She did not strike hard, but his feet had pained him throughout our journey, and with each blow he let out a

161

groan and gripped the wooden bed frame with his soft white hands. He muttered something in Latin, and though his voice was weak and his accent thick, I heard words of regret and repentance. What had he to regret, beyond the minor lapses of any traveller? If he was a sinner, I was a far worse one, and I felt no need to confess or repent. Not even the chaplain's talk of Hell at Arras had made me feel guilty. I only regretted what had made me look a fool, which I could easily blame on others.

The nun kept up the flagellation, and Aeneas stretched out his body like a man on the rack, writhing and twisting with each blow of the scourge. The regular succession of lashes, gasps and groans dragged Aeneas into a rhythm of pain and penitence. Why was he emulating those painted saints, contrary to his own advice? And why was he imitating their suffering, not their virtue? Surely he was debasing himself, being reduced to something less than a man? And that debasement was double if he secretly aspired to sainthood. What was I to make of the advice Aeneas had given me, if his own behaviour was so contradictory?

I watched, bewildered, until Aeneas's spasms grew weaker, and he lay almost calmly. The nun changed her position, rising from a crouch and poising herself over Aeneas's naked buttocks. She raised the scourge and whipped his soft flesh, but only once or twice. After a loud cry, which I feared would wake whoever slept in that house and send them to discover my spying, he rolled over onto his back. The nun dropped her scourge and stood over Aeneas. His *membrum virile* had swelled to a huge size, and was barred with red where it had pressed against the hard wood of the bed frame. It trembled and jerked, springing free of his sweating belly. The nun looked at his member for a moment, then grasped it in the hand that had held the scourge. Then she stepped over the bed, lifted her gown and sat astride him, guiding his member into her. She rode him as a young groom rides a horse, her knees high, her rhythm urgent. And the race was a short one. It was not long before Aeneas cried out with what might have been either pain or pleasure, and the nun, having drained him dry

like a succubus, fell off the bed and onto the floor. The painted martyrs looked down on Aeneas and the nun, their halos untarnished by the agony they endured.

I have no idea how Aeneas spent the rest of the night. I tired of watching him and dragged the settle back to its place, determined to sleep if I could. But I lay awake for a long time thinking about what I had watched. In the past, I had seen men inflict pain in order to enjoy the pleasures of love, but never on themselves. Aeneas, who had led a soft life and never served as a soldier, can have known little of suffering. I wondered about the barefoot walk he had made to that Scottish shrine, when his feet had been frozen. His piety had seemed out of character, the pain he inflicted on himself unnecessary. For most men a thankful prayer would have been enough. Perhaps he got some secret pleasure out of it, which he explained as a penance. His activities that night suggested that, for him, pleasure and pain were not so far apart. Whatever the truth, he showed me that love held more secrets than I had imagined.

In the morning Aeneas said nothing about his exploits, or about anything else. Did he know that I had been watching him? Was the grille there for that purpose? Was being watched part of his penance? Or of his pleasure? Whatever the answers, I was sure that the best policy was to say nothing, and Aeneas's only words were a request that I hired a horse to carry him away from Walthamstow. A second viewing of the Hackney Marshes did not inspire him, and we returned to London with no talk but the porters' memories of their ale-house antics. For them, pleasure was simple, and could be bought with a few coins. While the porters chattered, I pondered my future, which seemed increasingly uncertain as Aeneas neared the end of his journey. What would I do if he did not take me with him? How could I make myself a gentleman without his money and learning?

After London, I did not have much longer in Aeneas's company. There was only time for a few more of his stories as we rode to Canterbury. He inspected the cathedral and the

jewel-encrusted tomb of St Thomas à Becket. He knelt on the hard floor and said prayers to the martyred archbishop, asking for a safe continuation of his journey and giving thanks for the completion of his mission. I was surprised to hear him describe our mission as successful. I was still not sure what I had helped him to do, and feared that whatever it was might be treason. But I had little time to worry about it, as soon after that we were at Dover. Lacking a passport, but still pretending to be a merchant, Aeneas bribed his way onto a ship for Calais.

"Well, Thomas," he said as he waited at the waterside for his ship. Or was it our ship? "England has been a most interesting place. The more so for those, like me, who are free to leave it." He then reached into his pouch and pulled out some gold coins, which he pressed into my hand. "Take these," he said. "You have been very useful to me. I hope you are able to make some sort of a life for yourself now that you are free to wander your native country."

I stared at the coins in my hand, not counting but wondering. Was my assistance really worth that much? What was it I had helped him to do? I was still wondering when he slipped away and boarded his ship.

I knew the country when I reached it. The woods and rivers were just the same, though the farmland had been neglected. But that was the way of it when men went off to war, and perhaps my coming back would change things. I followed the road towards my father's land, shouldering a small bundle of things, just as I had when I left for Sir William's house. There were dog roses in bloom, and honeysuckle scenting the hedgerows. I noted each turn of the track, and each tree and bush, remembering the few times my father had taken me to town, and what had been said on those journeys, and on the way back. I walked warily, still wearing the Flemish clothes Aeneas had given me, ready to pass myself off as a merchant if need be. But I kept my knife handy. There were risks in going home. I was a deserter from Sir William's company, and even though my master was dead I owed some sort of allegiance to

his heirs, who might hold my family responsible for my misdeeds. But no one in England knew of my time with Umberto's men. If anyone found out, I might claim to have been held by him against my will, and to have escaped to England with Aeneas's help. Revealing his secret mission might help my cause, though not if I was thought to have supported it. In any case, I was reluctant to portray Aeneas as a villain. He had shown me more friendship, and taught me more, than anyone else I had met.

As I walked, I thought of my father's house. As soon as he returned from France, he bought the land and chose the site, a high spot that would be seen by all, but was blasted by the East wind in winter. He went with the woodsmen and chose, not the tallest oaks, but those, most twisted and useless, that could be got for almost nothing. Then he watched the sawyers and made sure they cut straight and wasted nothing. They complained that he was asking the impossible, and, behind his back, offered up twigs and asked what he would have made of them. None of the timbers really fitted, and as they dried they shrank and twisted far more than green oak should have done. That was why the house creaked and groaned so, and rocked in the East wind. I was reminded of it every time I travelled by ship. Through all the changes in my life I remembered the place clearly, often seeing its crooked timbers and cracked walls in my dreams. In my memories, it was a safe and good place, even though I had been sent away from it by my father. I had not seen my parents for more than ten years, and did not even know whether they were still alive. That thought filled me with guilt, and made me keener to see them.

I knew that there might be difficulties. I had been no prodigal son, but there were things my parents might reproach me with. My father had said that I should come back rich, or not at all. I had the gold coins Aeneas gave me, but I was hardly rich. I expected no great feast, but I hoped that they would welcome me, and that I would take my place in the family.

I had discovered that there were no fortunes to be made by fighting. Not for me. Since the peace of Arras, even Umberto would be finding life harder. I wondered where he was. Had

he gone back to his castle, or sought his fortune elsewhere? I imagined him fighting the Moors, or the pagans in Lithuania. After my adventures, I longed for nothing better than peace and quiet among my family. That was good enough for me. As Aeneas had said, this life is good, if lived well. I would cultivate the land, marry perhaps, and take pleasure in what I had. My mother would find me a good wife, the daughter of some family like my own, though a little richer perhaps. She would be pretty, and we would have sons, and I would send them off to school, not to war.

But the life I pictured for myself as I walked those Norfolk lanes was not quite satisfying. I had learned a little on my travels, and might still make something of myself. The books I had read at the castle had whetted my appetite for knowledge, and the talks I had had with Aeneas had given my curiosity an even keener edge. There were so many things I did not know, and which I might learn, with a little patience. I might make myself a gentleman through learning. Then I might be respected, as my father never was, and neighbours might come to me for advice, which I would dispense wisely, throwing in a word or two of Latin.

I was deep in such thoughts when I approached the hill the house stood on, and when I looked up, the sight was like a spear thrust into my heart.

The hill was bare. There was no house, and no sign of it. It was as though a fiend or magician from one of Aeneas's fanciful stories had made the house vanish. I could not understand how I had so misremembered the view. I went on, climbing the slope, knowing, but not believing, that I had reached the right hill. There was nothing at the top. Where the house had been was a tangle of brambles, already clothed with dark berries.

I dropped my bundle and plunged in, eager to find some trace of what had been there. As I thrashed about in the undergrowth I tore my arms and legs on the thorns, and my fine Flemish coat got hooked and caught. I tripped on brambles and stumbled in postholes, but found nothing left of the house but earthy heaps overgrown with grass. Only the

mound that had been the bread oven remained to show that my memory was not wrong. The house had been there, and was gone, its timbers dragged away, its thatch and wattle rotted.

When I saw my mother I did not recognise her. The white-haired woman who crept along the lane clutching her skirts to keep them out of the mud was far too old. My mother was not yet fifty. It could not be her. Perhaps I had been misled. To the people of those parts, I was an outsider. None of them recognised me. When I had asked about Genevieve Deerham in the village, no one would tell me anything. Unless I could show them some reason why they should help me, they would not. And I would not reveal myself until I knew how matters lay, and perhaps not even then. I wandered wider, asking at other places, until I learned that my mother was to be found at Sir William's old house, where she was employed as a servant.

I felt like a brigand again when I hid in a spinney near the house. But I felt a fool when no one passed but strangers. Instead of being welcomed by my parents I was sitting on a mossy stump, peering through the branches at anything that passed, whether man or beast. At least the old woman in the shabby gown might tell me something. I stepped out into the lane and waited for her to pass. There was a sack over her shoulder, probably to be filled with something gathered from the hedgerows. When she drew closer I got a good look at her face, and saw that she was my mother, aged and impoverished, but still the same. As she shuffled past, I called her over.

"Do you know me?" I asked. She looked bemused when she heard me. Surely a mother ought to have recognised her son sooner than she did?

"No," she said, not looking up. "Nor do I care to."

"You might care, I hope, if you knew." She raised her eyes and stared at me. "I am your son," I said. "I am Thomas."

In old romances, and the tall tales told by Aeneas, mothers greet their long-lost sons with tears. But my mother met me with cold silence.

"Where is my father?" I asked.

"In God's care, it is to be hoped. He died five years ago."

I had guessed that, though no one would tell me. She would not have lost the house and been a servant otherwise. "Of what cause?"

"At the hand of an enemy."

"He had enemies?"

"Everyone has enemies, if they have property, and lack the strength to defend it. And we had that house. It was his pride and joy, as you know. I think he loved its timbers better than he loved me."

"What happened to it?"

"Pulled down." She gave me a hard stare. "Not directly, of course. First they drove away our beasts, then they let theirs loose on our land. But they made sure that theirs were well watched and could not be driven off as ours were. After that there were the lawsuits, then the threats. Neighbours claimed the land, and when my Robin died, they set out to have it. And who was I, a widow on her own, to defend the place?" I wondered about Walter, who had studied law. Why he had he not helped? "It's all your doing," she said. "If you hadn't deserted all would have been well."

"But I had no choice. Sir William died."

She looked at me coldly. "I know that well enough."

"I had no master."

"You owed allegiance to Sir William's family. To his heirs and followers. I serve them now, in your place. My Robin served his master better than you did."

"Sir John?" I said. "But when Sir John died, my father joined a free company, just as I did."

"He joined a band of good men, who fought for the king."

"I have heard stories about what they did in France. My father . . ."

"Your father!" She glared at me. "Your father! I'll tell you something about your father! Something that might explain why you're a rogue and he was only a fool."

"My father a fool?"

"Well, he never knew the truth."

"Which was?"

"You are my son. I cannot deny that. But Robin Deerham was not your father. It was Sir John. Sir John was your real father."

That stunned me more than the missing house had. I listened in silence while she talked on, telling me how worthless Sir John was, and what a fool my supposed father had been, and how, whichever of them I had taken after I was bound to be no good myself. She told me, too, about my brother Walter, and how he had drunk away the money he had been sent to London with, and how he was probably still there, sitting under the Sign of the Four, letting his life flow away with the ale while his mother slaved, forgotten, in Norfolk. She lamented the fact that neither one of her sons had made a good marriage that might have linked the Deerhams with some more powerful family or increased our lands. But most of all she chastised me for my wanderings, and for my desertion, and for my failure to be a good son.

As she talked, she slipped into her native Gascon, remembering old words that she had not used, and I had not heard, for years. I listened hard, trying to find meaning in what she said, trying to learn more about what had gone wrong. But she, as bitter memories flooded back, grew angry. Everything she had hoped for had come to nothing. I was an unnatural son. All the men in her life were worthless. Life was nothing but one disappointment after another. She raged at me, shouting nonsense, waving and gesturing until I feared that someone might notice us.

She was right about one thing: I was a deserter, and I might be arrested if Sir William's family knew who I was. While she ranted, I slipped away. Perhaps I should have held and comforted her. Perhaps I should have given her my gold, or bought her out of servitude. But I did not. I left her in the lane, still raging. And it was not until some time afterwards, when I was well on the way to London, and had time to think on everything she had said, that my anger matched hers.

I found the Sign of the Four easily enough. It marked a tavern near the river at Southwark, and while it was known to

everyone by that name, the sign showed only three men. I knew enough of taverns not to declare my business directly, but sat for a while drinking with a few travellers and river folk, listening to their gossip. None of them could explain the inn's name, except to say that it was owned by three men, who had got their money by serving in France, like my father had. Or like my supposed father had. I could still not quite believe what my mother had told me, though she would hardly have shown herself in that light if it were not true.

I had been sitting and supping for some time when I finally asked after my brother.

"And who might he be?" the server asked.

"Walter Deerham."

"He never mentioned a brother."

"You know him then?"

"He comes here often enough."

"When will he come again?"

"I don't know." The server pointed to an old man who sat hunched over his tankard. "But *he* might." The old man's face was hollow and lined, and rimmed with a straggle of grey beard. As I walked over to him I realised I had drunk too much. I stood as steadily as I could as I asked after my brother.

"What do you want of him?" the old man said, mumbling into his ale.

"He is my brother."

The old man sat up straight and looked at me directly. "So you are another of Robin Deerham's sons?"

I was not drunk enough to repeat what my mother had said, so I agreed with him.

"We are no friends of Robin Deerham's here," he said.

"Yet my brother drinks here."

"He has renounced his father. He is one of us."

I knew that Walter had not helped my father, but why should he renounce him? The question hung in my ale-fuddled mind.

"What do you want here?" the old man asked.

"I came to find out the truth."

"What truth would that be?" He raised his tankard and tipped the last of its contents down his throat.

"The truth about what happened to the rest of the money," I said, "The money my father should have had."

The old man almost choked on his ale. "Money your father should have had? Is that what he told you? Robin Deerham always was a liar."

I touched my coat, feeling for the knife that lay beneath it, hardly thinking what I was doing. But the old man understood my gesture. "You can leave that where it is," he said. He was looking past me to someone who might, or might not, have been standing behind me. I was not such a fool as to turn and look. "Sit down," he said. "And listen."

The old man's face was so sad, and so resigned, that I forgot my knife and sat. I glanced behind me as I sat, and there was indeed a man there, a man armed with a knife as long and as sharp as mine, which had been pointing at me as I spoke.

"There was no other money," the old man said. "He had it all. It was the rest of us who should have had our share and didn't. We got it at Caen, you know?"

"He told me it came from Agincourt."

"There was no money to be had at Agincourt. Just mud and slaughter and dysentery."

"But the prisoners? The ransom money?"

"They were all killed. Except for a few of the noblest, that the king kept for himself. None of us got any money for prisoners. It was at Caen."

"There were prisoners there?"

"There were, but it was not from them that the money came. Not for us. There was no gentlemanly business with ransoms and safe conducts. We got our money from robbery. When the city was sacked we went through the houses grabbing what we could. And Robin Deerham was the greediest robber of the lot. Not that I complained about that at the time. We had our agreement. We'd sworn on it. Whatever we got was to be split up evenly."

"That's just what my father said."

"Well, he told you one true thing. And perhaps it would

have turned out that way if the rest of us hadn't been a bit greedy, too."

"What happened?"

"It was later on. After we'd been through the merchants' houses and were well loaded down with loot. We climbed into a church. It seemed like a good place to take stock. We spread a cloak on the floor and threw in everything we'd taken. There was plate, and coin, and jewels. It was a good amount, even split between the four of us. But we didn't share it out then. We had to get it away. And can you guess how we did that?"

"You gave it to my father."

"Not gave. Entrusted. He was the smallest of us, you see. The leanest. So we stuffed the loot into his clothes. We stamped on the cups and plates to flatten them, then filled his doublet until he had as fine a figure as his old master."

"And then?"

The old man called for more ale. "And then we sent him out into the street. It wouldn't have done for all of us to go together. We might have stood out. Someone might have killed us for that loot."

"You risked my father's life."

"Oh no! We knew he'd be safe enough. He was a small fellow, like I said, and good at slipping into the shadows and hiding. We knew he'd not be caught, and he wasn't." The old man paused to drink his ale, drawing deeply as though that cup might be his last. "It was the rest of us that were caught."

"How?"

"We stayed in the church for a while. To give Robin a chance to get clear.

The three of us were to leave one by one, slipping away like Robin had. But while we were waiting we had a look round. You know how it is. There are often things worth looking at in churches."

"And worth taking?"

"That's it. And worth taking. You've done it, too. I can tell by the look of you that you take after your father. Well, it was a cross we found. All covered in jewels and suchlike. It was

worth more than all the stuff Robin carried." The old man looked at me anxiously. "He would have got his share."

"Why didn't he?"

"We couldn't divide up that cross. Not there and then. And it was worth so much that none of us dared trust it to the other two. So we all left together. And we all got caught. Taking things from merchants' houses isn't a crime, if you cut in your masters. But looting churches is a crime, if any but nobles do it. And we were caught and thrown in prison, and were lucky not to be hanged. And your father, who might have used the loot we had to get us out, left us to rot."

"And he was the fourth of the Four? The one not shown on the sign?"

"He was."

The old man fell silent then, and I did not provoke him by asking questions. Instead, I sat and drank, and thought. The story sounded true enough. I had guessed part of it already, from things I had heard in France. But it made me wonder about what my mother had said. My father had always seemed big, to me, but I was only a boy when I left home. The description of my father I had just heard was much more like me than my father's description of Sir John. But my thoughts were interrupted by a disturbance in the tavern.

"You!" a voice shouted from behind me. "You there!" it repeated. The other drinkers were looking at me, so I turned round to look at the speaker. He was a big man, tall and fat, his doublet gaping, his face flushed and furious. He was much drunker than I was, despite having only just arrived at the tavern. "You!" he said. "They told me you would be here. Don't look away. It is you I want! You are the bastard!"

I had decided by then that I was not a bastard, and I could not see what business it was of his, anyway. I stood and faced him, filled with sudden anger. So many conflicting thoughts filled my mind, and only action seemed likely to drive them away.

"I am no bastard," I said.

He puffed out his chest and spoke again, his voice filling the

tavern. "Well I say you are. And if you deny it again, I will fight you."

"I deny it."

A cheer went up from the drinkers, who dragged benches out of the way to make a cockpit for us to fight in. Faced with sudden danger, my mind cleared and I looked more carefully at the man who stood before me. He was twice my size, and the favourite of all who looked on. I was still dressed as a merchant, and had no sword, only the knife Aeneas had given me, which I pulled out from under my coat. My opponent had a knife too, though I could tell, just by looking at him, that he had spent his life in taverns and knew little of real fighting. He roared a few more insults for the amusement of his friends. Then we faced each other and tried a few thrusts and parries. As I suspected, he was an unskilled fellow, who only knew how to slash and hack like a woodsman.

He was a drunken oaf, and I might have mocked him with a fight without blows. I could easily have humbled him without drawing blood. But something happened to me then that had never happened before. I was overcome with battle-fury. When fighting in France, I had seldom been driven by anything but the desire to avoid danger. Perhaps that was why I had failed to make myself rich. The rest of the free company were often maddened by the desire for loot or by lust for women. They hacked and slew until they got what they wanted. But I always held back, not wanting what they wanted as much as I wanted my own life and safety. But in that tavern, made drunk by ale, and bold by insults, I was enraged. My heart swelled, and my head raged, and my knife-hand lunged and slashed. I cut his forearms and gashed his doublet and slit his hose, ducking his feeble counterthrusts with ease.

When I saw how bad a fighter he was, instead of pitying him and holding back, I fought all the harder, determined to bring him down. While he stumbled, I danced, dodging round him like a dog baiting an ox. He stared at places I had just been in, surprised to find me gone. And I appeared behind him, taunting him with my blade. But the pricks and

gashes I gave him had little effect. I might just as well have been a gnat. He twisted and turned, staring wildly at nothing, slapping with his fat hands, wielding his knife like a trowel. His friends cheered him anyway, urging him on as though he were the finest fencer in France. He called me a bastard, and each time he called out the word, the others shouted it too, filling the tavern with my shame. I hated him, and I hated those who urged him on. And I hated my mother for making me the bastard he called me. But I could not hate him for long. As he stumbled and bragged my hate turned to disdain. What did he know of anything, who had drunk away his afternoons surrounded by tavern sweepings too poor or lazy to serve in any army? At least I had served! At least I had fought! I felt nothing but contempt for him, and that contempt made it easier for me when I killed him.

Lacking new blows or strokes, he brought only insults to bear. He lurched forward, his mouth flapping and slobbering. His fat face spewed obscenities. Out of his soft mouth came a bloody flux of words, damning me and all who knew me. He was like a devil, dredging up foul words from a swamp of filthiness. He was a beast, a bellower, a roarer, a spouter of empty words, a man whose utterances meant nothing. But the words were about me. He named me. He called me a coward and a deserter and an unnatural son. He cursed me. He called me a bastard again and again.

I had to stop him.

The next time he lumbered towards me, instead of dodging back I stepped forward. When he raised his arm to emphasis a curse, I thrust under it. The knife struck deep, sinking into soft flesh before I pulled it out. He fell suddenly silent, then toppled towards me, his arms flopping limply. I struck again, feeling the blade cut through his doublet, through his skin, and through the fat of his belly. My fist touched his soft skin, and ran with hot blood. But I did not stop. As he toppled forward I jerked the knife up. The fine Italian steel went through him like a hot knife through lard. I kept going until the blade hit his ribs. Then I jerked and twisted it downwards until it hit his belt. He was almost on top of me by then, and I fell and rolled

175

to get from under him. I am sure he was dead when he hit the floor.

I lay for a while, my chest heaving, my hand hot with blood and guts, wondering what I had done and why I had done it. I had killed a man, and the room was full of his supporters. They would kill me next, I was sure. They would not let me get away with killing their favourite. They would cut my throat and dump me in the river, and no one would know I had ever been there, or who I was, or what I had done. I would never right the wrongs that had been done to me, or to my family.

But no one moved to kill me, or even to lay a hand on me. I was left on the floor where I lay. They stood back, and watched me with what looked like respect.

"Do you know who he was?" one of the men asked me, while I gasped to get my breath back. "He was Walter Deerham."

PART TWO
1446–1461

7 A Pilgrimage

I will not describe my imprisonment. It can easily be imagined, and an account of it will add nothing to this story. It might have broken me, had my spirit been weak. But I was kept from breaking by anger. Had my father been truthful, had my brother not been an idler, had I seen him recently enough to recognise his face when I saw it again, had my mother remembered accurately which of her sons was the bastard, had Sir William not died at Orléans, had a hundred other things not turned out as they did, I would not have been at the Sign of the Four to kill Walter when he challenged me. Or perhaps it was all Sir John's fault. I had never seen him, but even in my father's stories he sounded selfish and ruthless, not the jovial old soldier my father imagined him to be. Sir John may or may not have been my father, but he was probably the father of my predicament.

My punishment might have been far worse, but for the Latin that Umberto's chaplain taught me. The prison chaplain showed me the psalm, and I read it out, loud and clear, once in Latin, then, just to prove I understood, in English:

Have mercy upon me O God, according to thy loving kindness:
According to the multitude of thy tender mercies blot out my transgressions.

I meant every word, and would have read on, had they not stopped me. My ability to read that verse won me benefit of clergy. They could not hang me after that, but they would not set me free. The men who held me were not concerned with justice, but with getting my gold. And when they had got it, and were sure there was no more, and had inflicted every indignity on me that they could think of, they threw me out. I wandered for a while after that, penniless and friendless and full of shame.

I kept clear of thieves and brigands, though there were plenty of them, flushed by the tide of history from France to England. By then I had given up the quest for wealth. There

was nothing left to me but redemption, in search of which I spent much time in monasteries. I wandered abbeys and friaries, visiting Cistercians, Franciscans, Benedictines, and other orders, both rich and poor, becoming quite expert in their ways. I worked for the brothers, doing whatever was asked of me in exchange for a bed and meal. Sometimes I stayed for a while, taking advantage of monastic hospitality. If they let me, I read the books in their libraries. If they were allowed to talk, I talked with them. I debated with Schoolmen, when I found them, but not to much effect. They knew a mass of facts and opinions, all attested by the best of authorities, both ancient and modern, but nothing that could help me.

I did not seek to join any of the communities I visited. There would have been too much confessing and explaining, and a life without women did not appeal to me. I had had enough of poverty and abstinence, and could not emulate the monks' humility. I wanted to share their learning, not their way of life. And I wanted to know, without them knowing why, what prospects there were for saving my soul.

I had committed many sins, both mortal and venial. I had sinned, and continued to sin. But what nagged at me during those years was the knowledge that I would have to face Judgement as a fratricide. How many sins are worse than that? The men of the free company boasted of many things, but not fratricide. I bore the curse of Cain. Like him, I was destined not to cultivate my family's land, but to wander the face of the earth like a vagabond. What penance could absolve my guilt? I had no money to buy indulgences, or to have masses said, or to do good works for the poor. I could not build a church or endow a chantry. A pilgrimage might suffice, but not a pleasant jaunt to Walsingham or Canterbury. I might win absolution by fighting the Turks, but they were a long way off. The pope, it was said, had preached a new crusade, but how could I get to Hungary, where the fighting was? It was impossible.

I would have to live as a sinner and outcast, knowing that those truly responsible for my misdeed lived and flourished, or had done so, without being punished.

I did not spend all that time among monks and scholars.

Sometimes I frequented taverns, where I observed mankind and his weaknesses. I was not free from sin. When I did not feel guilt I felt pride and anger. I resolved that, when I got the chance, I would seek revenge, as well as absolution.

My opportunity came when I met Robert Sturmy, a Bristol merchant. He was a big, red-bearded man, who had stationed himself in a tavern with a jug and purse. There are always such types about, eager to gather men for their ventures. The trick, as I had discovered on my wanderings, was to get the drink out of them without agreeing to do anything for it. Sometimes food could be had, too, by leading them on with stories and half-promises.

"Let me buy you some ale," Sturmy said, catching my eye as I looked for a seat.

"I would prefer some good Gascon wine," I said. There was no harm in testing his resolve. I would have drunk ale had he insisted.

"So be it," said Sturmy, looking me up and down. "Some wine." He shuffled along the bench so I could sit beside him, then called the serving boy to bring a cup and jug.

"I am looking for men," he said, when I had drunk half the cup.

"Well, I am a man."

"A man in need of employment?" It must have been obvious that I was, as men released from prison have a look about them which is well known to recruiting sergeants and sea captains.

"That depends. There are some things that would suit me better than others."

"Can beggars be choosers, now?" Sturmy said. "These are strange times!" He raised his tankard and quaffed a draught of ale. I could see from the way his hand shook that he had been drinking for some time. "There was a time when men knew their places," he said. "When lords ruled and vassals served. Well, that's what my father used to say. But old men always regret the past. I don't know whether he was right, but it isn't like that now. Men wander the world and forget their places.

They make fortunes out of war and think themselves better than they are. Servants turn themselves into masters and lords lose everything. You say there are things that would not suit you? I wonder what they might be? You look like a man who's done a few things I wouldn't care to do. Perhaps you fought in France? I thought so. War wouldn't suit me. It's far too risky. But I expect you know that. I make my living out of trade, by buying things where they are cheap, and selling them where they are dear. And I mean to make more than a living, if I can. I intend to make a fortune."

Sturmy leaned towards me until we were almost eye to eye and his beard brushed my shoulder. He tapped his nose, then spoke in a loud whisper. "This is a secret," he said. "I'm in the cod trade, among other things. No, that's not the secret. It's how I mean to make a fortune that's the secret." He drank from his tankard again. "Men say, and I believe them, that there are new grounds, somewhere in the west, where untold numbers of cod can be caught. And there's land, too, where the fish can be taken ashore and dried. I've seen the fish. I've bought them, and sold them, too. Best quality stockfish, as white as you like. The fish are real, so the grounds must be real, too. That stands to reason, doesn't it?"

"It does."

"Well, I mean to go after them. I'm looking for men to sail for me, to find the new grounds and make a fortune."

Sturmy belched and fell silent for a while. I knew about those islands in the west. Men had sailed to them, giving them names and settling there. Irish monks, fugitive Norsemen and Basque fishermen had all crossed the Ocean, or so it was said. The Portuguese claimed most of the islands, and others, that might not exist. Aeneas had told me all about them, and how they might be part of some bigger land, as yet unknown. But I said nothing. Sturmy wanted a man of business, not a scholar. For a moment I was tempted by his offer. A new land might be a good place for a new start. Perhaps I could leave my sins behind by sailing west. Then I remembered the hazards of the open ocean, of the icy northern seas, which I knew well from the time I sailed to Scotland with Aeneas, and which could

only be worse when sailing to unknown parts. And to the usual ship-reek of pitch, tallow and foul bilge-water would be added the unpleasantness of holds filled with stinking fish. Such a voyage would be worse than prison.

Sturmy looked displeased when I declined his offer, and reached out to withdraw the wine jug. Wishing to drink what was left, I engaged his attention by telling him something of myself. I let him know that I was not a common criminal but a man who had travelled and knew something of the world, unfortunately brought down by the ill will of others.

Sturmy smiled a little to himself while I told my story. He must have heard many like it. He knew I had not told him the whole truth. Yet he released his grip on the wine jug and allowed me to refill my cup.

"Here's another venture," he said, when I finished telling him about myself. "One that would suit a man who speaks foreign tongues like you do. And one that will pay well, even better than the cod trade. I'm in the wool trade, too. English wool. The best in the world," he slurred. "They'll buy any amount in Italy. But can I get it to them?" He waited for a moment, raising his tankard and peering into it, before continuing. "No I can't! I can't get my wool to Italy without it passing through the hands of the thieving Flemings and Burgundians. I have to pay the middlemen, see!"

Wool stinks, it is true. But the smell is not one that taints or sickens. And, given what a bale of wool is worth, it is a smell one might come to tolerate, if not to love.

"I can deal with Flemings and Burgundians," I said.

"But I don't want to deal with them. That's the point. My scheme is cleverer than that! My idea is to sail direct, rounding France and Spain, landing the wool at Pisa without paying any more taxes than I have to. If I can establish direct trade there are surely great profits to be made. How does that sound?"

The wool scheme appealed to me better than Sturmy's other venture. A ship on such a voyage would call regularly at safe ports, in countries with a good climate, where a traveller would be safer than on the open ocean.

"There's more," he said, while I was still thinking. "My ship is to carry something even more valuable than wool."

"What would that be?"

"Pilgrims!"

"Are they valuable?"

"They are when they pay for their passage. After Italy the ship will sail on. To the Holy Land, where sins can be wiped out and virtue won. Men will pay well for that. And women, if their sins are bad enough. And who hasn't sinned?" He looked at me meaningfully, then carried on talking. But I had stopped listening.

Sometimes we must let the Wheel of Fortune roll, taking us where it will. The Wheel had almost crushed me when it led me to kill my brother. Now it promised to raise me up again, perhaps higher than I had ever been before. If he was not just a drunken prattler, Sturmy offered me everything I looked for. I would be able to escape England and expiate my sin. Not only that, but I would make some money. I might even become rich in his service, rich enough to buy my revenge on those who had provoked me into fratricide. I might make something of myself, and be able to return to Norfolk. And Sturmy did not care about my years in prison, for, as everyone knows, ships are full of ruffians and criminals, and a life of crime is a good preparation for a life at sea. For this scheme to succeed, Sturmy needed a man who could speak Italian, and had some knowledge of the world. My crime, which I had been careful not to name, was nothing to him, and my experience, which I had made much of, was everything.

Sturmy talked on, telling me of his plans while I supped more of the Gascon wine. I knew he needed me, and I did not show eagerness. Instead I raised objections to his scheme, reminding him of the dangers of the high seas and the hostile ports of France. But he knew all that, and told me about Saracen pirates in Granada and Barbary, the treachery and double-dealing of the Italians, and the intolerance of the Mamelukes, who ruled the Holy Land. It was the difficulties that had deterred Sturmy's rivals, and it was in overcoming them that his profit lay. When he had listened to my

objections he slipped a hand into his purse and pulled out some coins. I accepted them, and thereby became his agent and interpreter.

During the time I worked at Bristol I served my new master well, drawing up documents for him in French and Italian, getting the licences, permits and safe conducts we would need for a profitable and unhindered voyage. I made myself as useful as I could. I was determined to have a good share of Sturmy's profits, which was only my due if I did everything he asked of me. I had missed so many chances to make myself rich that it would have been folly to miss the one Sturmy offered me. Why had I not thought of trade before, instead of devoting myself to war? I suppose it was my father's influence, and I knew by then how lacking in judgement and honesty he had been. Sturmy, who had never risked his life at war, lived in a fine house with many servants, had enough money to finance new ventures, and was trusted by his fellow merchants, many of whom were happy to invest in schemes he could not finance himself. What I saw while I worked for Sturmy made me forget about books and learning just as surely as I forgot about war. It was not wisdom I wanted, but wealth.

Sturmy did not pay me then, though he clothed and housed me, and fed me every day. But I would rather that he had not, as the main item of our diet was stockfish, making my time at Bristol seem like a perpetual Lent. Whatever the quality of the merchandise Sturmy hoped to make his fortune with, those who worked for him were fed on fish as hard as leather, and as brown, that had to be soaked and pounded as though it was soiled linen before the cook could even begin his work. Whether Sturmy's stockfish was served with butter or mustard, simmered in a chaudrée, drenched with oil, stewed in wine with herbs and garlic, or set in a spiced sauce, it still stank of death and tasted worse. And stockfish had always been hateful to me, ever since the Feast of Fools. Each mouthful I ate reminded me of injustices I had suffered, and the wrongs I would right when I had the means. But there was no point in complaining. Sturmy's men all liked stockfish, which they ate eagerly in all its forms and variations. At sea, I later

discovered, they chewed bits of it unsoaked, snuffing up its vile smell as though it were fine perfume, and telling each other how much it reminded them of a woman's shameful parts.

Sturmy's ship was newly built, and he was very proud of it. "Three hundred tons!" he would say, pointing to the great sweep of oak planking that formed the hull. "Ninety feet from stem to stern! There's none but the king that owns a ship as big. Perhaps not even him. By all accounts, the king's not much interested in ships and suchlike. He prefers praying. And talking of the king and his men, if anyone asks, she's two hundred tons. We don't want to pay more dues then we have to."

It was indeed a fine ship, bigger than any I had sailed in before, with a tub-shaped hull that would make it stable in any sea, or so they told me. Sturmy often brought his partners to the quayside, and showed them how the ship was fitted out, pointing out the twin masts of Baltic spruce, the forecastle that sat high above the prow, and the sterncastle that housed the master's cabin, and which gave a fine view for miles around. Then, by way of a contrast, he took them below to inspect the rough cabins the carpenters had knocked together with planks. They were for the pilgrims, though Sturmy admitted that they would hardly do for dogs onshore. The cargo was to be stowed below and around them. There was no difficulty obtaining the goods Sturmy needed, and bolts and bales were soon stowed tightly in the hold. Pilgrims, too, were in ready supply, for there are many sinners, and would-be saints, all eager to tread the ground trodden by our Lord and long ago lost to the Saracens.

The ship was called the *Stockholm*, after a town Sturmy had traded with, but the crew called it the *Stockfish*. When I discovered that, I was strangely reluctant to go on board, and the feeling grew stronger as our sailing time drew closer. The pilgrims seemed equally reluctant, even though they had not yet seen their cabins, and huddled miserably at the dockside among their meagre possessions. Some of them, I guessed, had

sold everything they had to make the voyage to the Holy Land. Most of the pilgrims looked worse than the men I had been imprisoned with, and would be best avoided if I hoped to reach Jerusalem alive, though there was little chance of keeping away from them, even on a ship the size of the *Stockfish*. I could see in their bestial faces signs of the crimes they had committed, of the rapes and murders that only a voyage to the Holy Land could expunge. And if I had any doubts about them, I had only to think of myself. There were women, too, and some of them looked respectable enough, though they must have had some secret need, something beyond mere piety, to make them undertake so arduous a pilgrimage.

Sturmy kept the passengers on the dockside as long as possible, then, when he judged that the moment had come, urged them quickly on board. I could not believe how crowded the ship was when we were all on deck, surrounded by sacks, barrels, baskets and coils of rope. There were thirty or so in the crew, and a score of pilgrims, all jostling for position and trying to keep hold of their possessions. Before we set sail, the master sent all the passengers below, and told them to stay in their straw-strewn kennels. I was not sent with them, but went up to the sterncastle while the *Stockfish* manoeuvred its way out of the harbour and into the river. Though I had sailed before, everything on the *Stockfish* was new to me, what with the cargo, and the pilgrims, and the crew, some of whom were soldiers, there to protect us, as well as regular sailors. Watching the sailors at work with the sails and ropes, and listening to the wind and the creak of the new timbers took my mind off the great venture I was embarking on.

Once the ship got out into the estuary and began to rock the passengers were soon on deck again, heaving and retching over the sides. I felt sorry for them. At least I had a space in the master's cabin. It was not much, only a corner where I could sleep, but it was in the sterncastle, and had hatches that let in fresh air and light. But the pilgrims were packed together as tightly as oysters in a barrel, and tormented by vermin. Only the crew's threats could keep them below, and the crew soon tired of shouting at every man or woman they tripped over. It

was not long before the master's rule was abandoned, and the passengers lay or perched wherever they liked. The soldiers, who had little to do while we were under way, sat among them, whiling away the voyage with ungodly cards and dice.

It was no pleasure to be among that motley bunch of sinners. They reminded me of what I was, and had been, and of how futile the hope for absolution is. Whatever they might become in the eyes of God, to me those men and women would always be like wine-dregs, which sink to the bottom of the barrel whichever way you roll it. And they were rolled well on that voyage, as we had to keep well clear of Brittany, and it was not until we neared Guyenne that we dared hug the shore. By the time we reached Bordeaux I was eager for the feel of dry land beneath my feet, and I was tempted to linger, for I had never been to my mother's birthplace before. I wish now that I had seen more of the city, but no one knew then how short a time it would have left in English hands.

My only respite from ship life was to escort one of the pilgrims to the cathedral of Saint Andrew. She was called Alice. I had seen her going on board, though she had drawn her hood around her face. And I had seen her since, now and again, though she took care to stay below as much as possible. She had a servant girl to take her food and attend to her in other ways, but life in those hutches can hardly have been pleasant. I sometimes thought of her, and wondered why she kept below. Was it from shame, or pride, or fear of the crew or other pilgrims? Perhaps she thought to add to her penance by making the voyage as uncomfortable as possible. If so, her sin must have been serious, and I could not image what it might have been. She was no more than thirty, I guessed, and what I had glimpsed of her face did not suggest depravity.

Alice fancied herself a gentlewoman, and would not go ashore alone, or without her servant. Even I was not enough for her, as she insisted on having one of the ship's boys to carry her things, though there was little to carry and no distance to walk. We took a couple of the soldiers as an additional escort. Effect was what she was after, and while she said her prayers in a side chapel, I wondered whether her worst sin was not pride.

She sent the servant to buy a few things, then returned to the *Stockfish*, without seeing any more of Bordeaux. Perhaps she was wise, as great cities are full of great temptations. A few of the other pilgrims got no further than Guyenne, which, with its wine and warm climate, and opportunities for new sins, they found paradise enough. But the prospect of wealth and redemption drove me on, and I arranged the revictualling of the ship as quickly as I could.

At Belém we halted again, hoping to pick up a Mediterranean pilot. Some of the party thought the place auspicious, for its name means Bethlehem in the language of the Portuguese. Many of the pilgrims, Alice among them, went into Lisbon to pray to Santo António and leave a small offering at his church. But the saint did not protect them, and there must have been a pestilence at Belém, as soon after we set off, the passengers began to fall sick.

The privies were no more than a couple of seats at the prow, suspended over the ship's sides. They were good enough for sailors, who are cleanly and know the ways of ships, but the pilgrims, especially the women, refused to use them. They preferred to take a chamber pot below deck and relieve themselves in private. As the sickness spread, more people used the privies, and the master was obliged to have a sail rigged up to shield the more fastidious. Even so, many of the women preferred to stay below. The chamber pots were soon filled, and those who struggled to the deck in the darkness knocked over the pots and rendered the cabins uninhabitable.

Many slept in the open rather than endure the stench below, and their limp bodies filled the deck until it was almost impossible to move about. Those in need had to clamber over them, and often tripped, provoking fights and arguments. Queues formed on the foredeck, and even those who had formerly held back out of shame jostled for places, knowing that they would have to expose themselves to the elements, and to the stares of their fellow passengers. Those who waited to unburden themselves cursed those who kept them waiting, and danced with anguish on the wooden boards. Some, who were too weak to clamber up ladders and support themselves

on ropes, relieved themselves on deck, fouling the boards so that anyone obliged to pass nearby risked slipping. They were not popular with their fellows.

I took my turn at the privies, too, feeling smooth oak, wet and slippery under my feet, gripping hemp rope while I crouched over the open sea. Sometimes the fear I felt opened my bowels, at other times it closed them. And the food we were given, which was all dried or salted, even if it was not all stockfish, combined with the thick sea air to block the bowels of all those who did not suffer the Portuguese sickness. As the seas rose near the Straits, the privies were washed by waves, and to approach them was to risk a soaking. The men took to removing their clothes before venturing near the sides, and relieved themselves naked in full view. It was too difficult to rig the sheltering sail. And it was not just the men. The women were not immune to the demands of nature, and soon they too appeared nearly naked on deck, dashing for the privies in the vain hope that the men might preserve their decency by looking away. But the men, both crew and pilgrims, watched them intently, and their lusts were not damped by the shameful things the women were seen to do.

The sickness went round the ship in waves, infecting one person, then another, then striking again at those who thought themselves cured. Beyond Gibraltar the weather grew hotter, and the stink stronger. The caulking tallow turned rancid. The pitch in the deck-seams softened and bubbled, and defiled anyone who touched it. The soldiers, and most of the male pilgrims, had abandoned their clothes, or wore only thin things that clung to them with the damp. We were all scorched and blistered by the sun, our raw skin stung by salt spray. Some of the women attempted to preserve their modesty with a shift or undershirt, but those garments were usually so wet that they concealed nothing. The men continued to be aroused despite their sickness, and that of the women that provoked them. Even when the decks were awash with shit and seawater, men were roused to action, and not all the women resisted them. Couples lay together on the fouled deck, barely troubling to conceal themselves among

the barrels and coils of rope. Pilgrims destined for the Holy Land gave into their lusts and copulated openly on the deck. Others, inflamed by watching them, joined in, assuaging their lusts with anyone or anything they could. They were like the bather in Aeneas's story, who lost his identity when he took off his clothes. Men and boys joined with each other wallowing in sin on those filthy decks. They lost themselves in lust, and in their nakedness. They knew no secrets of love, coupling quickly like beasts, as though their days would soon be over and they knew no sin. They thought nothing of the Judgement to come, even though they travelled to win absolution. It was as though they foresaw their deaths, and did not care what happened to them afterwards.

"Look at them," the master said, as we leant over the sterndeck rail, watching the pilgrims cavorting below us. "I thought they had made this voyage to leave sin behind, but instead they wallow in filthiness. Have you ever seen anything as foul?"

In Arras such things were painted on the walls of churches. The Last Judgements there were as full of befouled bodies and eager sinners as the *Stockfish's* deck. I remembered their pallid flesh and twisted faces, and the sufferings they endured. The chaplain had made me study scenes of suffering and damnation when I was misled by love. Those painted sinners were prodded by hideous demons, driven to Hell with pitchforks, tormented with fangs and fire. But the sinners on deck were prodded by nothing more than their own desires. And I was prodded, too. Though I looked down on them from above, like the master, my desires were stirred by what those sinners did.

"They are beasts," the master said, turning away from the rail. "But they are paying beasts, and I am not their confessor."

The master seemed unsettled by what he had seen. He took to intoning psalms while looking down on the weather-deck, or muttering fearful things in his sleep, describing the torments of Purgatory, and horrors of Hell, and prophesying a terrible end for us all. *Help, Lord;* he chanted, *for the godly man ceaseth; for*

the faithful fail from among the children of men. When he reached the final lines: *The wicked walk on every side, when the vilest men are exalted,* he began again, calling on the Lord to aid him.

A week or so later, we were anchored off an island somewhere in the Mediterranean. I do not know the name of it, or who lived there, or which prince or emir it belonged to. It was a hot night, and to escape the master's babbling, I had taken my bedroll out onto the sterndeck. All around me, people were sleeping, stretched out on the deckboards, curled up in corners, heads resting on bundled clothes, or thrown back with mouths wide open. Even the watchmen slept, though they should have been looking out for pirates or Frenchmen.

I lay awake, looking up the full moon, and the stars that swept gently from side to side, arching over my head as the boat rolled. I was thinking of something Aeneas had told me, about the shape of the earth and the movement of the heavens. Could it really be true that the world was a globe, and that the stars circled round it like flies round a milk-pail? Some learned monks I had once talked to denied it, insisting that the world is shaped like a tabernacle, the heavens arching over its rectangular floor like a painted ceiling. But I had sailed through the Pillars of Hercules, and seen nothing supporting the sky. And I had observed that ships appeared gradually above the horizon, and that the land sank beneath it, just as one would expect if the world was round. If Aeneas was right, then what would happen to Sturmy's other venture, the ships sent west into the Ocean? If they missed their new lands and fishing grounds they might sail on, travelling right round the world until they reached the Holy Land from the East. It was a confusing thought, and I struggled with it for a while.

The silver light on the decks and rigging seemed magical, and made me think the world was far more mysterious than men like Aeneas seemed to think it. And the utter stillness of the sleepers on deck made them seem enchanted, perhaps by a sea-spirit, such as sailors speak of. The stars continued to swing, but back and forth, not round the world.

I lay for a while, gazing at the sky and musing on things Aeneas had told me about the seven climes, each of them

ruled by a different star, and how the weather grew warmer the further south one sailed. It was something to do with the roundness of the world, he said, though I could not remember why. Then I noticed that I was not alone in my wakefulness. Something moved on the weather-deck. A white, moonlit face stared out of the hatch that led to the pilgrims' hutches. As slowly as possible, I raised my head to get a better look. It was a woman's face, framed by long hair, which was unbound and hung over her shoulders. She looked around, making sure that she was safe, then hoisted herself up onto the deck. Pilgrims, both men and women, lay sleeping all around her, but she did not disturb them. She padded to the ladder and quickly climbed up it to the foredeck. At the top she looked back and scanned the ship. It was Alice.

I kept completely still and watched her through half-closed eyes as she stepped forward to the prow. She looked around again, then reassured, bent down and gripped the skirts of her night-gown. Her hair fell forward, reaching almost to the ground. She stood, lifting her gown. The white cloth rippled and gleamed as it rose, revealing her feet, her shins, her thighs, and then her marble-white buttocks. I could see everything clearly. She struggled for a moment with her night-gown, shuffling the coils of cloth over her head and shoulders, then the gown fell to the deck and she stood naked in the moonlight. Her hair fell over her shoulders again, and her breasts rose and fell as she got her breath back.

I was almost naked myself, and under the thin cloth that covered me, I felt my *membrum virile* stir and stiffen. Alice turned away from me and looked down at the dark sea. After a moment she stepped over the rail, just as though it was a country stile, and placed her feet deftly on the footrests of the privy. Thinking that no one saw her, Alice gripped the rope and squatted. While she was attending to her needs, I changed my position, twisting over so that I lay on my belly, and my swollen member pressed against the deck. I lay like that, watching her while she climbed back over the rail. Slowly, carefully, almost silently, she lowered a leather bucket into the sea and heaved it up again, using the water to clean herself. For

a moment, I thought Alice would get dressed. She seemed to reach for her gown, then thought better of it. The night was warm, and she had felt cool water on her skin. She lowered the bucket again, displaying her white buttocks as she leaned over the rail. After placing the full bucket carefully on deck, she squatted beside it and began to wash.

While Alice cupped her hands and gently trickled water over her back and shoulders, I rose from the deck and crept to the ladder. Turning my back on her for a moment, I climbed down to the weather-deck, then I crept forward, stepping carefully between the sleeping bodies on the boards. I was out of her sight as I climbed the forward ladder, but as soon as my head rose above the foredeck, she saw me, and almost fell back in surprise. Her face filled with panic as she groped behind her to find her gown. I feared that she might cry out, but she did not. Instead, her mouth opened and closed without making a sound.

I continued my climb, hoisting myself onto the foredeck until I stood before her, as naked as she was. Alice shrank back against the rail. She shook her head and mouthed a word. It was "no," but I knew by then that she would not say it out loud. Her sin, I thought, was pride. And what was worse for one such as her: to be dishonoured, or be seen to be dishonoured? She would submit silently, and no more say anything afterwards than I would. And I decided to make sure of that by being gentle, and by sharing my pleasure with her. I still remembered the Secrets of Love, even though I had not practised them for some time.

When I took Alice in my arms she felt as stiff as a stockfish. I dared not say anything to soothe her, so I touched her skin, feeling its damp coolness. She shuddered, and I realised that my own skin burned with feverish desire. The bucket stood beside me. I dipped a cupped hand in, drew out some water and splashed it over my face. Then I dipped again and spilled the water on her, watching while it trickled between her breasts. She shivered, and I dipped again, pouring more water, spreading it over her skin. I worked steadily, dipping and smoothing like a caulker working tallow into timber, reaching

a little downwards with every stroke. She stirred when I reached her belly, but I did not stop. I reached a wet hand between her legs and began to stroke, sure that what had worked with serving girls would work with her.

And so it proved. Alice was made the same way as less haughty women. There was Eve in her, just as there was old Adam in me. I added another sin to those I had to atone for, and so did she.

Alice stayed below deck after that, and I did not see her again until Italy drew near. When they saw that land was not far off, the pilgrims washed and dressed themselves, resuming their penitence. They assumed a sober manner, as though they had thought of nothing but virtue since they had left Bristol. And they talked of salvation, and of the Holy Places. But I was not surprised when, after we landed at Pisa, the pilot announced that he would go no further, saying that he would walk back to Portugal rather than endure another night on board the *Stockfish*.

Once we had discharged the cargo there was no point in waiting. It was clear that we would have to make our way to the Holy Land unpiloted. The master denied that there would be any difficulty in that, saying that the waters would be calmer in the East, and with the hold empty there was more space below for passengers. Even so, some of the pilgrims followed the pilot's example, and decided that a pilgrimage to Rome would be sufficient to expiate their sins. Perhaps they thought that they had already experienced Hell, and feared nothing worse. The master made the best of their loss, regretting the fares they would have paid, but maintaining that the ship would be more comfortable, and easier to sail, and freer of sin, with fewer people on board.

The land we sailed past was bleak and parched, best avoided if we were to reach the Holy Land. The Greeks call it Peloponnesos, or the Island of Pelops, though it is not an island, and everyone has forgotten who Pelops was. The Italians call it the Morea, or mulberry tree. Do we learn anything about a place

by knowing that it is someone's island or that it looks like a mulberry tree? Aeneas would have said so. Learning a language, as he pointed out, is like discovering a new country, a part of the world we do not know. So I studied the Morea, adding it to my picture of the world.

Jagged mountain disappeared into the clouds, and steep cliffs rose high above the toiling sea. There were white-stained islets where flocks of gulls perched, and little beaches where seals lay. But I could see no towns, or villages, or any sign that men lived in that barren land. Were we already in the Torrid Zone, where Aeneas said no men could live?

The seas ran high as we approached Cape Matapan. I huddled on the sterndeck, thinking my thoughts and wondering why the master hung so close to the coast. The headlands of the Morea dangled untidily into the sea just like the tangled branches of an unpruned mulberry tree. There was nothing but bare rock, lying in great blocks, split by gorges, tumbling into the sea. Surely the master would have been wiser to steer clear? He would have been wiser still to hire a Greek pilot to get us safely past the Morea's treacherous gulfs and capes. A shout from one of the crew seemed to echo my thoughts. But before anyone could react, the deck shuddered and tilted. I rolled forward and crashed into the rail. The breath was knocked out of me, and splintered wood gashed my skin. As I struggled to my feet blocks and spars fell from above, and ropes lashed the air like whips. I hung on, fearing the sea, waiting to be told what to do. But no one told me. The hull shifted again, bedding down on the sharp rocks that had ripped it open. Before I could get my footing a loose spar swung past me like a battering ram.

I clung on to the broken rail, helpless, while the crew rushed to save themselves. They ignored the pleas of the pilgrims, and the shouts and prayers of the master. Some of them launched a boat and made off in it, but the waves were so high that I would not have joined them even if they had let me. Others of the crew climbed the masts and rigging to get above the rising water, but the mainmast fell, crushing some of them and tossing others into the sea.

The master began a psalm, intoning the same words that had saved me from the gallows: *Have mercy upon me, O God, according to thy loving kindness.* When he reached the verse, *Wash me thoroughly from mine iniquity, and cleanse me from my sin,* the ship pitched forward, sending him crashing through the rail into the foaming waters. The sea closed over him, and that was his end.

What remained of the *Stockfish* broke up quickly, overwhelmed by great waves. I was thrown into the water, which was full of smashed timbers and sodden wool-bales. I clung to a broken spar at first, wrapping my arms and legs around it while the sea tumbled me over. I held on like that for hours, regretting my sins, praying that I would not be drowned, and promising to renew my pilgrimage if I was saved. Later, when the sea calmed, I exchanged the spar for a plank, which I could almost lie on. But when I saw a chest floating by, I grabbed it and held on fast, hoping that, as well as saving my life it might contain something valuable. I remembered a story Aeneas had told me about a merchant turned pirate who was shipwrecked, not far from the spot I swum in then, and clung, like me, to a chest. His chest proved to contain jewels, and the fortune he found was more than enough to get him home. The thought buoyed me as surely as the chest did, and I dreamed as I floated of the new life I might have if I survived the storm.

I was still clutching the chest when some fishermen hauled me into their boat. Naturally they took the chest as the price of my rescue, but it proved to contain nothing but clothes. They took me ashore, and gave me to the women of their village to look after. The women washed and fed me, and gave me new clothes. I was beginning to feel well enough to take an interest in the women, when the men decided to send me to Mistra, where their lord lived.

8 The Morea

Plethon was the oldest man I had ever seen. He lay on a couch, in the shade of a vine-arbour, on a terrace overlooking the hill I had just climbed. His small body was swaddled in white cloth, and his head lay limply on a cushion. He looked more like a severed head attached to bundle of rags than a man. But his chest was heaving gently, and I knew from that that he was alive. He started when I stepped out into the sunlight, breathing with a splutter through his toothless lips.

I greeted him in Greek, which I had, I thought, mastered quite quickly. I had learned it from the young son of the family I was billeted with, who had more time to give me than his parents, and saw in me the soldier he wanted to be himself.

The old man raised himself up slightly, making me wonder whether I should step forward and help him. I hesitated. How frail was he, and how proud? Then he began to speak. His voice was as weak as the last wheeze from collapsing bellows. His mouth opened and his lips flapped, but all that came out was a faint, inaudible murmur. I listened, intently, trying to make out words, but all I could hear was a meaningless babble. He stopped, perhaps waiting for me to reply, but I said nothing. He wiped some spittle from his mouth with a hand like a chicken's foot, then spoke again. His voice was a little less feeble, but I understood no more than I had the first time. The noises coming out of his mouth seemed to have no meaning in any of the languages I knew. Was he speaking a philosophical language, all his own? Or was it some ancient, learned form of Greek? He was the wisest man in Christendom, according to the Mistrans, and the oldest too. He was a great philosopher, a real one, not just someone mentioned in old books, a Greek who knew the Secrets of the Ancients, and had added some new ones of his own. He had written books, and taught, and had visited Italy and debated with the greatest thinkers of the West. I had climbed the hill to hear his

wisdom, but could understand nothing. I wondered whether I had come to the wrong house, or been shown the wrong man.

"Can you understand me now?" he said, in Tuscan.

"Yes sir, I can."

"They said you understood Greek."

"I thought I did."

"Perhaps you have been listening to the debased speech of the common people."

"I have done my best to learn your language."

"Those who wish to learn should seek out the best teacher."

"I will try to remember . . ."

"Now, let me see," he said, looking vaguely in my direction. "You are a Burgundian?"

"No sir, I am from England."

"An Englishman," he said, his voice growing stronger. "There were some Englishmen in Constantinople when I was last there. When would that have been? About forty years ago, I think. Would you have been one of them?"

"Forty years ago?" Surely he could tell that I was not that old? "That was before I was born."

I moved closer so that Plethon could see me more easily. I wondered whether he had lost his wits, as old men often do. Some of the Mistrans thought him odd. And he was nearly a hundred years old, or so I had been told. Seeing him for the first time, it was not hard to believe. I hoped I had not come too late.

"Really?" he said. "Take my hand." He reached out a claw, which I took, reluctantly, in my hand. His skin felt as scaly as it looked, and his uncut nails dug into my palm. "Those Englishmen at Constantinople were great big fellows." He reached out his other hand and ran it up my arm, pinching and probing. "But you are not," he said, letting go of my hand. "There used be a lot of Englishmen in the emperor's bodyguard, but that was centuries ago. Axe-men, they were. Why did they tell me you were Burgundian?"

"I serve with a Burgundian company, the men the Duke sent to help defend the Morea."

"Have you just arrived?"

"No, sir, I have been here in Mistra for two years. I live down there in the town." I pointed at the drop beyond his terrace, below which, at the edge of the town, lay the little house I had lived in for nearly a year. But Plethon did not seem to notice.

"You say you are not a Burgundian? I suppose that is plausible. The Morea is full of foreigners, or so they tell me. It's a long time since I've been down the hill, let alone out of the town. But the place was swarming with Frenchmen, then. Not to mention Venetians, Genovese, Catalans, Albanians, displaced Greeks and renegade Turks. They roam the country like scavengers picking over a corpse. I suppose they think that Greek rule of the Morea is ending. Have you come to feast on the corpse?"

"No, sir, I have come to the Morea to fight the Turks. I helped defend the Hexamilion wall against them, and have been in plenty of other action since."

"The Hexamilion! A lot of good that did. I told Constantine, and his father Manuel before him, that it was a waste of time building walls. What good are they when the Turks have their great cannons? And I was right, wasn't I?"

"The Turks certainly breached the wall."

"And what did you do? Come on now, be honest!"

"I retreated, like the rest of the survivors."

"I guessed it! That is what mercenaries always do."

"Despot Constantine led us back to Mistra himself. If we had all died at the Hexamilion, we would not have been able to continue the defence against the Turks."

"Perhaps you are right. I daresay we Hellenes should be glad enough for foreigners to fight for us. But it can't go on. Don't think I am ungrateful, but the Hellenes will only be free when we can defend ourselves, and that means no more mercenaries, like you."

"I am not really a mercenary. I was on my way to the Holy Land when my ship was wrecked. I volunteered to serve the despot . . ."

"I am sure you are paid."

"I am, but . . ."

Plethon seemed not to hear me, but gazed blankly into the distance. "Do you like my mountain?" he asked.

Mistra was not built on a mountain. Its buildings straggled up a ridge shaped like a wedge of cheese nibbled by mice. But Plethon's terrace was high up, and I did not want to offend him.

"It is a very fine mountain."

"All madmen should live on mountains, like eagles. They have told you I am mad, of course." I wanted to assure him that they had not, but his look told me that he knew that they had, and that there was no point in denying it. "When I die," he continued, "I would like to be left here on this terrace, and exposed to the air. The eagles can come down and tear the flesh off my bones, if there's any left. And the kites and vultures. Let my body return to the elements! That's what the Persians used to do, in the old days, when they were the enemies of my people. And who is to say that they were wrong? Who is to say that being left on a Tower of Silence is worse than being buried in the ground? Better be eaten by eagles than by worms! That's what I say."

He waited for a while, to get his breath back, or for my reply. But I said nothing.

"The little people are happy enough if they end up being eaten by worms," he said. "I see things that they do not." He flapped a bony arm, gesturing at the town below. "Look down," he said. "Look at the men beneath us." I looked down the slope, at the little men below us, toiling along the narrow streets. "They are like ants, are they not?" I imagined them sheltering beneath the red-tiled roofs or under the green treetops, hiding like insects under stones. Though I lived among them, it was easy to feel superior. Plethon spoke again:

"It is quite appropriate that I live up here. I see things from a lofty, philosophical perspective."

I looked back at him and realised that he saw nothing. His eyes were grey and misted. "You are blind?" I asked.

"Not entirely," he said. "I can see light and darkness. And

what more does one need, to understand the world?" He turned and pointed again. "There! Over there! Do you know what it is?"

"No." I saw only a dark streak on the horizon, where some ruins lay. I had ridden past the spot, but not paid it any attention.

"Sparta."

Plethon waited for me to respond. Obviously Sparta was important to him, but to me it was just a name I might have heard in some old story.

"The Spartans," Plethon said, "were the greatest warriors of my race. Sparta is our past and our future. It is here, within sight of those ruins, that the Hellenes will rise again. Mistra will be the new Sparta."

Mistra was unlike anywhere else I had lived. It was hot and dry, and everything was on a slope. Walking its streets was like crossing the deck of a listing ship. And the streets were clean and tidy, cleared of all rubbish by the despot's men. Such things were possible in a small place like Mistra, which, especially when viewed from above, resembled a model such as masons make to show what they might build, given the chance. But the Greeks had had their chance, and lost most of the great empire they had once ruled. Next to Constantinople, Mistra was the only important town they had left. It was a beautiful place, untouched by the turmoil around it, full of churches and monasteries, and houses that grew greater as they climbed the slope, becoming palaces at the top of the ridge. The Greeks seemed most themselves there, and I could see why men like Plethon might dream of bringing back their greatness in that pleasant city. But I could also see that greatness was only a dream.

"It will not be easy," Plethon said "Whatever happens, however much the priests and monks argue about theology, we will still be pressed by the Turks, and in debt to the Venetians. Perhaps the sultan will take Constantinople. The Roman Empire may finally come to an end then. But Hellenism will live on, here in the Morea. And one day, the Hellenes will be great again."

But there was little unity among the Moreans. The local Greeks disliked the Greeks from Constantinople, and maintained feuds with each other, often betraying their countrymen if it was to their own advantage. And I had been fighting the Turks for two years, and knew that they could not be stopped.

"Now, the question is," Plethon said, shortly before I left, "what use are you to me?"

"Use?" I said. I had been sent to see him as an oddity, one of the sights of Mistra, to be seen and remembered like its churches and palaces. Plethon had been described to me as a source of wisdom, something I had sought, but not often found. I had visited him out of curiosity, but not thought of doing anything for him.

"Bring me news," he said. "Tell me what is happening in the world beyond Mistra. Not that any of it is important, but it might be amusing to hear it from a foreigner's point of view. I think my family tell me what they think I want to hear. Anything to keep me quiet!"

When I had reported for duty at Mistra, destitute and barely dried out, I was sent to join the Burgundian company. Burgundy was England's enemy, but in the Morea all such things were forgotten. We were Christians, fighting Moslem invaders. As I had arrived with nothing, I was kitted out with a mailcoat, a padded jacket and wide-brimmed iron helmet. They had belonged to a dead man, but I wore them willingly, glad of the chance to fight the Turks.

That year the aged Sultan Murat sent a huge army against the Hexamillion, the great wall that crossed the Isthmus of Corinth. As winter fell, we marched north and faced the enemy at that narrow neck of land, with the sea on either side of us. It was like the trunk of the mulberry tree, and if we could hold the Turks there, we would prevent them from climbing into the branches and taking the fruit.

But it was not a simple fight of Christian against Moslem. The Turks had Christians on their side, followers of the Duke of Athens, whom the Greeks had expelled from their ancient

capital. And we had Karaman mercenaries, as well as a rabble of Albanians. But the sultan's army had something we lacked. They brought great cannons, which they fired ceaselessly until sections of the Hexamillion fell and their cavalry were able to ride through the gaps. The Albanians deserted then, and we had no choice but to retreat. The Turks ravaged the North of the Morea, and had the hardness of the winter not prevented them, the Turks might have followed us all the way to Mistra.

That was the battle I told Plethon about, when he accused me of running away. His accusation rankled, and I was not certain I wanted to visit him again. Whatever use he thought I might be to him, I was sure he was no use to me. What profit was there, in this world or the next, in spending time with an ancient madman? There were pleasures to be had in Mistra, and I was determined to enjoy them whenever I was not on duty. There was a woman I was seeing, a widow named Maria, a relative of the family I lodged with, whose husband had been killed at the Hexamillion. She was glad to find someone, even a foreigner, to protect her interests. And she was beautiful, too, with golden skin, huge dark eyes, and black hair thickly plaited and coiled. I cannot say that I loved her. That is not the way of it for most of us. My father used to say that he loved my mother as well as he loved his horse and dog, and that it was folly to do otherwise. Umberto was the same. His greyhounds meant more to him than any woman. I knew that, one day, it would be necessary for me to move on, to leave the Morea behind, and perhaps continue to the Holy Land. But I liked Maria well enough, and she was happy to share the secrets I had learned from Umberto's chaplain.

But Plethon seemed to know when I was back in the town, and sent messengers to drag me up to his hilltop house. I tried to resist, but they made it plain to me that it was as much my duty to attend him as it was to defend the Morea. I was given a meal, which I ate on the terrace while Plethon watched and sucked on dry bread. He would not even share the sweet wine they gave me. But I had eaten under his roof, and was his friend.

After that, whenever my duties permitted, I visited Plethon. Each time I climbed the hill I made sure I had something of interest to tell him. Sometimes he seemed pleased that I had visited him, and called for wine or sweetmeats to be brought, though he never touched them himself. He believed in living simply, almost like a monk, though he was rich enough, with lands the despot had given him, to enjoy anything he liked.

Sometimes he hardly noticed I was there. And though he had asked me to bring news, he listened without interest, as though he had heard it all before, or already knew what would happen. Even the news that a great army sent by the Hungarians had been defeated at Kossovo did not disturb him.

"War is the father of all changes," Plethon said. "War breaks everything down. Only when everything has been destroyed can it be built anew."

"But the Serbs betrayed the crusade. The Turks will win this war if the Christians don't unite. They won't just take Constantinople, but the Morea, too. How will anything be built anew after that?"

Plethon thought for a while before he spoke again. "I suppose you imagine you have some noble purpose, here in the Morea?"

"I volunteered to fight the Turks."

"So you are doing your Christian duty."

"I suppose it is a Christian duty, to fight the heathens."

"Who taught you your duty?"

That was a difficult question to answer. As a boy I had been taught to obey my father, and to serve Sir William. Later, I had learned to fear Umberto, and to follow orders from Fulk. Umberto's chaplain had given me some guidance, but it was confused, urging me to sin at one moment, and to repent at another.

"Many people," I said.

"And have you always done what you were taught to do?"

"Not always."

"Do you feel virtuous?"

"Not yet," I replied. I knew that Plethon was leading me into a trap, but the trap would be as toothless as he was, being made only of harsh words.

"Didn't you tell me that you were on a pilgrimage when you were shipwrecked here? Weren't you on your way to the Holy Land?"

"I was, but I thought I could achieve my purpose here. Fighting the Turks seemed as worthy as going to Jerusalem."

"So you hope to gain virtue?"

"Yes."

"I knew it. All pilgrims are the same. They are miserable sinners, rapists and murderers for the most part. They go to the Holy Land to expunge an unholy act. Am I not right?"

I thought of the pilgrims wallowing in filth and degradation on the deck of the *Stockfish*. "You are right."

"Tell me what you did wrong. You can trust me."

I hesitated before speaking. Plethon lay waiting on his couch. "I killed my brother," I said. Then, as Plethon said nothing, I went on, telling him more of that story, trying to justify my actions.

"So you are a fratricide, yet you say you seek virtue."

"That is why I seek virtue. Because I know I have sinned and am trying to atone for it."

"It is just as I thought. You claim a holy purpose, but have a selfish one. You sin, then atone for your sins, but only so that you can sin again. I expect when you have built up enough virtue by killing Turks in the Morea you will return to Burgundy and resume your wicked life?"

"I hope to go back to England," I said. "And I hope I will lead a good enough life."

"I am sure you will," he said, softly. "You will lead as good a life as you can, while mired in error."

"What error?"

"You have told me your secret," Plethon said. "So I will tell you mine. I seem to be a Christian, but I am not."

"What are you? A Jew? A Moslem?"

"Of course not! And I am not a Zoroastrian either, though there is something of all those faiths in what I believe. I am a Hellene."

"I know you are a Greek . . ."

"And I follow the faith of the Greeks. That is my secret. And you can share it."

"With respect, I have just told you that I came here to fight the men of other faiths."

"That, as I am trying to explain to you, is your error."

"I cannot redeem my soul by listening to heresy."

"No. But you can redeem it by listening to the Ultimate Truth. And that is what I am offering you."

"You are offering me the Ultimate Truth?"

"Yes. And if you have as much sense as I think you have, you will accept the offer."

"Why do you choose me?"

"I choose you because I must choose someone. I am like an overloaded donkey. I cannot carry my load of wisdom any longer, so I must shed it. You must take up part of my burden and bear it away."

"I am no scholar," I said, though I had had dreams of scholarship once. And nor, I thought, am I a donkey. But then I realised that perhaps I was no better than a brute, sent to fight one enemy with the help of another, employed by leaders who would betray their faith if it brought them power. And I was fighting in the name of faith, and in the hope of redemption. At least beasts of burden labour without false hope.

Years before, when Aeneas had befriended me, I had dreamed of continuing my education. But murder and destitution had put an end to that ambition. The monks I consorted with later had seemed to know everything, but understand nothing. I had listened to Plethon's ramblings, but only out of politeness. Now he was offering me wisdom. But was it wisdom, or madness?

"I am sick of scholars," Plethon said. "What do they do but kill ideas by writing them down and arguing over them? Scholars are worse quibblers than theologians. If you are not a scholar, that is your greatest virtue. You are not Greek, either. No one will suspect you of having any interest in my philosophy."

"I know little about philosophy."

"That is another virtue. Your mind has not already been filled with nonsense. But if you can master languages you can master ideas."

"You have picked the wrong man. I am no use to you."

Plethon seemed suddenly more feeble. "You are the only man that can help me," he pleaded. "The others will all betray me. They will deny the truth. But you! You will remember what others will try to suppress."

"I am not good at remembering."

"You will be. I will teach you how."

And so I began to attend Plethon more often, telling him news of the war against the Turks, and hearing his philosophy. He could not remember my name, and always called me the Burgundian. But I did not complain or correct him. He was an old man, and, having been to the West, did make some distinctions between the people most Greeks lumped together as the Latins.

When the Emperor John died, and Despot Constantine was proclaimed emperor, we knew that the empire would last a little longer. It seemed fitting that the eleventh emperor of that name should rule the city named after the first. Constantine was a good man, and a soldier, and was loved by the people, or most of them. He was also the son of the emperor my father saw at Eltham, and I felt that I was fated, in some way, to serve him. But when Constantine left for Constantinople, his two brothers had to share the Morea.

"Constantine is the best of the brothers," Plethon said. "And Despot Thomas will support him. But as for Demetrios . . . I'm not so sure."

The two brothers soon began to fight over their inheritance, and Demetrios plotted to replace Constantine on the throne. I had to serve under Demetrios, who had got Mistra as part of his share. It sickened me to fight alongside the Turkish mercenaries he hired. They stole and looted, and fought feebly, for Despot Thomas had hired Turks too, and they would not risk killing each other for the sake of Christians.

"For you, the world seems to be changing," Plethon said.

"But nothing will change my world. The universe is perfect and eternal. To add anything to it, to take anything away, to change anything, would make it less than perfect. And that," he said, fixing me with what have been a fierce stare, had he been able to see, "would be impossible."

"But I can see the changes."

"And I cannot?"

"I did not mean . . ."

"I may be sightless, but I am not a fool. I know that human affairs change. I know that kings and emperors come and go, that their armies fight and conquer, and that their dominions rise and fall. But that is trivial. The ripples on water change constantly, but the water remains the same. Men are like ants to the gods."

"Gods?"

"The Olympians. I expect they told you there was only one God?"

"Yes."

"But they told you that He was divided into three Persons?"

"Father, Son and Holy Spirit."

"The Christian God and all his attributes are no more than symbols. It is simple enough. They are like idols or icons. You have seen the pictures they set up in churches? Well, suppose you were to look behind one of them. Imagine taking an icon off the wall and turning it round. What would you see? Nothing? That's what! All you would see would be the back of the icon, the wood the artist painted on, with the marks of the smoothing tools. That would give the game away! You would know then that the thing had been made, that it was not God, or His Son, or His Spirit, or any of his saints or angels. The whole of Christianity is puffed up out of nothing, out of images and idols and empty words."

Of course, I had heard the Trinity doubted before. Who has not? But what men doubt in peace and daylight becomes real enough when they are faced with death on the battlefield.

"The Trinity cannot be nothing," I said, "if so many worship it."

"You sound like a typical Latin! I was in Florence when they proclaimed the Greek and Latin Churches united. Not that I could bear to listen to much of the debate. The fools argued about whether the Holy Ghost proceeds from the Son as well as the Father! Of course it doesn't! The Persons of Trinity are just symbols. They have no substance, and it is nonsense to speak of one of its aspect proceeding from any other. But that was what they thought was important at Florence. I have heard more sense in the wind that whistles round my mountain top. It is about time the Hellenes grew up and saw through the childish nonsense that makes up most of Christianity. That kind of thing is good enough for lesser races. Let the Latins have their Trinity if they want it. Let them eat unleavened bread and imagine they are eating God! And let the Greeks think the leaven is the Holy Spirit! What difference does that make to the truth? None at all!"

Plethon's frail body shook with agitation, and he had to wait a little before going on.

"The Trinity is a symbol," he said. "A feeble reflection of reality. The one contains three, but each of the three contains more, and each of those even more, and so on. The gods are arranged in hierarchies like the layers of society. There are the Olympians, and the Tartareans, and the entities some call angels, and beneath them, other spirits, all divided into multitudes. Do you see?"

"I'm not sure."

"Let me ask you this: is a kingdom one thing, or many?"

"One, I suppose."

"Yet it is made up of many. A kingdom is ruled by one king, but beneath the king are many lords, and beneath them, many lesser lords, then the multitude of middling folk and peasants. Yet you call that one!"

"It seems like one thing."

"Then what happens when one kingdom conquers another? Or when an empire splits into many despotates? Or where men live as savages with no laws and no rulers? Are they living in a single state of savagery, or in as many states as there are men?"

"I don't know."

"Mankind is both singular and innumerable, and divided into hierarchies and categories, from empires to families. So is every other kind of phenomenon. The universe itself is singular, yet it is one of many universes, each composed of innumerable phenomena." He waited for his words to sink in, and he might have waited much longer than he did, for I had little idea what he was talking about. "Who made the universe?" he asked.

"God," I replied.

"Or Zeus, as we Hellenes call him."

"I thought the word was Theos. Have I misheard?"

"That is what the Christians call Him. But those of us who know the Truth prefer His real name."

"I met a man once, who told me about names. He said that each language has different names for the same things, but that the different names, all taken together, give a different view of the things they describe. Like looking down on a town from a high tower, and seeing more than the people see who stand in the streets."

"And who was this man?"

"An Italian. Aeneas Sylvius Piccolomini, he was called."

"Piccolomini? But I know him! He came to the Council of Union when I was at Florence. His visit was supposed to be secret, or so he said. He was negotiating between the two popes. Two popes! There were even three of them at one time. How could the Latins expect the Eastern Church to unite with them, when they could not even unite themselves? As for Piccolomini, I suspect he is the sort of man who likes to create mysteries about himself. But he was polite enough to present himself to me and respectfully ask my opinion on various philosophical matters. I doubt that he took much notice, though. He struck me as being altogether too worldly, lacking in spirituality. Men like him do not seek the Truth."

"Was he right?"

"About names? Perhaps. But it may be that names are unimportant. Knowing the names of things in different languages may enable ordinary men to see a little further than

they might otherwise have done. To see the Truth, you have to stand much higher than the top of a tower, somewhere higher even than my mountain."

"And you have done that?"

"I have. I have risen into the realm of philosophy. I have communed with Aristotle and Plato. In my mind's eye I have seen the greatness of the past, a time when the Hellenes were powerful and wise, before we were misled by the Jewish Messiah. And as a result," he said. "I am the only one who understands everything."

"The only one?"

"I had some pupils, once," he said. "A few come and visit me still. Others are in Constantinople, or in the West. But none of them dared to think what I think. I have debated with other men, who were not my pupils. They took from me exactly what they wanted to take, but not enough to shake their faith."

"Did you tell all these people your true beliefs?"

"Not entirely. What takes a lifetime, and a very long one, to learn, cannot be explained in a moment. I taught them about Plato and Aristotle, and their relationship to Christianity. But I had to be careful. Even I cannot afford to offend the Church. Only a few years ago a man who called himself a follower of mine had his legs broken, then was thrown into the sea and drowned."

"For saying what you say?"

"For spouting a crude form of rustic paganism, which he blamed on me. Fortunately, the judges were able to see that the poor man's heresy had little to do with what I have publicly said and written. I am always careful how I express my philosophy. But one day it may be possible to speak more openly."

I wondered how a man as old as Plethon could hope for anything in the future. "Won't your philosophy always be heresy?"

"How can it be? Heresy is an offence against the Truth," Plethon said. "And the fact is that Christianity is finished. The proof is all around us. You keep telling me how the Turks

defeat the forces of the despots, and how our allies let us down, and how the West will send no help. Surely, if Christianity had any value, after all that nonsense about the union of the Church, the pope would have sent an army! But he sends nothing. All the Christians are good for is arguing. The Greeks are bad enough, but Latin Christians like you are even worse. But it makes no difference. They are all equally wrong."

"And you are right?"

"You sound doubtful, but why shouldn't I be right? Unlike you, I have had time enough to think. And my conclusion is that Christianity is the religion of the weak!"

Plethon, propped up on cushions, laid low by incomparable old age, was the feeblest man I had ever seen. He was by then scarcely able to do anything for himself, and had to summon help if he wanted to change position on his couch. But his mind was strong. He was right when he compared himself to an eagle, soaring high above other men. Yet, if he could see what other men could not see, he was also blind to some things we all know.

"The meek shall inherit the Earth," I said. "That is what we are taught."

"The meek will inherit nothing. Only strength will save us. Does the despot lead priests and monks out to fight the Turks? Of course not! He leads soldiers. The Moslems know they must spread their faith by force. They are not meek."

"Perhaps you want them to succeed."

"No. We may admire the Turks' strength of purpose, but Islam is no truer than Christianity. As I keep trying to explain to you, true wisdom is bigger than any of the faiths feeble mankind follows. We philosophers must see beyond superstition and tribal custom, and apprehend the Truth. The universe is arranged in hierarchies—in levels of being emanating from God. We must ascend the levels, purifying ourselves, leaving behind the impure, the physical, shedding the illusion of the material world. Surely you understand?"

"No. You forget, I am no scholar. I told you I was the wrong man for this. I cannot bear the burden of your heresy."

"You must learn to think, then you can abandon your illusions."

I could see why the Mistrans called Plethon mad, and I wondered whether I risked my soul by listening to him. But I had little else to do, as that year was the most peaceful the Morea had known for decades. Sultan Murat had died, and his son Mehmet was only nineteen years old, and was not taken seriously by the Turkish court. He established himself in Adrianople, and spoke of reconciliation with his neighbours, so the Greeks enjoyed a summer of peace, getting in their harvests and stocking their granaries. They imagined that the new sultan might leave them alone, and he did for a while. When the Karamans rebelled against him, Mehmet withdrew all his Turkish troops and sent them off to Anatolia.

With nothing better to do, apart from spending time with Maria, and avoiding her suggestions of marriage, I climbed the hill again and sat under the vine-arbour on Plethon's terrace. I did not object while he burdened me with his wisdom, if that is what it was. He must have thought me a stubborn beast, as the ideas he piled up tumbled down because of my stupidity. But gradually I came to understand more of what he told me, and to be more alarmed by it.

"Knowledge of the universe is as concentric as the universe itself," Plethon said. "True Wisdom is the outer circle, encompassing everything. Christianity is a lesser circle, enclosing parts of the Truth. The other faiths, Islam, Judaism, Manicheanism, Zoroastrianism and all the doctrines of the East, each have their own circles, greater or smaller, according to the degree of wisdom in their teachings."

"So those faiths are not all false, as Aeneas said?"

"Did Piccolomini say that? I told you he was not spiritual. There is some truth in all faiths. More than a little, if you consider them as metaphors. There is even truth in perversions of faith. Some in the West are so dissatisfied with God that they worship Satan. The King of France is one of them, I believe. He only kept hold of his country because his people were inspired to fight for him by a witch."

"I saw her," I said. "I saw her ride into Orléans, and I saw the way the battle turned against the English. My bad luck started then. I suppose that is why I am here."

"Bad luck? What nonsense! Believing in bad luck is as foolish as believing in witches."

"It is true that Joan was burnt for being a witch, but the French say she was inspired by God."

"They would! They always claim a holy motive for an unholy act. It was the same two centuries ago, when they attacked Constantinople and broke up the Roman Empire."

I was confused. Did he believe in witches and magic, or not?

"Is there truth in magic?"

"That depends on what you mean by magic."

"I knew a man, in France, who used knowledge found in old books to perform a secret ceremony."

"Did he conjure up the devil? That is the kind of childish trick Latin heretics get up to."

"No, he tried to transform a hunchback into a normal man."

"I don't suppose he succeeded?"

"No. It was all a trick, really. But I wasn't sure of that. I thought it might work."

"Not if he called on the devil, for the devil doesn't exist. Not as he is perceived by Christians. That is the ultimate absurdity! Those who worship the God of the Bible have to invent an anti-god to account for evil. And there is so much evil in the world that the anti-god must seem more powerful than God. No wonder so many Latins feel drawn to worshipping the devil."

"The man I spoke of did not worship the devil. Perhaps he invoked him. I did not understand the words we used. Might the magic have worked, if the man had done it differently?"

"Magic is just knowledge. And the malformed cannot be made beautiful, though they can be made to seem beautiful. But everything is possible for the Olympians. And the glimpses we sometimes get of worlds other than our own seem supernatural to us."

"Other worlds?" I was puzzled.

"Do you remember what I once told you about the universe."

"That it is arranged in circles, like the skins of an onion?"

"Yes. But that was only an image, to help you understand. Here is another image for you. Picture a wall made of bricks or stone blocks."

"Yes." That was easy. Many of Mistra's churches and houses were strongly built of fine masonry.

"Think of a brick, somewhere in the middle of the wall. That is our world. That is what we perceive." He stirred slightly on his couch, trying to raise his head up. "But it is not all," he said. "There are other bricks, rising above the one you are thinking of. In our image, they represent the other layers of reality, the worlds we cannot perceive."

"If a brick had feelings, it would know that another brick pressed down on it."

"It would indeed! Just as we know that there are higher worlds than this one. Heaven is our dim perception of that. And Hell. Heaven and Hell exist. They are the worlds above and below our own. But there are many of them, and our perception of those worlds is dim. Now," he said, "another image. Picture a lizard creeping up the wall."

There was one sunning itself on the terrace as he spoke. It lay lazily, flicking out its forked tongue.

"As the lizard climbs," Plethon said, "it passes from one brick to another, gradually ascending the wall. That is the image of a man's soul."

"But lizards climb down, as well as up. And sometimes they lie in one place."

"They do. I was describing the journey of a philosopher's soul, as it progresses through successive layers of reality to reach the ultimate Truth. A lizard that climbs downwards is like the soul of a wicked man who seeks to wallow in sin. You might call his destination Hell. To me, is no more than the absence of wisdom and knowledge."

"And the lying lizard?" I asked.

"It is the image of a lazy man's soul. Perhaps you are like

that, idling in the sun, enjoying life's pleasures, thinking nothing of the life to come?"

"No! I wish to save my soul."

"Then you must climb the wall."

A thought occurred to me. "What about the other bricks?" I asked. "The ones on either side of the brick the lizard starts on."

"Ah, I knew you were a clever fellow, though you pretend not to be. Now you are leaping ahead. But I will try to address your question. Those bricks represent other worlds as well."

"Worlds beside our own?"

"Exactly! Worlds of possibility. Worlds like our own, in which events have turned out differently."

"Do you mean that the Wheel of Fortune has not turned in them as it has here?"

"Wheel of Fortune? What nonsense! And to think I have just called you clever. There is no wheel, and no fortune, come to that."

"Then what happens when we face a choice?"

"Everything!"

"But there is only one result to each choice."

"In this world. That is the point. That is why there are other worlds, an infinity of them, stretching away beside this one, forever. That, at any rate, is what Anaxagoras taught. And he was a very wise man who lived a long time ago, longer ago than Aristotle, or even Plato. What he said was that each time we face a choice, both outcomes occur, creating two new worlds."

"I don't understand."

"Then let me give you an example. Have you ever done anything you regretted?"

"I have."

"Of course. You told me about it, didn't you? Well, try to remember it. Imagine yourself just before you did the act."

I saw myself standing in a Southwark tavern, an Italian dagger in my hand, with my brother, drunk, and lumbering towards me.

"There were two possibilities," Plethon said. "You could

commit the act, or abstain. In this world you did. In another, you did not. In that instant, the world divided into two."

So there was a world, according to Plethon, in which my brother lived, and I was not an exile. Perhaps, in that world, Walter killed me, or I walked out of the tavern without having met him. In which case, I might have gone back, and killed him on another day. Or I might have abandoned my quest to find out the truth about my father, and lived my life in peace. There were too many possibilities.

"Let me offer you another image," Plethon said. "Picture a small boat drifting down a branching river. You have only a single oar to guide you. Ahead lie either rapids or a calm lake. Or another image. Think of a tree, its great limbs forking into the sky, splitting into branches and twigs . . ."

"Enough!" I said. "Enough images. Enough branches. Enough choices."

Alarmed by my outburst, the basking lizard scuttled off into the shade. I wished that I might have some shelter from Plethon's terrifying ideas.

"We cannot avoid choices," he said, sadly. "At each moment when there are two possible outcomes, the world bifurcates. Within each new world, there are more choices, and so on. That is why there is an infinity of worlds."

"But that means," I said, "that our actions do not matter, that good and evil mean nothing."

"No it does not."

"Then how can we sin, if at the same time we do not sin?"

"Some of your selves sin. Others do not. And you are competing with them all. Think of the wall again. Imagine yourself, and all your other selves, attempting to scale it."

I pictured myself climbing a wall of smooth stone blocks, trying to reach the top, but slipping down. I saw many selves, climbing in unison, like a besieging army. Some of the selves fell. Others clung on, not daring to go up or down. A few climbed painfully to the top. They were all me. I failed and succeeded, many times, all at once.

"If I fail," I said, "another self will succeed."

"That is true. But what do you know of your infinite other

selves? Nothing! We can only know one self, and one path. The others all exist, as do all their actions and their consequences. There are many worlds, but we must make sure that the one we know is the best of all possible worlds. The important thing is to make sure that you make the effort to follow the right path and not the wrong one. And for philosophical men, the right path is the one that leads upwards, through the many levels, to the ultimate Truth."

"How do we know where that is?"

Plethon paused before asking me an odd question. "Have you ever studied ants? I thought not. You lack curiosity. But there are lessons for us in the behaviour of creeping things. When ants search for food they swarm aimlessly over the ground, darting this way and that, touching and tasting everything. But when one ant finds food, the others all follow. Once the swarm knows where the food is, they abandon their swarming and go straight to it."

"And men are like ants?" It was a point Plethon had made before.

"They are. Mankind is both singular and innumerable. The many men of this world are like the multiple selves that inhabit other worlds. For centuries men have swarmed aimlessly, like the ants, believing what they will, acting according to their natures. Now and then prophets and messiahs have appeared, telling us to go this way or that. They are like ants that have found food. But it makes no difference. No one follows their trails of wisdom. Man continues to swarm. Look at the way men of different faiths argue and fight! They should seek the Truth, and unite."

It was about then that Sultan Mehmet came back from putting down the Karaman revolt. We knew he was back because of the Turkish troops that poured into Thrace and began to press on the Hexamillion wall. Knowing that it could not be long before the Turks broke through into the Morea, the despots forgot their squabbles and prepared to defend their peninsula. We went north to the Isthmus, where we faced the enemy, spending a whole winter at the wall, and making

occasional sorties against the Turks and their Athenian vassals. We again faced Christian enemies as well as Moslem ones, and that made the winter more bitter than it might have been. I was confused by everything that Plethon had told me. What difference did it make whether we won the war against the Turks, or lost it? Whether I fought well or ran away? For every action I took there was a world where I did the opposite, my choices multiplying into infinity. Whether I paced the wall or rode into Attica, my life seemed more pointless than ever. Did it matter whether I redeemed my soul? How many Heavens were there, and how many Hells?

When the Turks withdrew, it was not because we had defeated them, but because they were needed elsewhere. The sultan was building a great fortress on the Bosphorus and was gathering his forces for the final assault on Constantinople.

It was summer by the time I was able to get back to Mistra. I climbed the hill to Plethon's house, and was shocked to find that he looked older. I had not thought that possible. He had seemed timeless, so old that he was beyond ageing. He had always been bald, wrinkled and toothless, but when I saw him that last time he was even more shrivelled and feeble than he had been before. A boy stood beside him, acting as his eyes and hands, doing everything for him.

The boy beckoned me, and gestured that I was to kneel by Plethon and speak into his leathery ear.

"You are the Burgundian," he said, when I had told him my name. I did not contradict him. "I want you to do something for me," he said, his voice feeble and wheezing.

"I will do my best," I said.

"I asked you to help carry my load of wisdom. Now I must lay down my burden altogether. I want you to carry my knowledge back to the West."

"I fear I may not be able to remember it all." I knew very well that I could remember very little, and understood less.

"I sometimes wonder whether I have remembered all of my own ideas. Perhaps I have not. It is true that what I have told you is not what I taught some of my pupils. I had to be careful. I had to put ideas in a form the Christians could

accept, just as I talked to the Turks and Jews in their own terms. And when talking to you, I have tried to put my ideas in a form that you can understand and remember. Memory is a good thing. But there are other ways to conserve knowledge. A few years ago I was visited by a wandering German. Christian Rosenkreutz, he called himself. He wore an emblem signifying his name. He was an odd fellow, and not altogether to be trusted. Unlike your friend Piccolomini, he was a seeker of wisdom. But the wrong sort of wisdom. He liked old books, and didn't mind how he got them. I didn't take to him. And I didn't tell him what he wanted to know. But he told me something interesting. According to this Rosenkreutz, books can be copied quickly in his country, by means of a mechanical contraption."

"I have never heard of any such thing," I said.

"He assured me it was true, though perhaps we should be wary of travellers' tales. Rosenkreutz may have exaggerated the abilities of his countrymen, though they are skilled at casting the cannons the Turks use to batter down our walls. But it seems fitting that, when books are being burned and banned, a mechanism should be devised for multiplying them."

I tried to imagine what the contrivance might be. A mechanical figure, perhaps, like the bronze men that strike the hour on some church clocks? My father had told me of statues that moved and spoke, but in Constantinople, not Germany. A moving statue might write, I supposed, but could it do so more quickly than a man? Perhaps the writing machine was more like a loom. I imagined a dozen pens lashed together, with pages turned by treadles. Could words be woven together like the threads of an Arras tapestry?

Plethon muttered something to the boy, who took a damp cloth and dabbed his eyes as though they were only tired and might see again if they could be revived. "In any case," he said. "You will doubtless go back where you came from, one day?"

"Only when the despots have no further need of me." I thought it best to be tactful. Thomas and Demetrios both had many spies in Mistra, and it would be unwise to seem disloyal to either of them.

Plethon spoke to his attendant again. The boy pulled a small coffer from under the couch, lifted the lid, and took out a cloth-wrapped bundle. I knew from its size and shape that it must be a book.

"They won't burn me," Plethon said. "Even if burning was customary here, there would be little point. I will be dead soon enough. But they will burn my books, or suppress them, somehow."

"Surely not? Your pupils will keep your work alive."

"I fear my pupils the most. They understand better than anyone does how dangerous my ideas are. Half of them are in the West now, turning Latin."

"Your sons?"

"They will inherit my property. And much good may it do them with the Turks on the way. Why burden them further with my philosophy?"

The boy held out the package, looking anxiously at his master.

"I want you to take it," Plethon said. "It is my *Book of Laws*. It contains the truth. All of it. It is the essence of what I believe. My spirit, in a sense. The book is brief, but it encompasses everything. Its meaning may be obscure to some, but it will be clear enough to those who know how to read it."

I took the book as unwillingly as I would have taken a red-hot iron. The boy closed the coffer and slid it back under the couch.

"There are two copies of the *Book of Laws*," Plethon said. "That one, in Tuscan, and the original, in the language of the Hellenes."

"What shall I do with it?" I asked.

"Keep it somewhere. Keep it safe. Take it with you when you go back to Burgundy."

"And then?"

"Have it copied. By hand, if not by mechanical means. The old ways are not so bad. Then circulate it, as widely as possible. There are men in the West who are thinking along the right lines. I met some of them in Italy. They will be glad of my

book, though it may offend some of their rulers. With my wisdom, the West might save itself, even if it cannot save the Hellenes."

I had very mixed feeling about that book. I knew it might be valuable. Umberto or Aeneas would have paid well for Plethon's wisdom, and I had heard of wandering friars buying, or even stealing, old books from Morean monasteries and churches. But the *Book of Laws* was surely heretical, and having it copied was the most dangerous course of action I could imagine. Even owning it was bad enough. How could the book be true? Plethon was the only person who believed in his philosophy. Even his pupils had renounced him. But he trusted me, and I could think of no way of refusing him. I took the *Book of Laws* back to my lodgings and hid it, postponing the day when I would have to decide what to do.

Only a few days after our last meeting Plethon was found dead. It was as though he really had given up his spirit when he gave me the *Book of Laws*. He was given a more Christian burial than he might have wished for, then a delegation of priests ransacked his house, searching for forbidden writings. Though Plethon was nearly a hundred years old, he might have lived for ever, had he chosen to. At least, that was what the Mistrans said, though they hinted that his long life owed something to the devil. I knew better. I knew that he denied the devil. But I also knew that he had denied God, as Christians knew Him. And that troubled me. Whatever Plethon had said, whatever doubts he raised, whatever the fate of the Greeks and the faith of the Turks, England was still a Christian land, and, if I were to return there I would have to redeem my soul from sin.

Fighting for the despot would not bring redemption. Not when he led us against fellow Christians, and made us fight alongside Turks. And Maria, the Mistran widow, was pressing me to marry her and convert to the Greek Church. I had run out of excuses, and she hinted that her brothers might make things difficult for me if I refused. Though Plethon did not believe in it, I felt the turn of the Wheel of Fortune. So, when

the chance came to leave the Morea, and take part in the last great battle against the Turks, I took it. I gave some of the gold I had accumulated to Maria, packed away the rest and set off for one last chance of glory. If I survived, I would be a hero, and redeemed. If I died, it would be in defence of Christendom.

9 Constantinople

High-towered walls rose sheer from the water, stretching away as far as I could see. Beyond them lay Constantinople, the greatest city man had ever built. It was no shimmering paradise of gold and marble, but a wedge of hilly land that stuck out into the Bosphorus like a ship's prow. An icy wind raised the sea into white-capped waves, and the rowers hunched low over their oars. The men I commanded were huddled near the stern to keep out of the cold, but they wore their mail-coats, and their weapons stood ready for use in case of attack. The two dozen Burgundians, a mixed lot of crossbowmen and handgunners, were all that the despot could spare if the Morea was not to be overrun. I looked around anxiously, hardly believing that we would reach the city without being caught. But the wind was strong, and there were no Turkish ships on the Marmora that day. One or two of my company rose for a better look, but most of them stayed where they were. There would be time enough to inspect the city when we were in it.

The galley made for a gap in the walls and slipped into a small harbour. The chain was quickly raised behind us. The ship that carried us was Ragusan, and one of the last vessels to reach Constantinople before the Turks blocked the Dardanelles. Constantine, who styled himself Emperor of the Romans, had no navy of his own, and could not control the land routes to his capital. Many brigands in France ruled over more land than the emperor did, though no one in the world could have ruled over a greater city than Constantinople. As we climbed ashore, I remembered the stories my father had told me. The city was huge. We could see it rising above us on a series of wooded hills, its domed churches and fine houses gleaming between the bare trees.

Once ashore we were met by a Greek officer who had orders for us. He was a grand looking fellow, with a long beard and a tall hat, well wrapped up in a thick wool cloak, and obviously keen to send us on our way. Rather than obey him

immediately, I made a point of inspecting my men, making them line up with their packs and weapons. They had long experience of the Greeks, and knew the game we were playing. When I was ready, I heard the Greek's orders.

"Must we go straight to the walls?" I asked him. "We will have seen nothing of the city we have come to save."

"There will be time to gawp at the sights later, *if* you save us." The officer gave us a contemptuous look. "The best place for Latins like you is at the walls."

"Where we can cause no trouble?"

"I wouldn't put it like that," he said, attempting a smile. "But no one will cause *you* trouble if you are safely lodged in a high tower by the walls."

I was glad that most of my men did not understand Greek, though they would have seen the contempt in the officer's bearing.

The officer assigned us a guide, our equipment was loaded onto a wagon, and we set off. Our route took us to the west of the city, where the land walls were. We soon left behind the fine houses and churches we had seen, and entered a half-abandoned district. We tramped along streets no better than farm-tracks, slipping in icy mud, accompanied by ragged children and baying dogs. We got rid of the children by throwing a handful of tiny coins into a ditch, which they leapt into despite the ice that encrusted it. Some of my fellows prodded the dogs with their swords, but that only enraged the beasts and encouraged them to snap and snarl all the more.

Though I knew what to expect by then, the most precious city in Christendom was still a disappointment. The quarter we crossed was deserted. The few people we saw cowered in hovels, fearing anyone who passed. I was reminded of the time I had trudged across France with Ralph's men. How could such desolation exist in such a fabled city? What had been a great metropolis, encompassed by impregnable walls and full of marvels, was no more than a collection of ruins, separated by tracts of wilderness. I wondered what Aeneas would have made of the place. He had praised Constantinople for its riches and learning, yet the city I could see was poorer than

London, which he had dismissed as squalid and primitive. Even in my father's time, fifty years earlier, when the Emperor Manuel had travelled to London, the city must have been half-empty. It was as though each visitor to the city had taken away buildings and people instead of stories. Their tales grew stronger in the retelling, and Constantinople glowed brightly in their memories. But the real city had faded like an echo.

The walls were real enough, and stood as high and strong as they had for a thousand years, built of huge stone blocks topped by courses of brick and masonry.

"Where is the rest of the garrison?" I asked when we reached our tower.

"The rest?" our Greek guide said. "You're it. This tower is all yours."

"But it would take fifty of us to man this tower."

"Yes, and fifty more for each of the other towers." The Greek waved an arm at the line of towers that stood like sentries along the walls. "But if we had fifty men for every tower, we wouldn't need you. You'll just have to do your best."

We took charge of the tower, and made ourselves as comfortable as we could by gathering straw for beds and wood for fires. Throughout December, we guarded the tower, anxiously looking out over the flat land beyond it, wondering where the Turks were. It was not the kind of soldiering I was used to. Instead of raiding and patrolling, matching the enemy's movements. We were trapped in a city waiting to be attacked.

I got to know the tower well, and paced its top for hours each day. It rained constantly, and we were soaked to our skins with little hope of drying out until our watch was finished. We were not quite on the front line. Beyond the wall we guarded was another, with small towers of its own, and below that was a wide moat, parts of which were still in water. The city had the strongest fortifications I had ever seen, and had they been properly defended no army on earth could have breached them. However, when we looked around, at the towers below and beside us, and at the expanse of land

between the walls, and saw the thin scattering of troops that manned them, I wondered what chance we had of holding off the Turks.

Sometimes a few of us were able to leave our post and see a little of Constantinople. The tower was as far from habitation as it was possible to be in a great city. There were tracts of unbuilt land along the walls, which were perhaps parks or pastures once, reduced to wilderness by then. But the land was not entirely empty. Men had walked it, and animals, their steps leaving faint trails that looped and crossed, netting the land like a spider's web. Though partly obscured by time, ancient roads still led east, branching as they went, like Plethon's route through life. That desolate land extended for a mile or so from our tower, and we crossed it quickly, huddling against the drizzle, always on the lookout for packs of dogs or sturdy beggars. After the wasteland came a decayed zone, full of memories of Constantinople's glory. Everywhere there were ruined houses, empty churches and abandoned gardens and squares. Here and there a dome or tower rose above the trees, showing that some ancient building still stood. Cold winds from the Bosphorus blasted empty forums where elegant citizens must once have strolled and chatted. There was a huge aqueduct, which spanned a valley as though built by giants. Its arches sheltered people driven from the surrounding country.

To the north, where the land ran down to the waters of the Golden Horn, was a strip of inhabited land where the Greeks hung on to their old life. It was the same in the south, by the Sea of Marmora. But the people who clung on to the city's margins were only a fragment of the million who once lived there. And the places where they lived were more like scattered villages than the quarters of a great metropolis. Only in the east of the city, where it jutted out into the Bosphorus, was much left of old Constantinople. The great palace of the emperors was decayed and empty, but even the ruins showed how wealthy the emperors must once have been. We climbed through an arch and wandered echoing halls thick with dust and cobwebs. I was reminded of my father's sad story of the

emperor who went to London to beg for help. Accidentally, and much delayed, I was answering that plea.

The hill above the palace was still inhabited. It was dominated by the humped and clustered domes of Hagia Sophia. The ancient church did not thrust into the sky like those of the North. It was a squat mountain of stone, cut from beneath the earth and piled heavily above it. We went inside and found an empty, echoing cavern, its gloom slightly lessened by a few shafts of light that struck down from a ring of high windows. Golden mosaics and columns and panels of figured marble glowed faintly in the gloom. There were no Greeks there, as they thought the place tainted by union with the Latins. Near the church were the palaces of the last nobles to live in the city, the houses of their followers, and the shops of the merchants who supplied them. But that quarter was a sad sight, as all the houses were in need of repair, and the finely paved streets were thick with mud that was as sticky as tallow. The few people who ventured out looked pale and thin. They looked up from the filthy pavement only to mutter a prayer or listen to the tolling of church bells, wondering what they portended.

There was not much pleasure to be had in that doomed city. There were a few places where Italian merchants hung on, and where a drink might be had by those who could afford it. And there were houses where women sold cheap what would soon be discounted to nothing. But we returned to our posts almost with relief, preferring the monotony of duty to the city's misery and decay. Constantinople was like an exhausted man, sunk in a squalid sickbed, waiting only for death.

The Turks came at Easter, just when the weather was brightening, and we had begun to feel some hope. A Genovese fleet had arrived a little earlier, bringing hundreds of extra soldiers. Their commander was put in charge of the land walls, and soon we were joined by Cretans and Catalans as well as the Genovese, who manned the outer walls and towers. The new men made us feel bolder, and when the Turkish vanguard

arrived, some of the Genovese dashed out of a postern and attacked them. My men stayed to guard the tower, and I was glad not to be part of that action. When the Genovese saw how many Turks there were they disengaged as quickly as possible, dashed back to safety of the walls. After that there were few sorties, and all we could do was watch while the Turks made their camp, their tents and equipment forming a solid mass, half a mile or so beyond the walls.

We had the Bashi-Bazouks opposite us, and the Janissaries to our right, and they were none of them men I wished to face in battle. The Bashi-Bazouks were the collected rabble of a dozen kingdoms. They might not be disciplined, but if they thought there was loot to be had, they would fight fiercely. The Janissaries were the sultan's best troops, well armed and highly trained. They thought God was on their side, and that their Prophet would lead them into the city he had promised them centuries ago. Not all the enemy were Moslems. Further along their line were some Christian vassals of the sultan, Vlachs or Serbs it was said, who had no love of their ruler, or wish to be fighting us. They tied messages to arrows and shot them over the walls, so we knew something of what the enemy was preparing. But I could guess well enough what was going on in the enemy camp. I had been at Orléans, and knew what a siege was like from the other side. And I knew how much better prepared the Turks were than the English had been then. The French had been saved by a witch, or by a miracle, but Orléans might have withstood our siege without supernatural aid. There seemed no likelihood that Constantinople would be saved by someone like Joan.

The rumours that reached us from the other end of the city confirmed Plethon's low opinion of his compatriots. The Greeks of Constantinople, like their fellows in the Morea, were too busy arguing to defend themselves. They would not even pray together, or with us, but kept to their own churches and worshipped in their own way. There were riots when priests who had accepted the union of the Church blessed leavened bread, or included the word *filioque* in their prayers. It was not just faith that divided them. The nobility and their

hangers-on had retreated to their palaces, fearing the poor, and their foreign allies, as much as they feared the Turks.

Where could they look for a miracle?

In truth, neither men nor miracles made much difference to that battle. It was machines, great siege engines bigger than anything any of us had seen before that took the city. And the worst of them was the cannon the sultan had cast especially for the siege. It was so big that it took sixty oxen to pull its carriage, and all the roads and bridges to Constantinople had to be strengthened to support it. When the earth shook, as it did several times before the battle, some thought it was God's wrath in the form of an earthquake, while others said it was the sultan's cannon, firing at us from so far away that we could not see it.

When the rain stopped, we could just see the sea from the top of our tower, and we could make out the Turkish ships that sailed on it. We knew there would be no more help from the west. We could only wait while more of the sultan's armies assembled before us.

There was some parleying, as there usually is before a battle, and the sultan offered a truce. But the offer was rejected, and, only a few days after the Turks had arrived, they began their attack. They fired at us with their cannons, while sappers tried to undermine the walls and fill the moats and ditches. Some of the other towers had cannons, but the Greeks were not skilled at firing them, and did more damage to themselves than they did to the enemy. It was best not to be near the Greek gunners, and I was glad none were stationed on my tower. When they did not explode, their guns often slammed back against the masonry, damaging the towers more effectively than the Turkish gunners. But the Greeks had Greek Fire, which was nothing like the stuff I had used in France, but a liquid launched from pumps or siphons, which set fire to anything it landed on and could not be put out. The Greeks used it to burn the timber the Turks piled in the ditches, and the wooden towers they sent against the walls.

My men only had crossbows and handguns, which made

little impression on the well-sheltered sappers. We cowered behind our battlements, rigging up bales and hides for extra cover, only daring to look up occasionally at the Turks scurrying beneath us. My tower was hit once, and two of the men were killed, disembowelled by shattered stonework.

But that was only the start. When the sultan had had the rest of his artillery brought up, the real bombardment began. The great gun could only be fired half-a-dozen times a day, but we dreaded the sound of it. It was louder than anything I had ever heard, and each explosion was followed by the sound of a ball smashing into masonry, reducing a section of the wall to rubble. Whole lengths of the outer wall were brought down like that, and men were sent out at night with sharp stakes, which they buried in the earth to form a stockade.

It was at night that we faced their first assault. The first we knew of it was the noise of the Janissary band. There was some gentle tinkling of the cymbals, which we thought might be some sort of campfire entertainment. There were rumours that they had dancing girls, and boys, in their camp. Then the kettledrums started, gently at first, with a skipping rhythm that made us think again of dancing. But their beat grew louder and stronger until the drummers were hammering like blacksmiths. Shawms blared out, their wailing sounding devilish in the night. Then we saw their fires changing, growing darker, then brighter, then splitting into a hundred little flares as the Janissaries gathered and lit torches. We knew what was happening then, and were ready and waiting when the flares formed up in lines and began to move towards us. I longed to be elsewhere, to be in the open where I could move around and avoid the enemy and not be trapped between a high wall and a row of sharpened stakes. The drums and cymbals had lost their jaunty rhythm by then, and made a sound that shook the earth.

The flares drew closer, advancing in lines, and in their light we could see the white hats of the Janissaries. Arrows began to fly, screaming through the stockade, clattering off stone and iron. Javelins followed them, and we began to fire back, shooting into pools of torchlight with bows and handguns, hoping

to stop the Turkish advance. But they kept on coming, marching in time to the drumbeats, calling out harsh battle cries. My Burgundians fired faster, surer of finding targets, and many of the Janissaries fell. We shouted with joy when we saw how many we had killed, but we had been fooled by the darkness. The Janissaries and their band were decoys. Around them and behind them, in darkness and silence, other forces had gathered. There were sappers with sacks of earth and bundles of wood, who filled the ditches as they advanced. And there were men with hooks and ladders, ready to scale the walls.

Some of the Genovese rushed out to face the new arrivals, and I thought they had sacrificed themselves. But they had seen what I had not, that many of the Turks were only lightly armoured. The Genovese wore full plate armour, and they carried heavy-bladed halberds that they swung at the Turks. They hacked and hewed and brought down a good number of the Janissaries, who were bolder than they should have been, and rushed into danger without pausing.

I learned later, when I had much time to contemplate the ways of the Moslems, that they think they will go straight to Heaven if killed in battle. If so, many of them ended their lives well that night, and only a few of us died. While the fighting grew fiercer the sound of the band faltered. The Turks could no longer advance to its beat, or feel its strength beneath their battle cries. Though they outnumbered us many times, the Turks were pressing through a narrow gap. We could not have hoped to defend the entire wall, but we could defend that gap. We held them at the stockade, and stopped the sappers from reaching the walls. And on that occasion, that was enough. Towards dawn, they realised that the spot they had chosen was stronger than they thought, and their trumpets sounded the retreat.

The next morning was calm. Some pious women brought us food, which we ate eagerly. They came again on other days, but they were followed by beggars who tried to carry off the food. The women silently retreated, leaving us to see off the beggars, which we did, by beating them with the flats of our

swords. As they ran off, we cursed them as ungrateful, and they denounced us as heretics. As we ate what was left, my men said they hated the Greeks, and were only fighting for Christendom.

All the time the Turks kept up their bombardment. They fired at us for six weeks, with cannons of all sizes, sapping morale as well as the walls. Our days were dominated by the rhythm of the great gun, which marked the hours like a church bell. We dreaded the sound of it, and the shaking of earth and masonry that followed. The women stopped bringing food, and the merchants who set up their meagre markets demanded far more than most of us could pay. We took our minds off hunger and danger by testing our weapons and repairing the damage done by the Turks. We slept little because of the constant bombardment, and tempers were short. Waves of rumour spread along the walls like water in a dry gully, buoying our hopes then dashing them on the rocks of defeat. We heard of huge armies from the Moslem lands of the East, of new and bigger cannons, attacks on outlying castles, massacres of monks and priests, and treachery among the city's defenders. A great fleet sent by the pope or the doge was constantly expected, but if any ships reached the city they made no difference. There was a great naval battle in the Golden Horn, during which the Turkish galleys were inundated with Greek Fire. I did not envy any sailor trapped aboard a burning ship, choked by sulphurous fumes and unable to put out the flames. The Turks were driven back, but the sultan ordered more ships to be dragged into the Golden Horn overland. I have no idea how they did it. During the two days it took them they increased the bombardment, and launched feints against the walls, so that we were fully occupied. We saw the smoke rising when the Turks burnt the Greek and Italian ships that resisted them, but that was all. After that the city was pressed closely on all sides.

The Turks sent miners to dig under the walls, and laboured constantly to fill moats and ditches. They built wooden towers on wheels, some of which we managed to burn. But there were limits to what we could do. The rain fell harder than

ever, and stopped our attempts to set fire to the Turkish siege engines. There were portents that disheartened us all, especially the Greeks. First the full moon faded, and the night sky went black when it should have shone with moonlight. Then, when the Greeks tried to carry one of their holiest icons round the city, there was a hailstorm, the procession was soaked, and the icon fell into the mud. After that the city was enveloped by a great fog, which the Greeks and Italians all thought a sign of God's displeasure.

A few days after the fog, the Turks launched their final attack. We knew it was coming from the preparations they made. They drove forward great herds of slaves and captives, loaded like mules with tree trunks, branches, sacks and barrels of earth. We watched them shuffling forward, throwing their burdens into the moat, sometimes tumbling in afterwards and being instantly buried. But there was little we could do. We knew they were Christians and had no choice but to slave for the Turks. Had we wished to fire on them, we had little ammunition, and that had to be conserved.

By evening, whole sections of the moat were filled with earth and timber, and masonry from the demolished walls. The Greeks did what they could to drag those items out and use them to repair breaches in the walls, but they had little will left for drudgery, and the Turks kept shooting at them.

That night the sultan must have ordered his army to illuminate their tents. As dusk fell we saw the glow of lamps and torches, some burning brightly, others diffused by tent cloth, forming a golden crescent round the city. We could see lights across the Golden Horn, from the hills above Pera, where the Italians had their markets and warehouses. The Turkish ships, afloat on the Marmora, hung lamps from their rigging, reminding us they dominated the city's approaches by water. If we had been able to see across the Bosphorus, I am sure we would have seen lights shining at us from Asia. The city was surrounded, with no hope of rescue.

The Turks celebrated that night, singing and dancing as though they knew they had already won. Some of the Greeks

went out and dug their ditches deeper, and tried to repair the worst gaps in the walls, but most of us rested as best we could. In the small hours, just when we were least alert, the Turks attacked. The Bashi-Bazouks came at us first. They were not disciplined troops like the Janissaries, and did not march in step to drums and trumpets. Instead they rushed at us, howling wildly like beasts, waving curved swords and firing their guns in the air. Behind them were men with whips and torches, urging them on. I almost pitied the Bashi-Bazouks. While they were being lashed and goaded from behind, we shot at them from above, aiming among their torches as best we could. There was such a crowd of them that we must have hit many. But clouds veiled the moon, and in the shifting darkness it was hard to tell. All we could make out was a swirling mass of men, their contorted faces fitfully lit, their weapons flashing, then disappearing into smoke and blackness. Arrows, crossbow bolts, stones and cannon balls all disappeared into the enemy mass like stones dropped into a deep well. Men flung themselves at the stockade, cursing us in a dozen languages. Some of them got ladders against the stockade and tried to climb over.

The Genovese held them off. With their better armour, and the cover we gave them, they were able to face the Bashi-Bazouks and beat them back. So many men pressed against the walls that they got in each other's way. After a couple of hours, the enemy retreated, and we realised the attack had been a feint. The Genovese pulled back while others rushed forward with stakes and barrels, quickly repairing the gaps in the stockade.

While the Genovese were resting, I was ordered to send some of my men down from the tower. They were to move forward and help defend the outer wall. I was reluctant to send them. What use would guns and crossbows be in hand to hand fighting? Before they could reach their new places there was a blast of trumpets, then the sultan's great gun fired, slamming a huge ball into the fortifications. In the confusion, a mass of Turks rushed forwards, their polished breastplates shining in the torchlight. The Genovese wearily clanked back to the

stockade and prepared to fight again. The Turks were more determined than the Bashi-Bazouks, and cursed us in their own language. They fought for their sultan, and their faith, not for loot. But they did not break through. Perhaps their attack was another feint, and the real assault took place elsewhere. Or it may be that, like the Bashi-Bazouks, they had been sent to keep us busy and wear us out. Whatever the reason, after an hour or so their advance ebbed away. But they gave us only a brief respite before the next attack.

Those of us who were not busy attending to wounds, repairing the stockade, or gathering up arrows, lay exhausted on the ground. Some men may have slept, but most must have prayed. The enemy ahead of us had gone quiet, though we could hear shouts and gunfire further along the walls. Then, in the darkness, the Janissary band began to play again. Shawms wailed, and the sound tore into us, twisting our guts, turning fear and anger into melancholy. When we had brooded enough, and considered the price we might pay in the next assault, the cymbals tinkled jauntily, mocking our fears. Drums rolled, and the cymbals clashed. The sound gathered, growing louder, its measure more regular. We could hear the Janissaries coming, their feet stamping in time to the drums, their armour and equipment jangling. Just then the clouds parted and we were able to see them, lined up like white-capped waves ready to break on the shore. They moved forward slowly, stepping surely and in unison, bearing their weapons high. They trod like dancers, like Umberto's favourites at the slowest and stateliest *branle*. The Janissaries march was a death-dance, a *danse-macabre*, a signal for all who manned the walls that their best chance of escape was a lively gallop.

The Turkish trumpets sounded, and if there was a moment for a miracle, that was it. My men crossed themselves and muttered half-forgotten prayers. Church bells rang in the city, and the men looked up at the clouded moon, full of hope and fear. But there was no rising up of the dead, no felling of the enemy with ghostly scythes, no appearance by saints or angels, no clothing of the living in invulnerable light. Instead, there was a great rush of arrows and a hammering of gunlocks. Balls

and arrows flew towards us through the darkness, hitting wood and steel, glancing off stonework, sinking into flesh. With much scraping of iron against stone, the Genovese staggered to their feet for the third time, and dragged themselves back to the parapet.

The trumpets sounded again, and the Janissaries broke their step and began to run. They shouted as they came, but they were calling to their God, not cursing us. And they did not dash wildly, but ran in ranks, like well-trained cavalry. My men were running low on powder and shot, and had few bolts left for their crossbows. The Janissaries were able to march over the Turkish dead by then, and were not held up by the moat.

When the Janissaries reached the stockade, my men loosed off what ammunition they had, then looked around the tower-top for anything they could re-use. They gathered up Turkish arrows to the sound of the Janissary band, which played louder and more urgently, filling the enemy with strength as surely as it filled us with fear. Below us, men with axes hacked at the stockade, splintering the timbers, while others brought up hooks and ladders, ready to scale what could not be destroyed. The Genovese raised their shields and swung their halberds, hacking at the Turks as hard as they hacked against the timbers. The clashing of steel joined the dull thud of axe against timber and the blaring and thundering of the Janissary band.

From the tower we could do little. We had run out of ammunition and fired off everything we had scavenged. The only course left was to join in the hand to hand fighting at the outer wall. I tried to urge the men to go down and help the Genovese. But they knew as well as I did that it was useless. We were only lightly armoured, and our one-handed swords would make no impression among the swinging axes and thrusting pikes at the front.

While we watched anxiously from above, the Genovese fought on. Though they must have been exhausted, they fought well, and, though the Janissaries kept on coming, they were flagging. As dawn lit the sky behind us, the battle seemed

to be slowing. But then, when the sky grew lighter we saw a commotion to our north. In the faint, grey light, men were milling around inside the wall, but whether they were arriving or departing, defending or attacking, it was impossible to tell. They swarmed like bees, circling and recircling, with no apparent purpose to their movement. Then a body of men detached itself from the crowd and streamed away from the wall, running into the wilderness of scrub and ruins behind it. As we watched, more men ran, abandoning their places. Then we saw Turks pouring through behind them. They halted at first, looking around as though amazed, perhaps unwilling to rush into a strange city where traps and treachery might still lie in wait. But as we watched, more men pressed through the gap behind them. The advance party stood aside while the newcomers marched through, stepping in time to the Janissary band. The whole Turkish army seemed to be flowing through the gap, in full order and high spirits.

The Genovese at the outer wall could not see the breakthrough and kept fighting, but the Turks in front of them wavered and began to stream away to the north. The Genovese looked up at us, and then along the wall, but it was not long before a wave of panic reached them from the north. When the Genovese broke, my Burgundians fled, rushing down the steps and out of the tower before the Turks could take it. We had tried to save the city, but knew we would die if we stayed at the wall any longer. I followed the men's example, grabbing my pack as I went. I ought to have left it, as it contained Plethon's book, which was to cause me much trouble later. But I was thinking about saving myself, not about books, and there were some gold coins in the pack that I hoped might buy me safety. I followed my men, across the trampled mud that lay behind the walls, into the emptiness of the wasteland. I could see them ahead of me, running into the scrub, plunging wildly through bushes and brambles. They were heading east, towards the inhabited part of the city, where all the Turks would be rushing for loot. The north of the city, too, was full of churches and rich houses. The only safe place was the sea, and the nearest harbours were to our

south. I shouted at my men to stop, but they carried on, disappearing into the scrub.

I had done my duty. I had tried to lead my men, but they had fled. I was entitled to try and save myself.

I knew where to head for. I set off for the south-east, running through scrubland dotted with ruins and hovels. Further on was an occasional church, or group of thatched huts clustered together like a village. And beyond them, on the watery edges of the city, were the places where people still lived. I tried to keep to the abandoned land, which would not tempt the Turks. I ran through deserted orchards and overgrown gardens, tripping and stumbling as I went, always looking behind me for fear of the Turks. And it was not just the Turks. The city's dogs seemed to know that there would soon be a surfeit of carrion, and anticipated their feast by blocking my path and snarling at me. They were a mixed pack of hounds and harriers, mastiffs and mongrels, all half-starved and wild, their coats matted and dull. I swung my sword at them, but they did not give way. How could brute beasts be so resolute when men fled in panic all around them? I swung again, but so clumsily that my sword flew out of my hands and clattered away into a ditch. With the dogs so close, there was no possibility of getting it back. They seemed to sense that I could no longer defend myself, and lunged at me with bared fangs. I ran from them blindly, dodging behind anything that would shelter me from their snapping jaws. I feared them more than I feared the Turks, knowing that they would not just kill me but feast on my bones. Dread of being eaten drove me on until my heart almost burst, and I fell exhausted to the ground.

I lay for a while, my chest heaving, my breath clouding the cold air. Damp soaked into my clothes. When my breathing eased, I looked around. I had escaped the dogs, but realised that I was lost. There were houses nearby. I was on high ground. Instead of making for the Marmora shore as I intended, I was heading for the heart of the city. I looked back. Smoke rose, thick and dark, spreading across the grey sky. There was a dull rumbling in the air, a blend of shouts, tramping feet, gunfire, drumbeats and axe-blows. The Turks

could not be far behind. I climbed to my feet and set off again. I had to keep moving, yet I was worn out. I trudged on, sometimes quickening my step for a few paces, then faltering and slowing. The villages grew bigger and clustered closer together. It was not long before I was surrounded by buildings. Some of the houses were shut and barricaded. Others were open and abandoned. I could see no sign of their owners, and I was tempted to creep into one of the houses and rest. But I knew that if I hid there I would be caught and killed.

I tried to go south, following the slope down to the shore. The sea could not be far off. There would be ships, and sailors, men I could bribe with the gold in my pack. But a mob ran at me from that direction, shouting that Turkish ships had landed and that the crews were pillaging the shore. Suddenly, having seen no one since leaving the tower, I was surrounded by wailing, sobbing people. They ran like a herd of beasts, numb with fear, wide-eyed, drenched with sweat, despite the morning's chill. They pushed and jostled, abandoning the old and infirm, trampling those who fell. Some of them carried bundles, or clutched at precious objects. I saw flashes of gold and the gleam of jewels. I heard the swish of silk and the clink of metal. There were women in fine clothes, such as I had never seen before, unveiled and uncovered. But there were poor people too, empty-handed and dressed in rags. And there were nuns and monks, swarming like a black tide. I struggled, but the flood of panicking people carried me away. They rushed on, beseeching God to protect them, bearing me along like a twig on a millstream. Just ahead of me, a priest raised his hands to the sky, calling on angels and spirits to drive out the Turks. It was surely too late for that, but the men and women who swirled around me echoed his calls. They spoke of visions, and of holy swords, and prophecies, of things that hovered above the city, protecting it. I did not look up, but kept my eyes to the ground, determined not to lose my footing and be trampled by the crowd.

They ran ahead into a great square, spreading and slowing as a river does when it reaches a lake. I hesitated, not wanting to go with them, not knowing where else to go. A priest

appeared, and drew me aside. He was some sort of bishop, I think, from the clothes he wore. He clutched my arm and babbled at me, begging me to change clothes with him so that he could escape. He promised me money, jewels, eternal salvation, a special place in Heaven. He showed me a purse, which he swore was full of gold. But I wasn't falling for that. I threw him off me, and left him kneeling and weeping.

I saw a gap in a wall and dashed through it, finding myself in a thicket of overgrown shrubs and bushes. Perhaps, I thought, as I collapsed exhausted in its shelter, it had once been the garden of some rich nobleman. I lay for a while beneath a flowering bush, getting my breath back, listening to screams and shrieks from the square. When I felt able, I raised myself up and peered through the branches.

The Greeks had run into a trap. Some Turkish irregulars, savage tribesmen from the East, had reached the square before them. Black-bearded men wearing pointed helmets swung curved swords and hooked halberds at anyone who came within reach. The terrified Greeks ran like sheep, fleeing one killer only to run on to the blade of another. Some tried to seek sanctuary in a church, calling on God to save them. The Turks dragged them out, killing some as they clung on to the door-posts, driving the rest into the open. Men died just because they were men, whether silver-bearded or smooth-chinned. Women were cut down brutally, despite their pleas and prayers. Children were hauled off their mothers' corpses and impaled on lances. They caught the bishop and beheaded him, spitting his head on a pole. Greek blood soaked into Greek soil, washing pavements Roman feet had trodden for centuries, splashing walls a thousand years old, defiling places so holy that only priests had dared enter them before that day. The Turks did not stop when their quarry fell, but hacked at corpses in a frenzy, cleaving heads, severing limbs and disembowelling. They seemed determined to wipe out the Greek race and supplant it with their own, to kill all the Christians they could and make themselves the masters of Constantinople.

When they had finished their work, the Turks looked at the

fallen, and at the few who had survived, and thought of loot. They bent over their victims, rummaged through blood-stained clothes, all the time quarrelling loudly over what they found. They tore the bishop's robes from his headless body, quickly finding his purse. While they disputed its contents, a troop of Janissaries arrived. They must have just ransacked a church. Some of them wore rich vestments over their uniforms, or carried gold and silver vessels as though they were earthenware jugs. Others swigged from vessels of holy wine. Did they know it was Christ's blood they drank?

One of the Janissaries pulled off his white hat and stuck it on top of a jewelled cross. Hoisting the sacred symbol on his shoulder as though it was no more than a piece of timber, he paraded round the square, stepping carefully round Greek corpses and pools of blood. A few of his fellows capered after him, mocking the obeisances of the priests they had just robbed. While the leader held the cross high, they bowed and scraped, forming their faces into pious grimaces and calling out Turkish obscenities. After half a circuit they threw the cross to the ground and smashed it to get out the precious stones. The irregulars, their clothes spattered with fresh blood, saw what the Janissaries were doing, and pushed forward to get their share. There was a scrabble for the jewels, and the two groups began to brawl and shout. Then they drew their swords and prepared for a real fight.

I crept forward, determined that, when the moment was right, I would dash out of the thicket and get away. Without taking my eye off what was happening in the square, I felt my way over roots and rubble. But before I could get very far, another body of Turks appeared. They were herding together a great crowd of Greeks. The Janissaries and irregulars rushed forward to claim their share, grabbing at anyone who was young, beautiful or richly dressed. They fought over the prettiest girls, and boys, almost tearing them in half, roping them together with whatever came to hand, ready to lead them away. The irregulars were the worst. They killed the old and ugly, cutting them down with swords or axes while drunken Janissaries looked on, laughing.

There were some nuns among the captives, who fell before the Janissaries, beating their breasts and begging for mercy, a look of wild excitement on their faces. They writhed and twisted and shrieked, desperate to escape. But the way their captors manhandled them made their fate quite plain. Some of the other Turks did not wait, but threw their chosen victims to the ground, letting them fall among mangled corpses and gore. Enraged by bloodlust, they fell furiously on their captives, tearing off clothes, violating virgins, raping matrons, forcing themselves on young boys, rolling and slithering in a slime of mud and blood. They did not care whether the flesh they coupled with was young or old, male or female, dead or alive.

I looked away. What was happening in that square was what everyone had feared, and what a thousand priests and monks had prayed would not happen. The sultan had prevailed, and the Roman Empire had fallen. From that day on, Constantinople would be Turkish, and no crusade would wrest it back. All around me, the vanquished were paying the price. I had seen such scenes before, and taken part in them. Umberto's men had killed ruthlessly. They did it to impose Umberto's will, for gain, to terrify their enemies, and to make women submit. I had done it with them, and killed on my own account, striking down my own brother in anger. But had I killed for the sake of killing? I hoped not. As I crouched in that abandoned garden, I hoped that I was better than those Turks. I hoped, also, that I might escape from them.

I could not hide in the undergrowth for ever. If any of the Turks wandered away from the square, or collapsed drunkenly in the bushes, I would be found. And I could not go back the way I had come. I had to find a way forward that would get me to the sea, and freedom. That moment, with the Turks distracted by loot and captives, seemed the time to escape. If I was fast enough I might make it. I edged forward again, and was almost at the edge of the bushes when I heard a terrible scream. Ahead of me, through the gap I was aiming for, came a half-naked body. It was a nun, her habit ripped off and

hanging about her waist. She fell forward, only a few paces in front of me. And as she fell, a torrent of words, holy and unholy, gushed out of her mouth. Who would have guessed a nun would know such things? I ducked down, just in time to conceal myself from her pursuer. He was a huge man, a Vlach by the look of him, clad in shaggy sheepskins and lightly armed. He had done well to survive the attack, when men like him had been thrown at the walls with no thought of whether they lived or died. His good luck must have made him forget he was a Christian, and he flung himself onto the nun, yelling something in his savage language. He grabbed the nun's shoulders, tearing her flesh carelessly. When he had turned her over he began ripping away her girdle to free the shreds of her habit. She kicked him, and cursed him in Greek, spitting and scratching like a cornered cat. He shut her up with a blow from the back of his hand, then got on with job of stripping her. Before he took his pleasure he wanted to be sure she was hiding nothing valuable. She was young, and her body was well formed, as I could see clearly. I was only a few feet away, crouching down in the bushes. I watched him fumbling at her, marvelling at the whiteness of her skin, and the filthiness of his, which he revealed when he hitched up his short tunic. It was hard to distinguish his hairy buttocks from the noisome pelt that had covered them. I was so close I could smell him.

When he forced himself into her, a memory forced itself into my mind. Instead of the nun, I saw Catherine, raped in Umberto's castle, while I was forced to look on. That sight, and the fool's taunts, had killed my love for the girl. I felt a surge of hatred for the Vlach. Despite my fear, and the danger I was in, I wanted to rush forward and get my belated revenge. I wanted to kill him for raping the nun, to save her as I had failed to save Catherine. I was a Christian, and had pledged to defend the city and its inhabitants. But I was a soldier, and knew that I was not free of sin. I, too, had taken a woman against her will. All soldiers do, when they get the chance. How could I judge the Vlach when I was no better than he was? Yet I had my duty, and still had hopes of salvation. How

could I hope to save the nun when all around us the sultan's army were stealing and destroying and defiling everything they could grab?

I might easily have stepped forward and taken the Vlach by the neck. But what then? I had lost my sword, and when I put a hand to my belt I found that my knife was missing as well. The Vlach's short sword still hung from his belt, but he was twice my size and might have overpowered me before I had drawn it. I watched his thrusting buttocks, waiting for my moment. But how would I use it? Would I grab the Vlach's sword and kill him at the moment of rapture? Or would I vault over the writhing couple and dash for freedom?

The Vlach's slow performance gave me a long time to think. I was still debating the question when I heard a commotion in the square. I looked up and saw that a new troupe had arrived. Among them was a splendidly dressed trumpeter. As he raised his instrument to his lips and gave a warning blast the clouds parted. Bright sunlight caught his golden silk robes and plumed hat. I took a step forward. The Vlach was still heaving and grunting. I would have to step over him to escape. And it was then, just as I was poised to run, with the sound of the trumpet ringing in my ears, that the ground opened beneath me. Instead of the roots and rubble that had impeded my progress, I felt nothing. My feet hung in emptiness, then I dropped.

It was, I thought, the Last Judgement. I had heard the trumpet, and, in the twinkling of an eye, all was to be changed. God had punished the Greeks and brought to an end their rule of New Rome. But He did not, after all, intend the Turks to triumph. Instead, He would weigh all Creation in the balance. What was earthly would be returned to the earth, and what was heavenly would be raised up to Heaven. I had sinned, so I would fall.

But the earth did not swallow me up completely. Instead, with a sudden jolt, I stopped halfway, my legs and buttocks under the ground, my chest and arms above it. I had hit my shins as I fell, and the pain blinded me for a moment. I could no longer see the Vlach and his victim, or the Turks beyond. I was aware only of myself and my predicament. My eyes

running with salt tears, I pressed down at the ground, trying to lift myself out. But I was stuck. The bulk of my mailcoat and the padded jacket I wore under it had stopped my fall. I ought to have thrown them away while I was hiding in that thicket. They marked me out as a soldier, as well as encumbering me. But I still wore those military garments, and they held me fast. I struggled to free myself, not sure whether I wanted to go up or down. What was worse: Hell, or the Turks?

I raised my stiff arms, holding my pack above my head, then kicked my legs. Nothing happened, so I kicked them harder, striking solid rock. As I struggled, I was overcome by a sudden terror. I thrashed about, kicking and twisting, ripping my clothes and tearing my skin. But I could not shift, and hung there, powerless.

Had I travelled all that way, fought all those years, just to die in a hole?

Then my ankles were gripped from below. I was so startled that I almost leapt out of the ground, but the unseen hands held on to me and, whether I wanted to go or not, I was steadily heaved downwards. My arms were pinned upwards in the hole, and it was all I could do to hold on to my pack. More hands grabbed my legs and heaved again. I could hear voices beneath me, but they hardly sounded human, and I could not make out what they were saying. The hands found new places to grip, then heaved yet again. My arms were almost pulled out of their sockets and I could hardly breathe. I struggled and resisted, but the hands were strong, and they hauled until my shoulders were dragged through the gap. I dropped, then the hands caught me and held me up like a victor. I hung there, looking up at the small square of sky above me, swaying as though buffeted by waves. The din continued, rising in an incomprehensible babble as I lurched from side to side. My arm hit something solid and I reached out to grab it. It felt like a railing. If only I could hold it I might pull free of my captors. The hands tried to stop me, but I had got my breath back and managed a twisting lunge towards the unseen rail. The hands lost their grip. I swung for a moment, hit the rail, felt timber smash and splinter, then fell.

I tumbled down into dark emptiness. I let go of my pack and held my hands in front of my face, bracing myself against a shock. As I fell, I imagined what lay beneath me: dank cobbles, swarming vermin, jagged rocks, rivers of filth, smoking brimstone. There would be chasm beneath chasm, all filled with lakes of fire, fountains of bitterness, spiked beds, toad-wives, and throngs of worms and maggots. Then there was a great splash, and icy water filled my mouth and nose. I plunged under the surface of an unseen body of water. The weight of my mailcoat pulled me down. My padded jacket filled with water, dragging me deeper. I dropped into darkness, not knowing which way was up or down, gulping water as I sank.

It was not how I had imagined my end. I had expected to be shot by a Turkish arrow, gutted by a Janissary's sword, or crushed by the ball of a great bombard. Instead, I was to drown, and in darkness.

But I was not alone.

As I struggled in the water, I could feel limbs and bodies touching mine. Did they belong to the dead who had preceded me? Or to those who, answering the trumpet call, were in the process of rising up? What sort of a place had I fallen into? Was it a nether world, a lower level of reality, as described by Plethon? Or was it Hell, after all? Was I already dead? Was I a damned soul wallowing in a watery region of the underworld?

Hands grabbed me again. Damp, cold, toad-like hands. Hands that could only belong to devils sent to torment and terrify me. I tried to free myself from their grip. If I was not already dead, I would die without their aid. I thought of my sins, which were many, and prepared to face my Judgement. But the devils were stronger than me. Their clammy fingers gripped my arms and legs, and pulled at my face and hair. They dragged me backwards, heaving my head and chest out of the water. Then they shoved me forwards until I was bent double and my face was almost back in the water. Were they going to drown me again? Was that my punishment? Was I in a watery Purgatory where I would be endlessly drowned and

revived? That would be fitting. I had killed my brother. What could be more appropriate than struggling forever at the edge of death, feeling its agonies again and again, dying yet not dying, thinking always of death?

I had only a moment to ponder my sins. The hands that had heaved me up began to pummel my back, striking me repeatedly until I had coughed up all the water I had swallowed. As my ears cleared I began to hear uncanny, echoing voices. When I had stopped retching, the hands helped me to stand upright, and I realised for the first time that the water only came up to my waist.

A little light came down from the hole above, and I could see grim faces peering at me. I blinked, and rubbed my eyes, and stared at my tormentors. Their faces were thin, pallid, and fringed with lank beards. They did not look monstrous. I looked in vain for the sharp tusks, hairy bats' ears, or tongues of flame that church-wall devils always have. I could not tell whether they had goats' hooves. Perhaps their feet were webbed, like a frog's. They were dull, dark, watery creatures, I thought. I had fallen among feeble old devils, demons of the lower ranks, sent to punish lesser sinners. I felt sudden hope that I might escape without too much suffering. Fighting the infidel must have done me some good, and offset the seriousness of my sins.

A face peered at me, looming out of the half-light. Its skin was white and puffy, like a maggot. The eyes were deep and dark, like holes in snow. A slit mouth opened and thin lips fluttered. A voice sounded softly in my ear. Other voices joined it, booming and echoing. But I could understand nothing. Perhaps they spoke a devilish Babel-tongue. Would I have to learn it, to understand my punishment? One of the creatures moved his face near mine and mouthed more words, speaking very slowly. Gradually I began to understand. He was speaking Greek. Of course, they would speak all tongues, to tempt all men.

The creature was asking if I was hurt.

I had been cut, bruised, battered and almost drowned. I was soaked and freezing. I could feel nothing. I did not know

whether I was hurt or not, or whether my answer made sense, but the fact that I answered reassured them. Two of the creatures led me gently to a bank of rubble that rose from the water like an island and set me down on it. My numb hands clawed at the loose stones until I had dragged myself out of the water. Though the stones were as sharp as a spiked bed, I lay on them gratefully, sinking into sleep almost as quickly as I had fallen into the water.

The voices did not stop. While I slept they wove into my dreams, sometimes waking me, sometimes fuelling my confusion.

"He is one of those who came to the save the city," one of them said.

"To save himself," another answered. "He is sinner like all the others, we can be sure of that."

"There may have been some good men among them."

"No. They were all heretics and schismatics."

"So he is damned."

"Can we be sure?"

The two voices began to bicker about theology, finding fault in everything they could think of. They knew their subject well, and easily have tempted the most steadfast believer into doubt and confusion. I drifted off into unconsciousness, only to be woken again by a voice that sobbed and snuffled by my ear. "Men are like ants," it said. That was Plethon's maxim. Was he there? Was the voice his spirit, or of the spirit of his book? He had hoped to go up, not down. Perhaps the many worlds merged in the underworld. "Most men are beneath morality," the voice continued. "They are driven by their appetites like beasts."

New voices drifted down from above, faint and quavering. "The Eye of the World has been put out."

"The sinful have been expelled from Paradise."

"Driven into slavery."

"God has abandoned the Greeks."

"And so has Constantine." The voice dropped to a whisper, which susurrated round the watery chamber. "He ran away! He threw off his armour and insignia and got himself

onto a boat. He will be in the Morea by now, and we are stuck here like rats in a sewer."

"Nonsense!" another voice said. "Constantine was killed defending the walls. I saw his headless body."

The speaker had seen it. Did these creatures emerge from beneath the ground wander the battlefield like ghouls?

"Headless?" a new voice said. "Then how did you know it was him?"

"By his clothes and armour. And by other signs. The Turks cut off his head and carried it round the city on a pole. But his body was unmistakable."

Why would devils care about the death of an emperor? What were worldly things to them? Unless they were spirits of that place. Perhaps it was their city too, and they lived beneath it in their own special Hell. I opened my eyes, peering through the darkness. They surrounded me, clothed in black, and black in mood, lamenting the fall of the city. One of them sat near me shivering, whimpering, so bound up in his own misery that he hardly seemed to notice I was there. A devil's misery was salutary. I tried not to feel so sorry for myself. But pain throbbed through my limbs, and wherever my skin was not frozen, it burned. I began to explore my wounds, touching myself in the darkness, unable to tell how badly I had been injured.

"God did not abandon our emperor," a voice called from high above me. "He bore Constantine up to Heaven on a milk-white steed."

"You're both wrong," a deep voice said, echoing in the darkness. "The emperor was not borne up, and did not die. He walked towards the walls of Hagia Sophia, which opened up to swallow him. He is in the cathedral now, and will slumber there until it is time for the empire to rise up again."

"Whatever happened to Constantine," the first voice said, "we all saw what happened to the city."

"It's God's will," said another. "He made the Turks strong because the Christians were weak. He withheld Constantinople from them as a test. But we were divided, and vacillated, and disagreed on everything. Now we are all

suffering, the righteous as well as the heretics and schismatics. God has granted the Turks our city to do with as they will!"

"It may not be so bad."

"How can defeat and conquest not be bad?"

"Better the sultan than the pope."

Devils, I realised, did not speak like that.

"Did you see what the Turks did?" another voice whispered. "They raped nuns and looted churches. They desecrated altars with their filthiness. They smashed the holiest of icons. They prised the jewels from crosses and chalices, and burned our ancient books." The speaker paused to weep and snuffle for a while. "And what did God do?" I could give him no answer. "Nothing!" he said. "God did nothing. He has forsaken us, for we have sinned."

When my eyes adjusted to the gloom I saw that I was in a great cistern. It was as big as a cathedral, perhaps bigger, as it stretched farther away than I could see. Pillars rose from the water, their rows receding dimly into the darkness, supporting a vaulted roof that rippled with faint reflections. There were many such places in Constantinople, I was told, built centuries ago and forgotten when the city's population declined. The hole I had been pulled through was far above me. And I had fallen among monks. They were all around me, standing in the water, squatting on half-submerged blocks, crowded onto a wooden platform above my head, sitting beside me on the rubble bank, leaning against me while they slept.

Though the cistern was not Hell, the three days I spent in it were a sort of Purgatory. I hung between life and death, between one fate and another, contemplating my past and our future. I had to listen to what the monks said, and some of it made sense. If there was a miracle, as some said, it did not save their city. And if God allows a whole city to be destroyed because its inhabitants are heretics, what punishment does He have in store for an unredeemed sinner like me? He had allowed me to survive, but my soul was still in peril. Could it be true, as Plethon claimed, that there is no difference between the world's faiths, and that God does not care what

we call Him, or how we worship Him, as long as we understand truly what He has revealed to us. In that case, the Turks had been rewarded for understanding His word better than the Greeks had. But I could not believe that, and regretted that Plethon was dead, and that I could not ask him to explain the calamity that had befallen his nation. He would have had an answer.

10 Slavery

"What is this book," Halil said, peering at the open pages of the *Book of Laws*. I tried not to look angry. As a slave, I had no rights, and Halil was perfectly entitled to search my bedroll if he wanted to. He stood in my cell, dressed as always, in white, a bulky turban wrapped round his head.

"Is it a Bible?" he asked, smiling. "It has no blasphemous images in it."

"No."

"Then you have broken the rules. You are entitled to a Bible but no other books. Unless," his smile widened, "unless you wish to study the True Faith. Then you can have as many books as you need."

Halil was a doctor of the Moslem religion, attached to the house I worked for, and had set himself the task of teaching me his faith. I listened with interest to everything he told me, watching as he stroked his beard and smiled with the assurance of one who knows he is right, now and always.

I had considered turning Turk. There were many advantages to it, as converts were valued at the Ottoman court, which the sultan had transferred to Constantinople. There was employment for all ranks of men, from soldiers to scholars, and many of the Greeks, even their nobles, had prospered after going over to the enemy. Mehmet himself was said to value the wisdom of the people he had conquered, and learned men competed for his attention, translating books and dedicating them to the new emperor. He needed men of all sorts, and I thought hard about converting to his faith. It is true that Moslems are not permitted wine, but they are allowed much else, and may take on several wives. Plethon had had primed me for conversion by pointing out that all the great faiths are the same, at heart. But there is a price to be paid, and a painful one, for becoming a Moslem. In the name of cleanliness, which the Turks think much of, the skin of the *membrum virile* must be

snipped off, to the accompaniment of prayers and incantations.

"What sort of book is it?" Halil asked, looking again at the pages.

I had weighed his words like a merchant, hoping to assess their true worth, noting his promises of Paradise in the life to come, and a healing poultice of green herbs in this one. When I had the chance, I studied the *Book of Laws*, hoping for guidance. Umberto's chaplain had once told me that it was no use just reading books. "You won't learn anything by browsing," he said. "Books have to be learned. That's what I had to do at the university in Paris. We learned everything by rote."

"Did that help you understand the books?" I asked him.

"Understand? It helped me know them."

So I set myself to learn Plethon's book as well as I could. I would know the book even if I could not understand it. And it was not an onerous task, given my circumstances. As I read, I remembered his shady terrace, and the times we had sat there and talked. The *Book of Laws* contained ideas that Plethon had only hinted at when he told me about his beliefs. It outlined the shape of the universe, elaborating on his image of the onion, naming the spheres and their guardians. And it explained the soul and its ascent. But I was just as puzzled as ever. Even after reading the book several times I was left with the same question. Should I turn Turk, as so many Greeks had done? Or should I keep the faith I had been born into? Plethon thought Islam as good as any other religion, though no better. Aeneas had called Islam a filthy faith spread by a false prophet. Who was right: Aeneas or Plethon?

Whichever of them it was, I suspected that my sinful soul would not escape punishment if I fled the Church like a disobedient servant searching for a new master. We must settle our debts before we move on. And a man who has betrayed one master will soon enough betray a new one.

Halil still held the book, and if I told him too much about it, I was in danger of betraying myself.

"It is an ancient book of my people," I said.

"A Christian book?"

"A book of wisdom."

"Is it Christian wisdom? You can tell me the truth. We Moslems respect the beliefs of the Christians."

"There is Christianity in it. With a little of all the other faiths. And some wisdom of the ancient philosophers."

"I do not know the language. Is it Latin?"

"Tuscan."

"Will you read me some of it? This passage here, at the beginning."

I had to think for a while before I began, as turning Plethon's Tuscan into Turkish was not easy. But I was glad Plethon had not given me the Greek version of the *Book of Laws*, which Halil might well have understood for himself. When I began to read, or rather talk, for I was making much of it up, Halil listened, smiling.

"This is true enough," he said. "God is indeed the supreme ruler of the universe, the best and greatest being that could ever be, or be imagined. This is true in all faiths. Is there more?"

"Beneath God," I said, " are other entities."

"What are these entities?" he said, suspiciously. I scanned the page, and saw that what came next was pagan and dangerous.

"It is difficult to say." I could not tell Halil about the hierarchies of Olympians and Tartareans without revealing the true nature of the book.

"But why?" he held out his hands, as though to take the book back again. "You have read the book. What are these entities?"

How could I describe them? Gods would not do, and the Tartareans sounded devilish. "Angels?" I said, hopefully.

"Angels!" Halil smiled.

"Exactly! Angels." I paused for a moment to gather my thoughts, looking at the book for inspiration. "These angels are intermediaries. They rule over the various domains of the world."

"Such as?" Halil sounded doubtful.

"The sea, the air, the sun, the earth . . ."

"Domains? Perhaps you mean realms?"

"Of course. Forgive me. It is hard for me to find the right words sometimes."

"But there are only three realms," Halil said, slipping a finger beneath the folds of his turban and scratching his head. "There is this earthly realm, in which we dwell. Then there is the heavenly realm above. And beneath us is the chaotic realm of the underworld."

"Is Heaven one realm?" I asked, remembering what the *Book of Laws* said. "Is it not divided into seven spheres, each ruled by a planet?" The book named the deities that that governed the spheres, describing their natures and significance. But it went on, subdividing the spheres, hinting at infinite worlds.

"Perhaps," Halil said. "Aristotle divided the heavens into fifty-five spheres. But why complicate things? Everything above is best regarded as One." A calm smile spread across his face, letting me know that he confidently expected to know what lay above us, one day. "Now," he said. "Tell me more about these "entities". Can the angels be said to rule? Some would say that angels are messengers, or envoys. It was the Angel Gabriel, after all, who brought the Word of God to the Prophet Mohammed. Even in your faith, angels have performed that function. Did not Gabriel announce to Mary that she was to give birth to a son?" He paused, smiling, his mouth forming a pink slit fringed by beard and moustache. "We need not enquire too closely into the true nature of that son. You would no doubt call him one thing, and I another. But our faiths have much in common."

"Perhaps I have translated badly," I said, not wishing to be drawn into comparisons. It was important not to offend Halil, but it might be safer, for the moment, to stress the differences between us. "Intermediaries are much the same as messengers, are they not? And if we obey the messages they bring, we are ruled by them."

Halil frowned. "To accept a message is not to be ruled by the messenger."

I wondered whether Halil was referring to our own positions.

"Perhaps," I said. "But I did tell you this book was full of ancient wisdom. It may be that we know these things are false now."

"And what is your opinion?"

"I think that angels may be said to rule, but only in a sense that I cannot express in your language."

"I see."

I thought Halil might take the book with him when he left. If he could not read it, there were bound to be men who could, among the many captives. But he handed it back to me, perhaps glad to be rid of it. "Remember," he said. "You have broken the rules. I can overlook it this time, especially if you are receptive and helpful. But if there is any change in your attitude, you may find that your master becomes dissatisfied. You can always be sent back to hard labour. There is still much to be done in the city."

Halil left me in peace, but not for long. A few days later he returned, and demanded to be shown the book again. I gave it to him reluctantly, again fearing that he would take it away.

"Let me see," he said, opening the book at random and peering closely at the first page he came to. "Sometimes books have hidden meanings. Other words concealed in the first letter of each line." He turned the book upside-down, then held it sideways, tracing rows of letters with a thin finger. "Jewish books are full of such things," he said. "Devotees of the Kabbala hide all their knowledge in codes and ciphers. To them, every letter has a mystical meaning."

"It is not a Jewish book."

"No? I could have it looked at."

"There is no need."

"Then convince me that it is not offensive to the true faith. Tell me again what the book says about angels."

"They are messengers," I said.

"We have already agreed on that. What else?"

"They guide and guard us."

"Yes?"

"They rule the seven spheres of the planets."

"Do they?" He said. "You seem to have changed your mind since we last spoke. Let us get this clear . . ."

We talked on, Halil trying to trap me, while I attempted to make Plethon's ideas sound as Christian and inoffensive as possible. That was something Plethon himself must have had long practice at, and by changing the names of the entities he described, I was able to keep Halil at bay. Sometimes he objected to what I said, but I was able to escape by blaming my poor command of his language.

"I daresay you think you have a guardian angel," Halil said at the end of that conversation. "And perhaps you are watched over. But beware! What you take for an angel may be a jinni. And jinn, as I am sure you know, are not at all the same thing."

Perhaps Halil was right, and some spirit was watching over me during my time in Constantinople. I felt that the *Book of Laws* had brought me luck, of a sort. It may be that Plethon's wisdom, condensed in that book, took the form of a jinn-like spirit, neither angel not devil, capable of aiding man, but also of leading him astray. Though I feared the book when Plethon gave it to me, it seemed to preserve me, and by doing so, itself. Perhaps it guided me to the cistern where I was able to take shelter while the Turks sacked Constantinople. Some of the monks in the cistern had caught my pack when I fell, and kept it safe for me, not knowing what it contained.

When I climbed out into the open air, I found that the sultan had restored peace. The looting and raping was over, and so, for the most part, was the killing. Ordinary Greeks who had avoided capture were allowed to go back to their homes, though anyone suspected of being rich was likely to be held for ransom. But for foreigners there were still risks, and many of the Genovese and Venetians had been rounded up and killed as traitors.

The men who caught me were glad to find the gold coins I had in my pack, but they ignored Plethon's book, which did not look valuable. I pretended to be Greek, and a scholar, but the monks gave me away, saying that I was Italian, and a soldier. The Turks tried to ransom me, sending for money to the

Genovese merchants of Pera, who refused to pay. Being of no other use, I was given hard labour.

I was shackled to a gang of miscellaneous prisoners and set to clear up the damage done by the Turkish assault. At first we worked beyond the walls, digging graves ready for the wagon-loads of corpses that trundled out to us hourly. Starved and unwashed, we stank worse than the corpses, and it was a wonder we did not all die of loathsome diseases. Sometimes we teetered on the edge of the pits we dug, half-dead with exhaustion, and almost ready to slip down among the corpses. At night, when we slept in a heap on a hard floor, still chained together, I often dreamt I was dead, taking my fellow prisoners for carcasses. Waking to the truth was hardly better.

When the dead had all been cleared, we were sent back into the city. While more skilled men demolished unsafe buildings, we carried away the stones and stacked them for future use. I had little time to look up from the ground, or think about anything but the burdens I bore, but occasionally I reflected that I was, at last, in the city my father had described to me thirty years earlier. But where were the wonders? Where were the palaces and libraries and talking statues? If they had ever existed, they had been looted and destroyed by the Turks. All I saw was ruins.

Sometimes the new rulers of Constantinople came to watch us work. Noble Turks, followed by teams of architects, surveyors, engineers and builders, decreed what should be demolished and what should be rebuilt. Where Greek churches and monasteries had been, mosques and markets would rise up. Once, the Sultan came to survey the site of his new palace. We had strict orders not to look up, but of course, we did. His party was some distance away, and upwind of us, but I managed to see him. I was amazed by his youth. He was not much more than twenty-one, and his face was soft, despite his blade-like nose and dark beard. He looked too small for the rich robes and huge turban he wore. Yet he seemed com-posed and dignified, absolutely in command of himself, des-pite the rumours of his fierce temper, drunkenness and unnatural lusts. To gratify him, we were whipped harder.

When we were worn out by our labours we were sold. The sultan had new captives by then, fresh from his campaigns in Rumelia and Anatolia, and skilled men were needed to build on the ground we had cleared. Like most of the other slaves, I was sold into domestic service. I do not know what price I got, but it cannot have been much. Constantinople was flooded with slaves, both fresh and exhausted, and the humblest of the city's new citizens were able to surround themselves with attendants as though they were sultans themselves.

My owner was a Turkish merchant from Adrianople, who, commanded by the sultan, had transferred his business to the new capital of the Ottoman Empire. His house was built of timber, and rose high above the sloping ground of the northern shore, its upper rooms overhanging the street. It was in a busy district, not far from the sultan's new palace, and there always was a bustle of activity in the narrow alleys that led down the slope to the Golden Horn. The merchant's house was one of many of the same kind, all built tall and crowded together, vying for the best view. It was possible to glimpse water from some of the streets, and to feel the breezes that blew from the Bosphorus. But I was not allowed outside. I worked in the kitchens at first, sweeping and scouring, doing the work that was too dirty for the cooks to do. While I laboured, I could hear the clamour of the people in the streets, and the hammering of the builders, whose task seemed never-ending. It was torment to be drudging indoors while all around me a great new city rose from the ruins left by the Greeks. But there was no escape from slavery for one without friends or compatriots. When my owner found out that I could read and write, and speak several languages, he gave me lighter duties. I was taken away from the kitchens, cleaned up, given new clothes, and set to work in the merchant's offices, which could be reached by crossing a small yard at the back of the house. But I was still a slave, and had to obey the orders of the humblest clerk, returning to my cell each night. Crossing the yard to the merchant's offices was the nearest I got to freedom.

★

I might have been resigned to my fate, and even have converted to Islam, had it not been for Zelmi, my master's wife. After a couple of years I was trusted enough to carry out my duties without supervision. The merchant often went down to the waterside, taking the other clerks with him to inspect cargoes and record bargains. On that particular day, I had been working for some time, copying items from one list to another, struggling with an untidy script written by a Greek merchant's clerk, when I noticed that Zelmi, was watching me. That was unusual, as she normally kept away from the counting house, preferring the women's quarters, high up in the wooden house, and the company of her servants. I had seldom seen her before, even from a distance, and I was surprised to find her in the same room as me, and without her husband. She meant to surprise me, as she came into the room silently, without rustling the skirts of her gown.

It was her perfume that alerted me to her presence. I looked up and saw her standing before me. She wore indoor dress, and was unveiled, her hair falling over her right shoulder in a single thick plait. Her gown, tightly buttoned and cut low, pushed up her breasts, which were quite visible through the silk gauze of her smock. I could not help wondering whether she knew the Secrets of Love, and, if she did, how often she enjoyed them. The life of women in that city was a mystery to me.

I looked down again quickly, running my finger down a list of goods, as though checking it.

"You may look up," she said.

"Yes, mistress," I said, glancing up briefly. I sat, as I always did when writing, cross-legged on the floor, working at a low desk. I was not sure whether to stand or remain seated in her presence. Perhaps I should have risen, then bowed. I was not used to dealing with Turkish women.

"You may stay seated," she said. "And look at me again. Properly."

"Yes, mistress."

I looked up, and she stepped over to my desk, mincing in the little hook-toed slippers she wore. Not having permission

to stop work, I carried on, and added a couple of entries to my list.

"Do you speak any other words of Turkish?" she said. "Apart from 'yes mistress.'"

"Yes, mistress. I believe I speak your language quite well, or so I have been told."

She looked down at the papers on my desk. "And you write Greek. Is that your native language?"

"No, mistress. I am Italian." In that household I kept up the fiction that had led me into slavery. My true identity was of no interest to the Turks, who tended to lump all westerners together.

"Three languages!" Zelmi said. "What a clever fellow you are. No wonder my husband bought you. I expect you make yourself very useful to him?"

There was mockery in her voice. "I try to," I said.

"You have something he needs?"

"I have my skill in languages, mistress, as you have observed."

"Nothing else? Nothing that brings my husband pleasure?"

I could not think what she was hinting at. "Nothing that I know of, mistress. My master is happy with my work, I hope, but no more than that."

She thought for a while, her brow furrowing in a way that might have been attractive, had our positions been different "You are a Christian, I suppose?"

"Yes, mistress."

"So Halil has not converted you yet?"

"He is diligent and persuasive, mistress. But I am too slow to follow his elevated thoughts."

"Nonsense! Didn't I just say you were a clever fellow? Well, I am sure you are clever enough to follow everything Halil says. And clever enough to do everything I say."

"Of course, mistress."

"Good. I thought you would be." She took a small step closer. "There is something I would like you to show me."

I looked at the document chest beside me. Did she want to inspect the accounts? I was not sure my master permitted that.

"Whatever you wish, mistress," I said, wondering what the merchant would do if he found out that I had been alone with his wife.

"You may stand up now."

I struggled to my feet with as much dignity as I could manage.

"How old are you," she asked, looking me up and down.

"About forty years old. I have not kept count of the years recently."

"That is as it should be. A slave's years are his masters, not his own." She looked at me again. "You are younger than my husband. Much younger."

That was true. The merchant was an old man, and, as is the custom, had bought himself a young wife, even though he was more interested in boys. He followed his sultan in that fashion, and in keeping a wife for show, which the Turks do, just as a Christian might keep hawks or hounds.

"Now," she said. "I cannot wait all day. Show me what marks you out from a Moslem."

I did not entirely understand her. Perhaps my Turkish was not as good as I thought. Whatever she had in mind, I had nothing to show her. Unless, I thought, she was referring to Plethon's book. Perhaps Halil had mentioned it to her, and told her that owning it marked me out as an unbeliever. But if he had not told her, and even if he had, producing it would be unwise. I did not have it to hand, in any case.

"Where is your husband?" I asked.

"He is at the *hamam*, being steamed and pummelled. Or at least, that is what he tells me. I daresay they indulge in other pleasures, too."

"What is it exactly, mistress, that you wish to see?"

She waved a limp hand at my lower half. "Show me . . . that part."

"Which part, mistress?"

"You know very well the part I mean. The part that you have, that I do not. The part that makes you a man. Show it to me!"

I could not believe what she was asking of me, and still

thought that perhaps I had misunderstood her. "It would be shameful," I said.

"What do slaves know of shame? I want to see that part of you, shameful or not. Yours is different from that of the faithful, I believe. You still have attached what men of my faith have had snipped off."

"I am, as you say, not circumcised."

"Show me!"

"Surely, mistress, that would offend you. I am unclean, by your reckoning."

"Yes, I am sure you are unclean. That is the nature of Christians. I expect you are covered with hair like a beast, as well?"

"I have as much hair as a man should have. No more."

"Let me see it. Remember, you are my slave."

"I am your husband's slave."

"It is the same thing. Now, are you going to do as I say, or shall I call my husband and tell him you have attacked me?"

"Yes, mistress, I will do as you say."

"Stand on the table!"

I hesitated. She lifted her slippered foot and gently kicked the documents off the table. "Stand!" she said.

I had no choice. Reluctantly, I did as she said, carefully avoiding the inkwell, which stood at the edge of the table. Then I unfastened my trousers and let them fall to my feet. I felt as though I were back in the slave market, with all the other captives.

"Lift your shirt," she said. I lifted it, and displayed my *membrum virile*. Unlike previous occasions when I had bared it before a woman, it was far from firm. Instead, it hung soft and small, almost concealed by hair.

She leant forward and peered at it, as though inspecting produce at a market. I thought she might poke it, as though to assess quality or freshness. Any vegetable as limp would have been rejected as inedible.

"Is that it?" she said. "Is that what Turkish maidens have been taught to fear?"

It was fear that had shrunk my *membrum virile*. Had we been caught together I might have lost the whole of that organ, if

not my life. I had no wish to be made a eunuch for the sake of my mistress's curiosity. But I had my pride, too. I remembered stories the Burgundians had told, of what they claimed to have done with Turkish captives. I thought of those Oriental maidens, and their fear of being ravished. Constantinople was full of women, but they were all hidden away. I pictured myself bursting into the sultan's harem, and seeing his wives disporting themselves half-naked.

And as I imagined those things, my *membrum virile* began to swell. Her eyes widened then. She bent over it, inspecting its protruding end and unfamiliar flap of skin. Under her gaze, my member grew more, but its growth was temporary. Somewhere behind us a door slammed, and a gust of wind blew into the room.

Zelmi said nothing, and had no need to say anything.

I bent and grabbed my trousers, hoisting them to my waist, fastening them as best I could before stepping to the floor. Fortunately, Turkish trousers are loose, and my subsiding member disappeared into their folds, joined by the tails of my voluminous shirt. I grabbed my work from the floor, spread the papers on the desk, and squatted behind it. I was still pushing and tugging my clothes into order when Halil entered the room. He must have heard the swish of Zelmi's gown as she left, just ahead of him by the other door, even if he did not see her. But he did not mention her.

"Have you thought about our last conversation," he asked.

"I have thought of little else. Your words have inspired me."

Halil gave me a curious look, perhaps noting that my words exaggerated my true feelings. "If you have thought that hard, then perhaps you are ready to adopt Islam."

"Will I ever be ready for that?" I said in as sad a tone as I could manage. "I am too humble, too doubtful, too full of sin."

"No one is too humble," Halil said, sharply. "Islam is the universal faith, fit for slaves as well as emperors. And if you have sinned, that is all the more reason to offer yourself to God. If you thought to redeem yourself by fighting my people, then submission will be all the more worthy." He

stared for a while at my dishevelled clothing. "And as for your doubts, you know I am willing to deal with them. What could you possibly not be sure of, after all we have said?"

"It is the angels," I said.

"But we have discussed them before. There is no difficulty. Envoys or ambassadors: it makes no difference. So long as we do not think they rule. That would make them gods, and even your faith admits no more than one."

Halil was right. We had already exhausted the subject, but I raised new doubts and affected fresh misunderstandings until he tired of talking to me and left me to my work. His unpleasant smile seemed to linger in the air like Zelmi's perfume, long after he had gone.

Zelmi did not, as I hoped, forget our encounter. A few days later she summoned me to visit her in a room just off the women's quarters. Getting there was hazardous enough, even though she had made sure her husband was away and all the servants were busy elsewhere. I knew as I crept up the creaking stairs that there could be no secrets in that house, and that any knowledge would be valuable to those who had it.

I found the room and tapped softly on the door. Her voice commanded me to enter. She lay back on a low divan, her gown unfastened, her smock open to the waist, her drawers in a heap on the rug. Her girdle, slippers, and other things I hardly knew the names of, also lay by her feet. As I closed the door, she sat up, allowing her breasts to escape from their silky covering.

"At last!" she said. "Take off your trousers."

I unfastened the drawstrings, and allowed the loose trousers to slip to the floor. Despite my fear, I was already aroused, and she looked at me greedily.

"Well," she said. "You are certainly ready. I hope it will not be over too soon."

Finishing soon, and escaping from that room, was what I desired most earnestly. But I knew that leaving her unsatisfied might lead to worse trouble. I held back, not sure how to

approach my master's wife, who had over me the power of life and death.

"By the look of you," she said, "it has been some time."

"There are not many opportunities for one in my position."

"Then you had better make the most of this one."

She lay back and hoisted up the skirts of her smock, revealing all. I saw then that her *pudenda*, unlike those of any other woman I had seen, were hairless, though whether plucked or shaven I could not tell. I had heard of such things. In some towns in the West prostitutes were supposed to be shaven. But they were also supposed to dress humbly and distinctively, and few obeyed that law either. Among the Turks, it seemed, respectable women aped prostitutes.

Was that, I wondered, why Zelmi had made mention of my hairiness? Were Turkish men not hairy, too? They had beards and moustaches like other men, but as for the rest of them, I did not know. Not being a body servant, and not being allowed in the *hamam*, I had never seen a Turk naked.

Whatever the *membrum virile* of a Turk might look like, Zelmi's *pudenda* were naked and oiled, and as pink and folded as a rose. Had I seen such a thing before, the Secrets of Love might have been easier to discover, even without the chaplain's book. I remembered my time at Umberto's castle, and the pleasure those Secrets had brought. And I pondered my future. What lay ahead of me but slavery and humiliation? The Moslems believed that their Heaven was full of unclothed beauties. But I did not. Nor did I believe that my guilty soul was destined for Heaven. Whatever my ultimate fate, Zelmi lay before me there and then, naked and ready. I resolved to play my part like a master, not like a novice, and to give her what pleasure I could, in whatever way she wanted it.

"Get on with it," she said. "Or have you forgotten how?"

I knelt before her. I had not forgotten how. Zelmi shuddered when I touched her, but whether with pleasure of horror I could not tell. In my mind's eye, I was as handsome as I had been as a youth. But I knew that time, and slavery, had changed me. I was rough, hairy and unclean. I was older than

Zelmi, though nowhere near as old as her husband. My knees ached as I knelt, and I knew that, before long, my back would ache as well. To Zelmi, I realised, I must have been as ugly as Umberto's fool. Would she really let me share her pleasure? Or would I always be merely a slave?

With hands still rough from shifting the rubble of the ruined city, I began to knead her flesh. Zelmi moaned and wriggled, spreading her legs wider. She urged me on, using words I did not know. Remembering what Aeneas had once said about language and geography, I explored, mapping out new territory. She was clean, smooth, anointed and perfumed. Aeneas had been keen on women as well as languages. Perhaps each woman known forms part of a greater picture of womankind.

As I pressed on I roused Zelmi to such a state that she called out loudly. Fearing more cries, I held back, but she pulled me to her and urged me on. She had forgotten the danger we were in, and cried out again and again. She seemed more than ready, so I shuffled towards her, my knees rubbing on the carpet. She struggled up from her couch, looking down at me with dismay. Her eyebrows were thick and dark and met in the middle. To calm her, I renewed my caresses, being as gentle as I could. Then I pressed myself forward, ready to enter her. I was by then more than ready.

But she cried out even louder. "No!"

I held back. Surely someone must have heard her. I froze like a hare that knows a huntsman is near. But there was no sound outside, no commotion in the corridor, no delegation of servants ready to drag us off to their angry master.

Zelmi shuffled backwards, raising herself against the back of the couch.

"Surely, mistress, you wish me to bring the matter to a conclusion?"

I was aware that my phrase was clumsy, and that I sounded as though I was writing a letter for her husband, but I did not know the Turkish words for the deeds we were doing. Perhaps that lack of the right words was my undoing.

"Not like that."

"But how else . . ."

She looked with horror at my swollen member. "You must not bring that near me."

"But I thought you wanted . . ."

"It is horrible," she said. "It is unclean. I will not have it near me."

"I thought you liked it. You asked to see it."

"Only out of curiosity."

"But you asked me to . . ."

"Don't tell me what I asked. A slave's duty is to know what is really wanted."

It was as I feared. I was to be her slave and give her pleasure, taking none myself. I did as she commanded, then slipped away, sure that our liaison had not gone unnoticed.

There were many other encounters with Zelmi, afternoons when she summoned me and lay before me. She devised an etiquette that required me to kiss the floor on entering the room, then creep towards her, hardly raising my head in her presence. Sometimes she required me to exhibit my *membrum virile*, but only so that she could be roused to a state of fascinated horror by it. As a Christian, I was unclean, and my uncircumcised member was never permitted to be brought near her again. There were times when I wondered whether someone watched us through a lattice, just as I had watched Aeneas in London. But I saw no sign of it, and Zelmi was so keen on her own gratification that I cannot believe those sessions were intended to give pleasure to anyone else. She did not relent and let me share her raptures, but grew more careless, sending for me when others were around, so that I had to invent excuses for wandering the house. The merchant seemed blind to anything but his own pleasures, but Halil caught me more than once, and listened with cruel pleasure to my stories of mislaid documents and forgotten messages.

Zelmi's reaction to my hairiness reminded me of something Plethon had once said. He did not always talk about philosophy, but sometimes told me about the country lore of the Morea. I was surprised that someone like him would concern

himself with such humble matters, but he regarded rustic customs and beliefs as proof of the Greeks' antiquity and purity. Plethon listed old gods and their attributes, which he compared with the saints who had supplanted them, citing every similarity as evidence of Greek ingenuity and endurance. Just like their ancestors, the peasants understood that the gods were many and that the world was many-layered, despite what the priests told them.

I listened politely to all that, but what caught my imagination was his account of the monsters that, by tradition, dwelt in the mountains. In the wooded slopes and upland valleys, far above the hot plains I had campaigned on, there were centaurs and satyrs and other hybrid beasts, such as I had read of as a child.

"Surely they are not real?" I said. "Such creatures are just myths or travellers' tales."

Plethon, despite his blindness, had a way of looking at me, or seeming to, that made me feel stupid. "Reality," he said, "is complex. Perhaps satyrs and centaurs do not exist in our world. But if country folk know them so well, and if they have figured in stories and legends for centuries, then they must visit this world from time to time. Perhaps they live in a layer immediately below ours, just as the gods live above us. And it may be that they visit our world to guide us, just as the gods do."

"How can a shaggy man-beast guide us?"

"There are bad examples as well as good. We can be guided by both. Satyrs and centaurs are emblematic. They are, as you point out, both man and beast. They consist of a man's head and torso shackled clumsily to the hindquarters of a goat or horse. Curiously, they are all male, and their male members are monstrous. The important thing is that their upper halves are human, their lower halves beastly. In that respect they resemble most men, who have the capacity to understand spiritual matters, but prefer an easy life of drinking, fighting and whoring. It is in our upper halves that reason resides, whereas our lower halves are full of lusts and passions. Centaurs and satyrs signify the beast that is in all of us."

It was hard to imagine the beast that might once have been in Plethon. His weak and shrunken body was easily dominated by the power of his mind. Even so, I thought I could see a flaw in his argument.

"Not all hybrid beasts are like that." I said. "There is the cynocephalus, with its dog's head and human body."

"The cynocephalus? That is not a Greek beast, despite its name. If it exists it must live far away, in the Indies or in Africa. But I am inclined to think it does not exist. It would be too paradoxical. There are examples of centaurs doing noble deeds, being led by their human heads, even if they were usually dragged down by their lusts. But a beast like the cynocephalus would have no opportunity to be anything but a beast. It would have no thoughts, only appetites. Few men, even the Latins who have done their best to destroy the Hellenes, are as debased as that."

As a slave in Constantinople I was as debased as anyone. Despite my skill in languages, a skill that, according to Aeneas, marked me out as fully human, I was dragged down to the level of a shaggy half-beast.

I was determined to be a man again, not a slave. I had to get away from that house, from Zelmi's demands, and from the attentions of Halil. But how? I was not closely guarded, but that was hardly necessary. Having no possessions, not even outdoor clothes, I lacked the means to buy my freedom, or to escape. The only thing I owned was Plethon's book, which he had charged me with having copied. There was little chance of my reaching Germany, where such things could be done. Even if I were freed, the sultan might reach Germany before I did, after his victories in Hungary. The *Book of Laws* had protected me, I thought. But it had also become a liability, leading me into dispute with Halil, who would surely not wait much longer before obliging me to convert. Getting rid of the book might be a good thing in itself, even if it brought me nothing. It was unique, and embodied Hellenic wisdom, and I had often wondered whether it was valuable. Perhaps there was a market for such things, among those who valued philosophy.

There was, I remembered, a quarter by the Golden Horn, where Greeks still lived. I had looked down at it, sometimes, when I worked at clearing the ruins above, and envied those who had avoided slavery by surrendering. While I was running from the walls, desperate to hide and save myself, the inhabitants of that district were handing their keys to the Turks. Unlike the foreigners who fought for them, those Greeks had retained their privileges. Merchants traded by the waterside, some of them with my master. Perhaps one of them would buy the *Book of Laws*, and give me the means of escape. If not, I would throw the book into the waters of the Golden Horn, and be free of its influence.

One afternoon, when all was quiet and no one watched me, I slipped away from my desk. I already had the *Book of Laws* tucked inside my shirt, and I hoped it would protect me, even though I planned to get rid of it. If the book really did have a spirit of its own, as I sometimes suspected, it would preserve itself. At the door, I stole my master's cloak and wrapped it round me. The days were growing cold then, and if I did not return by nightfall I would need its warmth. The cloak was long enough to cover my slave's clothes, and the indoor slippers I wore. I also found a capacious hat and pulled it over my head, carefully pushing my hair under it to conceal the fact that my head was not shaved all around like a Turk's. I was not sure whether my disguise was adequate, or how I would represent myself if stopped.

I stepped into the forbidden street without being seen, and made my way to the Golden Horn. It was not far, and in the brief time it took me to walk down those narrow, sloping lanes, I felt a mixture of fear and hope. I was almost free. And yet, if I was caught, I was almost dead. Glimpsing masts and water through the gaps between the houses, I fixed my thoughts on freedom. Pera lay just across the water, and the Genovese still traded there. Reaching it would be a first step to escape.

Along the waterside were boats, boatyards, timber merchants and rope-makers. Nearby were chandlers selling all the things needed by sailors and fishermen. They were no use to

me, unless I had the means to pay for my passage away from the city. I quartered the district, searching it as though for a lost hound, crossing and re-crossing it until I found what I needed. Huddled by an old church, one that had survived the conquest and not been turned into a mosque, was a small shop that sold books. I pulled the merchant's cloak around me and went up to it. There was a hatch with a few saints' lives laid out for inspection. I knew from my time in Mistra that such works were cheap, and common. If that was all the shop sold, its owner would not be interested in Plethon's book. But I had to try.

I pushed open the door. There were more books inside, arranged on boards. Some of them had rich bindings, though they lacked the jewels that had once studded them. A few of the books were propped open to show their illustrations. There were icons, too, and a few carefully placed lanterns made their gold leaf shimmer and vermilion glow. Even though the *Book of Laws* was slim and undecorated, my hopes rose.

At the back of the shop two men were huddled over a big book, their faces lit by lamplight. One of them was tall and fair-haired. The other, the bookseller, was short and dark. The tall man had the book in his hands, and was anxious to get it away from its owner. But the merchant would not let go, and kept telling his customer how valuable the book was, pointing at its neat script and elaborate illustrations. As I drew nearer, I saw that it was indeed a fine thing, such as Umberto or Aeneas might have paid a fortune for. But the fair-haired man had evidently offered too little. I stood and watched them for a moment, hoping to learn something of how books are bought and sold.

When he saw me the bookseller looked up.

"What is it?" he said.

"I have a book."

"Who hasn't? The city is full of books. You'd think the Turks burned nothing. You'd think books bred in the darkness! People are always bringing me books. But as for books that are worth anything, that's another matter."

"This book is one of a kind." I knew that was not quite true, but was fairly sure that the priests of Mistra had destroyed the Greek version. I pulled the book from my cloak and offered it up. The bookseller took it reluctantly.

"I'll take a look," he said. He took the book and held it by the lamp. As he leafed through the pages, his bored expression changed to one of horror.

"No," he said. "No, I can't take this. It wouldn't be right. The patriarch . . ."

He threw the book back at me. "I'm busy," he said. "You'd better get out."

I felt a surge of resentment. The Greek had surrendered while I fought to defend his city. He had grown rich, by the look of his shop, while I had slaved for his conquerors. I was tempted to argue with him, to tell him that he owed me something, that he should give me a good price for the book, which I had rescued from the ruin of his country. But I could not say any of that without revealing who I was.

I pushed the book beneath my cloak and walked towards the door. The bookseller turned back to his customer and prepared to resume his bargaining. But the customer was following me. I stepped outside to find him right behind me, his fair hair tousled by the wind that blew across the water from Pera.

"What is it?" he asked. He spoke Turkish quite well.

"A Greek book, though it is written in Tuscan."

"Where did you get it?"

"In Mistra."

"Let me see."

I gave him the book, fearing that he would throw it back, like the bookseller. My chances of raising money for escape seemed remote. "Is it worth anything?" I asked. He tried to look unimpressed.

"A little, perhaps." His eyes told the truth. They burned with interest.

"More than a little, surely?"

"Perhaps."

"It is worth something, is it not?"

"I would pay you for it, certainly."

"How much?"

He reached beneath his cloak and pulled out his purse. Then he seemed to have second thoughts and pushed the purse back. "How much?" I said, reaching out to take the book back. It was growing dark. I was already in danger. Perhaps I should run back to the merchant's house and resume my place. With luck I would not have been missed. But the fair-haired man did not let go of the book.

"I will give you these coins," he said, shaking a handful from his purse.

I felt the cold metal fall into my hand. There was more money on my palm than I had seen for years. My master trusted me with his accounts, but was careful to keep his cash well locked up. I cupped the coins in my hand, and considered running. Then I looked at his face and saw the anxiety there. "It is not enough," I said, gripping the book more firmly.

"I will pay you these, also," he said, picking out a couple more coins. I could see he was desperate to have the book.

"More," I said. He upended the purse and poured the remainder of his money into my hand.

"That is all," he said, snatching the book and stuffing it under his cloak. As he did so I saw something at his neck. It was a cross, with a little emblem at its centre. I leaned forward and looked closer, just as he pulled his cloak shut and turned away. The emblem was a rose.

Behind me the bookseller was shutting up shop, his shutters slamming closed. I walked briskly to the waterfront. On the far side of the Golden Horn, lights glimmered in Pera.

"Row me across," I said to the first boatman I found, holding out the smallest of my new coins. The boatman looked at the coin, then at the darkening sky, then at the choppy water. Finally he looked at the coin again before snatching it from my hand. I felt the boat rock beneath me as I stepped in. As the boatman pulled away I looked back to the waterfront. There was no sign of the man who had bought the book.

I was half way to Pera, with the spray stinging my face, when I realised what the rosy-cross meant. Could he really

have been Rosenkreutz, the wandering German Plethon told me about? Or were there many of them, all wearing the same emblem like a knightly order? If it was Rosenkreutz, he had got what he wanted. And perhaps Plethon had got what he wanted, as well. The *Book of Laws* might well end up in Germany, and be copied by some mechanical contrivance. I had not betrayed him, I told myself.

By the time I reached Trebizond I had no money left. The coins the rosy-cross man gave me must have been cursed. Each one of them I spent took me further east, as though Anatolia was a river, and its current flowed away from Christendom. I struggled through wrecked lands and rebel emirates, passing myself off as a Turk or a Greek, until I reached the Black Sea coast. It was a soft, green, watery land, that reminded me of England, sharpening my appetite for home. There at Trebizond, Greeks still ruled, calling themselves emperors, and men of all lands gathered in the lee of the mountains, seeking shelter from the Turks. The Trapezuntines were rich, their churches and monasteries were many, and their women were beautiful. But no women awaited me, only Friar Lodovico.

Lodovico, I knew straight away, was a rogue. Seeing that I too, was not what I claimed, he almost admitted it. But he liked to dress up his scheme in lofty language, claiming the pope really had sent him East, and that he really could raise a great army for a last crusade against the sultan. As for being made patriarch of the East, he said, that was a minor matter that he was prepared to leave to the pope. Having delivered his troupe of ambassadors to Rome, he would happily retire to his friary if that was what the pope asked of him. But I could see that he was consumed by ambition, and would do anything to be made patriarch.

I made the most of my imprisonment, telling Lodovico terrible stories of my suffering, and showing him my scarred hands for evidence. I said nothing of the good treatment I had had later, my near conversion, or the trouble with Zelmi. I

thought my story might make the friar sorry for me, and more willing to help, but I was mistaken. He knew he had me at a disadvantage, and that I would do anything he asked. He offered me nothing but the chance to follow his instructions.

And that was an offer I was reluctant to accept. I did not trust Lodovico, and his scheme involved a long and risky voyage, by sea and land. However, even if I discounted half of what he told me, it was clear that the Turks, of one sort or another, prevailed throughout the East, and that there was no escape except by Lodovico's scheme. In return for meagre food and squalid lodgings, I helped him recruit the rest of the troupe, while he searched for a ship to take us north.

11 The False Ambassadors

I was sick and tired by the time we reached Rome. Lodovico's scheming caused us more difficulties than it cured, and I was exhausted by the constant effort of trying to seem a Scythian. I had held back when Lodovico first produced his chest of clothes, but he had found me a Turkish kaftan, a fur-trimmed waistcoat and some pointed riding boots. I wore them with a red felt hat that flopped over at the back like a Janissary's. To make myself look military, and support the story that my race was ready to fight the Turks, I tucked a curved dagger into my sash, and always carried a bow and quiver. I had grown a beard while among the Moslems, but Lodovico insisted that it be shaved off, leaving a long and drooping moustache, which, he said, was more Oriental. I felt foolish, but who was I to say that that was not what Scythians looked like? I was not, as I had at first feared, the most ludicrous of our company. That honour went to the two Greeks, who would have made themselves look gaudy if given friars' habits to wear.

Much to my surprise, we were received with honour in Venice. The doge and senators gave Lodovico gold, and received us all in a gilded palace. Knowing the prohibitions of eastern faiths, they fed us on creeping things from the sea, and watched to see which of us would eat them. According to the Trapezuntine, they were placing bets on us. Making fun of foreigners seemed to be a sort of sport among the Venetians. Even so, we might have lingered there had not the Mesopotamian ignored Lodovico's advice. He was found drunk in a brothel, babbling in a language he was not supposed to know. Lodovico, by disbursing some of the senators' gold, managed to persuade those present that they had witnessed a miracle, a speaking in tongues that foretold the conversion of the Moslems. He then led us quickly away, cursing the Mesopotamian for having frustrated whatever plans he had had in that watery city.

Lodovico tried to raise money wherever we went, but I think our winding route to Rome was also intended to make our arrival there an event to be anticipated by all who might be present to witness it. Whatever he intended, our progress through Italy was more like the wanderings of a troupe of jugglers and acrobats, who parade through each town to advertise their shows. Everywhere we went, the people turned out to watch us, gawping at our gaudy costumes, making ribald remarks they thought we could not understand. At each inn or guesthouse we had to act the part of foreigners, pretending not to know what the food was or how to eat it. The Trapezuntine and the Sinopite, being Christians, of a sort, did not fare too badly, wolfing down whatever they were offered.

I, in my Scythian guise, fared worse. I did not know how to be a Scythian, but I could make myself seem a Turk. To guide me I had the experience of my captivity and the example of the Karaman. I became his shadow. What he did, I copied, and what he did not do, I avoided. He would not sit on a bench or stool, but squatted cross-legged like a tailor. He washed at inconvenient times, demanding water when the rest of us felt no need of it, and prayed when it was time to sleep or make haste. Because of the Karaman's scruples, I was obliged to feign horror if pork was served, and refuse all wine, however much I craved it. At mealtimes he sat apart, and poked his food as suspiciously as one who fears poison, searching for forbidden things, as though one unclean bite would send him straight to Hell. And I knew that anyone who went there would be fitted with garments of fire, and tormented forever in heat and smoke, with only boiling water to quench his thirst. That was something Halil had told me about often, contrasting it with Paradise, where dark-eyed women waited to pleasure any man who adopted his faith.

I became so like the Karaman in outward things that I almost lost my identity, like the bathing merchant in the story Aeneas had told me. I had no wisp of straw that I could tie to myself, no reminder of who I was, no badge or emblem, marking me out as an Englishman, or as a Christian. On the contrary, I dared not reveal myself, or let anyone know my true

nature. Throughout our journey, I longed for the Karaman to forget himself. If we were served with a dish of plump faggots, or a stew of tripe and bacon, or spiced sausages in gravy, I willed the Karaman to reach out and spoon some of the unclean food into his mouth. Yet he never did, and I had to eat what he ate, while the others made great play of enjoying what we could not. Like a penitent or prisoner I often made do with bread and water.

I almost came to hate the Karaman for the way he overshadowed me. Yet I was bound to him by language. Lodovico forbade any of us to speak Italian, and warned us against Greek. Among ourselves we spoke a mixture of languages, a rich stew of Levantine tongues, a thieves' cant which would not be understood by other guests in the inns and hostels we frequented. The other ambassadors understood Lodovico well enough, and each other. But the Karaman affected not to understand anything except Turkish, and I was set to translate for him, which I did, as well as I could. Lodovico spoke to me, and I spoke to the Karaman, who listened with anger and said little in return.

I fully expected that when we reached Rome, we would slip in unnoticed and lodge in a backstreet while Lodovico schemed to get money for his proposed crusade. But I was wrong. Lodovico actually seemed to have influence with the papal court, and we were met some way off from the city and led, with all appearance of honour and respect, to the guesthouse of a monastery a mile or so outside the walls. It was a good place to stay, as there were no opportunities for my fellow ambassadors to make fools of themselves. We waited for a week, sleeping in an airy dormitory on beds of clean straw, playing dice and cards for money we did not have, despite the monks' disapproval, while Lodovico went daily into the city. After my lengthy travels, it was all I could have wanted, lacking only the company of women. But I knew it could not last. Each evening Lodovico returned, telling us about the arrangements he was making, lecturing us on our duties and deportment.

"We know well enough what to do," I said. "You have told us constantly, ever since we left Trebizond."

"In that case," Lodovico said, glaring around the dormitory, "why do some of you persist in behaving more like beasts than men? The guestmaster has had words with me. He says that you are eating a week's ration of meat each day. And quaffing gallons of wine. What sort of behaviour is that?"

"We are not monks," I said. The two Greeks nodded in agreement. "We are ambassadors, as you keep reminding us. I am sure the pope would wish us to be treated with hospitality."

"I know what you think," Lodovico said, fingering the wooden cross that hung round his neck. "You think I can't bring this off. You think we'll be caught, like we nearly were in Venice. Well, you've underestimated me." He glared around the room, daring any of the ambassadors to disagree with him. "The pope has agreed to receive us. Yes! His Holiness Pope Pius II himself!"

And so, a few days later, we tidied up our costumes as much as was possible, and assembled outside the monastery. We set off, mounted on fine horses provided by the papal stables, escorted by a cardinal and his entourage, and by youths dressed in fanciful costumes representing the four corners of the world. I was pleased to see that Lodovico could hardly stay in the saddle. He had to be supported by a couple of grooms, whereas I, despite not having mounted a horse for some time, was able to ride with ease. I began to think myself a true ambassador as we rode towards the Porta Maggiore, and, from their self-satisfied expressions, so did the rest of the troupe. The Mingrelian and Iberian puffed out their chests, showing off the fine waistcoats they wore, while the Armenian stroked his beard, which he had washed and combed that morning. The two Greeks took off their plumed hats, and waved them graciously at the crowd of Romans who lined the road. The Persian sat gravely, holding his conical hat high, allowing his spangled robes to billow in the breeze. But the Karaman, the only genuine ambassador among us, wore a fierce scowl.

At the Porta Maggiore, we were greeted by a deputation from the papal household. We had to hand over our weapons before entering the city, though the Karaman was most unwilling to surrender his sword. He said it had been given to him by his emir, and was a symbol of his office. He had to be calmed down by Lodovico with promises and presents. The papal master of ceremonies ordered us all into our places, then we set off across the city, escorted by a great horde of pages, heralds, and ceremonial shield-bearers. Their rich garments, I noticed, were soon befouled by the mud that splashed up from the city's unpaved streets. Velvet doublets and brocade copes were bedecked with filth as well as pearls, and cloaks and pennants trailed in the mire. It was a scene of wealth and squalor, just as my father had witnessed when the emperor came to London. But I, until someone saw through me, was an honoured guest, not a servant, and I wondered, as I rode, what my father would have thought of that.

When we reached the Vatican there was a great confusion as we and our escorts all dismounted and grooms rounded up our horses and led them away. There was much brushing down of clothes, readjustment of equipment, and forming up in ranks and orders. Then, despite our miscellaneous and uncertain faiths, we were ushered into St Peter's, where a great mass was celebrated. Apart from the Karaman, who would not enter a church, those of us who were not supposed to be Christians sat silently through the ceremony, while the others took part in as much as they felt able to.

Pope Pius II, wearing the three-tiered crown, his crimson robes gathered around him like a traveller's cloak, sat enthroned in the great basilica. His feet rested on a fine carpet that flowed down the steps of his dais like a river. Over his head was a canopy of cloth of gold that shone like the summer sun. It was impossible to imagine anything more magnificent. All around him were cardinals in their high, cleft mitres, priests in rich vestments, senators and courtiers dressed in costly velvet and brocade. There were friars of several orders, all competing in humility, and deacons and thurifers, and attendants of every sort, clothed so brightly and variously

that they seemed like birds or butterflies swarming among flowers.

Seeing the Vicar of Christ surrounded by the grandeur and wealth of the Church made me realise that Plethon had been wrong. Christianity was not finished. It was rich and powerful, and would not be toppled by philosophical quibbles. Perhaps the Greek Church would be overthrown by Islam, but not the Church of Rome.

I was glad I had got rid of Plethon's book.

I sat among that troupe of false ambassadors, watching the ceremony as though it was something I had never seen before. Observing the pope's splendour I was also reminded of my own insignificance, and of my sins. I had still not atoned for the sin of fratricide, and, in the course of not reaching Jerusalem, had committed a fair few other sins besides. Contemplating my imperfections in such a holy and powerful place, I was filled with awe and terror. I longed to rush forward and throw myself at the pope's feet, begging forgiveness for all I had done. Yet that was impossible. I was supposed to be a heathen, and any hint that I was not would ruin Lodovico's plans and risk all our lives. Even as a Christian, I would not have been allowed to get near his Holiness without going through all the rituals and ceremonies prescribed by his attendants and advisors. And there was, when I looked at them more intently, something unappealing about the pope's feet. They were malformed and swollen, poking out of the papal slippers like freshly risen bread, the toes hooked and lumpy beneath their covering of crimson velvet.

I turned my eyes away from the pope, and gazed about the basilica. There, among the papal dignitaries, was a party of Greeks from the Morea. I recognised some of them, who were dressed in the stiff court costumes they wore when attending the despot. Was the despot there as well? Had the Turks captured the Morea, or were Greeks in Rome to beg for help? I thought of the lands I had helped defend, and the house I had lived in at the foot of the slope of Mistra, and Maria, whom I had abandoned. What had happened to all the people and places I had known then? And what I wondered, would

happen to me if any of the Greeks saw through my disguise? I hung my head, covering my face with a hand, as though lost in pious thought.

As I sat in mock contemplation, another face filled my thoughts. It was that of the pope. Despite the lofty status of its owner, and the grandeur that surrounded him, there was something sympathetic about that face, and something familiar, too. As he sat there, above and beyond all other men, I felt that, if only I could tell him about my sins, he would understand and forgive. His face, full and round, serene, yet touched with pain, haunted me, and I felt that, in some strange and indefinable way, I knew him. It was not until after the mass and all its attendant ceremony, when we were settling into the new lodgings we had been given near the Vatican, that I realised who he was.

Pope Pius II was Aeneas Sylvius Piccolomini.

Aeneas had said, years earlier, that they might make him a bishop. Evidently they had done much better than that. I thought of the nights we had spent in inns and hovels, of the stories he had told me, and of the women he had taken his pleasure with. He must have left worldliness far behind him, and would hardly welcome my reappearance.

That evening, at our lodgings, Lodovico accused the Karaman of jeopardising our mission by standing on his pride and honour, and of drawing attention to our imposture by making himself seem different from the rest of us. The Karaman glared at me.

"You can tell Lodovico that I still have my pride and honour," he said. "I intend to behave like a true ambassador, even if I am surrounded by buffoons."

I translated the Karaman's words, but Lodovico had no answer. He turned his attention to the rest of us, pointing out all the trivial ways in which we had failed to look like ambassadors.

A few days later, Lodovico told us that we were to be received by the pope in person. We were to attend a session of the consistory, where we would be presented to the cardinals, and Lodovico would have the chance to report on the

situation in the East. Our task, Lodovico told us, was to support him in everything he did and said. We were to stand before the cardinals and declare the names of our rulers and countries, stating their willingness to send men against the Turks. If they asked us questions, we were to say as little as possible in response. Lodovico would translate and elaborate what we said, doing his best to impress our audience and press his case for being made Patriarch of the East. The ambassadors who could be acknowledged to understand Italian were carefully coached in the few words they were to allowed to speak, while the rest of us practised silent dignity and unspoken hostility to the Turks. The Karaman glowered very convincingly, though his hostility was clearly directed at Lodovico rather than Sultan Mehmet.

I wondered, as we prepared, whether we could hope to get through the audience without a slip. I was quite sure the pope would not recognise me. My Scythian disguise was impenetrable enough, and it was twenty five years since we travelled England together. And I could tell, from his squinting and peering, that his eyesight was poor, and that he was too vain, or too grand, to wear eyeglasses.

If I warned Lodovico of that danger, we might avoid detection, but I could not be sure of my fellow ambassadors. As the Karaman had hinted, the two Greeks might easily make fools of us all with their unseemly swaggering, or one of the Orientals might overdo the antics they had found it amusing to display on the journey. Lodovico himself might easily be caught out by a cardinal who knew more than expected of the East, or by one of the Morean Greeks, or even the Despot Thomas, if he was not still holding out in Mistra. I was not at all sure that I wanted to be there when Lodovico faced Pius.

During the night before the audience, as I lay sleepless, fearing recognition and exposure, the Karaman came to my bed and whispered to me in Turkish.

"You understand their language?" he asked. "The language of these Christians."

"Yes I do, but Lodovico has forbidden me to speak it."

"But you could if you had to?"

"Yes."

"Then I wish you to speak for me."

"About what?"

"About Lodovico's lies, and these false ambassadors, snoring all around us."

"I am false, too. You know that."

"True, but you might redeem yourself by speaking for me."

Who was the Karaman, I wondered, to offer me redemption?

"Who do you want me to speak to?"

"The pope, of course. He is the man I came to see, and he can help my master the emir, but not if I am mixed up with a bunch of tricksters."

"You want me to denounce Lodovico?"

"And the rest."

"I am not sure."

"If you will not speak for me, I will find another way. And you will be among the men I denounce."

"It needs some thought. Let me sleep on it, and I am sure the night will bring an answer."

The Karaman muttered something I did not understand, then crept back to his bed. But I did not sleep. His words had added to my confusion and anxiety. If I were to betray Lodovico, I would rather do it on behalf of a Christian power than a Moslem one. I tossed and turned, weighing up the dangers of speaking for him, and of staying silent.

After a while, when I had exhausted all the possibilities, I pulled on my clothes, and on the pretext of using the latrines, I slipped away from the sleeping ambassadors. I was not sure what I intended to do, and I knew that the Vatican, like Rome itself, was gated and guarded well.

I crept up on the doorkeeper, ready to strangle him if necessary. I was sure I could do it silently if he did not see me approach. But he was fast asleep, and I was spared from adding another sin to my account. I slipped quietly out of the door. As far as I could tell in the dim light, the street outside the hostel was empty. I walked along, quickly and confidently, as

though I had every right to be there. At the end of the street I turned the corner, and ran straight into a patrol. There were four of them, all dressed in papal livery, and bearing arms. Two of them held out their halberds, trapping me against a wall, while the others raised their torches to get a better view of me. They laughed when they saw my oriental costume, and I wished I still had my weapons, though they would have been little use against four men.

"It's one of those foreigners," a man with a torch said.

"And a queer-looking one at that."

"Can you imagine the likes of him fighting the Turks?"

"Being buggered by them, more like," the torch-bearer said. "They go in for that sort of thing, the Turks do."

"How do you know?" The other men sniggered.

"Everyone says so," the torch-bearer said, stepping quickly away from me. "Anyway, if you ask me, we shouldn't be giving good food and drink to heathens like him."

"How d'you know he's a heathen? He might be one of those heretics, like the Greeks."

"Of course he's a heathen!" One of the men reached out with his halberd and tweaked open the front of my kaftan, revealing the sprigged shift I wore underneath it. "Look at that fancy gown he's wearing."

"No Christian would dress up like that."

"He's a heathen all right."

"We can soon settle the question. Let's lift his skirts and find out if he's circumcised. That'll prove it."

They laughed at that, quite sure I could not understand a word they said. The halberd was still pointing at me, and I could not back away. Its bearer lowered it, then twisted the head, so that its hooked blade caught in the hem of my kaftan. I feared that, if I did not reveal my true identity, they might decide to liven up their night watch by roughing me up.

"As a matter of fact," I said, "I am a good Christian just like you."

The men jumped back, looking as startled as if a dog had spoken. "He speaks like a Tuscan," one of the men said. He pushed the torch into my face, forcing me against the wall. I

realised that I might have made a mistake, that they might think my sudden ability to speak their language a result of witchcraft or enchantment.

"Where d'you learn to speak like that," one of them asked.

"I learned it from His Holiness himself," I said, untruthfully. "When I served him in England."

"You learned our language from the pope?"

"In England?"

"When he was Aeneas Sylvius Piccolomini, and I was a young man."

The men withdrew, though they kept their halberds pointed towards me. They muttered among themselves, then turned back to me.

"If you served His Holiness in England, what are you doing here, dressed up like that?"

It was a good question, one I had asked myself repeatedly since arriving in Rome. "I serve His Holiness still," I said, "and have been on a mission for him to the East."

"What sort of a mission?"

"A secret one."

The guards were worried. I could see their foreheads furrow in the torchlight, and their bearing was less certain. I repeated my story, elaborating it with hints of urgency and rewards, hoping the guards might believe me and let me go. But they were clearly not convinced.

"Whatever kind of mission you say you're on," one of them said. "You can't wander about here at night like this." He turned to his fellow guards. "The best place for him is back in the hostel with the other foreigners."

"No!" I said, perhaps too anxiously. The men stared at me. "The one place I cannot go is back to the hostel. That would spoil everything." They still stared, holding their halberds and torches limply. "You must take me to His Holiness now!"

I was not at all sure that the pope would welcome me, but invoking his name seemed my best chance of getting away from Lodovico, and from those guards. I do not suppose they believed much of what I told them, but they grabbed my arms more gently than they might otherwise have done and

marched me away. I had to trust them, even though they were as likely to throw me in the Tiber as to lead me to the pope.

They took me to a gate and knocked on it loudly. Some more guards appeared from inside, and I was handed over to them. I had to repeat my story again, several times, before they showed any sign of believing me. They searched me carefully, making me take off most of my clothes, poking and probing for weapons or poison. They seemed satisfied, and allowed me to dress, but kept a close watch on me while messengers went to and fro inside the palace. Eventually I was brought a Bible, and made to swear that I was a Christian, that I had served Aeneas, that my mission was important, and that waking the pope was necessary. Then I was given a pen and paper with which to write a message. I daresay that, in my agitated state, what I wrote was barely legible. I feared that I might still be locked away as a madman. My story, I realised, as I waited in the guardhouse, was far from convincing.

But someone must have believed it, as the guards handed me over to a herald, who led me through a maze of passages to the papal bedchamber.

Aeneas Sylvius Piccolomini lay in the grandest bed I had ever seen, its canopy draped with enough silk to make a princely tent. He sat half upright, supported by cushions, covered with a thick eiderdown and a crimson silk coverlet with symbols of the Church picked out on it in gold. There was a puppy beside him, a tawny, silky-haired creature, which nuzzled his hand, licking it with a pink tongue. How many men, I thought, would be grateful for that privilege of freely kissing the papal hand.

As I entered, the pope gently pushed the puppy away, and raised my note from where it rested on the coverlet. A servant stepped forward with a lamp, and the pope made a pretence of reading.

"Come closer," he said, allowing the note to slip from his hand. I took a few steps forward, then stopped, but was nudged from behind. I continued, respectfully, until I reached

the pope's bedside. The puppy crept towards me, sniffing and snuffling.

"Thomas Deerham," Pope Pius said, looking again at the note. "I would never have known you. You have changed even more than I have. Yet it must be you. Who else would know that you had served me in England?" He struggled to raise himself up, and a couple of attendants darted out of the darkness to help him. "You were good at languages, were you not?"

"So it has been said, Holy Father."

"A useful skill. But how I wish it were not necessary! How much better it would be if all men spoke the same language and followed the same faith. But the Turks are too stubborn. And now that they have prevailed over the Christians of the East, they will be even more so. I have tried refuting their errors by logic, but they take no notice. Now it will be necessary to fight them." He slumped back on his pillows and lay silently for a while before speaking again. "So, you are Thomas Deerham. I remember you now. Do you recall the time my feet froze, after we landed in Scotland?"

"I have *some* memories of that voyage, Holy Father," I said. "Though much of it I have forgotten."

"Well," he said, stirring slightly, so that his attendants hesitated, wondering whether to help him again. "Look at me now. My feet never recovered from that freezing, and now I have such bad gout that I can hardly walk." His feet wriggled under the bedclothes, as though to illustrate his pain. The puppy slid off the coverlet and dived under the bed. I thought, not of Aeneas's penitent barefoot walk, but of the whipping he had had at Walthamstow. "However," he said, remembering himself. "I am no longer the man I was. I am Pius, not Aeneas."

"Yes, Holy Father, but I am your servant, as before."

"Then tell me, how do you come to be dressed in that absurd costume, in the company of Brother Lodovico and his ambassadors?"

I stood by the papal bed, recounting, as best I could, how I fought against the Turks and witnessed the fall of

Constantinople. As I spoke, the pope's puppy nipped and scrabbled at my ankles. My soft boots protected me, but the dog's attentions were distracting. How could I tell such a sad story when my feet were being used as playthings? Keeping my upper half as still as I could, I gave the beast a few gentle kicks, hoping to drive it away. It left me alone for a while, but then, just as was I describing how Constantinople had been sacked by Mehmet's army, I felt a warm wetness spreading over my feet.

"A tragedy," Pope Pius said, not noticing what his pet was up to. A mixture of emotions seemed to cross his face before he asked me his next question. "Did you bring any books or relics?"

"No, Holy Father, I brought nothing. I only just managed to escape."

"A pity. The Despot Thomas has promised me the head of Saint Andrew. If he ever gets here. And some interesting books have turned up among the refugees. But so few! It is terribly sad to think everything that was lost when the Turks sacked the city. Two thousand years of Greek civilisation! Libraries full of Plato and Aristotle, all gone!"

I thought of the well-stocked bookshop I had seen in Constantinople. Perhaps the Greeks told one story when they were selling, and another when they were buying.

"It could have been stopped," the pope said. "If the kings and princes of Christendom had sent enough aid. They promised everything, but they did nothing. Do you know what the Duke of Burgundy did?"

"No."

"Nothing. He waited until it was too late, then organised a great feast."

"A feast?"

"Oh, it was a sorrowful feast. The courtiers and their servants dressed up and acted out the tragedy. And the Duke got his master musician to compose a lament on the fall of the city. That will have scared the Turks! Knowing that the Burgundians sat around feasting and listening to sad songs!"

His Holiness told me a little more about how the princes of

the West had done nothing to support the crusade he had preached, then asked me for the rest of my story. I told him how I had escaped from the Turks and travelled west with Lodovico, and warned him not to believe anything the ambassadors told him, and to be especially wary of the Karaman.

"I had my suspicions, of course," the pope said. "There was something unconvincing about the men you came with. Some of them look more like rustic mummers than ambassadors. But I am grateful for your confirmation of what I already thought." He glanced at one of his attendants, who stepped forward and whispered in his ear. The two had a long, muttered conversation which I could not hear. "Now, Thomas Deerham," the pope said eventually, raising his voice for my benefit. "I must reward you. What would you like most?"

"What I would like most, Holy Father, is to return to England. I have not seen my native country for years."

The pope seemed surprised. "From what I remember, it is a wild and savage country, as well as a very cold one. But no doubt you would feel differently about it. I suppose it is quite natural that you should want to go back."

"There are some obstacles to my return."

"Such as?"

I gestured at my Scythian costume.

The pope smiled. "It is astonishing that anyone could have been fooled by such frippery," he said. "I think we can find you something more appropriate. Something in the Italian manner. That would make you a man of style in your own country, would it not?" He summoned a servant and spoke to him, giving him detailed instructions for my outfit. The servant looked me up and down doubtfully before departing. Having seen something of the Italian style as we travelled to Rome, I hoped what the servant produced would not be too extravagant. I had had enough of fancy dress and foreign disguise. I wanted to return to England as myself.

"I expect you will need some money for your journey," Pope Pius said, when the servant had gone.

"I would be very grateful for it, Holy Father."

"Then I will provide you with some." The pope spoke to his attendant, then to me. "You will be given it with your new clothes."

I suppose our interview was meant to end then, but something nagged at me and made me linger there, ignoring the stares and polite coughs of the pope's attendants, who were clearly indicating that I should withdraw. When the pope spoke again, it was not about me or my story.

"Where is my pretty little Musetta?" he said." Where has she gone?"

The attendants began to search, looking under the bead and chairs, elbowing me aside and glaring at me. But there was something else I wanted to say, and I stood my ground.

"Why can't you find her?" Pope Pius said. "Kennel-man! Where is my kennel-man?"

There was some hurried talk among the attendants. I heard footsteps and shouts. Then a hunched old man limped into the room. He was just a shape in the shadows, his head bent, his feet dragging. He stood for a moment at the edge of the circle of light from the pope's lamp. Then he raised a hand to his mouth and began to make noises. They were strange, mewling sounds, unlike those made by any real beast. But the puppy knew its keeper and crept out from wherever it had been hiding.

"Bring her to me!" Pope Pius said. "Bring me my pretty Musetta!"

The old kennel-man stooped stiffly and grabbed the puppy with one hand. "I have her, Holy Father," he said. Though cracked and old, there was something familiar about that voice. He shuffled towards the papal bed, his head respectfully bowed, the puppy held in his crooked arm. Then, when he got near the lamp, I saw his face. There was a prominent nose, bulging eyes, and unshaven but unmistakable, a chin cleft like a pair of buttocks.

It was Umberto.

Already weak and unsteady, I almost toppled with the shock of seeing him again after so many years. I stared in

disbelief, wondering how he came to be there. He stared back, surprised by my attention, his eyes dull, his face uncomprehending. He showed no sign of knowing me. Safe in my Scythian disguise, I felt triumphant. Umberto had been a great fighter, a stern leader, and a ruthless seeker of fortune. Yet he had failed, and was broken, both in spirit and body. All that was left to him was his love of dogs. The man who had once had the power of life and death over me had ended up as a papal kennel-man. I could not say that my life had been successful. But I would do better than Umberto. Soon I would have some money and a new suit, and be on my way to England. There was just one more thing I needed.

Umberto lowered Musetta onto the bed, then shuffled back into the shadows. The puppy scrambled over the silk coverlet to her master. Pope Pius patted his pet, then looked up, surprised to find me still there. A couple of his attendants, seeing his look, advanced on me. Before they could grab me and escort me out, I spoke again.

"There is one more thing," I said. "Something that prevents me from returning to England."

"And that is?"

"A sin. A very great one."

"And you are guilty of this sin?"

"I am, Holy Father."

"You had better tell me about it."

I stepped closer to the papal bed, wondering whether I should kneel. Pope Pius gestured to his attendants, who withdrew to the corners of the room, out of earshot. Remembering how, when he was known as Aeneas Sylvius Piccolomini, the pope had entertained me with stories, I told him what had happened to me after leaving his service, ending with my killing of my half-brother.

"Well," he said, when I had finished. "That is bad enough. There are few worse sins than fratricide. But I daresay you were provoked. And you have served me well, both then and now. And you have tried to absolve yourself with a pilgrimage." He paused, closing his eyes for a while, so that I feared he would fall asleep, leaving me standing there.

"Holy Father," I said. The papal eyes opened. "I wish to be free of my sin."

"Who does not, Thomas. I expect you would like an indulgence."

"I would."

I waited, swaying backwards and forwards with the effort of standing still.

"Not now," he said. "I am tired."

After that, Pope Pius pulled his eiderdown up to his chin and settled back as though there was no more to be said. He did not ask me to withdraw from his chamber, or give me any other instructions. Instead, he drifted off into sleep. The puppy slept too, whimpering and twitching.

I wanted to lie or sit down, but the only chairs in the room were too grand for any but the papal posterior. I did not feel that I could take my ease on the couch at his bedside without being invited to, and there were no truckles or pallets such as servants might have slept on.

I stood for nearly an hour, shifting from one foot to another, reflecting on the circumstances that had brought me to the pope's bedchamber, and wondering what had brought Umberto so low. As Aeneas himself used to say, when the Wheel of Fortune raises one man up, another is dashed to the ground. Umberto had clearly been crushed. Did that mean that I was to be raised up?

I could not tell whether the pope really was asleep, or whether he was just teasing me. One or two of the servants were definitely asleep, and snored quite loudly. I thought I would be left there all night. I wanted to get away from that bedchamber, away from Rome and Italy. I wanted to speak English, and only English. And just as I had that thought, English was what I heard.

"Come with me," a voice said from behind me. It was a herald, but not the one who had led me there. "There is a room prepared for you. It would not be wise for you to return to the hostel."

I followed him, hardly seeing the narrow twisting passages we walked along, until we reached a door. The herald pulled

out a key, opened the door and gently guided me in. I could see nothing in the darkness, but I felt a bed ahead of me. Gratefully, without even pulling off my wet boots, I collapsed onto the bed and fell into a deep sleep.

The knocking that woke me wove itself into my dreams. It was the sound of men breaking down a castle door, it was blocks and spars falling from the rigging of a foundering ship, war hammers piercing steel-clad heads, the cantering of centaurs, Bashi-Bazouks axing a palisade, the stamp of horses' hoofs and the thundering of Turkish guns. Then the door opened, and the herald came in followed by a servant bearing bread, cheese and wine.

"Am I to see the pope again?" I asked, as I tore at the bread.

"His Holiness is rather busy today," the herald said. "There is a session of the consistory, and some ambassadors to receive." He smiled. "But I daresay he will find time to see you eventually."

"What will happen to me in the meantime?"

"You must remain here. The room is quite comfortable. And you will be fed regularly."

The herald and servant withdrew, leaving me to finish my breakfast. I heard the lock turn as they left, and wondered again about my fate. I feared nothing from Umberto. He did not know me, could not see in me the boy who had once tricked his fool. The pope knew who I was, and remembered that I had done him a service. But that might be no guarantee of my safety. Lodovico was a good talker, and might persuade Pius that he was genuine despite what I had revealed.

I lay for long hours, thinking and dozing, eating the food I was brought, watching the sunlight slowly sweep across the wall. The window was far too high for me to see anything out of it, though it indicated the passage of time well enough. Sometimes the herald returned and questioned me.

"I have been asked to find out a little more of your story," he said. His accent was not that of an Englishman. I wondered how I would sound to my countrymen, after speaking other

languages for so long. Perhaps they would take me for the foreigner I had once pretended to be.

"Tell me," he said. "How, exactly did you come to be in Constantinople?"

I had already told Pius about my crime, so I had nothing to gain by concealing my attempts to absolve myself. While I told him about my imprisonment, my subsequent wandering and failed pilgrimage I wondered whether I had lived my life well or badly. I knew that I had sinned, and that only an act of penance could save my soul. The story I told the herald reminded me how unsuccessful I had been at that. The pope had mentioned an indulgence. I needed one to return to England, but would it really wipe away my sins? And had I lived so badly? Aeneas did not seem to think so, and he had been made pope, despite his sins. Had I lived more like a man than a beast? That was Aeneas's measure of a good life. Perhaps Pope Pius would tell me the answer.

After I had languished in the cell for a few more days a barber came to shave me. While he removed my oriental moustaches my spirits rose. I was obviously being prepared for another audience. Perhaps Pope Pius had drawn up an indulgence. If so, it would not be long before I was free to return to England with honour. I was brought a suit of new clothes, not the fashionable outfit I had imagined but a suit of papal livery. The parti-coloured coat, bright hose and velvet hat were laid out on the bed by a servant. Was I expected to go back to England dressed like that? Or was the suit just something to wear until my new clothes were ready? I put the livery on, grateful at least to get out of my Scythian disguise.

But I was not led straight to Pope Pius. Instead I was left in the cell for a few more hours, and watched the sunlight creep slowly across the wall yet again. When they sent for me it was night, as though our meetings could not be acknowledged, and had to be kept secret. My new livery was no more than another disguise, another way of concealing my true nature from myself.

Pope Pius received me in his chamber, though not quite in

bed. He was propped up on a couch, and wrapped in eider-downs. Musetta lay sleeping on his lap. Umberto stood meekly in the shadows, one of many servants who attended the pope that night. A footman ushered me forward, and urged me to kneel beside the pope. I kissed the hand he offered. It was damp, and smelled of dog. Despite that, kissing it was a great honour, which dispelled the anxiety I had felt earlier. As I stood up I saw that on the papal couch, half-hidden by the sleeping puppy, was a folded paper. It could only be my indulgence.

Pius asked me a few questions about my treatment since our first meeting, as though it was nothing to do with him. Then he pulled the paper from under his pet and raised it to his weak eyes. Musetta, disturbed by her master's actions, awoke and looked around.

"You were good at languages, I seem to recall."

"Yes Holy Father."

"What do you make of this?" he said, feebly waving the document at me.

I hesitated. Why was he asking my opinion? Did he mean me to take it from him and read it? Or was his question one of those that required no answer? I looked anxiously at the servant, but his face, illuminated from below by the lamp he held, revealed nothing.

"What are you waiting for?" the pope said, waving the paper again. "I want you to read it." Musetta scrambled off her master's lap and slid to the floor.

I held the paper near the servant's lamp, expecting to see a string of Latin formulae announcing the remission of all my sins. But the document I had been given was a poem.

"Well?" the pope said.

"It is a poem, Holy Father."

"I know that. And I know that it is in French, of a sort. What I want you to do is demonstrate your linguistic skill by reading it out loud."

I did as I was told. The verses were a lament on the passing of time and the ravages of old age, written in the person of an old woman who has lost her beauty. But it was written in the

language of the tavern rather than the high style that pleases courtiers. I hesitated to read some of the words out loud in the presence of the pope and his retainers. But I read on, through verses describing shrivelled limbs, wrinkled flesh, sagging breasts and blotched skin, which the pope, prematurely aged himself, seemed almost to relish.

"Indecent isn't it?" he said when I had finished. There was a faint smile on his dry lips. "But that is hardly to be wondered at. The author is in prison, and faces death."

"For his verse?" I asked. I had been saved from the gallows by reciting a few lines of Latin. Surely no poet could be so bad that he deserved a worse fate?

"No. For his crimes. According to the French, he is guilty of theft and murder, and perhaps even sacrilege. The poet claims the privilege of genius, as well as the benefit of clergy. But his accusers take the opposite view, that his verse exacerbates his crimes. I am expected to decide his fate." Pius paused for a moment, peering at me. "You read the poem fluently," he said. "You know the jargon. Can it be that you have associated with thieves and wantons?"

If the pope really did remember me, then he knew that I had, just as he had himself. But I said nothing. It seemed possible that he was teasing or testing me, perhaps still trying to remember who I was or work out what use I might be.

"Tell me," he said, reaching out and taking the poem from me. "What does *sadinet* mean?"

That was something I knew well. I suspected that Aeneas would have known the word, too, even if Pius pretended not to. "It means a woman's *pudenda*, Holy Father."

"I thought so! They wouldn't tell me. They just said the poem was obscene and ought to be banned like all his others. It seems to me that our prisoner-poet describes age and decay rather well, even if his language is indecorous. Should I condemn this Frenchman for telling the truth, just because the truth offends? Or, should the truth be suppressed when it conflicts with the interests of the state?" Pius was looking at me as he spoke, but I knew that he did not expect me to answer. "I wrote some stories once," he said. "Of course, I

have written many things, but it was the stories that attracted attention. They were stories about love. Some people said that what I wrote was indecent. Perhaps they were right, though it did not seem so at the time. But I was Aeneas then, not Pius. Whatever the truth, I have recanted and repented. There seems to be no reason why this French poet should not repent, if given the chance."

I was not paying attention to his words, which seemed to have little to do with me or my case. The puppy had found me, and was nipping my ankles again. I had no boots to protect me, only thin hose. I squirmed and kicked, trying to drive the slobbering creature away.

"What is the matter?" Pius said. "Is it my pretty Musetta? Is she bothering you?"

"No, Holy Father, it is a pleasure to be her plaything."

Pope Pius frowned. "She must be hungry," he said. "Kennel-man!" Umberto shuffled slowly forward. "Take my little Musetta away and give her something to eat. Something delicate, mind! Some breast of fowl, perhaps, or some minced veal."

Umberto was only a pace or two away from me. In the dim lamplight, I could see the shabbiness of his livery coat, the dog fur that clung to him, and the piss-stains on his hose. Feeling sorry for him, I bent and picked up the puppy, holding her out to him. Umberto looked at me. I could not tell whether he knew me, but he must have seen the pity in my eyes. He glared at me, grabbed Musetta roughly and bore her away.

"Gently, old man!" a voice said. It was not the pope, but who else would command Umberto? The voice spoke again. "Treat little Musetta well, or it'll be a dog's life for you!"

There was a tinkling sound as the speaker limped out into the light. He was as bent as Umberto, and as lame. But he was not dressed in papal livery. Instead, he wore a motley coat and a cap with bells. With an effort, he turned his face towards me. Then he swept off his cap in a jingling, ironic homage. It was Umberto's fool. Or rather, it was the deformed creature who had once been Umberto's fool. The grin he gave me, a

grimace that almost split his ugly face, told me which of them was the master now.

The fool stood silently by the pope's couch. There was no need for him to speak. I could well imagine all that lay ahead of me if I remained any longer at the papal court. I had to get away.

Pius had closed his eyes. He seemed to have forgotten I was there.

"Holy Father?" I said.

"Yes?" His eyes blinked open.

"There is one more thing."

"There is?"

"My indulgence. You promised . . ."

The fool watched keenly.

"Did I promise you an indulgence?" Pius said. "I think I merely speculated about your needs."

"What is the matter Holy Father? Have I misinformed you?"

"No. It was all exactly as you told me," the pope said. "The ambassadors are all false, every one of them."

"Will you have them all arrested, Holy Father?"

"No. I think not. I will send them on their way. They can tour the courts of the West, and drum up support for my crusade. It makes no difference that they are false."

"So my information has not helped you?"

"It has helped, though perhaps not in the way you intended."

"Will I have my indulgence?"

"An indulgence is not just a matter of drawing up a document. There is much more to it than that. I must be sure that you are genuinely contrite."

"You heard my confession, Holy Father."

"So I did. But you must prove your contrition. And I must prescribe you a good work."

"I attempted a pilgrimage. I joined a crusade."

"Attempted. That is the word. As I understand it, you did not actually reach the Holy Land. And the defence of Constantinople can hardly be described as successful."

"With respect, that was not my fault. As you have often observed yourself, the Turks might have been defeated had the princes of the West sent more troops."

"That is very true. That is why I am launching another crusade, a final one, to rid the world of the Turks and their false faith. And that is why you must stay here in Rome and serve me."

The fool grinned again, his stiff legs twitching with pleasure.

"How long must I serve you, Holy Father?"

"Until we have assembled all the troops we need. Until we have sailed for Constantinople. Until we have freed the greatest city in Christendom from the Turks."

Contemporary Literature from Dedalus

The Land of Darkness – Daniel Arsand £8.99
When the Whistle Blows – Jack Allen £8.99
The Experience of the Night – Marcel Béalu £8.99
Music, in a Foreign Language – Andrew Crumey £7.99
D'Alembert's Principle – Andrew Crumey £7.99
Pfitz – Andrew Crumey £7.99
The Acts of the Apostates – Geoffrey Farrington £6.99
The Revenants – Geoffrey Farrington £3.95
The Man in Flames – Serge Filippini £10.99
The Book of Nights – Sylvie Germain £8.99
The Book of Tobias – Sylvie Germain £7.99
Days of Anger – Sylvie Germain £8.99
Infinite Possibilities – Sylvie Germain £8.99
The Medusa Child – Sylvie Germain £8.99
Night of Amber – Sylvie Germain £8.99
The Weeping Woman – Sylvie Germain £6.99
The Cat – Pat Gray £6.99
The Political Map of the Heart – Pat Gray £7.99
False Ambassador – Christopher Harris £8.99
Theodore – Christopher Harris £8.99
The Black Cauldron – William Heinesen £8.99
The Arabian Nightmare – Robert Irwin £6.99
Exquisite Corpse – Robert Irwin £7.99
The Limits of Vision – Robert Irwin £5.99
The Mysteries of Algiers – Robert Irwin £6.99
Prayer-Cushions of the Flesh – Robert Irwin £6.99
Satan Wants Me – Robert Irwin £14.99
The Great Bagarozy – Helmut Krausser £7.99
Primordial Soup – Christine Leunens £7.99
Confessions of a Flesh-Eater – David Madsen £7.99
Memoirs of a Gnostic Dwarf – David Madsen £8.99
Portrait of an Englishman in his Chateau – Mandiargues £7.99
Enigma – Rezvani £8.99

The Architect of Ruins – Herbert Rosendorfer £8.99
Letters Back to Ancient China – Herbert Rosendorfer £9.99
Stefanie – Herbert Rosendorfer £7.99
Zaire – Harry Smart £8.99
Bad to the Bone – James Waddington £7.99
Eroticon – Yoryis Yatromanolakis £8.99
The History of a Vendetta – Yoryis Yatromanolakis £6.99
A Report of a Murder – Yoryis Yatromanolakis £8.99
The Spiritual Meadow – Yoryis Yatromanolakis £8.99

Memoirs of a Gnostic Dwarf – David Madsen

'A pungent historical fiction on a par with Patrick Suskind's Perfume.'
The Independent on Sunday Summer Reading Selection

'David Madsen's first novel *Memoirs of a Gnostic Dwarf* opens with a stomach-turning description of the state of Pope Leo's backside. The narrator is a hunchbacked dwarf and it is his job to read aloud from St Augustine while salves and unguents are applied to the Papal posterior. Born of humble stock, and at one time the inmate of a freak show, the dwarf now moves in the highest circles of holy skulduggery and buggery. Madsen's book is essentially a romp, although an unusually erudite one, and his scatological and bloody look at the Renaissance is grotesque, fruity and filthy. The publisher has a special interest in decadence; they must be pleased with this glittering toad of a novel.'
Phil Baker in The Sunday Times

'. . . witty, decadent and immensely enjoyable.'
Gay Times Book of the Month

'There are books which, arriving at precisely the right moment, are like life-belts thrown to one when one is drowning. Such a book for me was *Memoirs of a Gnostic Dwarf*.'
Francis King

'. . . its main attraction is the vivid tour it offers of Renaissance Italy. From the gutters of Trastevere, via a circus freakshow, all the way to the majestic halls of the Vatican, it always looks like the real thing. Every character, real or fictional, is pungently drawn, the crowds are as anarchic as a Bruegel painting and the author effortlessly cannons from heartbreaking tragedy to sharp wit, most of it of a bawdy or scatological nature. The whole thing mixes up its sex, violence, religion and art in a very pleasing, wholly credible manner.'
Eugene Byrne in Venue